THE SOUTHWEST

THE SOUTHWEST

GOLD, GOD, & GRANDEUR

PAUL ROBERT WALKER

PHOTOGRAPHS BY GEORGE H. H. HUEY

Canyonlands National Park, Utah

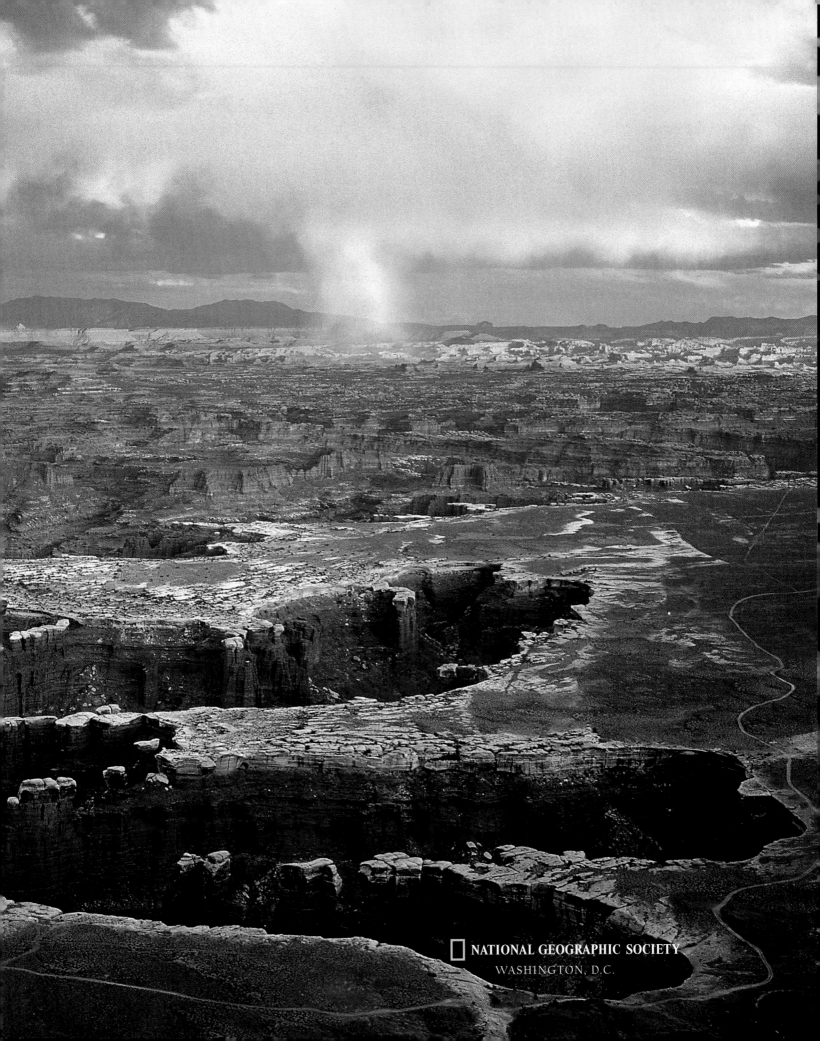

NATIONAL GEOGRAPHIC SOCIETY
WASHINGTON, D.C.

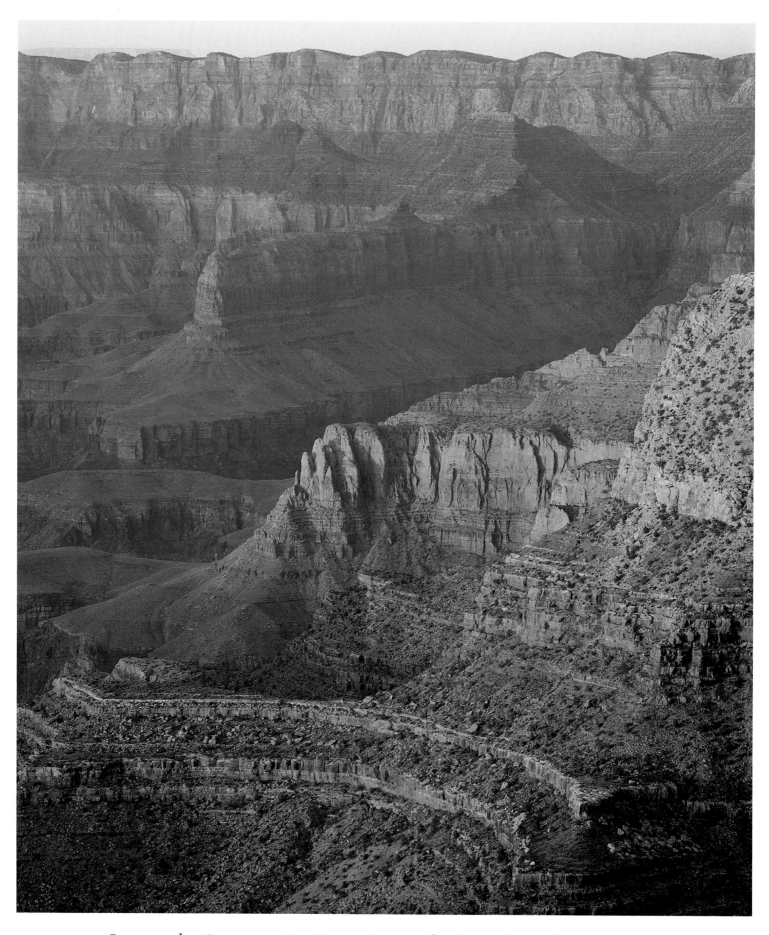

Grand Canyon National Park, Arizona

CONTENTS

AUTHOR'S NOTE

I FIRST SAW THE SOUTHWEST ON A MAD-DASH, SPRING-BREAK TRIP

TO TUCSON DURING MY SENIOR YEAR IN HIGH SCHOOL. WE LEFT CHICAGO AT NIGHT,

IN EARLY APRIL WITH PATCHES OF SNOW ON THE GROUND, AND FOLLOWED THE PATH OF OLD

ROUTE 66, WHICH IN THOSE DAYS STILL HAD BREAKS WHERE THE TRAVELER HAD TO

LEAVE THE INTERSTATE AND DRIVE THROUGH THE STREETS OF A TOWN. I WATCHED THE

SUNRISE IN MISSOURI, STEPPED OUT OF THE CAR AND STRETCHED MY LEGS IN OKLAHOMA.

IT WAS NOON, AND I HAD A PALPABLE SENSE OF BEING IN A DIFFERENT PLACE THAN

I HAD EVER BEEN BEFORE: NO SNOW ON THE GROUND, WARM SUN, AND PLAINS THAT SEEMED

TO STRETCH FOREVER. YET THE JOURNEY WAS ONLY BEGINNING.

We drove westward, through the Texas Panhandle and into New Mexico, reaching Albuquerque around dinnertime. There we left Route 66 and headed south, following—though I did not know it at the time—the route of Spanish settlers as they retreated in defeat after the Pueblo Rebellion of 1680. At dusk, we drove slowly through a sleepy New Mexican town, Truth or Consequences or Las Cruces, I don't remember which, but there was a magic in the warm, dry, evening air and an inviting kindness in the faces of the people as they sat outside their adobe homes, enjoying the air and watching the cars go by. We continued on through the desert in darkness, like many desert travelers before us, and by the time we reached Tucson it was so late that we could only pull into a vacant lot and catch a few hours sleep. Two police officers awakened us with orders to move on, but though we obeyed that morning, I knew I had found my place, not in Tucson specifically but in a broader and deeper sense: I had found my place in the Southwest.

Today I live in an inland valley of northern San Diego County, in a city called Escondido, "Hidden" in Spanish, a name that dates back to the pioneering 18th-century journey of Juan Bautista Anza, who carried a crude map showing a "hidden" river in southern California. Like most of the Southwest, it is a place of high, blue skies that stretch into heaven. A place

where Spanish is heard with English, where Anglos eat tacos and burritos while Mexican-Americans eat hamburgers and french fries, where Anglo men buy Tecate or Corona beer to celebrate Cinco de Mayo while Mexican men buy Budweiser. Surrounded by small Indian reservations, where native people find hope with gambling casinos that bring jobs and income where there were none before, it is a place where migrant workers stand on the corner waiting for low-paying day jobs while Border Patrol cars cruise the streets and helicopters interrupt the night.

Escondido is not unique, and I can testify to that for I have traveled almost 10,000 miles through the Southwest while researching this book, visiting places I write about, talking with people who live in those places and other places along the way. This book is a history, but I hope it's a history with heart, a history that captures the people who lived on this land before us and made this land what it is today. It is a history of three great peoples—Indian, Hispanic, and Anglo—who met in a land of stunning beauty and little water, and found ways to use and sometimes abuse the limited natural resources as they built a life for themselves and their families. Other groups have made important contributions as well, especially Asian immigrants and African-Americans, but the heart of the Southwest story is the conflict and commingling of three primary cultures, a story unlike any to be found in the history of our country, perhaps unlike any in the history of the world.

This story spans over 11,000 years of human history, and though my narrative is continuous from prehistory to present, a book like this must be selective in which stories are told. I have emphasized key moments when cultures arise, decline, or collide; points of con-

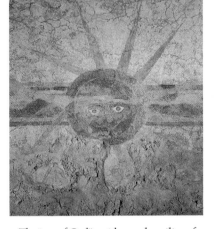

The "eye of God" resides on the ceiling of Mission Concepción along the San Antonio River—a single eye was visible until 20th century restoration revealed a full sun face.

flict and transition; events that brought change to the present and a new course for the future. I have also told stories that are representative of other stories that cannot be told and touched on tales that must be told because they are so deeply woven into the fabric of popular conceptions. In every story, I have emphasized the characters involved and the importance of the events for the larger picture of the Southwest.

Many people helped me along the way, and I thank them all, but I would like to offer special thanks to the following individuals who read portions of the manuscript, provided me with research materials, or took time to discuss important issues: Art Austin, Tombstone Courthouse State Historic Park; Susan Berry, Silver City Museum; Anthony Boldurian, University of Pittsburgh-Greensburg; Joanne Dickenson, Blackwater Draw Locality #1; Don Garate, Tumacacori National Historical Park; Matt Hillsman, Blackwater Draw Museum; Jolene K. Johnson, Casa Grande Ruins National Monument; Stephen H. Lekson, University of Colorado; Linda Martin, Mesa Verde National Park; Don McAlavy, Billy the Kid Outlaw Gang; Wallace L. McKeehan, Sons of DeWitt Colony Texas; David J. Meltzer, Southern Methodist University; Leon C. Metz, El Paso; Josh Newcom, Water Education Foundation; Luz Maria Prieto-Wilmot, San Antonio; Joe S. Sando, Indian Pueblo Cultural Center; Gregory Scott Smith, Fort Sumner State Monument; Herb Stevens, San Carlos Apache Cultural Center;

. . .and last, but never least, James Ridgley Whiteman who, though blind at the age of 90, could still see the past and evoke the exciting days when he explored the sand hills near Clovis, New Mexico, and found ancient spear points that led to a new and deeper understanding of the long, rich history of the Southwest.

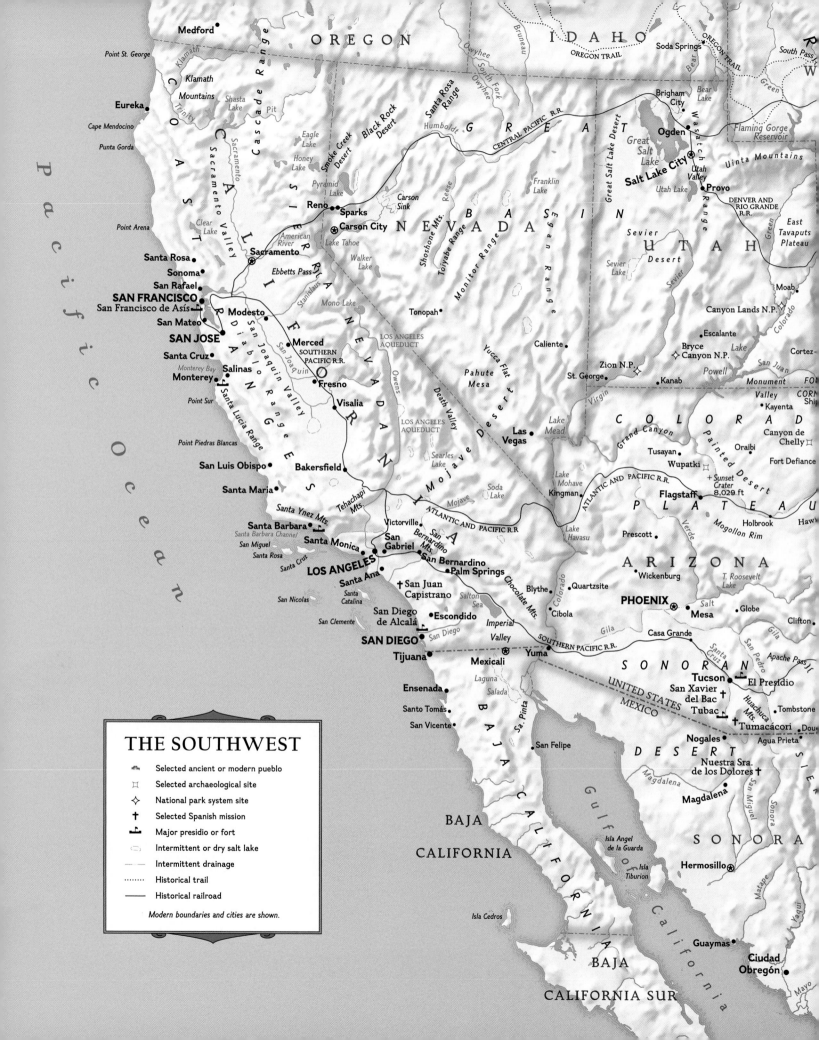

THE SOUTHWEST

- Selected ancient or modern pueblo
- Selected archaeological site
- National park system site
- Selected Spanish mission
- Major presidio or fort
- Intermittent or dry salt lake
- Intermittent drainage
- Historical trail
- Historical railroad

Modern boundaries and cities are shown.

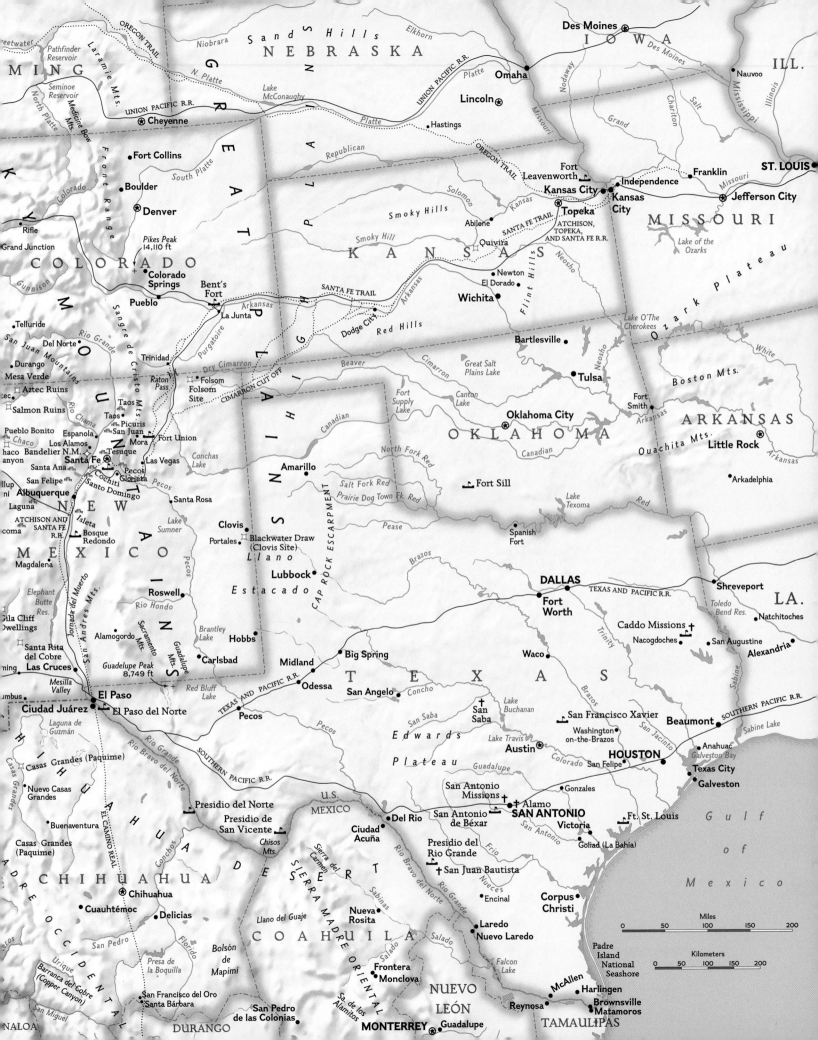

OLD ONES

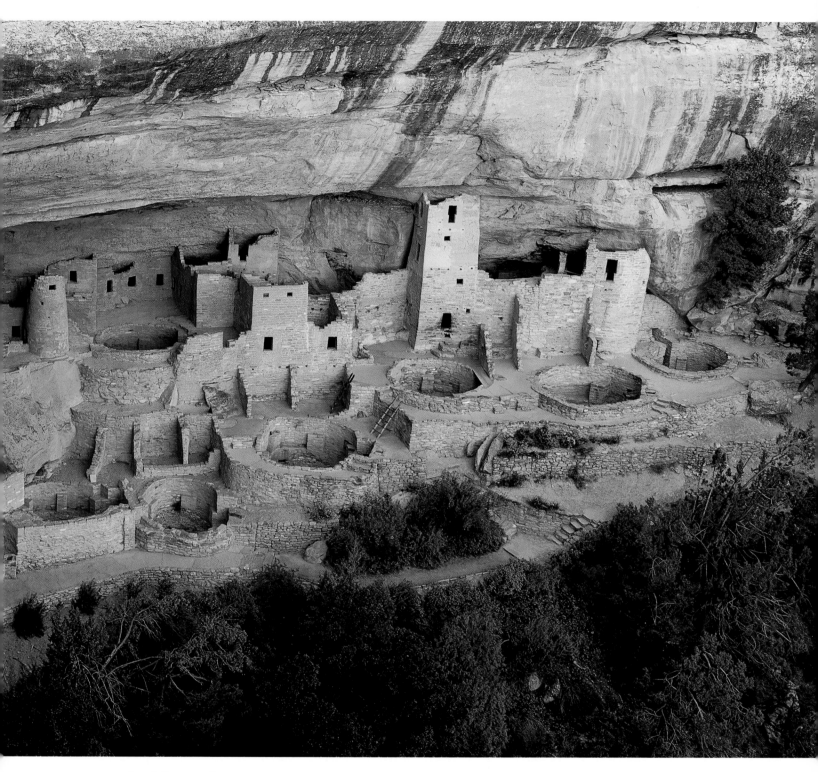

Cliff Palace, Mesa Verde National Park, Colorado

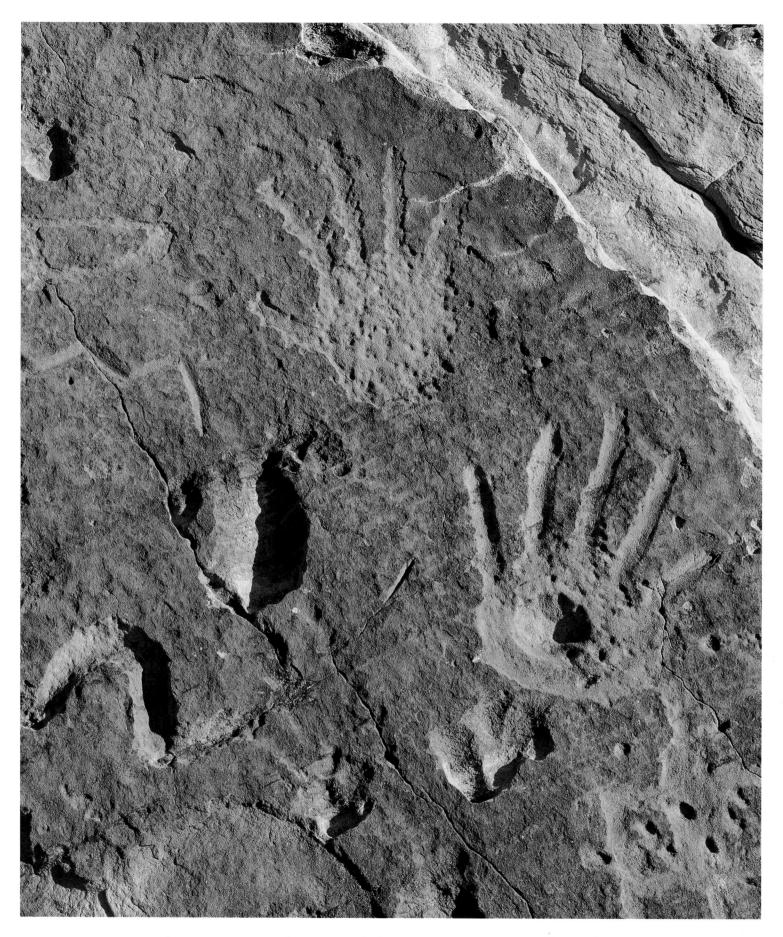

Ancestral Puebloan Petroglyphs

PREHISTORY - 1528

OLD ONES

On the evening of August 27, 1908, a hard rain pounded the valley of the Cimarron, a rough and broken rangeland in the desolate northeast corner of New Mexico Territory. Hispano pioneers had called this river the Cimarron Seco, or "dry Cimarron," for its unpredictable water supply, but now the river ran wild, wiping out the railroad bridge and half the buildings in the thriving town of Folsom. At least 17 people died in the flood, along with countless head of livestock, devastating the surrounding ranches. Folsom, which had once rivaled Fort Worth as a cattle center, never recovered.

Soon after the flood, a black cowboy named George McJunkin rode out to break a horse on the Crowfoot Ranch, about ten miles northwest of town. McJunkin was foreman of the ranch and the best all-around cowboy in northeastern New Mexico. No one in the county, maybe no one in New Mexico, could break a horse like George McJunkin in his prime. But he was in his 50s now, and his hard-riding days were over, so McJunkin took a young horsebreaker-in-training along to a place called Wild Horse Arroyo.

Normally the arroyo was only a few feet below the surrounding land, but the flood had cut through the bottom, and now it was ten or more feet deep in places, and the barbed wire fence that McJunkin had laid across the channel dangled uselessly in the air. While the cowboy studied the fence, wondering how he could fix it, he noticed something white sticking out of the arroyo wall. The bone looked as if it came from a

huge buffalo, bigger than any McJunkin had seen in a lifetime on the High Plains.

George kept that bone and other bones as well from what he called the bone pit. A man of intelligence and insatiable curiosity, George McJunkin asked questions about these bones of everyone he knew, but no one could explain them. The old cowboy died in 1922, never knowing that he had discovered a site that would forever change the way we look at the human prehistory of the New World.

IN THE LATE 18TH century Thomas Jefferson suggested that diversity among the Indians required "an immense course of time; perhaps not less than many people give to the age of the earth." The future President was pilloried for his opinion, and in the century and a half that followed—even as the age of the Earth was pushed back and human origins acknowledged as the glacial Pleistocene—

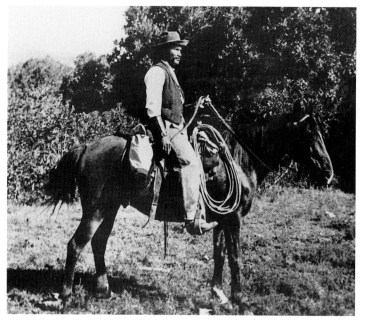

George McJunkin was born a slave in Texas but found his own brand of freedom as a cowboy. His discovery of the bone pit near Folsom, New Mexico, led to a major breakthrough in American archaeology.

the orthodox scientific community refused to grant the Indians more than two or three thousand years of history. Racism, Old World bias, and lingering biblical notions all played some part in this obstinate refusal, but the most powerful factor was that there was no undeniable evidence.

In the early 20th century George McJunkin's bone pit produced that evidence. On August 29, 1927, a friend of McJunkin named Carl Schwachheim, working under the director of the Colorado Museum of Natural History, uncovered a well-crafted spear point

stuck between the rib bones of an extinct large bison. Schwachheim had uncovered similar points before, each with a long groove or flute up the central axis, but this time he left the point exactly where he found it, in situ, between the bones. Eminent archaeologists quickly flocked to the site and agreed that the hunter who had made this point and killed this bison lived in the late Pleistocene, at least 10,000 years ago.

In early 1929, just 18 months after the great breakthrough at the Folsom site, a 19-year-old Boy Scout named Ridgely Whiteman, who lived 170 miles south of Folsom in Clovis, New Mexico, sent several projectile points he had found to the Smithsonian Institution. One of these had the characteristic fluting of the Folsom point, but the archaeologist the museum sent to investigate the windblown sand hills where the point was found missed the site's importance. Ridgely Whiteman persisted in believing he had found something significant. Unlike McJunkin, he saw the fruits of his discovery; he joined excavations in the 1930s that yielded not only further evidence of the Folsom people but also a deeper layer of soil where bigger, cruder, partially fluted points were found with the bones of ancient mammoths, evidence of wide-ranging hunters known as the Clovis culture.

The discoveries at Folsom and Clovis opened the floodgates to similar discoveries in the years that followed. Folsom sites have been found clustered in

the Great Plains, the region where the original points were unearthed; Clovis sites have been identified throughout North America with evidence of similar technology in South America as well, which suggests an adaptable and mobile people who spread rapidly through the New World. Modern radiocarbon dating places the Clovis culture at about 11,200 to 10,900 years before present (BP), which technically means before the radiocarbon baseline year of 1950. In fact, radiocarbon dates do not correlate directly with calendar years, and a current effort to calibrate radiocarbon dates based on tree-ring and coral dating suggests that the Clovis people may have lived some 2,000 years earlier, around 13,000 years ago. Either way, the development of the Clovis culture fits nicely with the opening of an ice-free corridor along the eastern slope of the Canadian Rockies a thousand years before the Clovis sites, allowing big-game hunters to move southward from the Bering land bridge into what is now the American Southwest and beyond.

Although it is romantic to see the Clovis people as fearsome mammoth hunters chasing great beasts across a wetter, colder landscape, the evidence from kill sites, including the original Clovis location (now called Blackwater Locality #1), suggests that they were opportunistic hunter-scavengers who waited at water holes where mammoths and other large mammals became mired in mud. Mammoth kills were rare events, and the Clovis people ate a variety of foods, including tapirs, sloths, camels, bison, rabbits, turtles, snakes, and plants. They were remarkably adaptable, surviving in widely disparate ecological settings—fitting forerunners for those who would follow them into a challenging and often inhospitable land.

As THE GLACIERS RETREATED, the Southwest climate grew warmer and drier, causing most large Ice Age mammals (including the mammoth) to die out in an extinction process that may have lasted several thousand years. Some scholars suggest that Clovis overhunting contributed to the ecological catastrophe, but this remains controversial. Whatever the cause, the Folsom people focused their hunting energies on one of the few large mammals that survived: an ancient bison several hundred pounds heavier than the bison of today, with horns a good foot longer. Though smaller than a mammoth, the bison was in many ways a more formidable adversary, wilder and faster on the hoof, running in great herds, more dangerous to a hunter on foot than a mammoth wallowing in the mud. The atlatl, or spear-thrower, used during Clovis times became essential to Folsom hunters, and instead of waiting at water holes, they drove the bison over cliffs or into arroyos.

The smaller, more finely articulated Folsom point was an adaptation to hunting this new quarry, but what role, if any, the fluting played in the new hunting strategy remains a mystery. Some scholars have suggested that the flute may have had ritual or artistic significance rather than practical application. Whatever its purpose, the long and carefully crafted flute is the mark of the Folsom people, found throughout the Great Plains from eastern New Mexico all the way into Canada.

Although fluting and the Folsom culture disappear from the archaeological record around 10,000 BP, bison hunting continued on the southern plains with unfluted points for several thousand years. West of the Rockies, however, in the deserts and dry basins where there was not enough big game to sustain a hunting culture, a new lifeway called the Archaic had begun to develop simultaneously with the bison hunters. In southern Arizona archaeologists date this period as far back as the end of the Pleistocene immediately following the Clovis period. On the plains the turning point came around 7500 BP (5500 B.C.), when a long, dry spell called the Altithermal pushed the bison north into present-day Wyoming, Montana, and Canada. This drought, which lasted an astounding 2,500 years, not only forced the remaining hunters on the southern plains to adapt Archaic lifeways that were already practiced to the west but also caused a gradual shrinking of the huge *Bison antiquus* into the smaller *Bison bison,*

which provided the main food source for Plains Indians in historical times.

The Archaic period saw a greater reliance on wild plants for food, developing a deeper knowledge of harvesting and plant preparation that would serve the Southwestern people well in their later transition to agriculture. Archaic sites are often marked by traces of baskets used to gather foods, grinding stones used to pulverize seeds and nuts, and coarse scrapers and choppers used to strip seeds from plants. The yucca root, which requires complex cooking and preparation, became a staple food in some areas. Smaller game such as deer, antelope, and rabbit supplemented the diet, but women who gathered and prepared plants contributed more to the food supply than did men. The new diet allowed population to grow. Though bands still moved with changing seasons and environments, these movements no longer ranged over the vast distances covered by the big game hunters of the Pleistocene. Language and culture diversified as specific bands began to consider specific areas and even specific campsites as home.

The Altithermal faded around 3000 B.C. As game returned to the newly watered land, an innovative, more lethal hunting point appeared, probably developed in coastal California and passing rapidly eastward across the desert valleys into the Four Corners region. There it is called the San Jose point. Triangular in shape with a stem at the base and sharply serrated edges, it was attached to a five-to-seven-foot light, springy shaft and hurled with deadly power by an atlatl. Deer was the most common game, but these darts were also fired at elk, antelope, bighorn sheep, and bison. The serrated point would rip a gaping hole in the flesh, causing deadly damage and leaving an easily followed trail of blood.

This new hunting technology, combined with more plentiful game and continuing development of plant processing, allowed further growth in population. All prehistoric population estimates are guesswork, but one scenario suggests that there were no

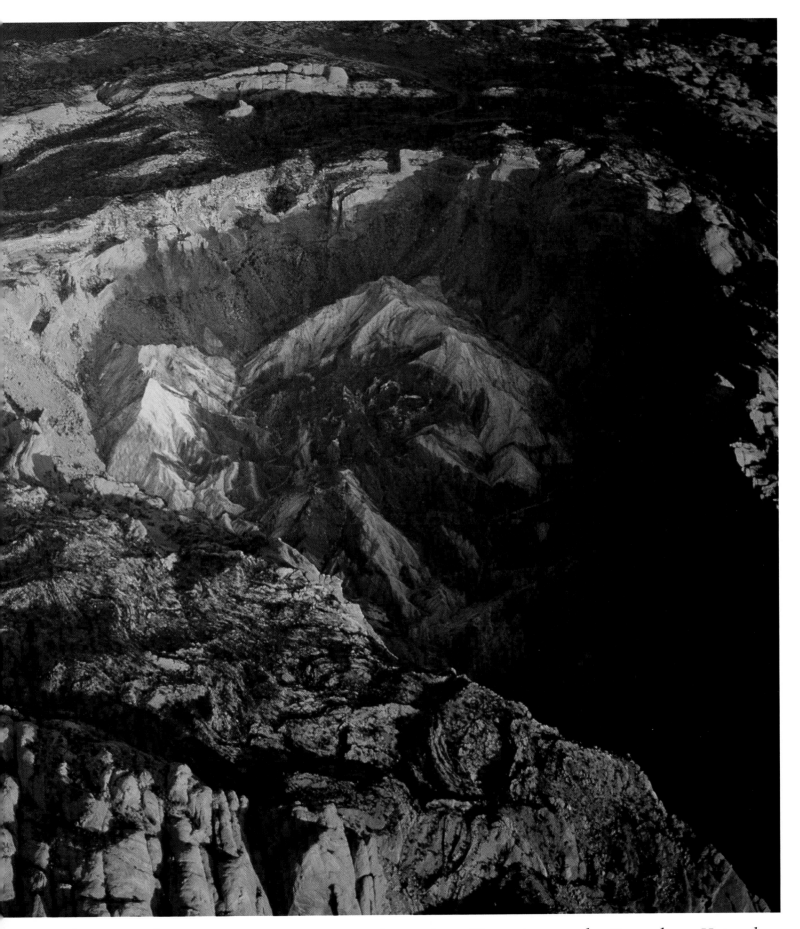

U p h e a v a l D o m e , C a n y o n l a n d s N a t i o n a l P a r k , U t a h

more than 2,000 to 6,000 people in present-day New Mexico during Paleo-Indian times and perhaps 15,000 to 30,000 at the end of the Altithermal, or one person for every four to eight square miles. A thousand years later, after a millennium of mild weather and continuing development, some desirable areas may have had as many as one person per square mile—hardly overcrowding by modern standards but enough to create pressure on a hunter-gatherer society.

The weather grew even wetter during the period from 2000 to 500 B.C., allowing the larger population to subsist for a time on available plant and animal resources. But no Southwest culture could depend for long on plentiful rainfall; sometime between 1500 and 1000 B.C. the Archaic hunter-gatherers began to develop a new, more predictable food supply. Corn, originally cultivated in Mexico, appeared in the Southwest at this time. Beans and squash followed over the next millennium. At first the effect of domesticated crops was minimal. Early varieties of corn were small cobs with tiny kernels, and corn of any variety is not a highly nutritious food. People who subsist on corn usually increase its nutritional value by soaking the hard kernels in lime water, followed by long boiling and grinding into mush—a complex process requiring ceramic cooking utensils and large grinding stones that the Archaic people had not yet developed. Still, the small, primitive corncobs, roasted whole and often burned on the fire, provided protection against starvation in bad times and a welcome supplement in good times. By 500 B.C., when drier weather forced innovations, these three staple crops—corn, beans, and squash—offered the Archaic people a path that would in time lead to highly complex cultures.

Agriculture requires a more sedentary lifestyle, but it is unclear which came first, the lifestyle or the agriculture. By the time corn arrived, some groups had already begun to settle into semipermanent villages on a seasonal basis, and this seasonal pattern fit naturally with the new lifeway. In the Santa Cruz River Valley near modern-day Tucson, Arizona, for example,

Archaic people who had once gathered wild plants along the river during the summer months now tended crops in the same general location, while migrating as they always had to hunt and gather wild plants in the nearby foothills during the rest of the year. A typical riverine farming village might consist of a dozen round pit houses, each about eight feet in diameter, built over a shallow hole in the ground and constructed of wooden poles and brush. Some villages also had a big house of more stable construction, as much as 30 feet in diameter, suggesting that the more sedentary lifestyle of the late Archaic people led to increased ritual activity and community interaction, one of the hallmarks of the cultures that followed.

POTTERY FIRST APPEARED IN THE SOUTHWEST around A.D. 200 in the mountains along what is now the Arizona–New Mexico border and the desert basins near present-day Tucson and Phoenix. Like corn, the technology of ceramic manufacture was transmitted by the more sophisticated cultures of Mexico.

Archaeologists call the mountain people the Mogollon for one of the ranges in which their villages and artifacts are found. From about A.D. 200 to 600 these people lived in small pit-house villages, usually on hilltops or ridges that could be easily defended. The wetter mountain region offered richer natural resources than the desert valleys or the Colorado Plateau. Although the Mogollon remained committed to hunting and gathering, small garden plots supplemented their diet and ceramics gave them the ability to boil corn into a mush or paste and make something similar to tortillas. The ceramic vessels protected their surplus corn in good years and kept precious seed corn safe for the next planting.

During the sixth century A.D. a more artistic pottery appeared, with red pigment decorating brown ceramic forms, and the Mogollon began to move their villages to mountain valleys where they could be closer to cultivated fields. While agriculture allowed greater population growth, they still depended on hunting and

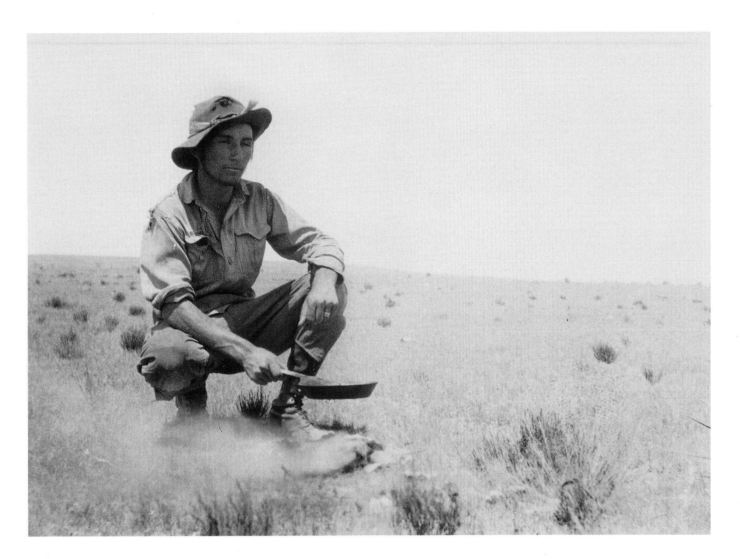

gathering for many foods and spent substantial time away from their villages. Still, the concept of village life developed in important ways. Their pit houses, originally round, now tended to be rectangular with a ramplike entrance and the larger communal pit houses became more formalized as ceremonial subterranean chambers—forerunners of the underground chambers called kivas, which would play a central role in the religious life of the Southwest. Non-Mogollon people, primarily the ancestral Puebloans, peacefully shared some villages, taking advantage of the rich mountain resources and exposing the Mogollon to their own rapidly developing cultures.

For the ancestral Puebloan people the Mogollon provided a conduit of ideas from Mexico. They brought the good news of pottery, they were the first to develop kivas, and they later brought news of spiritual beings

Above: Nineteen-year-old Ridgely Whiteman camps near the Pecos River in 1929, the same year Whiteman first wrote to the Smithsonian Institution with information about points he had found in sand hills near Clovis, New Mexico. The Smithsonian declined to investigate, but Dr. Edgar B. Howard directed excavations at Blackwater Draw between 1932 and 1937 under sponsorship of the University of Pennsylvania with Whiteman among his assistants. Below: A large stone point with the partial fluting characteristic of the Clovis culture, with two smaller points used by Archaic people.

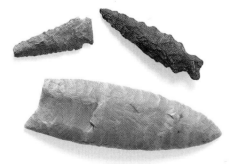

THE BEGINNINGS OF
SOUTHWESTERN ARCHAEOLOGY

On a snowy December day in 1888, Colorado rancher Richard Wetherill and his brother-in-law, Charlie Mason, were rounding up strays from their Mancos Valley ranch when they first gazed upon the ruins of Cliff Palace in Mesa Verde. From then, Richard Wetherill spent summers ranching and winters digging in the ruins of the Four Corners region, first at Mesa Verde, then at Keet Seel, and finally at Chaco Canyon. He gave tours and aided Swedish archaeologist Gustaf Nordenskjöld in excavations at Mesa Verde with the artifacts exported to Europe. In 1896 he began digging at Chaco, excavating almost 200 rooms before the federal government forced him to stop.

Richard Wetherill was not the first to dig in Southwestern ruins; Adolph Bandelier had begun extensive work on the Pueblo culture in 1880 for the Archaeological Institute of America, but his investigations were considered scholarly while Richard Wetherill was a freewheeling cowboy who gave precious artifacts to whomever paid his bills. Due to Wetherill and others like him Congress passed the Antiquities Act in 1906, which allowed the president to reserve public lands of historical or scientific importance as national monuments. By this time, a new aca-demic, yet field-savvy Southwestern archaeology was developing, personified by Harvard-educated Alfred V. Kidder, who combined Richard Wetherill's love of field work with the systematic approach of a scientist. Kidder's great field project was the excavation of Pecos pueblo, where the relatively long period of continuous occupation allowed him to refine stratigraphic concepts of late prehistory and early history.

In 1927, a former stockbroker and friend of Alfred Kidder named Harold S. Gladwin began excavations at Casa Grande; three years later young Dr. Emil Haury joined him in a frenetic search for the past. "There was no time to get bored," Haury recalled, "and not enough time to get one's work done. Any archaeologist truly interested in what he or she was doing would find the schedule fulfilling one's wildest dreams." In 1933, Gladwin and his wife, Winifred, formally presented the Hohokam as a distinct culture, but Emil Haury led the way to uncovering the secrets of the Hohokam while also identifying the Mogollon as a culture separate from the Anasazi.

In the meantime, a new tool emerged in 1929 when University of Arizona astronomer A. E. Douglass made a major breakthrough in dendrochronology, or

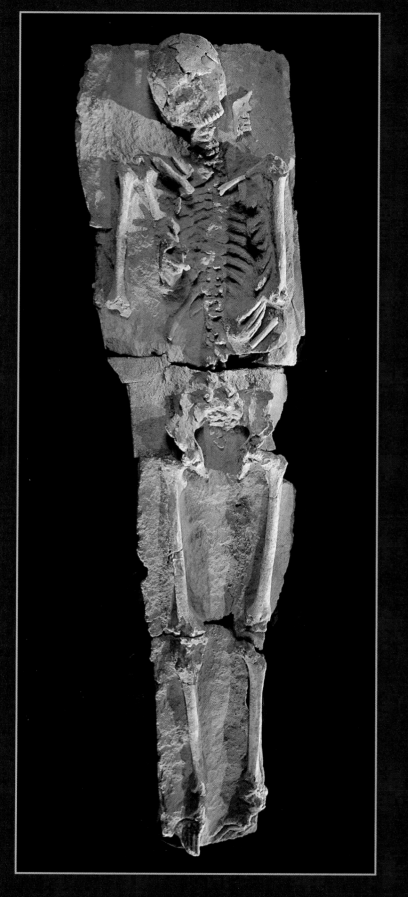

tree-ring dating, a remarkably accurate calendar based on the annual variation in tree growth depending upon rainfall and other factors. Douglass closed the gap between the historic tree ring sequence and the prehistoric sequence, thus creating a master calendar dating back into the ancestral Puebloan period. Today, tree-ring dating goes back some 11,000 years, providing an essential tool for dating archaelogical sites using pine and other woods that create a clear ring pattern. Some woods, however, do not work well with tree-ring dating and some desert sites have no wood at all. In these cases archaeologists must use less accurate methods, including radiocarbon, archaeomagnetic, and relative dating based on analyzing strata and pottery.

Radiocarbon dating, developed by Willard F. Libby during the 1950s, extends far beyond tree-ring dating, although the more accurate tree-ring system is used to calibrate radiocarbon dates when the two systems overlap. Even radiocarbon dating does not always work in the desert, and in the 1970s archaeomagnetic dating was developed, based on the position of iron in rocks relative to shifts over time in the Earth's magnetic pole. Today's Southwestern archaeologists, with these tools and more at their command, search for a deeper understanding, not just of who and when but why.

This skeleton of a young woman found near Arch Lake, New Mexico, is believed to be around 9,000 years old by standard, uncalibrated radiocarbon dating methods. Seventeen beads found with the skeleton may have signified her age.

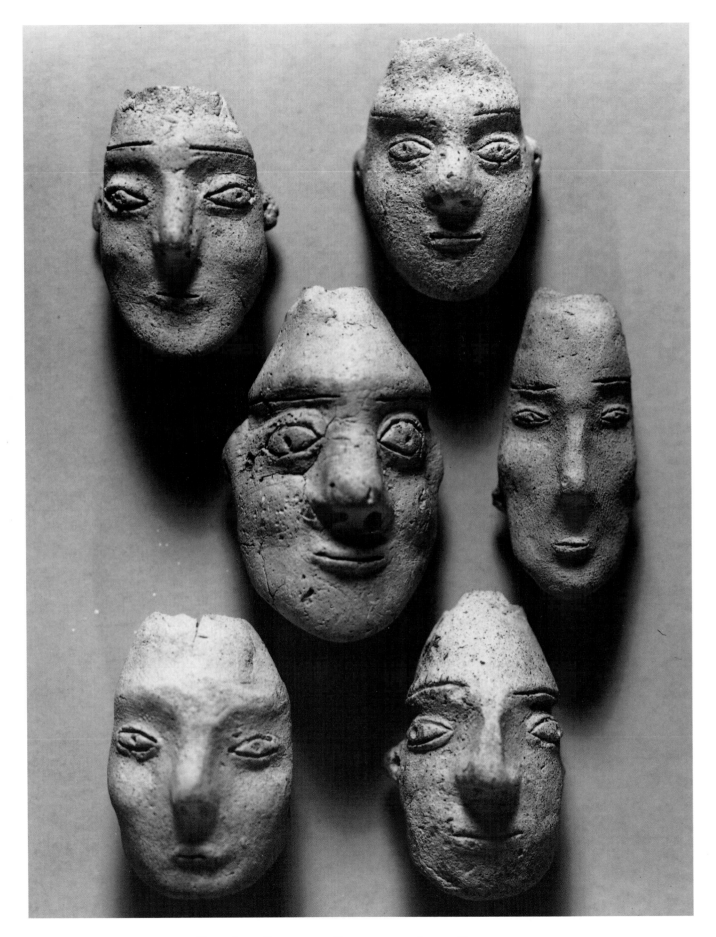

Hohokam Ceramic Faces

called kachinas who would form the heart of Pueblo religion. The most highly developed of the Mogollon people, the Mimbres, created beautiful black-and-white pottery with intricate designs that speak of a rich spiritual and mythological world. Yet even so, the Mogollon remain a mysterious and elusive people who all but disappeared into the dominant Pueblo culture; their more sophisticated villages and lifeways after A.D. 1000 are best viewed as an expansion of the emerging Puebloan society of the Colorado Plateau.

TO THE WEST OF THE MOGOLLON, in the desert of present-day Arizona, cultural progress after the development of pottery was so swift that some archaeologists believe new immigration from Mexico brought a more highly developed people who subjugated the Archaic natives. Others believe it was these late Archaic potters themselves who developed the new culture. In either case, between A.D. 300 and 500 a remarkable society had begun to develop called the Hohokam, from an expression in the Pima language meaning "those who have gone" or "all used up."

The Hohokam were lords of the Sonoran Desert, a land of endless sunshine and little rain. From a homeland between the Gila and Salt Rivers near present-day Phoenix, the Hohokam turned the desert into a garden by constructing a sophisticated network of irrigation canals—over a thousand miles in all, some as much as 50 feet wide, dug with stone tools and massive organized labor. Although irrigated farms were their most impressive achievements, they were also skilled hunter-gatherers, utilizing scarce desert resources with such careful efficiency that in some circumstances they would practice a "second harvest," cleaning and reusing undigested seeds from human waste. They developed exquisite pottery, a vast trade network, and an elaborate ritual life centered on raised platform mounds, sacred ball courts, and cremation of the dead.

Archaeologists divide the long, complex development of Hohokam culture into four periods. The earliest, called the Pioneer period, saw the first irrigation canals in the Gila River area, with floodwater farming along the Salt, the Verde, and the Santa Cruz. Villages were small, with simple square or rectangular pit houses constructed of mud, poles, and brush. The plain red pottery that marks the beginning of this period was augmented by more decorative vessels with painted red lines on a gray or brown base during the late 600s, and changes during the following century suggest rapid development or an influx of ideas from Mexico. Irrigation systems became more complex, craft items finer and more varied, and death rituals more elaborate. Ceremonial mounds covered with adobe began to appear, as did oval-shaped ritual ball courts, both patterned after structures and practices in Mesoamerica.

These developments led to a phase called the Colonial period, which lasted from the late 700s to 900s. By this time the Hohokam had mastered the art of desert survival. Their villages became more complex, organized into courtyard groups of two to ten houses, with a number of courtyards making up small villages; larger villages were even further subdivided. Public structures like platform mounds and ball courts were built on the edge of residential areas. Hohokam settlements spread throughout the Sonoran Desert. Hohokam traders reached even farther, bringing highly valued macaw feathers and copper bells from Mexico and shells from the Gulf of California, which Hohokam artists enhanced with what may be the first form of etching in the world. During the later Colonial period a beautiful red-on-buff pottery appeared, decorated with complex geometric designs as well as human and animal images. The ceramic forms themselves became more fluid and varied, ranging from spheres and graceful curves to stylized human and animal effigies.

Hohokam society continued to grow during the Sedentary period, from about 975 to 1150—a time of peace and prosperity aided by higher than average rainfall. The explosion of artistic creativity that marked the end of the Colonial period seems to have waned, though there were continuing artistic developments, including black designs on a white-and-red base that may be the

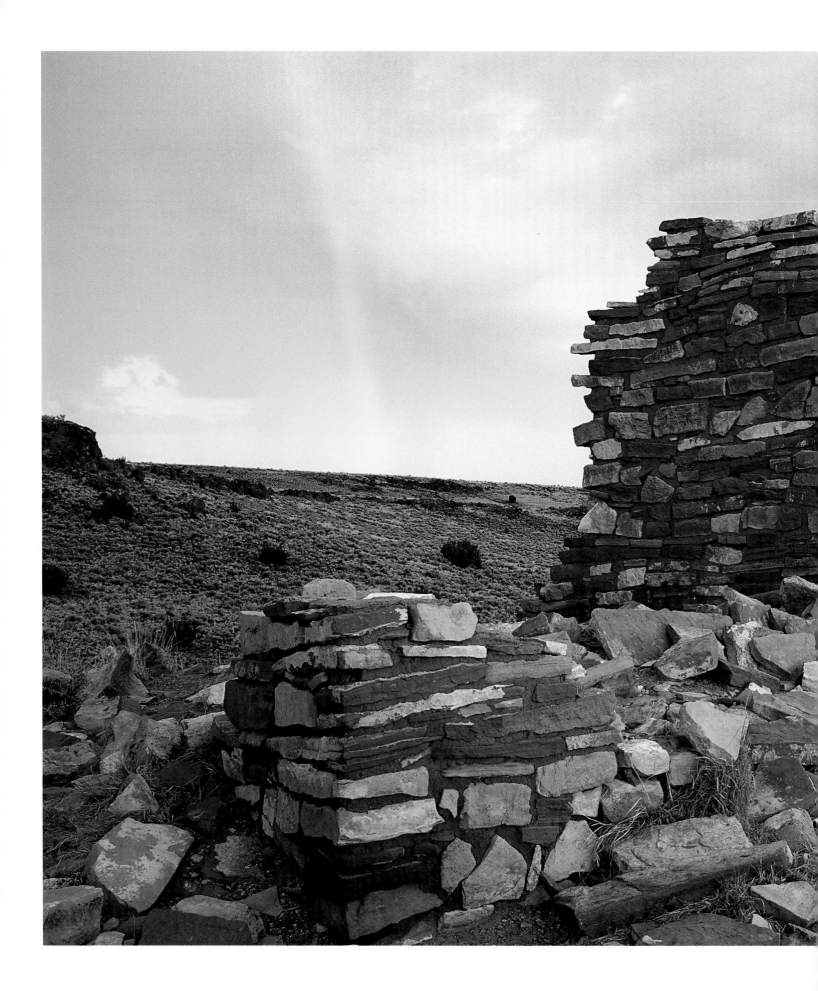

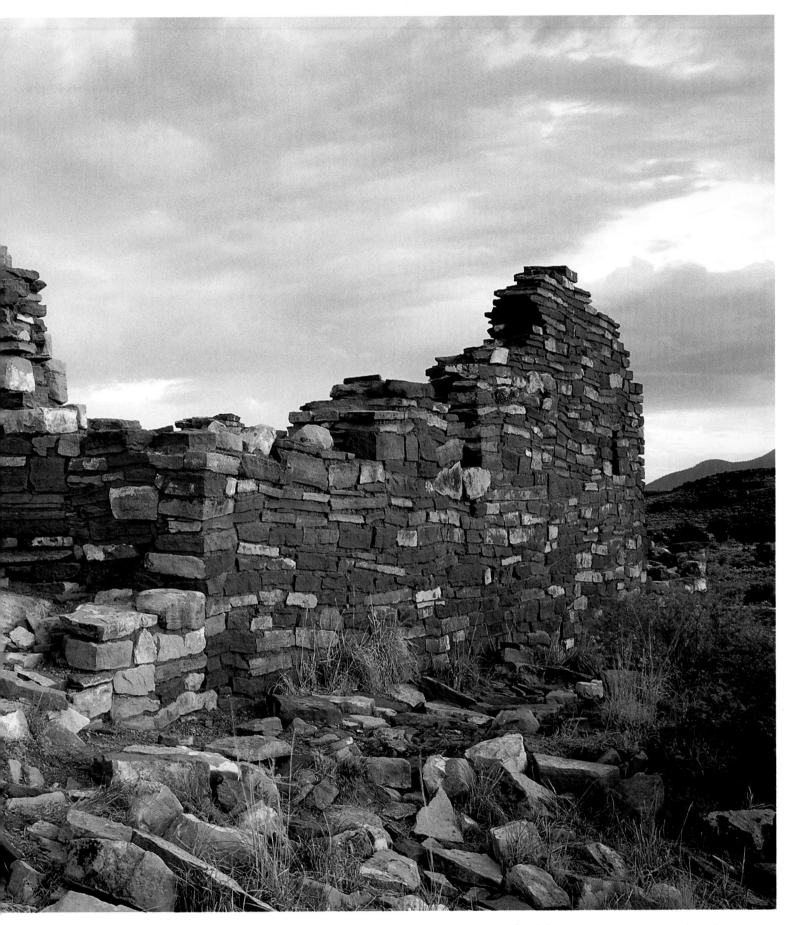

Box Canyon Ruins, Wupatki National Monument, Arizona

first polychrome pottery in the Southwest. The emphasis was on mass production of pottery for trade, everyday use, long-term storage, and burial of cremated remains. Platform mounds and ball courts spread more widely than before, with more than 225 such courts in an area of some 30,000 square miles—the greatest extent of Hohokam influence. The Hohokam themselves settled new areas, and other cultures adapted Hohokam ways. At the village of Wupatki, northeast of modern Flagstaff, Arizona, a people called the Sinagua—who were primarily influenced by the ancestral Puebloans—built a Hohokam-style ball court toward the end of this period that marks the most northerly reach of the Mesoamerican sacred game. It seems likely that ball court villages were also regional trading centers; perhaps before or after the game, traders would enter the great oval space to hawk their wares.

The final phase of Hohokam culture is called the Classic period, a misnomer for a time of rapid changes in the traditional components of Hohokam culture. Pit houses were replaced by aboveground adobe structures, and adobe walls were often built around groups of houses. In some villages, large, multistoried great houses were built, which—based upon the well-preserved structure at Casa Grande, south of Phoenix—may have been astronomical observatories, perhaps occupied by a high priest. The ball courts became less important, while platform mounds became larger, more formalized, and more significant to social and religious life. Although cremations continued, there were many more uncremated burials than before. Pottery changed, too, and in the Phoenix area, the original heartland of Hohokam culture, the beautiful red-on-buff designs all but disappeared.

Archaeologists disagree on the meaning of these changes. Aboveground construction reflects growing influence by ancestral Puebloan people, but the Hohokam were more than imitators, and their adobe villages and great houses are substantially different from Puebloan structures. Other changes were at work as well: internal division, religious and social reorgani-

zation, perhaps an influx of non-Hohokam immigrants. Although there is little evidence of violence, there may have been wars with these newcomers or wars among the Hohokam, and there was certainly greater raiding in outlying villages. Hohokam territory began to shrink, old trade networks were cut, and the volume of trade goods declined. Powerful floods in 1353 may have so damaged the irrigation canals that a weakened society no longer had the communal resolve to rebuild them.

During the 1400s the once great Hohokam empire collapsed. It was probably a slow rather than sudden disintegration, with village after village abandoned and the survivors adopting a simpler way of life. The O'odham, who still live in the Sonoran Desert and have traditionally been called the Pima and Papago, consider themselves direct descendants of the Hohokam. Some scholars accept this point of view, while others refer to linguistic and dental evidence that suggests they may be later immigrants who adopted certain Hohokam lifeways. The Spanish who first crossed Hohokam territory in 1540 under Coronado offered unwitting testimony to the end of a great civilization: They called this land *despoblado*, depopulated.

IN THE SOUTHERN COLORADO PLATEAU—a dry and rugged land of mountains, mesas, valleys, and canyons—a culture developed that archaeologists have traditionally called the Anasazi, from a Navajo word meaning "enemy ancestors" or "ancestors of my enemy." Modern Pueblo and Hopi people, who claim direct descent from the ancient ones, object to this designation for its negative connotations, and today the trend is to call this civilization ancestral Puebloan. (The western branch of these people, who lived in and around Arizona's Canyon de Chelly, are also sometimes called by the Hopi word Hisatsinom, which means "our ancestors.")

Just as in the desert and mountain areas to the south, the civilization arose gradually out of the Archaic culture. The earliest development was dubbed the Basket Maker phase by a late 19th-century cowboy and amateur archaeologist named Richard Wetherill,

Sunset Crater National Monument, Arizona

who found well-preserved sites in southern Utah with fine basketwork but no pottery. Due to their greater separation from Mexico, pottery appeared later among the ancestral Puebloans than among the Mogollon and Hohokam, reaching the San Juan River Basin in the fourth century A.D. On the other hand, because of their closer proximity to the plains, the Puebloan people received the bow and arrow earlier, sometime between 1 and A.D. 300. The new weapon, which made it easier to hunt small game, improved the food supply and encouraged small pit-house villages, but it was the ability to cook and store food in ceramic pots that led Puebloan farmers to develop new varieties of corn that could feed larger populations.

Just how much larger is suggested by a 1980 archaeological survey of the San Juan Basin, with 102 preceramic sites and 934 late Basket Maker (postceramic) villages—a ninefold increase in a few centuries. These later villages were bigger, with perhaps 10 to 20 pit houses, yet the houses themselves were smaller, suggesting that younger nuclear families may have lived in their own houses. Large community houses had some features of later ceremonial kivas, and there was a trend toward burying the dead close to dwelling places—in stark contrast to the hunter-gatherer practice of avoiding places of burial. Although families still traveled seasonally in search of wild plants and game, the people of the late Basket Maker period saw their winter villages as something close to permanent homes. But they faced the problem of how to feed their growing population.

During the mid to late A.D. 700s, a time when rainfall was more unpredictable than usual, they moved into wetter upland regions and banded in even larger villages than before, working and experimenting with agricultural methods in the fields, moving on to new land if too many experiments failed. Although ready to move when necessary, the Puebloans built more permanent aboveground structures of wooden poles and plastered mud to augment their pit houses. The early structures were usually two rows of square or rectangular rooms, with living quarters in front and storage rooms behind.

These well-protected storage rooms, along with their continuing development of pottery, held the key to survival: Now they could safely stockpile crops from good harvests to feed them in bad times. And when even the storehouses were empty, increasingly beautiful ceramics decorated with black-on-white designs offered a new medium of trade that they bartered for corn with other people whose harvests were better.

This new system stabilized the emerging society by spreading the risk of crop failure among a larger number of people, a larger area of land, and a longer period of time. The system was not adopted by all people at the same time; late Basket Maker sites are found, usually at even higher elevations, contemporary with these new upland villages, which archaeologists label Pueblo I. Around 900 the most daring of the ancestral Puebloans moved from the large upland villages into the warmer, drier valleys, building even more permanent structures of sandstone and adobe and creating a new lifeway called Pueblo II. Over the next two centuries, as population continued to increase, Puebloan people spread over every arable acre of the San Juan Basin, establishing more than 10,000 separate farm sites. This was a logical response to unpredictable weather: The more land they could cultivate, the better chance that some of that land would catch the rain.

THE PEOPLE OF CHACO CANYON, a dry, rugged 18-mile stretch of land carved by a seasonal wash between flat-topped mesas in what is now northwestern New Mexico, had a unique vision early on. While contemporaries settled the uplands, they alone built Pueblo I-style dwellings in a dry, lower valley, with unusually large storage rooms. In the late 800s they replaced these with Pueblo II-style masonry, constructing a curving, two-story bank of some one hundred rooms at the base of a mesa that would ultimately grow into Pueblo Bonito. They built a similar structure nearby and another one 50 years later. All these buildings were significantly larger than the typical masonry structures in farming districts—it seems that the Chacoans saw themselves as

more than farmers from the beginning. The canyon was not a bad place to live, but it was never an easy place to farm. In the early years, when there was plenty of arable land available, it was a curious choice—one that suggests they saw larger implications in the setting.

Chaco sits between two different precipitation patterns. To the west and north there are two wet seasons, rain in the summer and rain or snow in the winter. To the south and southeast there is a single rainy season in the middle to late summer. The crops in each of these areas would have differing rates of success, and the people of Chaco Canyon were perfectly situated to carry on trade between the regions, buying corn from those who had a good harvest and selling it to those who were hungry. The currency in this exchange was probably pottery, but the Chacoans themselves made relatively little pottery, just as they grew relatively little corn. They were the brokers, and by gaining power over the corn, they ultimately gained power over a vast region of the Southwest.

Things started slowly. For more than two centuries the Chacoans and the farming people around them struggled with unpredictable rainfall. Although the Chaco people made inroads with their neighbors—trying to control trade, perhaps introducing them to religious ideas—the other ancestral Puebloans were too busy working for survival to really buy into the Chaco vision. Around the year 1000 the rains began to fall with more consistency, and with one brief exception this pattern continued for the next 130 years. Rich surpluses filled the Chaco storehouses, and the surpluses continued to come in year after year. This was the real beginning of what archaeologists call the Chaco phenomenon, and it was about 1020 that Chaco exploded in a building frenzy that turned Chaco Canyon into the greatest settlement yet seen in the Southwest.

Developing increasingly sophisticated styles of

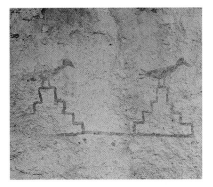

A Mogollon artist at what is now Gila Cliff Dwellings National Monument in New Mexico created this pictograph of two birds.

masonry construction, the Chacoans raised multistoried, apartment-like structures called great houses. Pueblo Bonito is the largest of these. When building stopped in the 1100s, after three centuries of construction, it contained over 700 rooms and some 40 ceremonial kivas, rising to four stories in the back and tapering down in the front. The complex has a characteristic D shape, curving around a large double courtyard with a solid corridor running down the middle that served as an easily protected entranceway. Covering almost five acres, massive and awesome to behold, Pueblo Bonito was the largest building complex in North America until the late 19th-century development of large-scale steel production.

Although Pueblo Bonito was the epicenter of the Chaco world, there were eight other great houses in the canyon, some nearly as large as Pueblo Bonito, and three more in the surrounding mesas. Archaeologists have discovered at least 150 great-house-style structures outside the canyon, marking a sphere of Chacoan influence that extended over 40,000 square miles. A network of well-engineered roads at least 200 miles long—12 to 30 feet wide and so straight they run up and over mountains rather than around them—links Chaco Canyon with many of these outlying settlements. Extending far beyond the roads and great houses, the Chacoans operated a trade network that embraced a half million square miles. They began by trading locally in staples like corn, squash, beans, tobacco, and cotton, but farm products can only be carried so far on foot before they lose their value in man-hours, quality, or both. And so the Chaco people also developed a luxury trade in objects that were rare and beautiful and often carried ritual meaning: turquoise, pipestone, shells, carved flutes, mosaic baskets, fine pottery, copper bells, and macaw feathers.

Some 215,000 ponderosa pine logs were required

to support the roofs of the great houses in Chaco Canyon alone, and each of these had to be cut with a stone ax and carried or dragged at least 20 to 30 miles from the nearest stands of pines. As many as two million man-hours may have been expended on building the canyon great houses between 1020 and 1120, and millions more were required to build the outlying big houses and the roads.

Chaco was about power: economic, religious, political. It was mastery of the many by the few. Surprisingly few people actually lived in central Chaco, perhaps 2,500 to 3,000, perhaps twice that many, but in

THE BATTLE AT WHITE HOUSE

AS TOLD BY ELDERS OF THE ACOMA AND SANTA ANA PUEBLOS WHO VISITED WASHINGTON, D.C., IN SEPTEMBER-OCTOBER, 1928.

. . . *Before long the people at White House could hear the katsina coming, yelling in the same way they had heard Gomaiowish yell. Country Chief called all the men together. He told the people not to do anything to the katsina. "If they are going to harm us, let us do as they like. Maybe this is to be our punishment. I know that we have been doing wrong." The two sons of the Sun man were present as common men; they did not think anything serious was due to happen.*

The katsina brought clubs and they had picked up sticks of hard wood, and broken branches off the trees. They were all very angry. They did not pause as they came to the village but came right in by the back way, all in a bunch, and began striking the people with their clubs and killing many of them. The sun twins rushed to their house. . . . They saw their people were being rapidly killed and they got angry toward the katsina. So they started putting on the costumes their father had given them and painted each other as their father had shown them, and put on their quiver with bow and arrows. . . . The Twins selected the largest bunch of katsina in the plaza and gave the yell their father had taught them (through which they were to get power from the Sun). . . . After giving their yell, each one let fly a hunting stick at the katsina in the plaza, decapitating them and scattering the others in every direction. The Twins killed all the katsina but Tsitsanits the leader. . . . They then captured Gomaiowish. . . tied him and castrated him. Then Gomaiowish confessed and said, "Oh, it is you! Please forgive me!"

[After apologies all around, the Sun Twins bring the kachinas back to life; it is decided that the kachinas will come no more, because they might get angry again, and instead the people will imitate the kachinas and invoke their aid through ritual. The Twins then fail to revive the people the kachinas killed; these are the first deaths and the beginning of the funeral ritual.]

either case only half of those resided in the great houses. The other half lived in smaller masonry dwellings called unit pueblos, which were more typical of the standard homes of farmers at that time. Based on examination of skeletons, the people of the great houses were taller and healthier than the common people, and they were buried with an impressive array of luxury items. In an age of high infant mortality, their children were three times more likely to live to adulthood than the children of the farmers who lived in the same canyon. Although the great house people were the architects, they probably did not build the houses and roads with their own hands, and they certainly did not grow their own food. The presence of large cooking areas in the courtyards and few hearths in the inside rooms suggests that they may not have even cooked for themselves.

Clearly these were a people of privilege and power, an elite. The residents of outlying great houses were a second tier of the elite carrying out the will and vision of the highest class who lived in Chaco. At first the Chaco traders controlled the surplus corn, and somewhere along the way they convinced the farmers that they also controlled the seasons and the rains. The Chacoans were expert astronomers who laid out walls, windows, and roads in alignment with the cardinal directions and astronomical events. Fajada Butte, a tall, lonely outcropping near the mouth of the canyon, was the most sophisticated astronomical observatory in the Southwest, with petroglyphs placed precisely in the rock formations to mark daily noon, the solstices, the equinoxes, and the 18.6-year lunar cycle. Along with their functions as elite residences and trading centers, the great houses in Chaco Canyon probably served as hotels for people from the surrounding areas who came to the canyon for seasonal religious ceremonies. The Chaco priest-astronomers told them when to plant and when to propitiate the gods with sacred rituals. They told them when to build houses and roads.

As long as the rains kept falling, the common people obeyed, but when the rains stopped, the Chaco elite faced something close to open rebellion from the farmers they ruled. The unraveling of Chaco society began with a six-year drought in 1090-95, lasting just long enough to deplete storehouses and make the people question the power of their priestly class. The rains had been tapering off for a decade. The Chacoan priest-astronomers may have seen the writing in the sky, for even as the drought began, they were completing an unusually large great house at the end of the Great North Road, on the San Juan River at a place called Salmon. The rains returned in July 1096, and Chaco hung on for another 35 years. But these later times were marked with increasing concern over security, and for the first time we find burials of men who seem to be warriors. In 1130 a longer drought began, and the Chaco elite abandoned their sacred canyon.

The site at Salmon had not proved suitable, for the San Juan River was too difficult to control. So around 1110 the Chacoans had begun building an even larger complex on the next major tributary to the north, the Animas, at a place late 19th-century white settlers called Aztec because the ruins they found were so impressive they could imagine them being built only by the great Aztec Empire of Mexico. Exactly what happened at Aztec is questionable. The traditional view is that the Chaco people stayed only until around 1150 and then abandoned the site, to be replaced a half century later by another ancestral Puebloan group from the northern settlements at Mesa Verde.

However, more recent evidence suggests continuous occupation at Aztec, and archaeologist Stephen Lekson maintains that the Chaco elite lived there until the great drought of 1276, which led to a final, irrevocable breakup of the Southwestern cultures. In this view Aztec was the next ceremonial city, not as big as Chaco but still the dominant force in the ancestral Puebloan world, with six great houses and others densely packed into the surrounding area. Lekson believes that when the drought of 1276 forced the Chacoans to abandon Aztec, they moved southward on the Great North Road, passing back through Chaco Canyon and continuing almost 400 miles farther south along a remarkably straight line he calls the

Chaco Meridian, finally building a third ceremonial city called Paquimé in northern Mexico.

Traditionally thought to be built by the Mogollon Mimbres, Paquimé was constructed of poured adobe rather than sandstone blocks and was marked by typical Mexican ritual structures such as ball courts and platform mounds. Lekson maintains that though descendants of the Mimbres formed the bulk of the lower class, the Chacoans ruled. They had already been experimenting with adobe walls in the north, while courts and mounds may reflect a synthesis between Chaco religion and the rituals of southern peoples. Whoever built it, Paquimé marks a key transition to the architectural styles of the later Pueblo period, and it was the dominant city and trade center of the Southwest for two centuries.

THE BREAKUP OF THE CHACO power structure and the trade network it controlled had an enormous effect on the widespread farming people who formed the bedrock of the culture. Farmers in the lower valleys near Chaco began to leave with the first drought of 1090-95, and the exodus turned into a mass defection when the next drought began around 1130. At first the tendency of these farmers was to return to the ways of their ancestors, building pit-house villages in the upland areas that surrounded the San Juan Basin. In some areas they met stiff resistance, for there were already pockets of upland pit-house people who had never subscribed to the Chaco way. In the Gallina Highlands, northwest of modern Santa Fe, one site bears mute testimony to the conflict that ensued. The pit-house village was heavily stockaded, and not a single human skeleton was completely intact. The bones of both adults and children tell a gruesome tale of dis-

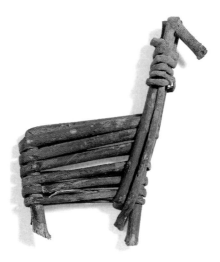

This palm-sized willow-twig figurine, representing a deer or bighorn sheep, was found in a cave in the Grand Canyon and probably dates to the later Archaic culture around 2000 B.C.

memberment, crushed skulls, and decapitation.

In time, some Chacoan refugees built masonry pueblos, but beginning in the 1190s and continuing for 70 years, a new wave of building began as the ancestral Puebloans constructed a series of stunning cliff dwellings at Mesa Verde, Canyon de Chelly, and other sites in what is now the Four Corners region. These cliff houses, built of sandstone and nestled under huge overhangs, are generally well preserved, with a striking beauty that speaks powerfully across the centuries.

The idea of widespread warfare in the Four Corners region remains controversial, but new evidence suggests that some villages suffered violent attacks during the tumultuous 1200s. Sand Canyon Pueblo, in the Montezuma Valley below Mesa Verde, was burned, and as many as 250 people, a third of the population, may have been killed trying to defend it. Mesa Verde itself was relatively safe from wholesale violence, but that was precisely the point: The cliff sites were chosen for defensive purposes, and in the 1270s the people of Balcony House— already among the most defensible cliff dwellings—built new walls and limited access to a 12-foot tunnel 18 inches in diameter.

Who were the attackers? Some scholars think they were Athapaskan-speaking hunter-gatherers, the ancestral Apache and Navajo who swept down from the north. Others point to Shoshonean-speaking Ute who came from the west. Though tribal oral histories suggest that all these peoples were in the Southwest by this time, the standard academic opinion is that the Apache and Navajo did not arrive until around 1500 and that none of these nomadic peoples were strong enough without horses to attack large Pueblo villages. Archaeologist

Stephen LeBlanc believes that the ancestral Puebloans themselves split into at least three warring factions: one at Mesa Verde, another in the Montezuma Valley, and yet another in the Aztec area. The 1200s were a time of colder weather, and in the upland areas the effect of the cold on crops would have been accentuated. An otherwise peaceful agrarian people may have turned to violence when faced with starvation.

Around 1276 a long drought began that continued until the end of the century, and by 1300 the San Juan Basin was completely abandoned. Not a single ancestral Puebloan site has been found after that date. Certainly the drought, the colder weather, and the war-

Giant human and animal figures, called intaglios, were etched into the desert near Blythe, California, by people known as the Patayan—a wide-ranging culture who occupied the Colorado River area from the Grand Canyon to the Colorado Delta. The intaglios were religious art, perhaps representing the creation myth, and intaglios on both sides of the Colorado River were connected by a network of trails that suggests they may have been part of a sacred pilgrimage to the mountain of mythic origin, similar to the pilgrimage of Yuman-speaking peoples in historical times.

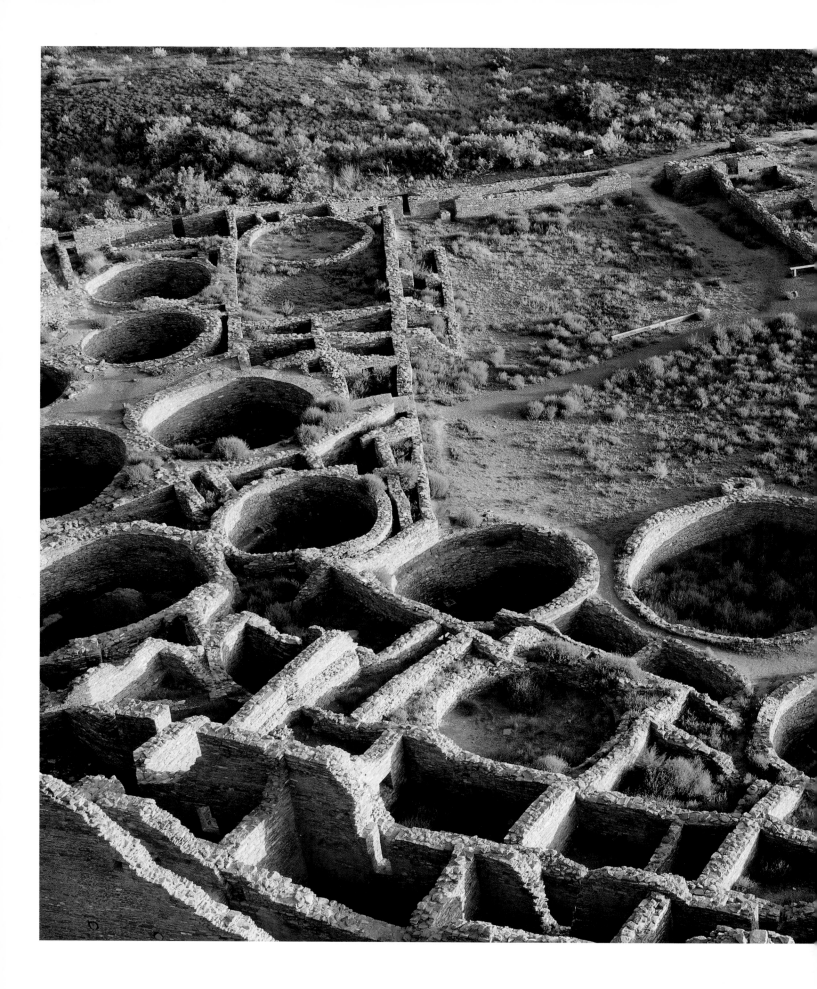

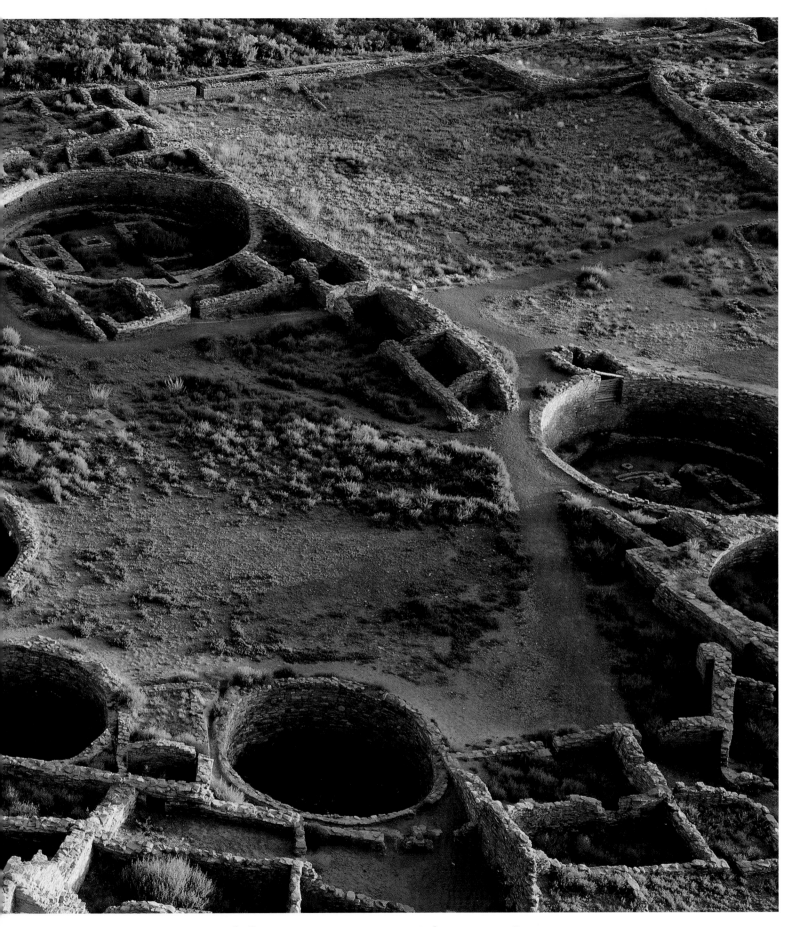

Pueblo Bonito, Chaco Canyon

Fajada Butte, Chaco Canyon

fare all contributed to the exodus, and there may have been other factors, such as disease and exhaustion of resources. If people were starving and killing each other, many must have died before they could leave. Yet there is something strangely organized about this total abandonment of what was once the homeland of a great culture. If we accept Stephen Lekson's idea that the Chaco elite were still hanging on at Aztec, then perhaps their decision to create a new ceremonial city far to the south sent a message to the other Puebloan people that it was all over in the San Juan Basin. If so, some must have followed the Chacoans to Paquimé, but the most important migrations for the future of the Southwest were to closer regions that offered a more predictable water supply, primarily the upper Rio Grande Valley and nearby highlands. Some refugees joined already established settlements at Taos and in the Acoma and Zuni areas of west-central New Mexico. In Arizona the ancestral Hopi people settled on the mesas where they still live today.

In all these places a new way of life developed that archaeologists call Pueblo IV. (Chaco, Aztec, and Mesa Verde are lumped together as Pueblo III, a holdover from earlier times when the distinctions between these cultures were not well understood.) This new lifeway was a remarkable adaptation to all that the people had learned over the previous centuries. At its best the great Chaco trading network had allowed an unusual level of specificity for a preindustrial society; one farmer might grow a single crop, while another farmer grew another crop, a hunter supplied meat from a particular area, and a potter made ceramics from a specific clay. As long as the network functioned, the people within it could obtain the food and materials they needed, though they paid a heavy price for those goods in taxes and service to the elite.

During the Pueblo IV period, each village strove to become a world unto itself. The typical farming village ran from fertile bottomlands along the river to higher elevations where dry farming techniques could be used to even higher elevations where wild game,

plants, and wood were more prevalent. Farming became more complex, with every village cultivating a variety of crops under differing conditions and technologies. Irrigation canals, never used to any great extent by the Chacoans, were employed in the river bottoms, while in drier areas an innovative covering of rocks was used to catch the morning dew and drip precious water onto the soil. Unlike the fearsome Chaco elite, the new Pueblo society was more egalitarian, with a small core of leaders chosen for their wisdom and talents. These leaders were honored, and in some villages they may have been supported by a tax called "the good share," but they were not fundamentally different from the people they led. Everyone in the village was expected to contribute to the greater good, and as long as they worked the land, those whose crops failed were gladly fed by those who brought in a better harvest.

Along with these socioeconomic adaptations, the Pueblo embraced new religious rituals involving the kachinas, benign spiritual beings who brought the rain and other good things to the Pueblo people. Originating in Mexico, the kachina cult first appeared in the Southwest among the Mogollon during late Chaco times, and it seems likely that the ideas reached Chaco Canyon by the 1120 drought. Stephen Lekson believes that it was this new religion, as much as the drought, that led to the downfall of the Chaco elite. In Lekson's view the Chaco world split along religious lines, with the more populist kachina cult dominating in the south while the Chaco elite tried to maintain their more formal priestly religion in the north at Aztec and Mesa Verde. If so, then the later abandonment of these sites may have marked the final defeat of the Chaco religion in the Southwest. After 1300 the kachina religion emerged triumphant throughout the Pueblo world.

Under the right conditions this new religious, social, and economic system proved highly successful, and some late Pueblo IV villages were larger even than their Chaco predecessors. The largest of these, Sapawe, had over 2,500 ground-floor adobe rooms and may have had as many as 4,000 with a second story—all enclos-

ing eight separate plazas. Other villages were impressively large as well, and by the late 1400s to early 1500s there were 100 to 200 of these thriving pueblos. Pottery, weaving, and jewelry making reached a level never before seen in the Southwest, and the people in general approached a level of health and longevity that had once been reserved for the Chaco elite.

It was during this late flowering of Pueblo IV culture—just when things were looking good after centuries of struggle—that the Apache, Navajo, and Ute began to seriously pressure the Pueblo villages. Whenever these nomadic peoples first reached the Southwest, they were unquestionably a force to be reckoned with by the time the Europeans arrived, and their raider-warrior culture posed a threat to fundamentally peaceful farmers who lived in permanent villages. Adding to this threat was the fact that the Pueblo were not a unified people; they spoke different languages, belonged to different ethnic groups, and took pride in the independence of their villages. The central authority once exercised by the Chaco elite was only a memory.

What would have happened if the white newcomers had met the Chaco or Hohokam civilizations at the height of their power? The result might have been the same—the Spanish crushed the powerful Aztec and Inca Empires with relentless brutality—yet at the very least the negotiations and exchanges between two complex cultures might have been more balanced. But it was not to be. If the Spanish called the Hohokam heartland despoblado, they called the heartland of the ancestral Puebloans nothing at all, for they barely skirted the edges of the San Juan Basin and never saw the once great settlement in Chaco Canyon. The New World the Spanish found was not a great civilization at the height of its power but rather the survivors of that great civilization trying to re-create themselves and their culture in the face of new threats from hunter-gatherers who roamed the open land. Now they would face an even newer threat from across an ocean they did not know existed, and this threat would prove the most dangerous of all.

Bandelier National Monument, New Mexico

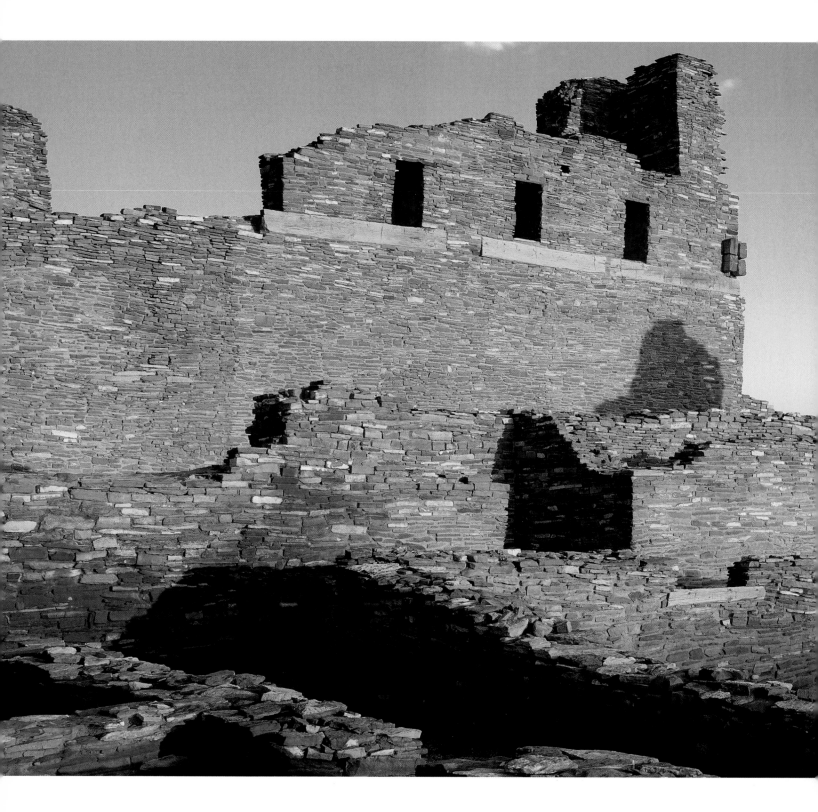

THE CROSS
& THE SWORD

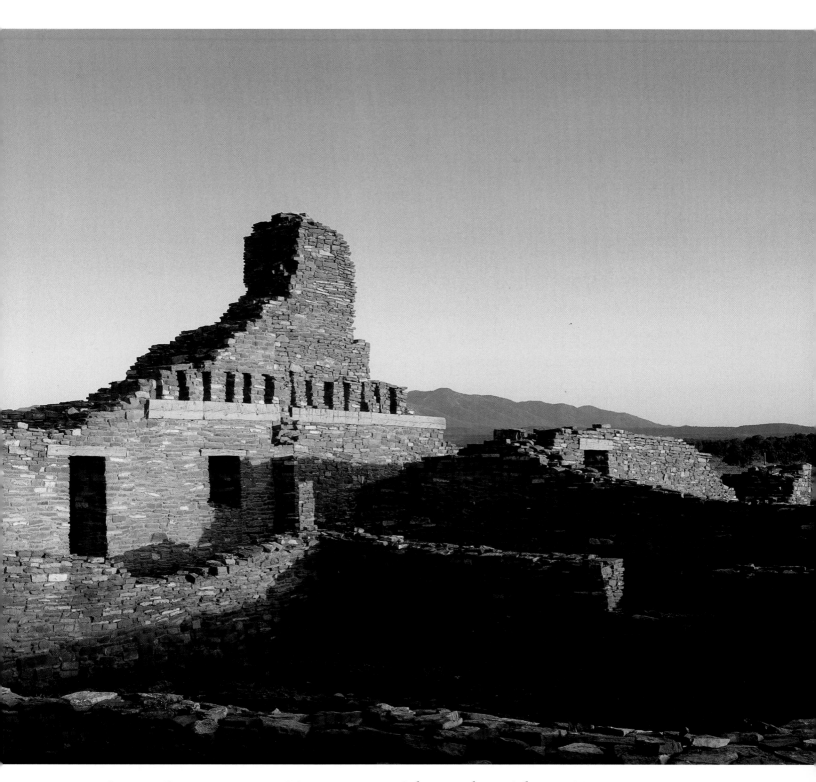

San Gregorio Mission Church, Abo, New Mexico

Padre Island National Seashore, Texas

1 5 2 8 - 1 7 0 0

THE CROSS & THE SWORD

IN SEPTEMBER 1534, ON THE 13TH NIGHT OF THE MOON, THREE NAKED AND

DESPERATE MEN GATHERED IN A STAND OF PRICKLY PEAR CACTUS SOUTH OF PRESENT-DAY SAN ANTONIO,

TEXAS. TWO OF THEM WERE SPANIARDS; THE OTHER WAS A BLACK SLAVE OF ONE OF THE SPANIARDS,

OR AT LEAST HE WAS A SLAVE WHEN THEY HAD LEFT SPAIN SEVEN YEARS EARLIER. NOW ALL THREE WERE

SLAVES OF A TRIBE THEY CALLED THE MARIAMES, WHO LIVED ON THE EAST TEXAS COASTAL PLAIN,

STARVING MUCH OF THE YEAR AND GORGING THEMSELVES DURING THE SEASON OF PRICKLY PEARS.

ANOTHER SPANIARD WAS ENSLAVED BY A NEIGHBORING TRIBE. THE TWO TRIBES MET THE FOLLOWING DAY,

OFFERING THE REFUGEES A LONG-SOUGHT OPPORTUNITY TO ESCAPE. THEY MADE A BREAK AND

HEADED INTO THE UNKNOWN INTERIOR OF WHAT IS NOW THE AMERICAN SOUTHWEST.

These four men—Álvar Nuñez Cabeza de Vaca, Alonso del Castillo Maldonado, Andrés Dorantes, and Estevánico, the black slave of Dorantes—were the only survivors of 300 who had set off on a disastrous gold-hunting expedition in May 1528. Hoping to reach the "river of palms," the present-day Rio Grande, they foolishly left their ships behind in Florida's Sarasota Bay against the staunch objections of Cabeza de Vaca, who served as second in command. Marching into the Florida Panhandle, they lost some 50 men before making barges and sailing along the Gulf Coast, past the

mouth of the Mississippi (so powerful it pushed them out to sea), and on to the coast of Texas, where all but these four perished—some in shipwrecks, others of cold, hunger, and disease, still others killed by Indians. At least one Spaniard murdered another, and some resorted to cannibalism in a hostile land where the natives lived on the edge of starvation.

The day they escaped, the four refugees reached another tribe to the west, the Avavares, who received them gladly and brought their sick to be cured of "terrible headaches," according to a remarkable account

later written by Cabeza de Vaca. The Spaniards had already established a reputation as healers with the coastal tribes, but now they brought their practice to new levels. At first Castillo was the favored healer, but he was "a timid practitioner." When he balked at visiting a neighboring tribe, Cabeza de Vaca went instead, accompanied by Dorantes and Estevánico:

> As we drew near the huts of the afflicted, I saw that the man we hoped to save was dead: many mourners were weeping around him, and his house was already down—sure signs that the inhabitant was no more. I found his eyes rolled up, his pulse gone, and every appearance of death, as Dorantes agreed. Taking off the mat that covered him, I supplicated our Lord in his behalf and in behalf of the rest who ailed, as fervently as I could. After my blessing and breathing on him many times, they brought me his bow and a basket of pounded prickly pears.

Leaving the man in apparent death, Cabeza de Vaca went on to heal others in the village before returning to his own quarters among the Avavares, where he received news that evening:

> that the "dead" man I had treated had got up whole and walked; he had eaten and spoken... [and] all I had ministered to had recovered and were glad. Throughout the land the effect was a profound wonder and fear. People talked of nothing else, and wherever the fame of it reached, people set out to find us so we could cure them and bless their children.

The Spaniards stayed with the Avavares for eight months before embarking on a bizarre and triumphant procession across what is now the American Southwest and northern Mexico. At every village they were greeted as shamans with awesome, otherworldly powers and they became enmeshed in a strange custom whereby the Indians who escorted them from the previous village would loot the next village, taking every-thing. The new hosts would in turn escort the visitors farther, taking everything from the next village. This custom, combined with the ever growing reputation of the visitors, inspired as many as three or four thousand Indians to follow them at any given time across rough mesquite plains, rushing rivers, harsh deserts, and soaring mountain passes. No Indian in their entourage would eat until the visitors blessed their food with the sign of the cross—not from Christian piety but because they believed that these naked, bearded men were children of the sun.

In March 1536 the wandering shamans encountered other "Christians," to use Cabeza de Vaca's term, in present-day Sinaloa, Mexico, not far from the Pacific Ocean. They turned out to be slave hunters casting covetous eyes on the 600 Indians still following the children of the sun. Cabeza de Vaca, who exhibited genuine empathy for the Indian people, protected his Indian followers from the slavers so vociferously that he and his companions were arrested and sent on toward Culiacán, then the northernmost outpost of New Spain. The *alcalde*, or mayor, Melchior Díaz, met them on the trail and released them from arrest. In the weeks that followed, the presence of these holy visitors had a healing effect throughout the region, which had been decimated and depopulated by the brutalities of the Spanish slavers. Farther south in Compostela, the tiny capital of Nueva Galicia, the brutal provincial governor Nuño de Guzmán—who was the driving force behind the slave trade and would soon be imprisoned for his brutality—outfitted the once naked vagabonds from his own wardrobe, although Cabeza de Vaca later remembered, "I could not stand to wear any clothes for some time, or to sleep anywhere but the bare floor."

The party received a hero's welcome in Mexico City, where the newly appointed viceroy, Don Antonio de Mendoza, along with the conquistador Hernán Cortés, conferred intently with these men who had crossed vast, unknown regions of the New World from sea to sea. In his written account, as in his discussions with these officials, Cabeza de Vaca told of receiving

five emerald arrowheads along the way. What really caused a stir was the Indians' explanation that the arrowheads came from "lofty mountains to the north, where there were towns of great population and great houses." Cabeza de Vaca also reported receiving turquoise and seeing indications in the mountains that suggested the presence of gold.

TALES OF GREAT CITIES, precious stones, and signs of gold lit the fire in Spanish hearts, conjuring visions of the legendary Seven Cities of Antilla supposedly founded by seven Portuguese bishops fleeing the Moors during the eighth century. Viceroy Mendoza was a well-educated man who may not have believed the legend, but he did believe what the travelers had seen and heard; Governor Guzmán had heard similar reports from the son of an Indian trader. So Mendoza determined to send an expedition to investigate. Cabeza de Vaca rejected the commission, choosing to return to Spain and his wife. Dorantes refused as well, but in what proved to be a key transaction in Southwest history, he either gave or sold Estevánico to the viceroy.

Estevánico had traveled as nearly an equal throughout the triumphant procession, but in Mexico City he was once again a slave—a slave who knew

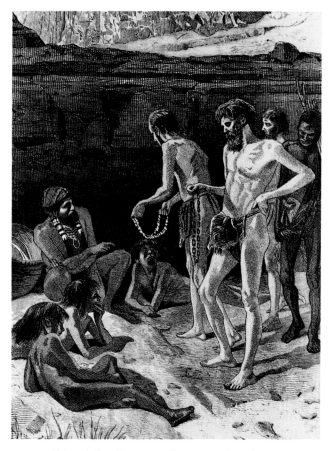

Although this illustration depicting Cabeza de Vaca and his companions trading with Indians on their trek through the Southwest does not reflect their actual appearance, it captures the emaciated nakedness of men in the midst of an ordeal.

more about the land, cultures, and languages of the Indians than any other available man. The viceroy himself called him intelligent. Yet a slave and a non-Christian, no matter how intelligent, could hardly lead a Spanish expedition, so Mendoza enlisted an energetic Franciscan priest named Fray Marcos de Niza, who had recently arrived in Mexico City after working among the native people in Peru and Ecuador.

In the fall of 1538 de Niza, another friar named Onarato, and Estevánico, with some 20 Indian servants, were escorted from Mexico City into Nueva Galicia by the newly appointed governor of the province, a 28-year-old petty nobleman and Mendoza protégé named Don Francisco Vásquez de Coronado. On Friday, March 7, 1539, the expedition left Culiacán and the protection of Coronado behind, heading north on a well-worn Indian trading route that, at the beginning at least, retraced the path of Cabeza de Vaca. Estevánico knew this path, as he knew the customs and perhaps some language of the people along the way. He enjoyed himself to the hilt, wearing feathers and bells around his ankles, turquoise and coral across his muscular chest, and plumes upon his head, sleeping in a tent on comfortable bedding carried by servants, eating his meals off a much prized table service of four green pottery dinner plates that only he could use. Two greyhounds trotted

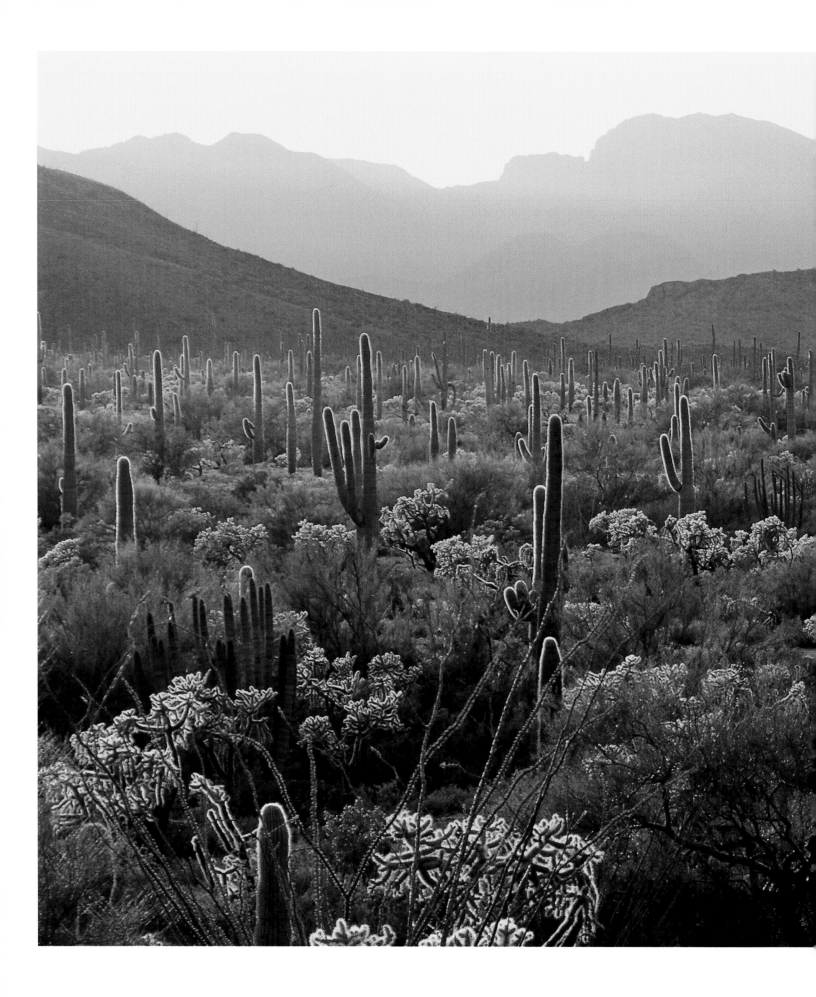

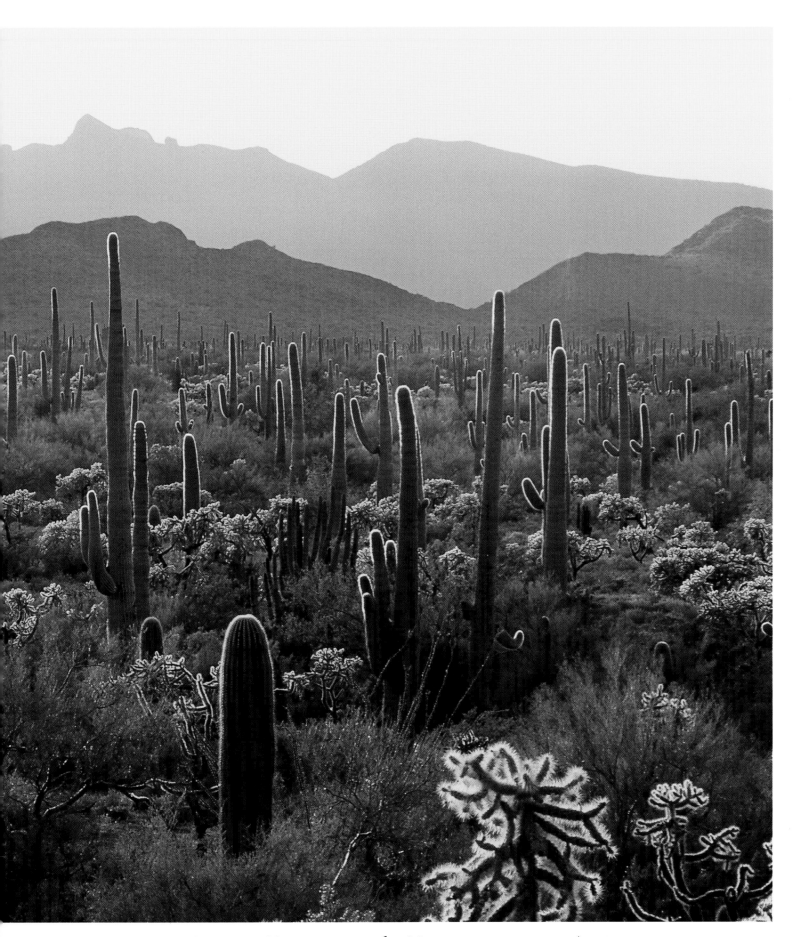

Organ Pipe National Monument, Arizona

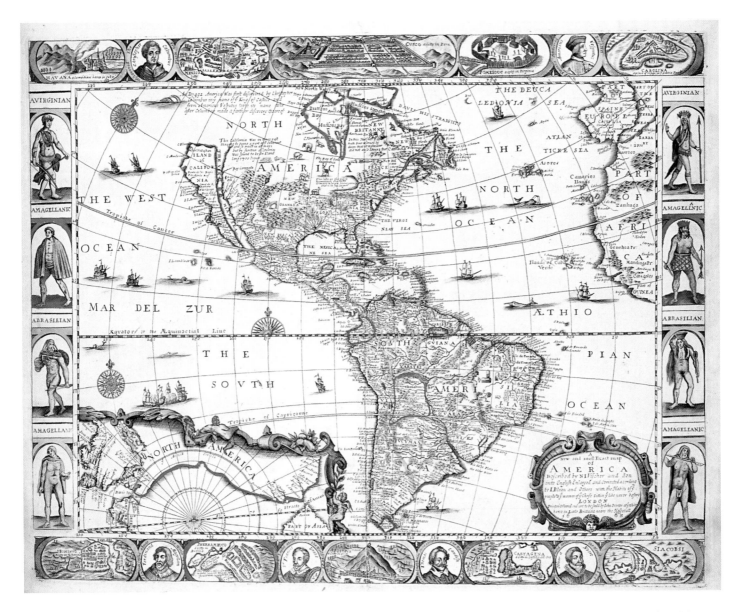

This "New and Most Exact Map of America" by John Overton, published in London in 1668, shows California as a large island. Early Spanish explorations along the Pacific coast established that California was connected to the mainland; however, the Spanish were so secretive that they not only withheld the information from other European powers but also lost the knowledge themselves—until 1700 when Italian-born Jesuit priest, explorer, and cartographer Eusebio Kino established a land route from northern Sonora into California, proving that California was not an island.

beside him, and pretty Indian girls followed behind, but these were not enough—he demanded turquoise and beautiful women at every village. Compounding these debaucheries, in the eyes of Fray de Niza, he joined the Indians in their dances and intoxicants.

De Niza put up with Estevánico because he had to. Early in the expedition, illness forced Fray Onarato back to Culiacán, leaving just the two: a pious, sturdy priest and a wily, womanizing slave who understood the people and country in a way the priest did not. To take a break from Estevánico, de Niza spent the Easter season in the northern Sinaloa village of Vacapa while sending the black man ahead with instructions:

...that should he learn of some inhabited or rich country—something really important—he should not go any farther but return in person or send me Indians bearing the following sign: If it were something moderate, he should send me a white cross a span in size; if it were of greater importance, he should send one two spans in size; and if it were something better and greater than New Spain, he should send me a large cross.

Four days later de Niza received a cross the size of a man with a message that Estevánico had reached people who knew of great cities to the north. One messenger had seen these cities himself, and he told the friar that the first was called Cíbola and that "in the first province there are seven very large cities, all under one ruler, with large houses of stone and lime, all joined in an orderly manner, and the ruler's house is four stories high. The doors have many decorations of turquoises, of which there is a great abundance, and the people are very well clothed." There were other provinces beyond these with even greater cities. Hearing all this, de Niza "rendered thanks to our Lord." With this message, the old legend of the Seven Cities of Antilla took new and more concrete form as the Seven Cities of Cíbola. In fact, the messenger had offered a fanciful description of the Zuni pueblos in what is now western New Mexico.

When de Niza resumed the trail, he heard reports of the black man's passing and occasionally received messages promising that Estevánico would wait at a particular place, but the friar never saw his companion again. Pushing northward, Estevánico and his Indian escort reached the Zuni pueblo of Hawikuh, and as he had done in previous villages, he sent a sacred gourd rattle ahead to announce his coming. Something about this rattle—or the jingle bells with which Estevánico had decorated it—deeply offended the pueblo leaders. Their offense turned to outrage when Estevánico himself arrived demanding turquoise and women and claiming that a white man was coming behind him, "sent by a great lord, who knew about things in the sky." The people of Hawikuh killed Estevánico, and to prove he was not a man from the sky, cut his body into little pieces and distributed it to other tribes with instructions to kill any intruder, black or white. They kept his prized green dinner set, his greyhounds, his turquoise, his coral, and his feathers, but they threw away the rattle.

De Niza heard of Estevánico's fate somewhere near the current border of Arizona and Sonora. Although he claimed he proceeded all the way to Hawikuh himself and saw a city "larger than the city of Mexico" from a nearby hillside, historians are divided on whether or not de Niza actually reached the Zuni pueblos. In any event, by late June he was back in the capital of Nueva Galicia, where he reported the wonders of the north to Governor Coronado, imbuing the young nobleman with such enthusiasm that, with de Niza in tow, he immediately set off for Mexico City to tell the viceroy the good news. While his protégé organized an expedition to the fabled cities, Mendoza sent a small reconnaissance party of horsemen as far as southern Arizona—the first time the Indians of the Southwest saw horses.

OFFICIAL PERMISSION FOR THE *ENTRADA* ARRIVED from the king of Spain in January 1540 and, as was the custom, Coronado raised 50,000 gold ducats to finance it by mortgaging his New World lands, while Viceroy Mendoza added 60,000 ducats of his own. Both hoped to receive untold riches in return. Fray de Niza and the other Franciscans preached so enthusiastically from the pulpits that almost 350 Europeans volunteered to join, most of them mounted on horseback, while about 1,300 Indian allies joined them on foot. Some 1,500 animals were gathered as well, including horses, mules, sheep, and perhaps some cattle. The massive force was just south of Culiacán when the small reconnaissance party returned with discouraging news: Although de Niza had said the path was easy and followed the coast, it was difficult and

veered inland. Many Indians had seen the cities of Cíbola, but their descriptions were not nearly as lavish or rich as de Niza had suggested. For a time spirits dropped, but Fray de Niza "cleared away these clouds," according to a soldier named Pedro de Castañeda, "promising that what they would see should be good, and that he would place the army in a country where their hands would be filled."

Coronado was concerned with the reports, but he was in too deep to turn back. On April 22 the handsome conquistador, resplendent in gilded armor and plumed helmet, rode out of Culiacán at the head of an advance force of 80 horsemen, some foot soldiers, perhaps 200 Indians, and some of the livestock. The main army followed about 20 days behind, while a third prong of the expedition—three ships carrying essential food, supplies, and winter clothing—sailed out of Acapulco and headed up the Pacific coast through the Gulf of California and into the Colorado River, under the grossly misguided notion that they could somehow approach Cíbola by water. In fact, the cities lay hundreds of miles to the east, and the armada returned to Mexico, leaving the expedition to fend for itself in an unknown desert land.

Guided by Indians who knew the trade routes, the advance party struggled northward and reached Hawikuh in a state of near starvation on July 7, 1540.

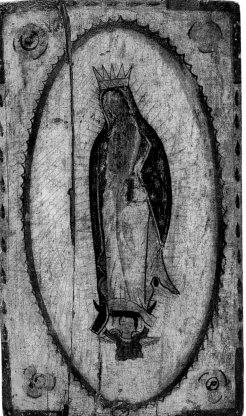

This painted wooden image or retablo of Our Lady of Guadalupe, patroness of Mexico, was found in the ruined church at Pecos Pueblo. Although this particular image was brought north from Mexico by a Franciscan friar, a native New Mexican folk art also developed.

Instead of the great city that Fray de Niza had described, they found "a little, crowded village, looking as if it had been crumpled up all together," or so it was described by Castañeda, who later saw it with the main army. "Such were the curses that some hurled at Friar Marcos," he remembered, "that I pray God may protect him from them." Coronado himself wrote that "in reality he [Fray de Niza] has not told the truth in a single thing that he said, but everything is the reverse of what he said, except the name of the city and the large stone houses." Actually the name of the city was wrong, too. Cíbola was not a city but a corruption of the Zuni name for their homeland.

The people of Hawikuh had warning of the intruders, so they had sent their women, children, and elders to safety in the surrounding mesas and enlisted warriors from other Zuni pueblos. A force of warriors stood outside the village walls, with more warriors within. Coronado sent a small group, including two friars, to assure the Indians they meant no harm. A formal statement, the *requerimiento*, was read through an interpreter, informing the Indians that the king of Spain was now their ruler and any resistance would be considered treason. Since none of the Pueblo peoples had a concept of kingship, let alone Spain, it is doubtful they paid much attention, even if the translation was adequate, which it probably was not. By a strange coincidence

the Spaniards had arrived when some of the Zuni were returning from a pilgrimage to a sacred lake in what is now Arizona, and the villagers had created a line of cornmeal welcoming them into the plaza. Coronado's men may have interpreted this as a battle line, which the Indians defied them to cross—yet another cultural misunderstanding that added to the confusion of the moment. Line or no line, there was no confusing the fact that the Spanish were not welcome. To punctuate the point, a warrior shot an arrow through the robe of a friar; when Coronado's horsemen arrived, the Zuni let loose a shower of arrows at them as well.

Although he later expressed some hesitation at doing so, Coronado gave the order to attack, and the first battle between Europeans and native people in the American Southwest began. Most of the Indians quickly retreated into the city, which—typical of pueblos during this period—was built as a defensive fortress, where the warriors took positions on the rooftops and rained stones and arrows down upon the attackers. At this moment food was more precious than gold to the starving Spaniards, so Coronado ordered an assault on the city, "as that was where the food was," and his account of what followed only emphasizes the strange and desperate nature of the situation:

The hunger which we suffered would not permit of any delay, and so I dismounted with some of these gentlemen and soldiers. I ordered the musketeers and crossbowmen to begin the attack and drive back the enemy from the defenses, so that they could not do us any injury. I assaulted the wall on one side, where I was told that there was a scaling ladder and that there was also a gate. But the crossbowmen broke all the strings of their crossbows and the musketeers could do nothing, because they had arrived so weak and feeble that they could scarcely stand on their feet. On this account the people who were on top were not prevented at all from defending themselves and doing us whatever

injury they were able. Thus, for myself, they knocked me down to the ground twice with countless great stones which they threw down from above, and if I had not been protected by the very good headpiece which I wore, I think that the outcome would have been bad for me.

Coronado was saved from further injury by one of his captains, Don Garcia López de Cárdenas, who "like a good cavalier" threw himself over the body of his fallen commander. They carried the conquistador from the field of battle with "two small wounds in my face and an arrow in my foot, and with many bruises on my arms and legs." Yet despite the temporary loss of their leader, Coronado's own journal records a victory: "by the pleasure of God, these Indians surrendered, and their city was taken with the help of Our Lord, and a sufficient supply of corn was found there to relieve our necessities."

Corn, along with some turkeys, was about all Coronado found in Hawikuh. With little exaggeration, one might say these were the most valuable commodities he found in his two-year odyssey through the Southwest. Making his headquarters in the village, which the inhabitants abandoned to the intruders, he sent an expedition south to contact the main army and search for the supply ships. Another party headed west to the Hopi villages on the high mesas of what is now northeastern Arizona. Although the expedition commander later claimed that the Hopi welcomed them after a short fight, other evidence suggests that the Spaniards may have wiped out an entire Hopi town. Still searching for a way to contact the ships in the lower Colorado, Coronado sent Cárdenas, the "good cavalier" who had saved his life, back to the Hopi, who led him on a wild goose chase that probably took him to the South Rim of the Grand Canyon, which he reported was "a useless piece of country."

In late August 1540 a delegation arrived in Hawikuh from the powerful eastern pueblo of Pecos, the key trading center between the Pueblo people and the buffalo-hunting Indians of the plains. Convinced

RECONQUEST AND CONQUEST

In 1492, the same year that Columbus first reached the New World, the Spanish drove the last of the Moors from the Iberian peninsula after almost eight centuries of battle. This prolonged warfare, called the reconquista or reconquest, forged the disparate Iberian peoples into a Spanish nation of hardened soldiers. The timing of the final blow against the Moors with the "discovery" of a New World was not lost on the Spanish, and the conquest of North America became an extension of the reconquest; when Coronado gave the order to attack Hawikuh, he invoked the patron saint of the reconquest: Santiago Matamoros, Saint James, Killer of Moors.

The reconquest established institutions that played a key role in the conquest of the New World. To mount a military expedition without draining the royal treasury, the king would appoint an entrepreneur called an *adelantado*, who would finance the expedition and raise his own army in return for honor, nobility, power, land, and a share in whatever he could take from the conquered domain. Among the tools at the adelan-

A wood-handled sword believed to have come to the New World with a soldier under Hernán Cortés in 1519 was used in the conquest of central Mexico before making its way to the Southwest.

tado's disposal was the *encomienda*, which allowed his soldiers to carve out their own fiefdoms to be worked by the conquered people. A royal decree in 1573 added another incentive, also adapted from the Moorish wars: Colonists who established new settlements would receive the hereditary title of *hidalgo*, literally "son of something." The lowest noble rank, it offered little except a coat of arms and the right to use the title "Don" before one's name. Yet in a world where honor was everything it was better to be the son of something than to be the son of nothing.

Along with military experience and feudal institutions, the reconquest created a Spanish mind-set that helps to explain some of their behavior in the New World. Whereas other European nations developed a prosperous and respected merchant class, Spanish men looked down upon trade as an occupation, as they looked down upon active and careful management of agricultural lands. It was better to conquer with the sword and if you lost the lands you won, you could always go back to the sword.

that the Pecos leaders were inviting them to their village (which seems unlikely), the Spaniards moved their operations eastward, first with a small advance party, ultimately with the whole army. On the way to Pecos the Spaniards caught their first sight of the Rio Grande, the lifeline of the Pueblo world. It was along the big river near present-day Albuquerque, in a province of Tiwa-speaking pueblos that the intruders called Tiguex, that the confrontation between Europeans and Native Americans turned truly ugly.

The trouble started when an advance party kidnapped two Pecos leaders and took them back to the Rio Grande, while another party under Cárdenas—who had returned from the Grand Canyon—evicted an entire Tiguex village to set up headquarters. Facing a long, cold winter with the main army on its way, the Spaniards asked the people of the Tiguex region for 300 or more pieces of cloth. While the Pueblo considered this difficult request, the soldiers took matters into their own hands, actually ripping the clothes off the Indians' backs. The situation escalated when a soldier entered the Tiguex village of Puaray and raped one of the women. In retaliation, villagers killed one of the Spaniards' Indian allies and drove off some horses, whereupon Cárdenas's soldiers set fire to the pueblo. Though the warriors tried to surrender, the Spaniards burned about 30 men at the stake and lanced a hundred others who tried to escape. According to one soldier, Cárdenas was following Coronado's orders "not to take them alive, but to make an example of them so that the other natives would fear the Spaniards." As the killing ended, it began to snow.

Now resistance centered on a pueblo the Spanish called Moho or Mohi, where a war leader the Spaniards nicknamed Juan Alemán, "John the German," because he resembled a German colonist in New Spain, organized the most effective resistance that Coronado faced in the Southwest. Strongly defended on a rise above a steep riverbank, Moho presented a military obstacle similar to what the conquistador might have encountered in a European castle. He

mounted a long siege from mid-January to late March 1541, cutting off access to the cold river. The Indians tried to dig a well, but it collapsed, killing 30 of those who worked on it; another 200 may have died in the fighting. In desperation the Indians gave up about a hundred women and boys, who they knew the Spaniards would not kill, because they were drinking precious water. Fifteen days later they gave up the village. Another large pueblo had also fallen to a siege, while others were simply deserted. The Tiguex War was over, but the native people had other plans.

Along with the two Pecos leaders, the Spanish had kidnapped two Plains Indian slaves. One of these slaves, whom they nicknamed Turk "because he looked like one" (according to Castañeda), told the Europeans there was plenty of gold and silver to be found in a great kingdom to the east where noble chiefs rode huge war canoes down a wide river—a fair description of the Mississippi River cultures, except for the gold and silver. Turk knew the Spanish wanted precious metals, and he was apparently involved with one of the kidnapped Pecos leaders in a plot to lead the intruders out onto the vast trackless plains of the Llano Estacado in the Texas Panhandle.

Desperate and dazed with golden dreams, in April 1541 Coronado took the bait and led his entire army toward the plains, where they saw vast herds of buffalo and encountered buffalo-hunting tribes, including one they called the Querecho, ancestral Apache. The cunning Turk got them hopelessly lost, but the other Plains Indian captive, who was not in on the plot, convinced Coronado they were going in the wrong direction. The conquistador sent his army back to the Rio Grande and continued to the northeast with 30 horsemen, finally reaching the captive's home region of Quivira in present-day central Kansas. There they found friendly people, probably ancestors of the Wichita Indians, who lived in grass mat houses and subsisted on both farming and hunting. Turk's own people, ancestral Pawnee, lived farther east in a region called Harahey. When a war party from Harahey

This painting, based on an illustration by Frederic Remington, captures the desolation and expectation of the Coronado expedition. Though the soldiers are portrayed in armor and helmets, in fact few men were wealthy enough to wear expensive armor. Coronado himself wore a suit of gilded armor and some of his officers may have worn armor or chain mail, but most soldiers relied on headpieces and shields of thick leather for protection against Indian arrows, while the Mexican Indian allies who accompanied them probably wore the thick cotton padding traditional in central Mexico.

approached and the Spaniards discovered that Turk had sent word to attack the intruders, Coronado ordered him strangled.

Disappointed at their fruitless journey—the only metal they found was a piece of copper belonging to one of the chiefs—the Spanish horsemen headed back to the Rio Grande, where they endured yet another long, cold winter. Finally, in the spring of 1542, after Coronado suffered a severe concussion while racing horses with another officer, the expedition struggled back to Mexico, carrying their fallen general most of the way. The once proud conquistador had lost his fortune, his health, and his reputation. He would die a bitter, broken man at the age of 44.

THE PUEBLO ENJOYED A RESPITE from Spanish intrusion for almost four decades, but as the borders of New Spain edged northward—spurred by rich discoveries of silver in what are now the Mexican states of

Durango and Chihuahua—it was only a matter of time before the two cultures would meet again. After the excesses of the early conquistadores, Spain enacted laws aimed at protecting the rights of native peoples. The idea of conquest and even the word *conquista* were expressly forbidden. The primary focus of "new discoveries and settlements" was to be "preaching the holy gospel," and the missionaries were given economic and legal independence to carry out that goal. The Spanish were not to make war, drive the Indians from their homes, or side with one tribe against another. The guiding principles were "peace and mercy." Peace-loving men, licensed by the king, were to serve as leaders. These laws were the most enlightened efforts made by any European power in the New World. But it was one thing to pass laws in Madrid and quite another to enforce those laws on a distant and dangerous frontier.

In 1581 and 1582 two small expeditions operating under the new laws set out from the frontier town of Santa Bárbara, located on a tributary of the Río Conchos about 425 miles south of the modern border between Chihuahua and New Mexico. By following the Río Conchos and then the Rio Grande, the Spaniards found a more direct route into the heart of Pueblo country. These expeditions expanded Spanish knowledge of Southwest geography at the expense of further alienating the Pueblo people and the death of three friars: one who attempted to return to Mexico alone, two others who bravely stayed behind in Puaray, the Tiguex village where Coronado's men had burned Indian warriors at the stake. The Pueblo remembered, and the priests died for the sins of the soldiers.

The next thrust, which was blatantly illegal, came from the southeast in the newly established colony of Nueva León in 1590. Disappointed with the lack of riches in their own region, some 170 men, women, and children, along with livestock and the first wagons to roll through the Southwest, crossed the Rio Grande south of present-day Del Río, Texas, under the leadership of Gaspar Castaño de Sosa, who disobeyed a direct order from the viceroy to stay put.

By the time the settlers reached the Pecos River, winter was closing in, and they were running out of food. The Spanish always considered the pueblos as storehouses of food and clothing. When the pueblo of Pecos refused to help them, Castaño attacked around two in the afternoon of a cold New Year's Eve.

The disciplined defense of the heavily fortified town impressed the Spaniards. "None of them abandoned his section or trench; on the contrary, each one defended the post entrusted to him, without faltering in the least," wrote the expedition's chronicler. "Women showed fierce courage and kept on bringing more stones to the terraces. . . . Such intelligence among barbarians seemed incredible." Yet even such "incredible" intelligence could not withstand Spanish guns; Pecos surrendered in the late afternoon. Two days later Pecos was completely deserted, leaving the intruders "such an abundant supply of corn that everyone marveled. . . . Moreover, there was a good supply of beans. . . . herbs, chili, and calabashes." Castaño moved his people to the more fertile Rio Grande region, where he took over a number of pueblos and appointed Indian leaders to serve at his command. Before the colony could take hold, a cavalry force sent by the viceroy drove the settlers back to Nueva León. Castaño was taken to Mexico City in chains and exiled to the Philippines.

Three years later a much smaller expedition set out from Santa Bárbara and settled for a while in the Pueblo country before heading out onto the plains in search of Quivira, which the Spaniards still believed might hold golden riches. Somewhere in the grasslands—perhaps in Kansas, perhaps in Nebraska—the two expedition leaders quarreled, and one killed the other. Nomadic Indians killed the rest, except for a Mexican Indian servant who escaped and, after a year of captivity with the Apache, found his way to Pecos pueblo. He was still there in 1598, when a new entrada arrived from the south, forever changing the Pueblo world.

The leader of this next expedition, Don Juan de

Sonora, Mexico, from the Huachuca Mountains, Arizona

Oñate, was a man of boundless ambition, rare ability, and frightening brutality when it served his purpose. A true product of the New World, his father had served under Cortés, acted as lieutenant governor of Nueva Galicia while Coronado chased rumors in the north, and played a key role in discovering the rich silver mines of Zacatecas. Oñate's wife was the granddaughter of Cortés and the great-granddaughter of the last Aztec emperor, Moctezuma II. Don Juan inherited a great fortune from his father and his wife's family, and he made it even greater through hard work and ruthless efficiency. He would need this fortune to mount the expedition; just as Coronado had done, he was expected to bear much of the expense. In return he was given sweeping powers and financial incentives, including a personal land grant of over 150,000 acres and a reduction in the king's portion of any mines he might discover from the traditional royal fifth to a royal tenth.

After three years of backstabbing intrigue and questions about Oñate's suitability as a leader, the expedition finally got under way in January 1598. One hundred twenty-nine men would serve as both soldiers and settlers, accompanied by an unknown number of women, children, servants, and slaves, probably over 500 people in all. A contingent of ten Franciscans caught up to them on the trail. The livestock herd was enormous: some 7,000 animals, including sheep and goats, cattle and calves, oxen, pigs, horses, mules, and donkeys. Eighty wagons pulled by oxen carried all the supplies necessary to establish a colony, along with a huge quantity of trade goods, including some 80,000 glass beads. Although the number of people involved was substantially less than Coronado's expedition, this was a very different and ultimately more dangerous intrusion. Like Castaño's aborted entrada, these were people who intended to stay and make the land their own.

To cut down on travel time for the slow-moving wagons, Oñate pushed directly north from Santa Bárbara, blazing a trail across the Chihuahuan Desert that greatly extended the Camino Real, or "royal road," the all-important supply line that began in Mexico City and would lead to New Mexico. Guided by friendly Indians, they reached the Rio Grande and prepared to cross at a place that would become known as El Paso del Norte, "the pass of the north." Before crossing, the Spaniards took possession of all the land drained by the Río del Norte and celebrated a thanksgiving Mass and meal 23 years before the pilgrims. Fording the river, they followed its opposite bank for a time before turning north and crossing a barren alkaline flat that would later be known as the Jornada del Muerto, or "Journey of the Dead." Here, after burying an older man who died from the rigors of the trail, Oñate pushed ahead with an advance party while the wagons labored slowly behind. "We all fared badly from thirst," he recalled, but they were saved from disaster when a dog that belonged to one of the soldiers found springs in a side canyon.

Emerging from the desert, Oñate's party reached the southern Piro pueblos, most of which they found deserted—although at one village the people remained and offered the intruders maize, an act of succor for which they renamed the pueblo Socorro, a name that still survives in a town that developed on the site. The pueblos of once hostile Tiguex were deserted as well, with the exception of Puaray, where the Spaniards found wall paintings depicting the murder of the two Franciscans who had stayed behind in 1582. Showing admirable restraint, Oñate ignored the evidence and moved on to the Keresan pueblo of Santo Domingo, where Castaño had tried to establish his capital in 1590. There the Spaniards found two Mexican Indians who had escaped the Castaño party and now lived happily among the Pueblo.

On July 7, 1598, with these Indians acting as interpreters, Oñate received a delegation of Pueblo leaders in the great kiva and informed them:

> *. . .that he had been sent by the most powerful king and ruler in the world, Don Philip, king of Spain, who desired especially to serve God our Lord and to bring about the salvation of their souls, but wished*

also to have them as his subjects and to protect and bring justice to them, as he was doing for other natives of the East and West Indies. . . . Since, therefore, the governor had come with this purpose, as they could see, it was greatly to their advantage that, of their own free will and in their own names and in those of their pueblos and republics, as their captains, they render obedience and submission to the king, and become his subjects and his vassals.

According to the Spanish chronicler, who like most of his countrymen of this period saw and heard what he wanted to see and hear, the Pueblo leaders "replied to this through the interpreters, all in agreement and harmony and with great rejoicing. One could easily see and understand that they were very pleased with the coming of his lordship." A more likely explanation is that the Pueblo, knowing of Spanish weapons and cruelty, decided to play along

GASPAR PÉREZ DE VILLAGRÁ

FROM *HISTORIA DE LA NUEVA MÉXICO* PUBLISHED IN SPAIN, 1610

VILLAGRÁ WAS ONE OF OÑATE'S MOST TRUSTED OFFICERS, AND HIS LONG EPIC POEM OFFERS THE MOST COMPREHENSIVE, DETAILED HISTORY OF THE OÑATE EXPEDITION. IN THE FOLLOWING SELECTION, VILLAGRÁ DESCRIBES THE FIRST ENTRY INTO THE FIRST OF THE PUEBLO TOWNS IN THE MIDST OF A DRIVING STORM.

And being well within sight of the towns,
It seemed the earth did tremble there,
Feeling the great force of the Church
Shaking the idols furiously,
With horrible, impetuous violence
And furious tempest and earthquake.
. .
The Lord, in pity, showed His power.
Of that frightful tempest that He had raised,
Like powerful sea, swelled up in pride,
Which, the wind going down, is calmed
And shows a great peace unto all,
So the high heavens turned about,
Showing themselves as calm and as serene
As the sun always is when his bright rays,
In the midst of his course he does show us.
In which noble weather, the General
Arrived at the town and then, all together,

The barbarians came out to us
And seeing the Commissary, who bore
A wooden cross in his right hand,
All kissed the same with great respect,
And they obeyed our General,
Lodging him within their town,
Within whose houses we then saw
A mighty store which they had there
Of haughty demons pictured,
Ferocious and extremely terrible,
Which clearly showed to us they were their gods,
Because the god of water near the water
Was well painted and figured.
The god of the mountains, too,
* near the mountains,*
And next to fishes, seeds, and battles,
Were all the rest that they revere
As gods of those things they had.

Inscription Rock, El Morro National Monument,

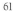

and see what developed. And what developed was not pleasing at all.

Oñate temporarily established his headquarters farther north at the Tewa-speaking pueblo of Okeh, which he renamed San Juan de los Caballeros, located on the Rio Grande near its confluence with the Rio Chama. The rest of the party arrived in mid-August and immediately began building a church and settling in. Franciscan missionaries fanned out to various pueblos assigned to them by Oñate, while the Spaniards took formal possession of the pueblos and read the Act of Obedience and Homage—the same act Oñate had presented to the leaders in the kiva of Santo Domingo. Considering that there were perhaps 40,000 Pueblo and less than 130 armed Spaniards, it seems remarkable that the colony met little resistance. But the Pueblo were by nature a peaceful people. For all their cultural sophistication they were never a united nation; they remained separated by distance and language. Although linguistically related villages might work together, as they did in the Tiguex region during the war against Coronado, each pueblo was an entity unto itself; one pueblo might offer food and friendship to the intruders, while another offered armed resistance, and yet another was simply deserted.

The first serious resistance came from Acoma, a Keresan-speaking pueblo located east of the Zuni on a red sandstone butte over 350 feet above the surrounding valley. One of Coronado's men had called it "the greatest stronghold ever seen in the world," and the Acomans used their stronghold to great effect. When 30 soldiers under Oñate's nephew, Juan de Zaldívar, arrived in December 1598 demanding flour and blankets, the situation grew tense—particularly after one of Zaldívar's officers took several Indian leaders hostage. Although Zaldívar himself quickly released them, the Acomans considered the Spanish demands unreasonable. After a group of soldiers climbed the narrow path to the town, the villagers attacked them with clubs, rocks, and arrows, killing 13 of the intrud-

ers, including Zaldívar. Oñate had been ordered not to make war upon the Indians, but even the friars agreed that this treason by people who had theoretically sworn allegiance to the crown constituted legal grounds for attack. And so Don Juan de Oñate declared *guerra de sangre y fuego*, war by blood and fire.

In January 1599 Zaldívar's younger brother, Vicente, returned with 70 men and entered the village through a daring plan in which the main army distracted the Indians in a frontal attack while Zaldívar and 11 handpicked men scaled the steep cliff to the rear, establishing an offensive position within the fortress of Acoma. Other men followed, and two heavy cannon hauled up with ropes blasted the ancient walls with horrible fury. By the time the carnage was over, between 600 and 800 Indians were dead. According to one Spaniard, many of them were killed after surrendering when Vicente ordered them hacked to death and thrown off the cliffs. Others died when he set fire to the village.

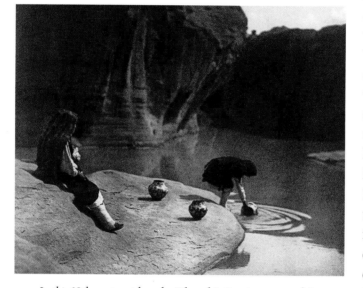

In this 19th-century photo by Edward S. Curtis, women of the mesa-top Acoma Pueblo visit natural cisterns to collect rainwater. A soldier with Coronado noted the same practice in 1540: "On the top they had room to sow and store a large amount of corn, and cisterns to collect snow and water."

Choosing Santo Domingo as a central location, Oñate presided over a trial of more than 500 Acoma captives. Every Acoma man over 25 was sentenced to have one foot cut off and forced into 20 years of servitude. Boys over 12 and women also faced 20 years of servitude, though their feet were spared. Young girls were given to one of the friars, and 60 were removed to convents in Mexico. Young boys were officially given to Vicente Zaldívar. Two Hopi visitors had their hands cut off and were sent back to their people as a warning. The brutality with which the Acoma rebellion was suppressed had a quieting effect on most of the pueblos, but the people of the Tompiro region east of the Rio Grande offered renewed resistance in 1600 and early 1601. Met with similar force and brutality, three pueblos were burned, almost 900 Indians were killed, and 400 more were captured and distributed as slaves.

Sometime during this early period the colonists at San Juan moved across the Rio Grande to a pueblo called Yungeh Oweenge ("mockingbird place"), which they remodeled as the Spanish-style town of San Gabriel de los Españoles—the first capital of New Mexico. But it was one thing to establish a capital and another to establish a functioning colony. Still hoping for instant riches, the Spaniards began no significant agricultural projects and depended almost entirely on tribute exacted from the hard-pressed Pueblo people. The arrival of 73 new male settlers, some with wives and children, seemed to offer new hope during the Christmas season of 1600, but in fact these new arrivals were yet another strain on already overburdened resources.

Ignoring everyday needs, Oñate explored the region from the Great Plains to the Colorado River, searching for rich mines that did not exist and a port on the South Sea that would transform his dying colony into a trading empire. When back in San

Gabriel, he became increasingly despotic in a desperate effort to hold his people together. Several men who complained or tried to escape were killed. One of Oñate's captains—who smuggled a letter to the viceroy past Oñate's censorship—wrote frankly, "The fact is we are all depressed, cowed, and frightened, expecting death at any moment." In September 1601 about two-thirds of the colonists risked charges of desertion and fled back to Mexico.

His colony on the verge of extinction, Oñate resigned in 1607, even as an order from the king relieving him of his post was on its way to the remote frontier. Around this time the Spanish established a more defensible and central settlement at Santa Fe, and the new governor, Don Pedro de Peralta, formally moved the capital to the site in 1610. Peralta expanded a system of Indian servitude called the *encomienda*, which granted settlers and missionaries the right to demand tithes of food and other goods from the native people who lived on land that the settler or mission "owned." A related system, the *repartamiento*, allowed the Spaniards to conscript Indian labor for minimal wages. Although Spanish legislation tried to mitigate the impact on the native population, these two systems were widely abused on the frontier, and they became the economic backbone of New Mexico, gradually building a functional, if still poor, colony while turning the proud Pueblo people into feudal serfs.

Even more destructive than the feudal system were the efforts of the friars to eradicate Pueblo religion and culture, which were essentially one and the same. At first the Franciscans had little success with the strong-minded and deeply religious Pueblo. By 1602 only 60 or 70 Pueblo had been baptized. Five years later Oñate, who had reason to exaggerate, estimated that there were only 600 converts. In the years that followed, however, thousands of Pueblo people accepted Jesus and Mary outwardly for a variety of reasons, if not in their hearts.

On the most basic level the Pueblo were starving, forced by the Spaniards to give up precious food supplies that sustained them in a dry and difficult land. By converting to Christianity, they could share in the food kept by the missionaries. At the same time, as their traditional economy broke down, the widely scattered pueblos were increasingly vulnerable to attack by nomadic Athapaskan-speaking Indians, especially the Apache and Navajo who had once come to trade but now came to raid and loot, often mounted on stolen Spanish horses. Those pueblos that accepted a missionary presence might expect protection from these external threats, although in reality the Spanish exacerbated the situation by kidnapping slaves from the nomadic tribes—the most lucrative economic activity available in New Mexico. Further increasing the pressure to convert was the shocking brutality of some friars who punished displays of traditional religion by whipping, beating, or cutting the long hair that Pueblo men considered a source of spiritual power. Several friars were accused of rape and, though perhaps not every such charge was true, some confessed to their crimes.

Adding to this difficult situation, the civil and religious authorities were in a near-constant state of conflict. They fought over rights to use Indian labor and exact Indian taxes, each accusing the other of abusing their charges. Four governors were imprisoned by Franciscan authorities, and two of these later faced the dreaded Inquisition in Mexico City. At the same time the governors tried various ways to undermine the authority of the friars. The most aggressive of these was López de Mendizábal, who not only limited the missionaries' powers to conscript Indian labor but also granted official permission for the Pueblo to perform their traditional dances, in part because he considered them "mere foolishness," in part because he wanted to harass the priests. In the midst of this confusion the Pueblo kept their religion alive in secret and took whatever advantage they could of the divide between church and state. But the situation could not continue, and many Pueblo leaders knew it. Weakened by hunger and racked by new diseases, the Pueblo popu-

lation fell from perhaps 40,000 when Oñate arrived to around 17,000 seventy years later, which placed an even greater burden on the survivors to support their Spanish masters. There were attempts at rebellion—most of them in outlying pueblos—but for the most part the patient Pueblo played the Spanish game and waited for a chance to strike.

THE SCREW BEGAN TO TURN in 1675 with the arrival of Governor Juan Francisco Treviño and a new spirit of cooperation between civil and religious authorities in cracking down on Pueblo religious activity. That year Treviño had 47 Pueblo men arrested as sorcerers, accused of bewitching a Franciscan priest along with other crimes. All the men were publicly whipped, and three were executed by hanging in their home villages, while a fourth hanged himself in his cell. Enraged by this treatment, 70 Pueblo warriors entered Treviño's private quarters and threatened to kill him and his family unless he released the rest of the men. He did, and one of those he released, a war captain from San Juan pueblo whom the Spanish called Popé, is often credited as the architect of the great revolt that followed. Harassed by Spanish authorities in San Juan, Popé moved north to Taos in the towering Sangre de Cristo Mountains, where, according to one native account, he was said to communicate in the great kiva with three Pueblo deities who told him to plan a revolt "because the God of the Spaniards was worth nothing and theirs was very strong, the Spaniard's God being rotten wood."

Although the Spanish later identified Popé as the supreme leader of the rebellion, there were in fact many leaders at many different pueblos—an unprecedented show of unity among a traditionally diverse people. Only the southern Piro pueblos, for unknown reasons, were excluded from the plot. The rebellion was planned so secretly that Popé had his own son-in-law stoned to death when he discovered the plan. Finally, in August 1680, the time was ripe. The Pueblo leaders realized the Spanish were at their weakest point just before the supply caravan arrived from Mexico. Popé rightly prophesied that the caravan, which came every three years, would be late that year. This would give the Pueblo time to work out final details.

The revolt was scheduled for the 11th or 12th of August. On August 9 runners carried knotted cords to the villages, the knots indicating the remaining days before the uprising. That same day the leaders of three pueblos decided to back out and leaked news of the plot to Governor Antonio de Otermín, who had replaced Treviño. Receiving similar reports from other sources, Otermín arrested and interrogated two runners from the pueblo of Tesuque, just north of Santa Fe. Realizing the plot had been revealed, the people of Tesuque began the revolt then and there. That night they killed a Hispanic man who lived among them. The next morning, when their priest, Fray Juan Pío, arrived to say Mass, he found the pueblo deserted and warriors armed and painted for battle in a nearby arroyo. "What is this children, are you mad?" Pío asked. "Do not disturb yourselves; I will die a thousand deaths for you." He died one of them in the arroyo, while the soldier who accompanied him barely escaped with his life and brought the news back to Santa Fe. The Pueblo Revolt had begun.

In the days that followed, some 380 colonists and 21 Franciscans were killed. Governor Otermín gathered the settlers in the Santa Fe area behind the adobe walls of the *casas reales*, a one-story, stockade-like structure that included the Palace of the Governors and was built around a large central courtyard. On August 15 Pueblo warriors, some armed with Spanish muskets, attacked Santa Fe. Otermín sent out his entire force of less than a hundred fighting men to meet them. After an all-day battle proved indecisive, the Spaniards retreated behind the walls while Indian reinforcements continued to arrive. By August 18 about 2,500 Pueblo had surrounded the casas reales and cut off the water supply.

Deciding "it would be a better and safer step to die fighting than of hunger and thirst," Otermín led a

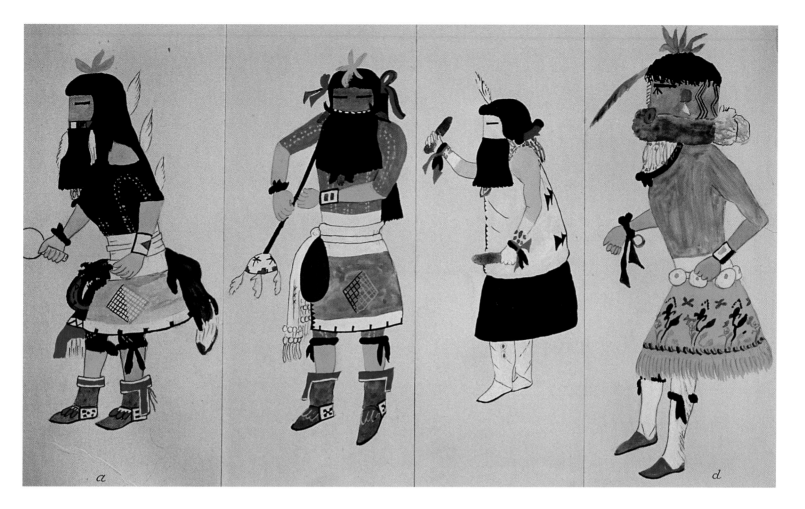

near-miraculous charge on the morning of August 20, killing almost 300 Indians, capturing and executing 47 more, and driving the others away—all while losing only 5 of his own men. However, many were wounded, including Otermín, who was shot in the face and chest. With reports of uprisings throughout the upper river region, the governor decided to march south to the Rio Abajo, or "lower river," where colonists had gathered under the lieutenant governor in the pueblo of Isleta. About a thousand dazed and frightened refugees whom Otermín termed "all classes of people"—Spanish soldiers, their families, their servants, and Mexican Indian allies—marched sadly to the south, finding abandoned pueblos, burned-out churches, desecrated religious images, and dead bodies along the way. The Pueblo watched them but did not attack. They did not really want to kill the Spaniards; they just wanted them to leave.

Otermín's party found Isleta deserted; the other

This early 20th century panel painting by native artists depicts Zuni kachina dancers wearing their sacred ceremonial masks and costumes. Benign beings who bring rain and other good things, the kachinas are important to all Pueblo people. According to the Acoma origin myth, the kachinas came to the village in person, but they became angry after men made fun of them in the kiva. A great battle broke out and after many humans were killed it was decided that the kachinas would no longer come in person. Instead the men of the village would impersonate them, invoking their aid through sacred dances and ceremonies.

Spanish contingent had already fled farther south. The two groups met on the trail and continued on to El Paso del Norte (modern Juárez, Mexico), where a mission had been established. For the next 12 years this became the lonely outpost of the Spanish province of New Mexico. In the meantime, following instructions from Popé, the Pueblo wiped out every vestige of European influence. They burned Christian images and destroyed churches that had survived the initial uprising. Those who had been baptized purified themselves with yucca soap, and Christian marriages were declared invalid. It was forbidden to speak Spanish or utter the name of Jesus and Mary. They uprooted fruit trees, and Popé went so far as to order them not to sow seeds from Spanish plants.

A better revolutionary than a leader, Popé mimicked the man he had driven out: He lived in the Governor's Palace and demanded tribute, just as the Spanish had done. The Pueblo maintained sufficient unity to repel an attempt by Otermín to retake the territory in 1681, but the unity and strength of purpose that had made the revolt possible eroded under pressure from old rivalries, drought, and increased attacks by nomadic bands. In 1683 Luis Tupatú, who had temporarily overthrown Popé and gained control of the northern pueblos, sent an emissary to Otermín in El Paso del Norte to discuss the possibility of a peaceful return, but the Spaniards were in such desperate straits themselves that they had to put off the idea. Popé regained power in 1688 but died two years later, leaving the Pueblo without his

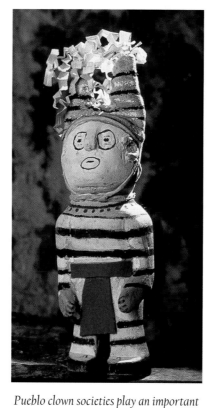

Pueblo clown societies play an important ceremonial role, serving both to entertain people and to perform sacred functions. This clown effigy was created in the 1930s.

resolute, if eccentric, patriotic vision.

In 1692 a new governor, Diego de Vargas, made a peaceful tour of his province, receiving assurances from 23 pueblos that they were willing to allow the Spanish to return. When Vargas returned the following year, however, with a hundred soldiers, 70 families, a contingent of Indian allies, and 18 Franciscan friars, only a few Keresan pueblos actually welcomed him. He was forced to retake the province through the same kind of brutal violence that Coronado and Oñate had employed before him. That such a small force could reconquer a vast land where they were greatly outnumbered by the native people was as much a testimony to the breakdown of Pueblo unity as it was to the Spanish guns. By late 1696 Vargas had regained control of all the pueblos except those of the Hopi, who remained independent on their high and distant mesas throughout the colonial period.

As the 18th century began, the Pueblo and Spanish settled into a wary, yet peaceful, coexistence. The encomienda was never reinstated, and the Franciscans were far more liberal in their attitude toward native religion. The Pueblo adapted quickly to the Spanish legal system, taking steps to protect their land and their way of life in terms the conquerors could understand. They saw the Spanish as allies against their shared enemies among the marauding nomadic tribes, and in the many military expeditions against these tribes, Pueblo warriors consistently made up the largest and most effective fighting force. Pueblo married Spaniards, while blacks and Mexican Indians added to the mix, which ultimately developed into a new hybrid culture called Hispano that still flourishes in New Mexico today.

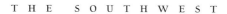

Pecos Pueblo Ruins, New Mexico

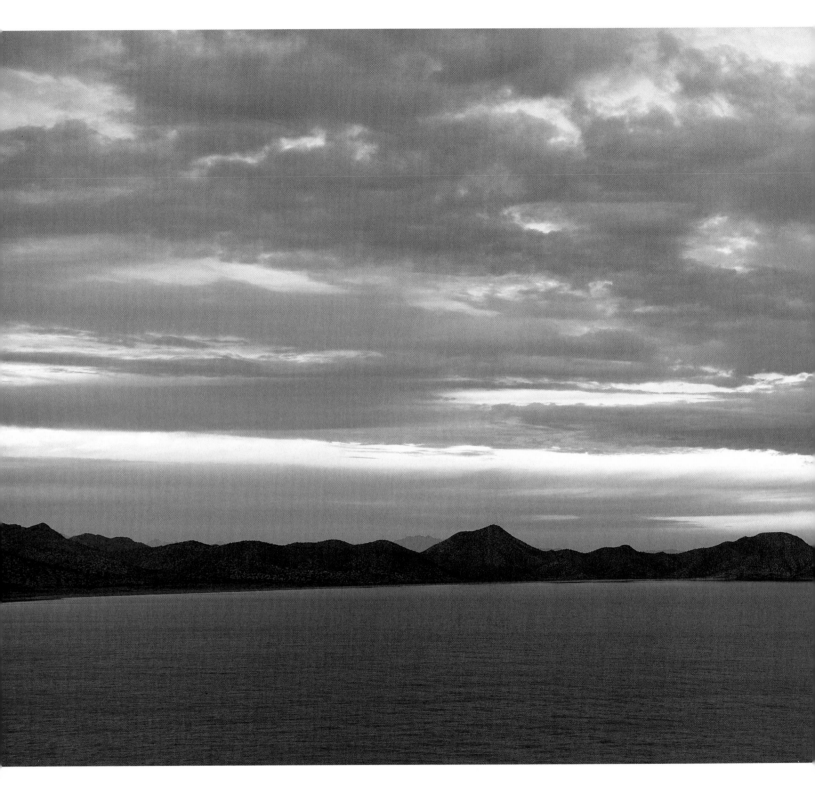

SUCH GENTLE
NATIVES

Sea of Cortés, Tiburon Island,
and Baja California

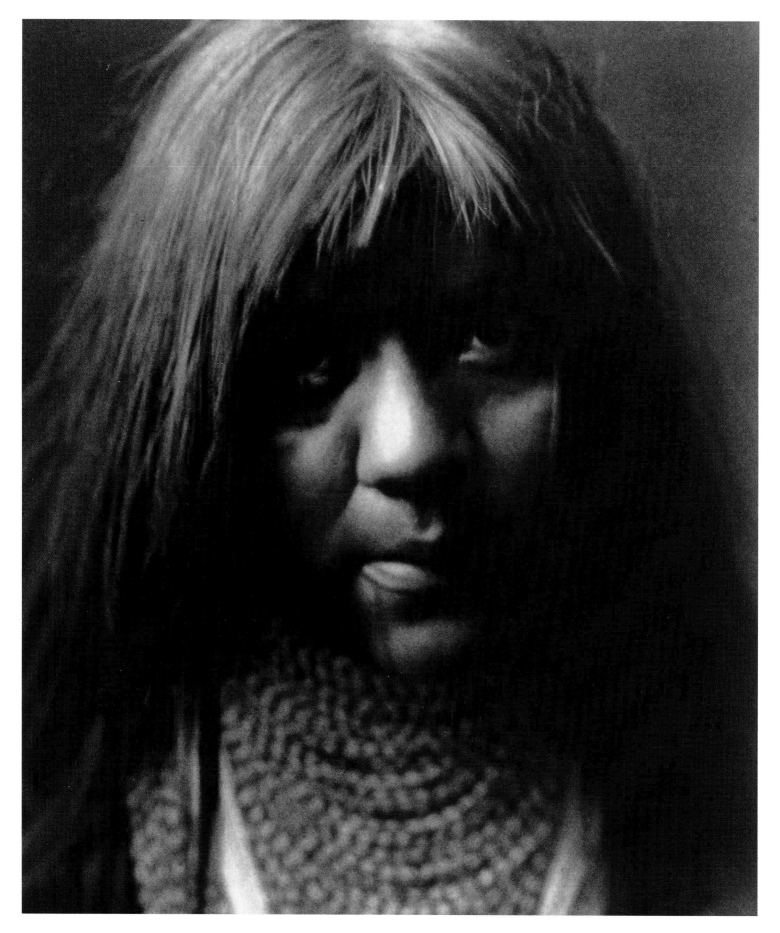

Yuma Indian

1 6 8 3 - 1 7 9 0

SUCH GENTLE NATIVES

On April 1, 1683, two Spanish ships sailed into the inner harbor of La Paz on the gulf coast of Baja California. Despite its name, which means "the peace," the harbor had proved disastrous for a succession of expeditions since the time of Cortés, and those that had reached shore had thoroughly alienated the Indian people. But times had changed, and this expedition had good intentions. On the flagship of Adm. Don Isidro de Atondo y Antillón a mulatto drummer called the passengers and crew together, and the royal scribe read the official proclamation, or *bando*.

The sole purpose of the expedition was the conversion of the Indians so they might become good, obedient, and ultimately tax-paying servants of His Royal Majesty. No man would molest the natives or trade with them, but if the Indians offered valuable treasures of their own free will, such treasures would be kept in the royal chest and locked with three keys. Any man could keep whatever treasure he found as long as he gave the usual 20 percent to the king. Having laid the ground rules, "some of the men went ashore and found a beautiful well of water, a plentiful supply of firewood,

a marsh, a pretty grove of palms, and tracks of Indians."

So it was told by a 37-year-old Jesuit missionary named Eusebio Kino, who watched this landfall from the second ship. We know he watched eagerly because this was his territory—California—a near-mythic virgin land that the Spanish believed to be the largest island in the world. Born in the Italian Alps, Kino was a near-mythic figure himself. Intelligent, practical, and indefatigable in mind and body, he was trained in cartography, geography, mathematics, theology, and the emerging field of astronomy. On this, his first mission-

ary assignment, Kino held an unusual dual position as rector and royal cosmographer, in charge of converting the Indians and mapping unknown lands. His scientific background would prove invaluable in the New World, but he had something even more valuable that could not be taught: a natural and honest compassion for the Indian people. Kino genuinely liked the Indians, and even discounting the pious optimism of missionary reports, it seems clear they liked him back.

Although Kino took enthusiastically to his work, the Spaniards aborted the expedition within a few months, after a violent skirmish. A second landing that fall, at a place north of La Paz they named San Bruno, proved more enduring. It was during their second year on the "island," in December 1684, that Admiral Atondo and Father Kino led the first expedition over the rocky volcanic mountains to the crashing surf of the Pacific Ocean, where they found "shells of rare and beautiful luster, of all colors of the rainbow, every one of them larger than the largest mother of pearl shells." Among these were blue abalone shells, which the native people used for drinking cups.

That May the Spaniards were forced to abandon their California settlement again, this time by rampant scurvy. Kino was heartbroken, and the "incredible" sorrow the Indians expressed at seeing them go only made it worse. "Everybody . . . was very much grieved," he wrote, "to see such gentle, affable, peaceful, extremely friendly, loving and lovable natives left deserted, when already many of them were begging for holy baptism." Kino comforted himself and the natives with the promise that he would return in two months. But the fates spun another tale. Eusebio Kino would never return to the Baja coast, but he never forgot those blue shells, and he never forgot California or the Indian people who lived there.

THE RETURN TO CALIFORNIA WAS CANCELED for lack of funds, due in part to a sudden demand by the king of France to compensate him for a treasure ship that had been sunk a few years earlier in Spanish waters—nei-

ther the first nor last time that petty European politics changed the course of American history. Kino was assigned to establish a mission among the Seri and Guaymas Indians, who lived along the coast of the Mexican mainland just across the Gulf of California from Baja California. But even as he rode north along the coast, he was diverted to yet another mission field.

The success of the Pueblo Revolt had emboldened other tribes, including the wide-ranging, warlike Apache, to attack other Spanish settlements on the northern frontier. Although the loss of New Mexico was frustrating, the loss of silver-rich Sonora and Chihuahua would be disastrous. Rumors swirled that the Upper Pima Indians, or Pimas Altas, who lived in the Sonoran Desert to the west of the Apache, were planning to ally themselves with the Pueblo against the Spanish. It was requested that a missionary be sent as soon as possible to bring them into the Spanish fold. Eusebio Kino happened to be the next missionary to arrive, and so he was sent not to the coast across from his beloved California but to the harsh expanse of the great Sonoran Desert—then the northern edge of the Spanish frontier, the "Rim of Christendom."

The Pima call themselves the O'odham, the People, and the name Pima comes from their word for "no" or "nothing." Some modern Pima suggest the term developed when Spaniards asked their ancestors what they were called, and the Indians tried to explain they had no idea what the whites were saying. At the time that Kino arrived among them, the Pima ranged widely over the Sonoran Desert, spoke a variety of dialects, and practiced various adaptations to desert life. The most settled and agricultural of the Pima were those who lived along the perennial rivers that run down from mountains on either side of the modern border. Following well-tested Jesuit logic, it was among these settled people that Father Kino founded his missions, and he pushed into the unknown by reasonable increments.

In March 1687 Kino established his first mission near a mountain village called Cósari on the Rio San

Sonoran Desert, Baja California

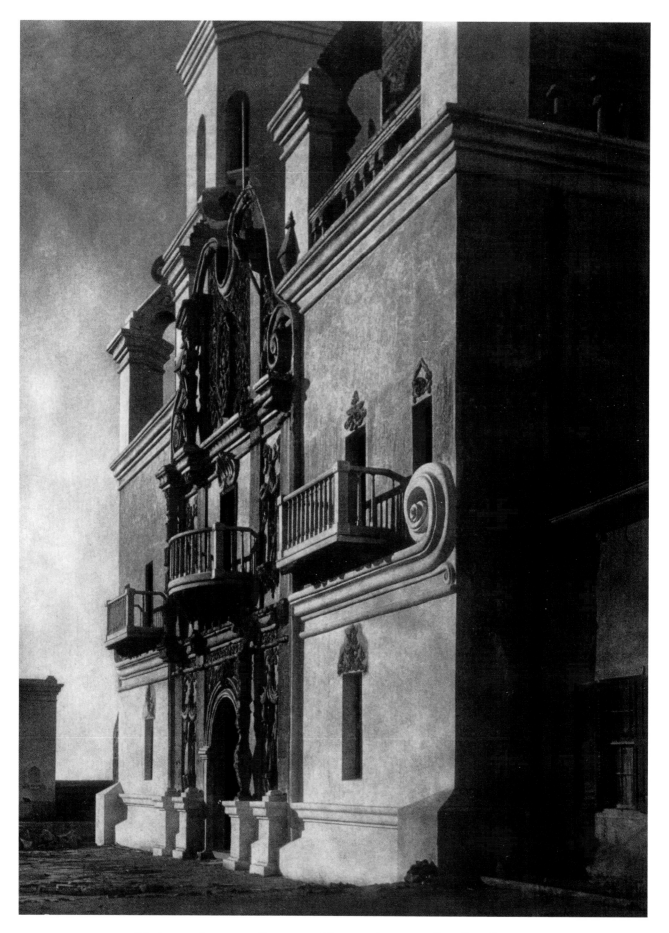

Mission San Xavier del Bac

Miguel of northern Sonora. The Pima were happy to see him; they had asked for a missionary after witnessing the improved living standards that missionaries had brought to other Pima farther south. Adding to their enthusiasm was the fact that Kino carried a royal order that exempted any baptized Indians from forced labor for a period of 20 years. Kino named this mission Nuestra Señora de los Dolores, Our Lady of Sorrows, after a beautiful oil painting he had carried with him as a gift from a famed Mexican artist. That summer the missionary made a breakthrough by baptizing a Pima leader named Coxi, who not only was chief of Cósari but also exercised authority over many villages to the west. As Kino recalled, five other chiefs came to witness the great event, and "although hitherto some of them had been little attached to our Holy Catholic Faith, since the fiesta and the ceremony of the baptisms they have been so content and consoled that they are requesting father missionaries for themselves and their countrymen."

For the next 24 years, until his death in 1711, Dolores served as Father Kino's home base as he pushed northward and westward into the desert, founding a chain of some 20 missions among the Pima, including several in what is now the United States. Of these the most substantial was San Xavier del Bac, located just south of modern Tucson. During his long years among the Pima he never had more than three or four priests to help him, and most of these served intermittently. Kino held his mission network together through the force of his personality and endless days in the saddle under the hot desert sun. The most conservative estimate of his travels on horseback is 8,000 miles.

The Kino missions changed the lifeway of the Upper Pima and ultimately changed the face of the American Southwest. His proclamation protected the Pima from servitude; his knack for straight talk and diplomacy smoothed relations between the Indians and Spanish settlers. Kino introduced new farming methods and new crops, including winter wheat, which increased the nutritional base and added a new growing season. He also introduced

Spanish cattle and is often credited as the father of the Southwest cattle industry. Contemporaries criticized him for baptizing neophytes without proper instruction and allowing traditional Piman practices, such as dances, polygamy, and the use of intoxicants. To an extent this was typical of the more worldly, pragmatic Jesuits, but it was also typical of Kino personally. He instinctively understood what the Franciscans learned the hard way in New Mexico: Flexibility with native culture went a long way in establishing trust and friendship.

Like all missionaries of his time, Kino was a willing participant in imperialist expansion, but he brought a unique passion and talent to the work of mapping and exploration, and in his mastery of the desert he learned as much from the Pima as he taught them. He followed an Indian trail now known as El Camino del Diablo, the Devil's Road, through the bone-dry desert in western Sonora and explored the Gila River drainage from modern Phoenix to the Colorado River. Kino was the first white man to see the Hohokam great house at Casa Grande; but, though he recognized it as the ruin of a great civilization, he believed it was built by the Aztec, who, according to the theory of the time, had come down from the north. Most important of all, however, was Kino's discovery that California was connected to the mainland.

It began in early 1699, when Kino and his frequent traveling partner, the Spanish soldier Juan Mateo Manje, led a major entrada to the lower Gila River, accompanied by another priest, a contingent of Pima vaqueros, 90 pack animals, 80 horses, 36 head of cattle, and eight loads of provisions. After pushing up the Devil's Road, drinking from natural granite water tanks along the way, they reached the lower Gila, where they found Pima living with another tribe who spoke a different language. These were the Quechan or Yuma Indians, an unusually tall, powerfully built people whose heartland lay along the Colorado River to the west. Among the gifts the Yuma offered the visitors were blue abalone shells that looked just like the shells

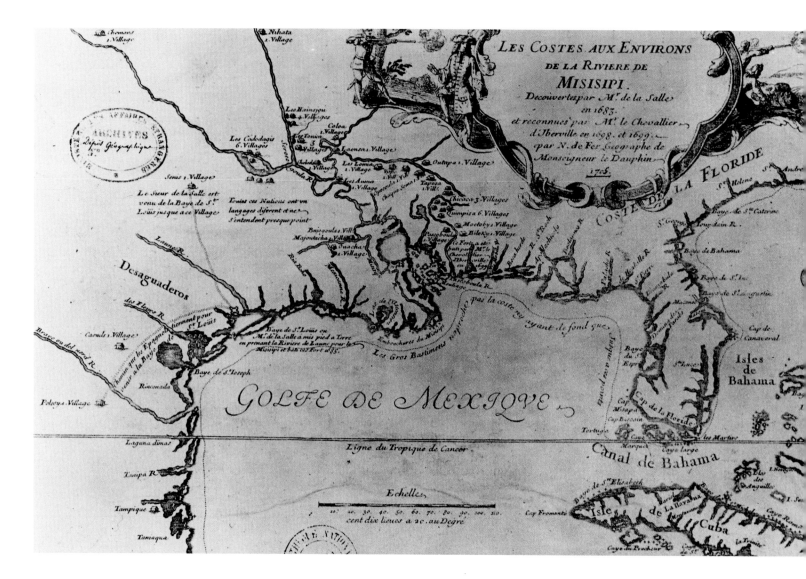

Les Costes aux Environs
de la Riviere de
MISISIPI.
Decouvertes par M.ʳ de la Salle
en 1683.
et reconnues par M.ʳ le Chevallier
d'Iberville en 1698. et 1699.
par N. de Fer Geographe de
Monseigneur le Dauphin
1705.

COSTE DE LA FLORIDE

GOLFE DE MEXIQVE

Ligne du Tropique de Cancer.

Echelle

Canal de Bahama

Isles de Bahama

Isle de Cuba

This 1705 French map of "The Coast and Environs of the Mississippi River" still shows La Salle's ill-fated Fort St. Louis on the Gulf coast of Texas, although the fort had been abandoned over a decade earlier, leaving the grisly remains of an Indian attack. The official chronicler of the Spanish expedition that found the ruined fort suggested that God had punished the Frenchmen "as an admonition that Christians should not go directly against the bulls and mandates of the pontiffs," a reference to the edict of the Renaissance Pope Alexander VI who had divided the non-Christian world between Portugal and Spain in 1493, with the lion's share of what became the Americas going to Spain.

Kino had seen years before on the Pacific coast of Baja.

Although they went no farther on this trip, Kino kept thinking about these shells and what they meant for the geography of the continent. By this time a new Jesuit missionary effort had begun in Baja, and Kino believed there might be a direct land route between his own thriving missions and the fledging missions of Baja California. The following year he proved his theory by sighting the Colorado Delta with a telescope. The year after that he crossed the great river and set foot on the land that would later become the state of California. The land route was no longer a question, but it would take many more years before the promise of Father's Kino's vision was fulfilled, and unfortunately the men who fell heir to that vision were not always cut of the same compassionate cloth as the apostle of the Pima.

IN 1685, THE YEAR Father Kino's mission in Baja California was abandoned, the French explorer Robert Cavelier, Sieur de la Salle, established a fort along the Texas coast in an ill-conceived plan to invade New Spain. The Spanish learned of the fort from a French deserter and, after ignoring Texas for a century, sent 11 expeditions (by land and sea) before discovering the ruins in 1689. Wild animals had gnawed the flesh of three dead colonists, including a woman who had been shot with an arrow, and two survivors living among the Indians told harrowing tales of disease, starvation, and Indian attack. La Salle himself had been killed by his own men while trying to reach the Illinois country up the Mississippi.

The French threat and steady stream of expeditions renewed Spanish interest in the area. In 1690 two Franciscan missions were established among a Caddo-speaking people who lived beyond the Trinity River, about halfway between modern Houston and Dallas. The Caddo were farmers who lived in permanent villages from the Trinity northeast into what are now Louisiana, Oklahoma, and Arkansas. These particular Indians belonged to a powerful political confederacy called the Hasinai; however, early Spanish reports referred to the area as the "Kingdom of Tejas," based on a Caddo word meaning "friends" or "allies," and so the region became known as Tejas, or Texas.

At first the Caddo welcomed the missionaries; they claimed to have been visited long ago by a mysterious lady in blue, who taught them about Christianity. This strange story was told by many Indians of the Southwest—Father Kino heard similar tales from the Yuma and Pima, while an earlier missionary in New Mexico met Apache and Jumano who saw the lady— and its roots are often traced to the Spanish mystic María de Agreda, who reported preaching to New

Numbering over 20,000 when the Spanish arrived, the Chumash Indians who made these fishhooks of abalone shell and deer bone lived on the islands, coast, and mountains of the Santa Barbara-Ventura area.

World Indians during out-of-body experiences in the 1620s. Yet mysticism has its limits, and the Caddo turned against the friars after an overzealous missionary insulted their high priest and explained a devastating smallpox epidemic as God's holy will. The Caddo had a God of their own, a Supreme Being surprisingly similar to the God of the Spaniards, but he did not kill people with smallpox. Faced with death threats from Caddo leaders, the Franciscans abandoned the missions in 1693.

New French incursions forced a more ambitious entrada in 1716, when six Spanish missions and a presidio were established among the Caddo extending into present-day Louisiana. The Spanish brought not only missionaries and soldiers but also some women and children and a large herd of livestock—evidence they had come to stay. They were aided in appeasing the Indians by a French trader named Louis St. Denis, who was greatly respected by the Caddo. St. Denis was arrested the following year for smuggling, and the new missions foundered without him. By this time the Spanish realized what should have been obvious all along: They could neither protect nor provide for these missions so far north of the Rio Grande. It was decided to create a halfway station along a beautiful river they had discovered in 1691 during the earlier missionary efforts.

One of the discoverers, Governor Domingo Terán de los Ríos, described the area as "a fine country with broad plains—the most beautiful in New Spain. We camped on the banks of an *arroyo*, adorned by a great number of trees, cedars, willows, cypresses, osiers, oaks, and many other kinds. . . . This I called San Antonio de Padua because we had reached it on his day." The missionary who accompanied him, Father Damián Massanet, listed other plant life, including cottonwoods, mulberries, and "many vines," as well as "a great many fish and upon the

highlands a great number of wild chickens. On this day, there were so many buffalo that the horses stampeded and forty head ran away." Twenty-five years later, another expedition reported a dizzying array of wildlife, including fish "in abundance," eels, alligators, deer, pumas, wolves, coyotes, bears, rabbits, squirrels, wildcats, and javelinas. This was the Eden-like world along the upper San Antonio River.

The people who lived in this world are often called the Coahuiltecan because at least some of them spoke variations of the Coahuiltecan language. Cabeza de Vaca and his companions lived among these people in the early 1530s, and his account offers a compelling if mysterious picture of a warlike hunter-gatherer culture deeply steeped in ritual taboos, struggling for survival yet so hostile toward neighboring bands that they killed their own daughters in infancy rather than allow them to grow up and give birth to their enemies.

Although simpler in material culture than the Caddo confederacies, they were not as simple as most Spanish reports would suggest, and it seems clear that their culture evolved after Cabeza de Vaca's time. On a preliminary visit in 1709 the man who later established the San Antonio Mission, Father Olivares, observed Coahuiltecan farming the river valley using terraced fields and irrigation canals; in 1744 another Franciscan commented that their bodies were "so well formed, so robust, agile, and freed [of blemishes]" that they could walk five times as far as others and "find little difference between level ground and the craggiest marches." They were taller than the Spaniards and taller than many other Indians. Human remains at one mission indicate an average height of five feet seven inches for men and five feet four inches for women—unusual for a people thought to be living on the edge of starvation.

Regardless of their impressive physiques, the Coahuiltecan were in serious trouble as a people by the time of the missions. Their always tenuous population was racked by early exposure to European diseases, and their traditional lifeway was threatened by Lipan Apache raiders from the north who, along with the

even more fearsome Comanche, had begun to develop a horse culture out of the Spanish herds in New Mexico. Like the Pima, the Coahuiltecan asked for missions, some traveling as far as Mexico City to plead their case. They saw the missions as a source of safety and sustenance, and they were not concerned about the theological details. Beginning in the 1670s, missions for the Coahuiltecan were established south of the Rio Grande, but it was the more promising Caddo missions that pushed the Franciscans to minister to the people north of the river.

IN MAY 1718 provincial governor Don Martín de Alarcón and the Franciscan Antonio de San Buenaventura Olivares formally established the first mission, San Antonio de Valero, as well as a nearby fort and village, the Presidio y Villa de Béxar. The term *villa* was a special designation ordered by the viceroy, second only to a *ciudad*, and this was the first villa so designated in Spanish Texas. Despite the optimistic terminology, there were only ten soldiers, six of whom brought their families, and another ten families of civilians. Twenty other families joined them in the following months. Much later the villa would be called San Antonio, and the mission, which was moved twice in the early years, would become known as the Alamo.

In the fall of 1719 pressure from the French forced the Spanish to abandon their missions and presidio in east Texas, and they pulled back to San Antonio, where one of the refugee priests founded a second mission on the river to the south. The following year an army of 500 men—the largest Spanish force ever employed in Texas—drove the French back into Louisiana, but French traders continued to hold the upper hand among the Caddo and other Indian people along the Spanish frontier. While the Spanish could not even supply their own needs, the French operated an efficient trading network that provided the Indians a steady supply of guns, which completely changed the balance of power. "We do not have a single gun," complained the Franciscans among the Caddo, "while we see the

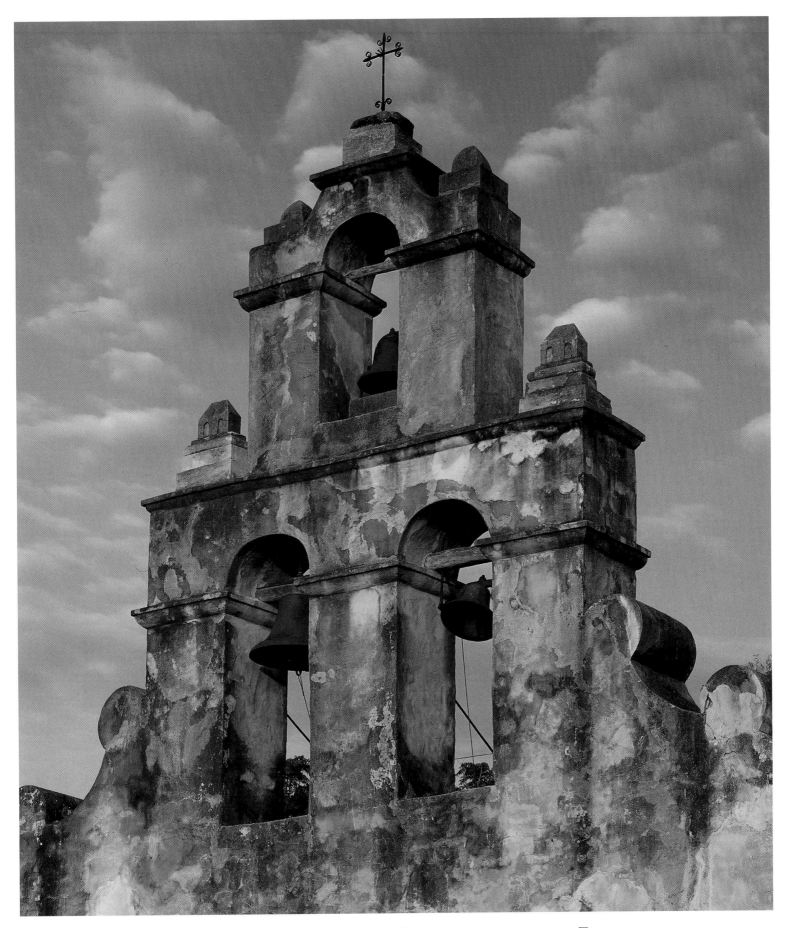

Mission San Juan Capistrano, Texas

French giving hundreds of arms to the Indians." Then, too, the Caddo people had lost their taste for religion; one priest reported that they resisted baptism because "they have formed the belief that the water kills them."

In 1731 three of the east Texas missions were permanently relocated along the San Antonio River, creating the most concentrated Catholic mission system in North America. That same year a group of 55 settlers from the Canary Islands arrived to strengthen the population of what would become the city of San Antonio. They created their own villa of San Fernando and promptly alienated the original soldier-settlers by trying to take the best lands for farming. In time these secular settlements merged through intermarriage and common interests, including a shared resentment for the missionaries, whose Indian labor allowed them to produce a surplus they could sell to soldiers and townspeople. The settlers had to work the soil themselves, struggling on the edge of poverty.

From the earliest years the San Antonio colony was harassed by the Lipan Apache, who coveted its horses and other livestock. The situation improved with a 1749 truce in which the Indians and settlers literally buried the hatchet along with a lance, six arrows, and a live horse in the central plaza of the fledgling town. In the peaceful years that followed, the Texas settlers, or Tejanos, were able to expand their irrigated farms and ranches in the San Antonio area, but efforts to expand the frontier north into Apache territory proved disastrous. In 1757 the Franciscans established a mission among the Lipan on the San Saba River, but they insisted that the presidio be built three miles away so the soldiers would

In their unceasing efforts to convert the native people, Spanish missionaries often used rosaries made of native materials, like these beautiful hand-carved mother-of-pearl beads with silver filigree cross.

not corrupt the Indians. Within a year 2,000 Comanche warriors and allies, enraged by this new alliance with their traditional Apache enemies, attacked and burned the mission, killing eight people, including two missionaries. The presidio was left unscathed, but it was unable to protect the mission.

A punitive raid deep in Comanche territory by the presidio commander proved even more disastrous. The Comanche and their allies waited in a Wichita Indian village on the Red River, which now forms the border of Texas and Oklahoma. Armed with French muskets, they had turned the village into a European-style fortification with a stockade and moat. Americans who later discovered the site called it Spanish Fort because they assumed it had been built by the Spanish, a misunderstanding that neatly captures the horror the Spanish soldiers must have felt. After two centuries of dominating the native peoples with superior arms, they now faced a more numerous enemy who had weapons as good as their own and knew how to fight on their terms. After an initial skirmish in which they lost 52 men to death, injury, or desertion, the Spanish retreated to the presidio at San Saba, where they hung on until 1769. The Comanche remained a constant threat until they formed a peace treaty with the Spaniards in 1785. This treaty, which followed agreements with several tribes in Florida the previous year, was a departure from the Spanish policy that the Indians simply owed allegiance to the king by right of conquest; faced with serious resistance, the Spanish recognized that at least some Indian peoples were, in the words of the governor of Florida, "free and independent nations . . . under His Majesty's protection."

At their height between 1745 and 1775, the San

Red River, Texas/Oklahoma

Antonio missions were among the more successful in North America, yet even so there were seldom more than 300 Indians at any one mission—hardly the great harvest of souls the first missionaries had imagined. Mission life was difficult for the Indians; they struggled with a bewildering assortment of rules and the idea of living a regimented daily life based on an abstract concept called time. Those who did manage to adapt lost their own culture as they learned the Spanish language and Spanish ways, including farming, ranching, crafts, and armed defense. Runaways were a constant problem, but disease was an even greater threat. It devastated not only the mission Indians but also the free Coahuiltecan who tried to maintain their traditional lives in the rolling grasslands. Beginning in 1775, the mission population went into irreversible decline, and by 1792 the father president of the Texas missions pointed out that there were no more "pagan" Indians within a radius of 150 miles.

Unlike the missions, the secular settlements were growing, but growth was dismal compared with other areas of New Spain. In 1790 the Spanish population of the Texas province from the Nueces River south of San Antonio to the present Louisiana border was about 2,500: 1,500 in San Antonio, 600 in a military settlement called La Bahía, founded near La Salles's old fort, and another 400 in Nacogdoches. In contrast the recently settled province of Nuevo Santander, which lay directly south of Texas straddling

Father Junípero Serra stood only 5'2" tall and suffered from ill health most of his life, yet proved tough enough to establish the most successful mission system in the United States, founding 9 of the 21 California missions before his death in 1784.

the Rio Grande, had over 25,000 non-Indian residents, while even the struggling colony of New Mexico had about 20,000. Farther south, Mexico City had over 110,000 Hispanic residents by 1793.

There are many reasons for the slow development of Texas: the poor judgment in trying to establish missions among the Caddo so far from the Rio Grande; the often harsh rule of the Franciscans that tended to discourage converts; the ongoing conflicts between church and secular settlements; and the organized, well-armed resistance of Plains Indians from the north. But perhaps the most basic problem was the refusal to open ports along the Gulf coast for fear of smuggling. San Antonio is less than 150 miles from the sea, yet it could only be supplied overland by goods that first arrived at the official port of Vera Cruz, then were transported to Mexico City, and were finally taken northward on a long and torturous journey. By the same token the settlers of San Antonio had no ready market for their livestock and farm products. In 1779 one exasperated observer exclaimed, "What an abuse! Do you not have the sea so nearby?"

The sea was indeed nearby, but the Spanish would not use it. Texas limped along as a sleepy backwater until new settlers from the north arrived.

IN 1767 KING CARLOS III ORDERED all Jesuits expelled from Spain and its colonies. Portugal and France had

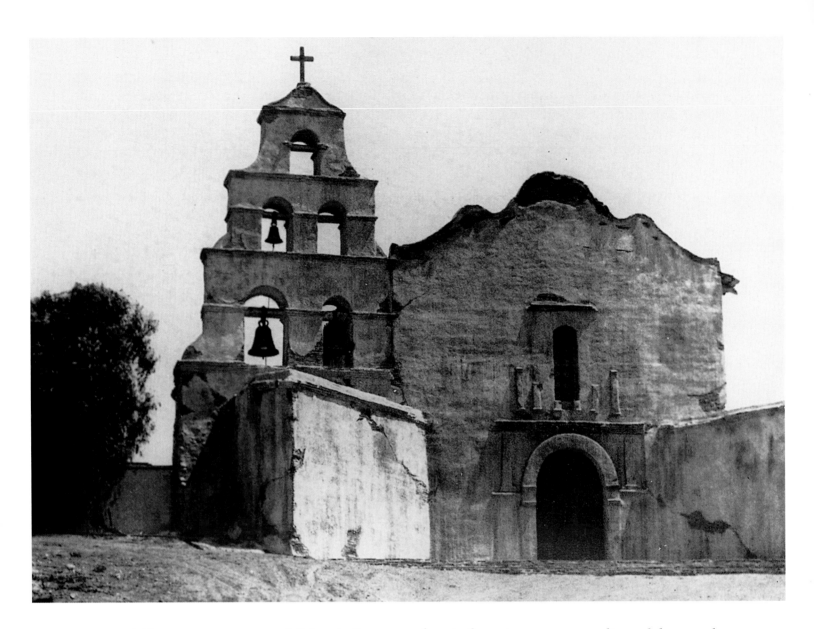

Founded by Junípero Serra in 1769 on a hill above San Diego Bay, Mission San Diego de Alcalá was moved five years later by Serra's protégé, Padre Luis Jayme, to a site farther up the San Diego River near the Indian village of Nipaguay, to assure a ready supply of water and potential converts. It was here that the first rebellion of the California Indians occurred in November 1775, leaving three Spaniards dead including Padre Jayme, his body so disfigured with bruises and arrow wounds that he could be identified only by his hands.

taken similar action some years earlier, and the general idea was that the highly educated Jesuits were too worldly and had more allegiance to the Society of Jesus than they did to any European nation. There were also suspicions that they had hidden away great treasures, especially ridiculous in Mexico, where most Jesuit missions struggled for simple survival. In Father Kino's old stamping grounds of Sonora, 55 Jesuits were arrested and subjected to such brutal treatment that 20 of them died before they even reached Mexico City. In all, over 5,000 Jesuits were expelled from Spanish territory around the world.

The less worldly Franciscans were more palatable to Spanish authorities, and they rushed in to fill

the void, but it was a discouraging situation. Kino's remote missions had seldom been adequately staffed or funded, and bad feelings still simmered among the Pima who had revolted in 1751, killing two Jesuits and at least a hundred others, including Spanish soldiers, settlers, and Indian sympathizers. In Baja California the Jesuits had established 14 missions running about two-thirds of the way up the peninsula, but the land was so arid and mountainous they could not consistently feed the Indians. Diseases brought by Spanish settlers who came with the missionaries had decimated the population, especially through the rape of Indian women, which often left the victim with syphilis and sterility. From an estimated 60,000 Indians in Baja when the first mission was established in 1697, the population had dropped to a little over 12,000 by 1775.

The Spanish had been hemming and hawing about Alta (Upper) California for years, but the man who finally decided to do something about it was José de Galvéz, sent by Carlos III to New Spain with the newly created title of visitor general and broad powers to reform the struggling colonies. Unlike most colonial officials, Galvéz saw the big picture and realized that California was essential to Spain's strategic position in the New World. Galvéz decided to occupy Monterey Bay, which had been named, charted, and praised to the heavens by Spanish sea captain Sebastián Vizcaíno in 1602 and which the Spanish wrongly believed to be the best natural harbor on the California coast. Galvéz also hoped to establish a new capital for the northern territories near the confluence of the Gila and Colorado Rivers. Both of these ideas had been advocated by Father Kino many years earlier, and though Galvéz did not like the Jesuits, he could appreciate their logic. Truthfully, Galvéz—like many secular leaders during the age of enlightenment—did not like missionaries at all. He believed they impeded settlement and economic development and held the Indians back in their progress to becoming tax-paying citizens. At first he did not want to include missionaries in the California project, but with other problems in New Spain he did

not have enough soldiers, and he realized he would need missionaries to control cheap Indian labor. So he turned to the Franciscans to aid him in what he once called a "sacred expedition."

To lead this expedition, Galvéz found two tough and competent men: a tall, intensely loyal career officer named Don Gaspar de Portolá and a tiny, asthmatic Franciscan from the island of Mallorca named Junípero Serra. According to Spanish military records, Portolá was commissioned as an ensign in the army at the age of 11, which is strange but possible, and if so he would have already put in 33 years of service by the time he was appointed governor of Baja California in 1767. As he himself put it, he was a soldier willing "either to die or to fulfill my mission," and unlike many military men of his time he maintained fairly cordial relations with the missionaries. The Jesuits received far better treatment from Portolá in Baja than they did in Sonora.

Serra had given up a promising university career to seek "martyrdom" among the Indians of the New World. Though he never managed to get himself killed in the service of God, he did make life fairly miserable for himself and his Indian charges. Fifty-five years old when the sacred expedition began, he was a throwback to an earlier time of religious discipline. He personally practiced the old custom of mortifying the flesh, whipping himself until he bled, burning his skin with a candle, wearing shirts of bristles or wire. More than 60 years earlier Father Kino had made similar efforts to control his passions; they apparently created a mental and physical toughness that helped these men succeed on an unforgiving frontier. Unlike Kino, Serra had no empathy for traditional Indian culture, and he was just as fast to whip the Indians as he was to whip himself.

The entrada into Alta California was launched in early 1769 with four separate thrusts, two by sea and two by land. All four groups were to meet in a large bay well south of Monterey, first explored in 1542 by Juan Cabrillo, who called it San Miguel, and later renamed by Vizcaíno in honor of San Diego de Alcalá. In January the *San Carlos* sailed out of La Paz

DAILY LIFE
IN CALIFORNIA MISSIONS

Daily life in the California missions was regulated by the mission bells, creating an artificial schedule that the Indians found difficult to understand and even more difficult to follow. The day began with bells at sunrise, summoning adults and older children to Mass in the mission church. Next, the neophytes, as mission Indians were called, might receive instruction in Spanish, followed by bells and a breakfast of atole, a gruel made from roasted corn or grain. Then the bells called them to work. Men tended cattle, sheep, fields, orchards, and vineyards, or labored in mission shops tanning leather, working iron, or manufacturing any of the myriad products that the mission supplied: barrels, adobe bricks, tiles, shoes, saddles, pottery, olive oil, or wine. Women made soap and candles from tallow, and did the cooking, sewing, and weaving, creating cloth out of mission-grown wool or fine baskets out of reeds or straw. Young children and older people helped with whatever jobs they could, and the children also received instructions from the padre during the morning and midafternoon.

At noon, the bells announced the midday meal, another gruel called pozole, made of boiled grains, followed by a siesta until two. It was back to work until five o'clock, when the neophytes attended service in the church. The Angelus bell marked the evening meal at six, yet more gruel spruced up occasionally with meat from the mission herds. After dinner, the Indians were free until eight o'clock, when the Poor Soul's bell tolled the end of the day. Married couples and their young children retired to their own quarters, often outside the mission walls, while unmarried girls and widows were locked into a high-walled dormitory called the monjero. Unmarried men and boys had their own dormitory across the courtyard with inevitable results. Most California Indians considered sexual relations to be a natural part of courtship, and a Chumash man from San Buenaventura Mission recalled, "The young women would take their silk shawls. . .and throw them over the wall. . .so that the Indian boys outside the high adobe wall could climb up. . . . They had a fine time sleeping with the girls."

Such antics drove the padres to distraction, but it was only part of a larger conflict between the Indians' culture and the new culture forced upon them by the Spaniards. California Indian men were accustomed to periods of intense physical activity in search of food, followed by periods of leisure, and the regimen of daily

work had to be enforced by overseers called mayordomos, who might be settlers, soldiers, or other Indians. Each mission had a small detachment of soldiers who backed up the padres and mayordomos and enforced serious infractions, including capturing runaways. The mayordomos carried a thick rawhide whip, and though Father Fermín Lasuén, who succeeded Father Serra as head of the missions, limited punishment to no more than 25 lashes, many exceeded the rules. "For the slightest things, they receive heavy floggings," one friar complained in 1799, "are shackled, and put in the stocks, and treated with so much cruelty that they are kept whole days without a drink of water."

The most damning reports of excessive brutality came from non-Spanish visitors. A Russian otter hunter claimed that runaways were "tied on sticks and beaten with straps," and that one particular chief was sewn into the skin of a dead calf "while it was still warm" and then kept tied to a stake until he died, his corpse still sewn into the calfskin. Even church attendance had to be enforced by the whip, and an American who visited California in 1840 reported that after driving

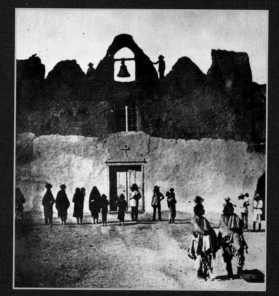

When Father Serra founded the Mission of San Antonio de Padua there was no church and no Indians in sight, so he hung the church bells on the bough of a tree and rang them shouting, "Come, Gentiles, come to Holy Church. Come and receive the faith of Jesus Christ!"

the Indians into the church, with "a large leathern thong. . .applied to their naked backs," men and women were segregated on either side of the broad central aisle. "In this aisle are stationed men with whips and goads to enforce order and silence, and keep them in a kneeling posture. . . . A guard of soldiers with fixed bayonets occupies one end of the church, who may suppress by their more powerful weapons any strong demonstrations against this comfortable mode of worshipping God."

There were good times at the missions, too. The same Chumash man who remembered the boys sneaking into the girls' dormitory also recalled playing traditional games and entertaining each other with songs and stories. "I remember that the men used to sing for the women, and the women for the men, in the weaving and other workrooms." Many padres gave their charges reasonable latitude and celebrated feast days with singing, games, and pageantry to demonstrate that Christianity could be joyful. Yet even so, it was the joy of the intruders, not the joy that the Indians had felt when the land was theirs and theirs alone.

with men and supplies, followed by the *San Antonio* five weeks later. Both of these small ships faced rough going in winter seas, traveling against prevailing currents. The *San Antonio* reached San Diego on April 11, and some men already had scurvy, while others would develop it onshore. The *San Carlos*, which had left five weeks earlier, was blown off course by a storm and did not arrive until April 30—after 110 days at sea. Every man had scurvy. A third ship, which Galvéz sent later to supply the planned settlement at Monterey, was never seen again.

The land expeditions fared better, though their path was far from easy. In late March an advance party of 25 leather-jacketed soldiers and 42 mission Indians under Capt. Fernando de Rivera left from a camp just beyond the most northerly Jesuit mission. Since January, Rivera and his men had been marching up the peninsula, commandeering livestock and other supplies from missions that were desperately poor to begin with. Now they had the unenviable task of driving 144 pack mules and 200 stubborn cattle through the uncharted northern regions of Baja California. It took 52 days to cover 230 dry and desolate miles, less than five miles a day, and by the time they arrived, the men were half-starved and dangerously exhausted. The final group, led by Portolá and Serra, left later and were able to follow Rivera's trail, with Portolá arriving on June 29 and Serra, lagging behind, on July 1. This group was by far the healthiest, and Serra rejoiced that they arrived "all in good health, happy and content." It is indicative of his point of view that "all" in this case did not include the 44 Indian helpers who had started the journey with him, 32 of whom either died or deserted on the way.

Portolá and Serra had expected to find the beginnings of a settlement; instead they found a cemetery and makeshift hospital. By July 4 Portolá wrote that 31 men had died of scurvy, and 20 more would die in the weeks that followed. Considering the situation, it was impossible to follow his original orders to take the ships to Monterey, but good soldier that he was, Portolá resolved to march overland with those who could still walk. "Leaving the sick under a hut of poles which I had erected, I gathered the small portion of food which had not been spoiled in the ships and went on by land with the small company of . . . skeletons, who had been spared by scurvy, hunger, and thirst." There were 61 men in all: 35 soldiers, two priests, two servants, seven mule skinners, and 15 Christian Indians from the south.

Portolá set out for Monterey on July 14, and two days later Father Serra, who had stayed behind to care for the sick, raised a large cross on a hill above the San Diego River just inland from where it flows into the bay. This was the beginning of Mission San Diego de Alcalá, the first in the great chain of Alta California missions. The people this mission would serve are called by a variety of names, including the Kutenai, the Ipai, and the Diegueño. They were linguistically related to the tall and powerfully built Yuma Indians, whom Father Kino had met on the Colorado, and though they were friendly enough at first, they soon proved themselves more than willing to defend their homeland against the white-skinned intruders.

Portolá's party made their way northward, receiving a warm welcome from the Indian people they met along the way. With its temperate climate and rich natural resources, the present state of California was the most densely populated region in North America—about 300,000 people at the time of this initial white contact. These people lived in some 500 different villages, speaking over a hundred dialects, most of them practicing a hunter-gatherer culture. The most advanced people that Portolá met were the Chumash, who lived along the Santa Barbara Channel in large, well-built houses and made impressive oceangoing canoes that allowed them to harvest the bounty of the sea. There was little intervillage warfare among the California Indians. In an atmosphere of peace and plenty they had a deep spiritual world that escaped the notice of the visitors.

Even with the kindness of the Indians, Portolá and his men faced a daunting assignment: marching

Santa Barbara Channel

into unknown territory with old, inaccurate maps of the coast made from the sea and no maps of the interior. On September 30, 80 days out of San Diego, they finally sighted the broad, sandy bay they had come so far to occupy, but it appeared so insignificant from the shore and so completely different from Vizcaíno's overzealous description that they did not even recognize it. Adding to their confusion was the fact that the supply ship was nowhere to be found. They decided to keep marching toward the north until they found their way blocked by a huge "estuary," later called San Francisco Bay, which had escaped the notice of earlier seagoing explorers. Although this first expedition did not fully understand the significance of this great bay, so much larger and better protected than the bay they were looking for, one of the friars, Juan Crespi, did remark that "doubtless not only all the navies of our Catholic Monarch, but those of all Europe might lie within the harbor."

Knowing now that they had somehow passed Monterey, Portolá and his officers decided to head back to San Diego. It was November 11, four months after they had left. Their supplies were almost gone, and the men were hungry, sick, and feverish from trying to live on acorns. On the way south they explored the coast again but still could not identify the bay. However, at a place called Point of Pines—in fact the southern end of the bay—they erected a cross and buried a written record of their frustrating journey. As they continued south, Portolá ordered "one of the weak old mules" killed at the end of each day's march. "The flesh we roasted or half-fried in a fire made in a hole in the ground," he later wrote. "The mule thus being pre-

A 17th-century miniature watercolor portrays a Spanish soldier riding on duty in New Spain— but the viewer has to imagine a patina of dirt, sand, and sweat under a relentless sun.

pared without a grain of salt or seasoning—for we had none—we shut our eyes and fell to on that skinny mule (what misery!) like hungry lions."

The men finally reached San Diego on January 24, 1770, over six months after they had left. Some were so sick they received the last rites, yet every one of them survived. When Portolá described their frustrating search for Monterey Bay, both Father Serra and an officer who had been left behind realized they had seen it but failed to recognize it, or as Serra neatly put it: "You come from Rome without having seen the Pope." Only the timely arrival of the *San Antonio*, which had returned to Mexico for supplies, allowed the San Diego colony to make it through the winter. The following spring Portolá gamely marched north again. This time he had no doubts that he was looking at Monterey Bay, though it was still nothing like the great port he had imagined. The cross they had erected at Point of Pines was surrounded by arrows stuck in the ground and offerings of meat and sardines.

Father Serra arrived in Monterey on June 1 aboard the *San Antonio* and officially established the Mission of San Carlos Borromeo two days later. Good Catholic that he was, Portolá believed that the cross should come before the sword, so he waited until after the mission ceremony to formally take possession of the land in the name of Carlos III. Serra would give the rest of his life to California, but Portolá sailed from Monterey for Mexico less than a week after the ceremonies and never returned. He believed that California would be too expensive to supply and would never be strong enough

to resist the advance of Russian fur traders down the Pacific coast. In fact, as far as Portolá was concerned, the greatest punishment Spain could offer Russia was to give them California.

PORTOLÁ UNDERESTIMATED the importance of California, but he was right about the supply problems. The man behind the mission, Jose de Galvéz, was already working on a solution as the first ships sailed north into storm-tossed waters. Returning to the Sonora coast, where he was waging an ongoing battle with Pima and Seri Indians, Galvéz soon faced storms within himself. A land route would be essential to the new colony, and Galvéz had to pacify the Indians to establish that route, but his soldiers were spread too thin, and the weight of the New World drove him temporarily insane. In the fall of 1769, even as Portolá's men searched for Monterey Bay, Galvéz stepped out of his tent in Sonora at two in the morning and announced to a startled officer that St. Francis of Assisi had written to him regarding the incompetence of his officers. He then explained his own brilliant plan to "destroy the Indians in three days by bringing 600 monkeys from Guatemala, dressing them like soldiers, and sending them against [the Indian stronghold of] Cerro Prieto." Things went downhill from there, with Galvéz believing that he was a variety of interesting people, including the Aztec emperor Moctezuma, the king of Sweden, St. Joseph, and God.

Galvéz recovered within a year, and he was later recalled to Madrid, where he served on the powerful Council of the Indies overseeing Spanish interests in the New World and further championing the cause of California. The overland route he had imagined and fought for was blazed in 1774 by another extraordinary soldier-priest team, Juan Bautista de Anza and Father Francisco Garcés. Unlike many officers who came from Spain, Anza was born in the presidio of Fronteras in northern Sonora, and both his father and maternal grandfather served as presidio officers. At the time of his first expedition the 37-year-old Anza commanded the presidio south of modern Tucson at Tubac, which was then the most northerly fort on the Spanish frontier. He knew that frontier, and through his father he had inherited the Kino-inspired dream of the overland route to California. In Anza the Spanish Empire found the right man at the right time.

Francisco Garcés was just as unusual and appropriate for the job. Young, strong, and willing to accept great hardships, he has been called the Franciscan answer to Father Kino, both for his travels and his empathetic relations with the Indians. A fellow Franciscan marveled at Garcés' ability to talk with Indians for hours and to eat their food "with great gusto." Indeed, it seemed as if "God has created him solely for the purpose of seeking out these unhappy, ignorant, and rustic people." Seek them out he did, although Garcés would not have used such pejorative terms. Between 1768 and 1771, while stationed at Mission San Xavier del Bac, he had followed in Kino's footsteps in exploring the lower Colorado River region and befriending the Yuma people. On one of these trips Garcés penetrated the California desert far enough to see "two openings" in a chain of blue mountains that he believed might lead to the coast. Anza caught his enthusiasm and convinced a new viceroy to let him blaze the trail.

Shortly before the expedition began, a lone Indian appeared as if by magic out of the desert in northern Sonora. This man, who had been given the Christian name Sebastián Tarabal, was originally from Baja, but he had gone north with Portolá and Serra. Having tired of mission life, he had recently left San Gabriel near present-day Los Angeles, surviving a grueling journey that brought death to his wife and another companion among the blazing sand dunes of southern California. Nicknaming him "El Peregrino," the Pilgrim, Anza enlisted Tarabal to help guide them back over the way he had come. The good fortune of finding such a guide was mitigated by Apache raiders, who ran off much of the horse herd Anza had carefully assembled for the journey.

Scrambling for new mounts, the Anza-Garcés expedition left Tubac in early January 1774, with 34 men in all. They took a detour south through the

Camino del Diablo, Arizona

Sonora missions in hopes of obtaining horses, but there were few to be found in the impoverished settlements. Pushing onward, they headed north along the edge of the Camino del Diablo and on to the junction of the Colorado and Gila Rivers where they received a warm welcome from the Yuma, who helped them cross the treacherous Colorado. For all his stoic bravery Father Garcés could not swim, so the friendly Yuma carried the padre in their arms while the rest of the Spaniards crossed on horseback. West of the river the party found themselves lost among the same trackless dunes that had brought death to Tarabal's companions. Anza wisely decided to return to Yuma territory and regroup, leaving half his pack train with a powerful chief called Salvador Palma, who had pledged his friendship and promised to protect the animals and supplies. Anza tried the desert again, this time sweeping south of the dunes and then north through the San Jacinto Mountains and into the Los Angeles Basin.

At sunset on March 22, 1774, the Spaniards reached the San Gabriel Mission, where the astonished missionaries—who had received no advanced warning of the expedition—"welcomed us," Anza recorded in his diary, "with unrestrained jubilation and joy, solemn pealing of bells and chanting of the *Te Deum* in thanksgiving for our safe arrival." By their own reckoning they had traveled about 700 miles in ten weeks. Anza sent Garcés to San Diego for horses and supplies, but there was little to be had so he ordered most of his men to return to the Colorado and the pack train they had left with the Yuma while he and a small party pushed on to Monterey. This trail was already known, but Anza had been ordered to find a route from Sonora to Monterey, and it must have been a joy for the hardened desert soldier to gaze out upon the blue Pacific. By the end of May, Anza was back in Tubac, having completed a round-trip trek of more than 2,000 miles in less than five months. Whereas missionaries were often critical of military behavior, Father Garcés was impressed by Anza's leadership and treatment of both his own men and the Indians they encountered. The "journey has

been made with all success," he noted in his diary, "without illness or fear of Indians, although some toils and difficulties have not been lacking."

The expedition was carefully watched in Mexico City and Madrid, or watched as carefully as it could be at a time when all communications had to be delivered in person. That October Anza was promoted to lieutenant colonel; the following month the viceroy ordered him to lead a group of colonists to California. Father Serra had begged for colonists on an earlier visit to Mexico City, but he was emphatic that they should be married men who would bring their wives and children and would presumably keep their hands off the Indian women. There were always problems with Spanish soldiers and Indian women on the frontier, but the problems in California were particularly disturbing and widespread, or perhaps they were just more accurately reported. The record in Baja was abysmal, and the Alta California missions were off to an equally inglorious start. Serra himself called it "a plague of immorality."

In one inflammatory incident a soldier working on the stockade at San Gabriel lassoed the wife of a local chief and openly raped her. When the chief led a war party to avenge the wrong, the soldiers killed him with a musket shot, cut off his hand, and placed it on a pike as a warning. There was no military punishment, and the military commander, Pedro Fages, fought bitterly with Father Serra over who had control of the soldiers at the missions. Hoping to spare his converts from such behavior, Serra moved both the San Diego and Monterey missions away from the presidios, but this was no solution. In November 1775, even as Anza's colonists were on the trail, the Kutenai Indians burned the new, poorly protected mission on the San Diego River and killed three people, including one of the priests. The best answer, Serra believed, was to bring civilization to the frontier, and in Serra's view that required Christian women and children.

Anza gathered most of his colonists in the southern Mexican state of Sinaloa and then moved on to Tubac, where Apache again drove off the horse herd, further delaying the departure, which had already been delayed by late autumn rains and various personal issues. With about 200 settlers, the majority of them women and children, and some one hundred soldiers, vaqueros, and other workers, the expedition finally left on October 23, 1775. The very first night on the trail a woman died in childbirth. Fortunately hers was the only death on the long journey, and by the time they arrived at San Gabriel on January 4, three more children had been born. The new commander in Alta California, the same Captain Rivera who had blazed the trail through Baja, was at the mission when Anza arrived. He immediately enlisted Anza and 17 other men to help put down the rebellion in San Diego, which they did by a nonviolent show of force. Such shows were tough to come by for the hard-pressed Rivera who had a grand total of 70 soldiers to defend the entire colony from San Diego to Monterey.

The colonists and others Anza would leave behind—perhaps 210 in all—nearly doubled the Spanish population of Alta California, but there were only 28 soldiers. Rivera fought with him over their official orders to establish a new presidio near San Francisco Bay and demanded that the men be used in existing forts at San Diego and Monterey. As a compromise Anza led his people to Monterey, yet also staked out a site for a mission and presidio in San Francisco as well as another mission on the southern tip of the bay, which would be named Santa Clara. He then bid the colonists an emotional farewell in Monterey and rode back to Tubac, leaving a subordinate officer, José Moraga, and Father Serra to battle Rivera over the details. As Anza knew from earlier meetings in Mexico City, the viceroy valued the strategic importance of San Francisco Bay. That fall Serra and Moraga established a presidio and mission. Monterey became the capital of Spanish California, both Baja and Alta, and the governor, Felipe de Neve, moved to the north while the recalcitrant Rivera was transferred to the south.

Although Anza had now established the southern trail, Spanish officials were also eager to connect

GUIDELINES FOR A TEXAS MISSION

FROM INSTRUCTIONS FOR THE MINISTER OF THE MISSION OF
PURÍSSIMA CONCEPCIÓN OF THE PROVINCE OF TEXAS
WRITTEN BY AN ANONYMOUS MISSIONARY IN 1787

No. 59

The missionary must have on hand medicines for the infirm, hay for the animals, ozote [a medicinal nut] for the unruly. In his dealings with the Indians he must be pleasant with all, prudent, and protector of their possessions. He must not give in to the rebellious nor to the arrogant; he must punish the wicked and be always zealous for the honor of God. Toward the sick he must be charitable, long-suffering, and patient, visiting them when they need it, and see to it that they use the remedies which he can obtain. Finally, he is Padre and everything to the Indians, being all to all in order to win them all.

No. 80

From time to time the missionary should journey to the coast and bring back the fugitives, who regularly leave the mission trying at the same time to gain some recruits, if possible, so that more conversions are realized and the mission does not come to an end because of lack of natives. While the missionary is on this errand, the supernumerary [an extra, roving friar] is taking his place at the mission, as has been decided by the commandant general and our superiors.

No. 81

Dealings and communications between the Indians and the Spaniards are not only allowed but are commanded by the commandant general. Nonetheless, the missionary must expel from the mission those Spaniards who come only to take from the Indians all that they can, gambling with them and exchanging trifles for utensils and practicing evil. This cannot be tolerated, and the missionary should not permit them at the mission. If he asks them not to return and they persist in doing so, he is to order them tied to a stake and whipped. Thus they learn by experience.

No. 82

The submission of inferiors to the superior and subjects to the prelate is indispensable in communities and in pueblos. Without it nothing could be well managed, but all would end up in confusion and disorder. The missionary must so conduct himself toward the Indians that all will show him respect, submission, and obedience. He must punish the disobedient, the rebellious, and the arrogant without losing his usual gentleness, affability, and prudence in governing.

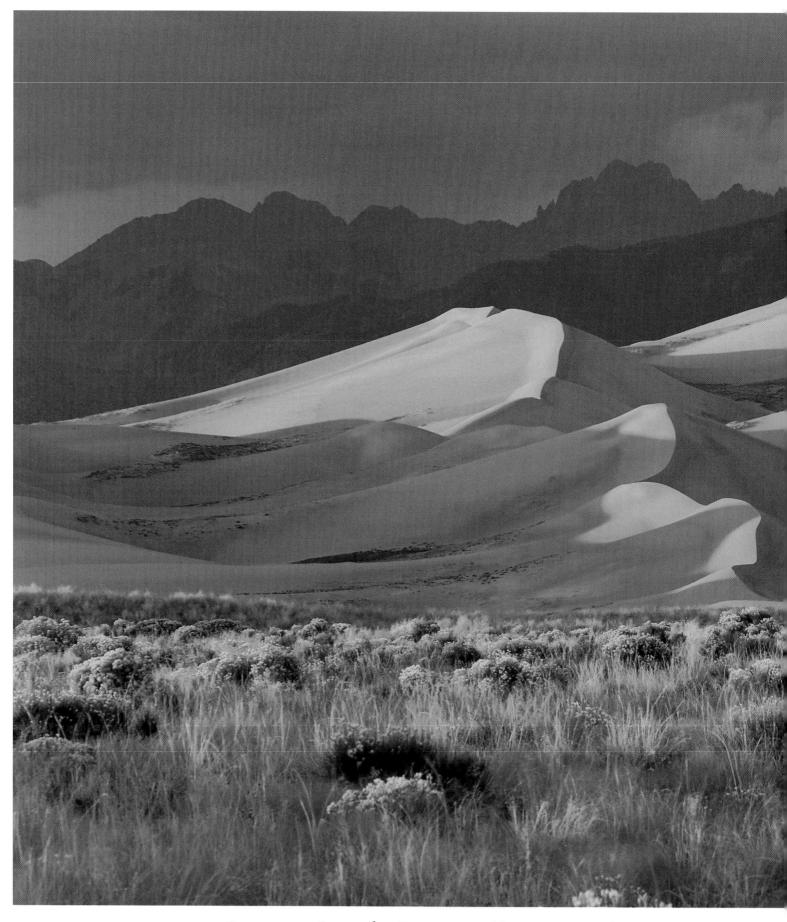

Great Sand Dunes National Monument

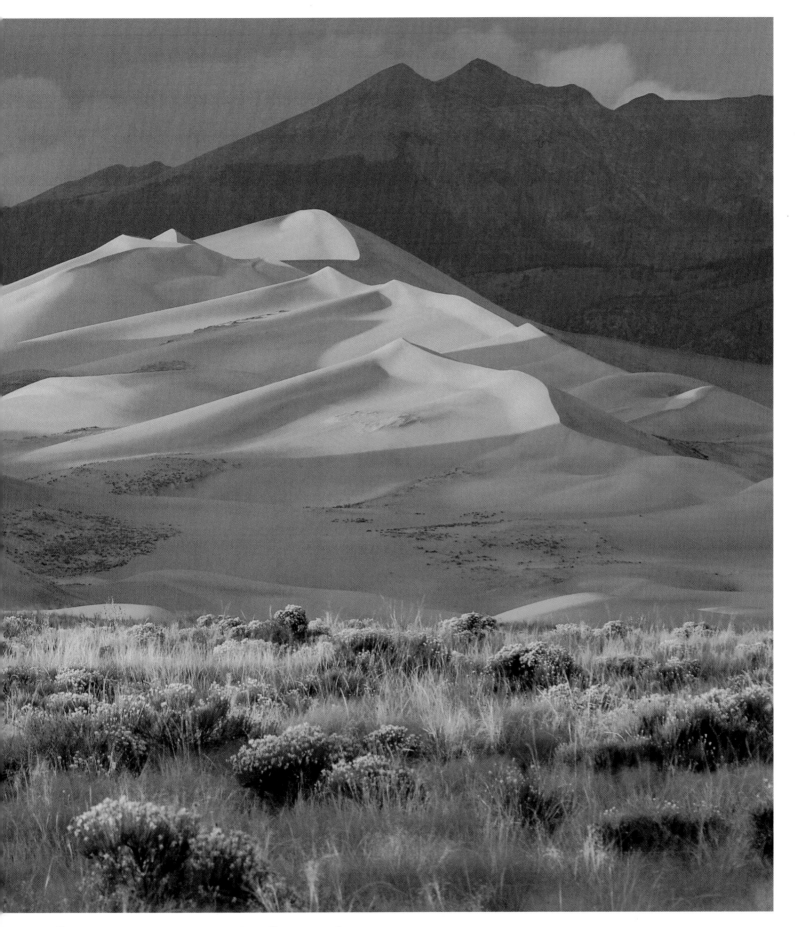

and Preserve, Colorado

Santa Fe to Monterey. The long-traveling Father Garcés, who had been left by Anza among the Yuma, attacked this problem in early 1776, exploring up the Colorado River and back to the west, finding yet another route to San Gabriel, and then to the east, reaching the Hopi village of Oraibi. There the Indian-loving padre met his match in the hostile Hopi, who had never accepted the Spanish after the Pueblo Revolt and had no intention of doing so now. On July 4, 1776, as American colonists on the Atlantic Coast celebrated their newly declared independence, Garcés gave up his journey to the east. But before he left Oraibi, he wrote a letter to the Franciscan at Zuni pueblo and convinced an Acoma Indian to carry it for him. In a strange twist of history, this letter ultimately reached the Zuni friar Silvestre Vélez de Escalante in Santa Fe just before he left in search of a route to California with his superior, Francisco Atanasio Domínguez. The friars ignored the implication that Garcés, or at least Garcés' letter, had found a direct route from the other direction, and the Domínguez-Escalante expedition ended up as a wild goose chase through the Rocky Mountains, the Great Basin, and the ruggedly beautiful northern regions of the Colorado Plateau.

Anza found his way to Santa Fe as well, promoted to governor after his impressive performance in California. By this time the New Mexicans—Spanish and Pueblo alike—were hard-pressed by nomadic warriors, including the Comanche, Apache, Navajo, and Ute. Just as in Texas, the Comanche were the most dangerous and immediate threat. In 1779 Anza led a party of Spanish soldiers and Pueblo allies against a large Comanche encampment in southeastern Colorado, destroying the camp and killing a powerful war chief called Cuerno Verde, or Green Horn. This battle impressed the Comanche with the fighting skills of the new governor, and various bands expressed interest in peace, but Anza would not negotiate unless the Comanche were united. Finally, in 1786, he signed a peace agreement that lasted into the next century. He also established alliances with the Jicarilla Apache, the Ute, and the Navajo, and both he and the governors who followed him enlisted the Comanche and Navajo in battling other Apache bands who remained hostile to the Spanish settlements.

While Anza served in New Mexico, the all-important trail he had opened to California was closed by an uprising of the once friendly Yuma Indians. In late 1780 two fortified villages were established near the Yuma Crossing with a mixture of soldiers, settlers, and missionaries—an attempt to move beyond the mission system and create something closer to Spanish towns while also allowing the missionaries to work with the Indians. The mix did not work. Soldiers abused the Indians, and settlers took long-held Yuman farmlands. The situation grew worse when a group of California-bound emigrants led by Captain Rivera passed through in late spring. On July 17, after most of the emigrants had moved on, the Yuma attacked the towns and killed some 55 Spaniards during three days of rage, including Captain Rivera and all four missionaries. Father Garcés, who deserved a better fate, was clubbed to death before the eyes of his longtime friend, the Yuman chief Salvador Palma. The Yuma spared most of the women and children, who were later ransomed and released.

The Spanish never reestablished the overland route to California, but the groups that Anza and Rivera had brought allowed the colony to survive. By the time of Father Serra's death in 1784, there were nine missions, four presidios, and two civilian towns. Although production at individual missions varied, the missions as a whole produced an agricultural surplus that allowed the supply ships to bring luxury items the Franciscans could use to entice more converts while also making life more bearable for the secular settlers. With its huge native population, California offered a seemingly bottomless trove of potential converts, but those who answered the call seldom lasted for long. "They live well free," one Franciscan complained of the California Indians, "but as soon as we reduce them to a Christian and community life. . .they fatten, sicken, and die."

They did sicken and die in sad, staggering

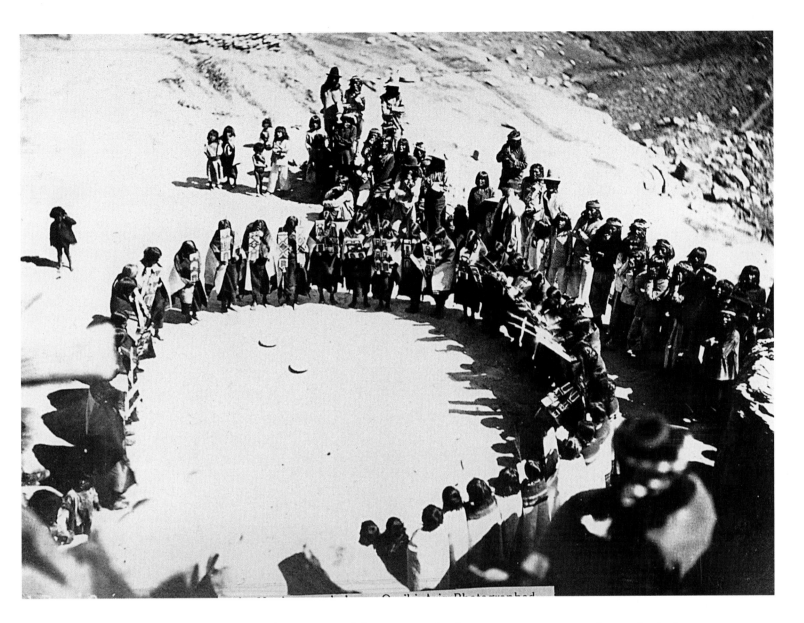

numbers. Out of an estimated 300,000 California Indians when Portolá and Serra reached San Diego in 1769, the population had been cut by a third when Spanish rule ended in 1821—a loss of some 100,000 due almost entirely to diseases passed from the Spanish to Indians who had no genetic immunity and were dangerously weakened by the disruption of their traditional lifeways. Yet this was only the beginning of what has been called cultural genocide. Forty years later, after the California gold rush, there would be fewer than 30,000—a tenth of the precontact population—of a displaced and devastated people forced into the shadows of the abundant land that had belonged to their ancestors a century before.

This photo captures a Hopi women's dance at Oraibi, Arizona. Inhabited as early as A.D. 1150, Oraibi may be the oldest continuously occupied town in the United States. At one time, it was home to 2,000 people, half the Hopi population, but drought, European diseases, and internal dissension led to migration to other nearby towns, including Lower or New Oraibi, built at the foot of the mesa where Old Oraibi still stands. Separated from other Puebloan peoples by language and distance, the Hopi have maintained their own cultural identity.

TRAILS, TRAITORS, & TEXANS

Santa Fe Trail

Llano Estacado, Texas

1783 - 1830

TRAILS, TRAITORS, & TEXANS

FOR ALMOST 200 YEARS THE ONLY ROUTE CONNECTING SANTA FE

WITH THE OUTSIDE WORLD WAS THE NORTHERN EXTENSION OF THE OLD CAMINO REAL,

FIRST BLAZED BY DON JUAN DE OÑATE IN 1598. OÑATE BEGAN HIS MARCH IN THE MEXICAN

MINING TOWN OF SANTA BÁRBARA. A THRIVING TRADING CENTER WAS LATER ESTABLISHED AT

CHIHUAHUA, FARTHER NORTH ON THE ROAD YET STILL SOME 600 MILES SOUTH OF SANTA FE.

EVERYTHING BOUND FOR NEW MEXICO PASSED THROUGH CHIHUAHUA, AND THE CHIHUAHUA

MERCHANTS KEPT THE NEW MEXICANS IN A STATE OF PERPETUAL POVERTY AND

EVER INCREASING DEBT BY PAYING LOW PRICES FOR NEW MEXICAN SHEEP, WOOL, CLOTH,

BUFFALO HIDES, AND OTHER FRONTIER PRODUCTS WHILE CHARGING HIGH PRICES

ON CREDIT FOR GOODS FROM MEXICO AND SPAIN. A FRANCISCAN PRIEST WRITING IN 1778

CALLED THE SYSTEM SO "DEFECTIVE AND CORRUPT" THAT IT MADE THE NEW MEXICANS

"PUPPETS OF THE CHIHUAHUA MERCHANTS."

Originally this isolation arose from the realities of the land, the vast distances that separated Santa Fe from other frontier outposts, and the often hostile Indians who occupied those vast distances. But it became hardened colonial policy as the Spanish enforced their trading monopoly and guarded the province as a buffer zone protecting the rich mines of New Spain, the real prize of the New World. From 1739 to 1752 a handful of French traders managed to reach Santa Fe from the Missouri River, but the first group lost their merchandise on the way, and those who followed had their goods confiscated and were

held in polite but indefinite detention. The Spanish and French were on good terms during this period—both thrones sharing a common lineage in the House of Bourbon—but family ties did not stop the government in Madrid from informing their counterparts in Paris that further intrusions might be met with the death penalty.

The outbreak of the Seven Years' War in 1756 (often called the French and Indian War in America) ended French incursions in the Southwest, while British victory nine years later spelled the end of the French colonial empire in North America. In late 1762, knowing its cause was lost, France gave Spain its Louisiana holdings west of the Mississippi in a secret deal that was supposed to offer compensation for various French debts and promises, including Spain's losses fighting as French allies. In truth it was not much of a deal at all because Louisiana had always lost money for the French and promised to lose more money for the Spanish, but Carlos III took what he could from his hapless French cousin. The Treaty of Paris, formally ending the war in early 1763, acknowledged Spain's claims to western Louisiana and New Orleans, while Britain would control the eastern side of the Mississippi north of New Orleans and take over Spanish Florida.

The new arrangement did not last for long. Although Spain had no official enthusiasm for the American Revolution—clearly a dangerous model for its own colonies—the Spanish saw a chance to gain territory at British expense and aided the American cause in the border regions with money, guns, and espionage early in the conflict. Spain formally declared war on Britain in 1779 as an ally of the French (who were allies of the Americans), and Spanish forces dominated the British in Florida and the eastern Mississippi River Valley, providing essential support on the southwestern flank of the rebellion. The peace treaties of 1783 returned Florida to Spain, but a large area to the north, including most of present-day Mississippi and Alabama and parts of Georgia and Tennessee, remained

in dispute between Spain and its new North American neighbor. Even so, the end of the American Revolution marked the height of Spanish expansion in the New World—a transcontinental empire in what is now the southern United States stretching uninterrupted from the Pacific to the Gulf of Mexico and the Atlantic.

Spain now saw Louisiana as the buffer zone, and colonial officials finally decided to do something about connecting Santa Fe with other frontier posts. Just as they had in Arizona and California, they found the right man for the job, only this time he was not a Spanish soldier or priest but an enigmatic French trader whom they called Pedro Vial. Born in Lyons, Vial was probably around 40 at the time he began his explorations, and he had been living among the Indians for some years, perhaps since well before the Revolutionary War. In 1779 the governor of Louisiana wrote "that this Vial professes the trade of gunsmith and that he usually lives among the savage nations, our enemies, for whom he repairs their arms, and even that he taught this trade to one of them. As this is very harmful to the king and his subjects, I beg you to check this Vial's doings and to stop him from returning among the enemy nations under any pretext whatsoever." The Spanish put Vial's knowledge of the Indians to better use, and the services he offered as a pathfinder more than made up for his "harmful" gun repairs.

Vial's first assignment was to find a new route from San Antonio to Santa Fe, a journey that then required a circuitous 1,700-mile trek through the Mexican state of Chihuahua. Interest in a direct connection had been brewing for some time, and the Comanche treaties of 1785 and 1786 finally created an environment conducive to exploration. On October 4, 1786, Vial left San Antonio with a single companion, Cristóbal de los Santos, and a single packhorse carrying provisions. Both horse and provisions were lost crossing the Guadalupe River the very next day, yet rather than return for more supplies, Vial pushed on, taking a wildly winding course northeast of San Antonio—though Santa Fe was northwest and he had

Carson National Forest, New Mexico

promised to find the most direct route. Vial knew the Wichita tribes who lived to the northeast, and he may have planned to visit them from the beginning, or perhaps he headed for their villages in search of supplies. The situation grew desperate the tenth day on the trail, when Vial got so sick he fell off his horse and lay unconscious for two hours, which prompted Cristóbal to ask him to sign a statement that Cristóbal had not killed him. Vial replied that he "trusted God," but he also wanted a good Indian medicine man. Two weeks later they found a Wichita village, where he spent six weeks recuperating in the lodge of the chief.

After his recovery Vial continued northeastward to a group of well-known Wichita trading villages on the Red River. This was the most important trading center on the southern plains, a key connection between the Caddo tribes in the east and the Comanche in the west, and it was at one of these villages, dubbed Spanish Fort, that these allied tribes had defeated the Spaniards after the raid on the San Saba mission. These people knew Vial and guided him westward to the land of the Comanche, where he passed another six weeks in a winter camp. Finally, on May 26, 1787, after seven and a half months and some 1,150 miles, Vial and Cristóbal arrived in Santa Fe, accompanied by six Comanche warriors and their wives. It was not the most efficient trip in frontier history, but they proved it could be done and done cheaply by two lone frontiersmen who depended on the bounty of the land and the generosity of the Indian people. Fluent in signs and a variety of Plains Indian languages, the French-born Vial spoke of Spanish and Indian friendship with an eloquence few Spaniards achieved.

At the time of Vial's arrival Anza was governor of New Mexico. The veteran pathfinder quickly realized that Vial, for all his knowledge and tenacity, had not followed the most direct route, so he sent a retired army corporal named José Mares back with Cristóbal to San Antonio with orders to do it right. Mares fell in with Comanche who wanted to trade at the Wichita villages, and he ended up following much the same path that Vial had taken, which much displeased the governor of Texas. who not only wanted a direct route but also had to provide gifts for 81 Comanche who followed Mares into San Antonio. The governor was so disgusted with Mares that the old corporal headed back to New Mexico in the middle of the winter, this time avoiding the Red River altogether and cutting straight across the forbidding, featureless plains of the Llano Estacado to forge a more direct route between the two capitals.

By this time Vial was ready to hit the road again. Beginning in June 1788, he blazed yet another trail out of Santa Fe: across the Llano and down the Red River all the way to Natchitoches, which was already tied by river to New Orleans, then back to San Antonio and Santa Fe, a monumental journey of almost 2,400 miles. The once isolated and mysterious frontier was suddenly connected by a network of known trails that offered exciting possibilities for trade and communication.

PEDRO VIAL'S PIONEERING JOURNEYS came at a pivotal time in the fortunes of Spain and its colonies. The two great architects of New World expansion, José de Galvéz and King Carlos III, died in 1787 and 1788 respectively, and Spain never found leaders to match them again. Carlos IV, who succeeded his father, was so dull and easily swayed that his wife convinced him to appoint her young lover as his chief advisor, with predictably disastrous results. Yet even a better man would have been tried by the times. No sooner had Carlos ascended the throne than his French cousin, Louis XVI, lost his head in the French Revolution, which even a dimwit could see did not bode well for royalty in general and Spanish royalty in particular. It was the best of times, it was the worst of times, but it was definitely a tough time to be the king of Spain.

In the meantime the colonies faced new pressures from the restless and expansion-minded Anglo-Americans, whom they had helped in the fight for freedom. A "new and independent power has arisen

on our continent," warned one colonial official who, despite his warning, deeply admired the Americans for their "active, industrious, and aggressive" character. On the other hand, he remarked sadly, the Spanish "spirit of aggrandizement, insatiable in the age of our conquistadores, is now a thing of the past." As he astutely pointed out, the Americans also had the advantage of being a nation located on the continent they wanted to control.

In the years after the American Revolution, contact between the Spanish and U.S. citizens was common east of the Mississippi. In some cases Spain offered generous terms to Americans who wanted to settle Spanish territory, including a dispensation from the traditional requirement that any Spanish citizen had to convert to Catholicism. Spain needed Americans for trade and colonization they were unable to provide themselves, yet they feared a wild onslaught of American frontiersmen, whom one Spanish governor described as "nomadic like Arabs and. . .distinguished from savages only in their color, language, and the superiority of their depraved cunning and untrustworthiness." The early explorations of Pedro Vial and José Mares demonstrated that these depraved and cunning savages could find their way to San Antonio and Santa Fe from the lower Mississippi, but at least there was a buffer in the Spanish forts and settlements along the way. Vial's next expedition was more disturbing: In 1792 he became the first white man to travel directly from Santa Fe to St. Louis across the vast buffalo plains controlled by Indians.

Originally established by French fur traders in 1764, St. Louis was officially turned over to Spain six years later, and at the time of Vial's journey it was the capital of Upper Louisiana or Spanish Illinois. It was logical to establish a direct route between Santa Fe and St. Louis, not only for military communications but also as a gateway to the virgin wilderness of the upper Missouri River. Vial himself probably spent time on the upper Missouri before appearing in the Southwest; he drew the first known map to depict the

three forks that form the river in what is now Montana. Even so the Spanish, including Vial, imagined that the Missouri rose mush closer to the source of the Rio Grande than it does, and thus control of the Missouri would protect New Mexico, which in turn protected the mines of New Spain. At least one Spanish official feared that if the Americans established themselves on the Missouri, "they will assemble troops of vagabonds and will unite to go to pillage" the Mexican mines.

Vial left Santa Fe with two young companions on May 21, 1792, with explicit instructions from the new governor of New Mexico, Fernando de la Concha. Governor Concha was one of Vial's biggest fans—he tried genuinely but unsuccessfully to get the Frenchman a commission in the Spanish Army—but his knowledge of geography and Plains tribes was hazy at best. According to Concha, Vial would at first meet only friendly Comanche "on whose assistance and knowledge he can depend," and he was supposed to head straight east through Comanche territory to the villages of the Osage Indians, who would then guide him northeast toward St. Louis. In fact, the Osage, a Siouan-speaking people, lived farther north, near what is now the Missouri-Kansas border. Vial would have never found their villages going due east, and even if he had found them, it is unlikely they would have helped him because they were soon at war with the whites on the Missouri frontier.

Vial must have understood the situation better than Concha, for though the governor kindly provided him with a compass so "it will be easy not to make a mistake in the directions," Vial and his companions worked their way northeastward early in the trip, moving into what is now central Kansas. There, while marching along the Arkansas River, they met a group of Kansas Indians who were not in on the carefully laid plans. Feigning friendship, the Indians caught the wily frontiersman by surprise, taking "possession of our horses and equipment, cutting our clothes with knives, leaving us entirely naked." Most of the band

Prairie Dog Town Fork, Red River, Texas

wanted to kill the intruders, but Vial and his companions were saved by friendly warriors, including two whom Vial had met before in his travels.

This incident occurred on the 29th of June, and Vial wrote in his journal that "they kept us naked in that encampment until the 16th of August [when] I traveled ten days on a northeasterly course across broad plains all the way to their village . . . on the banks of the Kansas River which discharges into the river called Missouri." They remained there until September 16, when a Frenchman appeared in a boat "loaded with various kinds of merchandise, with permission of the [Spanish] government to trade with that tribe." The trader gave Vial and his companions clothing and supplies and took them back up the Kansas River to the Missouri, stopping to hunt bears and deer on the shore, before finally arriving in St. Louis on the night of October 3. The entire trip had taken 152 days, much of it spent in captivity. Vial also had a bout of severe illness early on, and then there was that leisurely bear hunting. All things considered, Vial reported to the commandant of St. Louis that "had he not encountered difficulty . . . he could have arrived here in a good twenty-five day march." Twenty-five days from Santa Fe to St. Louis, or from St. Louis to Santa Fe—the idea boggled the collective Spanish mind. The depraved American vagabonds were practically knocking on their door.

Vial's return from St. Louis to Santa Fe took almost as long as the outward journey because he went out of his way to avoid the Osage, who were now on the warpath, and he spent almost six weeks on a diplomatic side trip to the Pawnee. These peacemaking visits were just as important as trailblazing, for Plains tribes were key players in a three-way scramble among the British pushing down from Canada, the Anglo-Americans pushing across the Mississippi, and the Spanish pushing from the south, all vying for advantage on the buffalo plains that formed a no-man's zone, or more accurately a no-white-man's zone, between their territories. The Spanish were at a disad-

vantage in this game, for they were cheap with trade goods and hesitant to provide liquor or guns, all of which the British and Americans offered in abundance. Pedro Vial was probably the most successful single diplomat to the Plains tribes that the Spanish ever had in their employ, and he came cheaply at six *reales*, or 75 cents, a day.

The benefits of the trail that Vial blazed between Santa Fe and St. Louis were not destined for his Spanish employers. In 1800, just seven years after Vial returned, the Spanish gave Louisiana back to France, now ruled by the aggressively brilliant Napoleon Bonaparte. The bizarre terms of this deal demonstrate Napoleon's growing power over the Spanish throne as well as the poor understanding in Madrid of Louisiana's true potential. Napoleon received Louisiana for a promise to set up the young nephew of Spanish Queen María Luisa on a throne in Tuscany. When the young man died soon after the agreement, Napoleon refused Spanish demands to give back the territory. The little general had visions of a new French empire in North America. But in 1803, faced with yet another war against Britain, he decided to take a quick profit and get out while he could, selling Louisiana to the United States for 15 million dollars in what has been called the greatest real estate deal in history.

Exactly how great the deal was depended on how one defined Louisiana. Spain, which was stunned by the quick turnaround, claimed that the "Louisiana" it had given to France was very small, a narrow swatch of land running up the western side of the Mississippi from New Orleans to St. Louis, about two-thirds of what are now the states of Louisiana, Arkansas, and Missouri. The United States claimed that the "Louisiana" it had purchased was huge, stretching all the way to the Rocky Mountains, encompassing the entire drainage of all the rivers that ran into the Mississippi from the west, including the Missouri. Just for good measure, the U.S. also claimed to have purchased all of Texas and eastern New Mexico, which was absurd. But the claim to the greater Louisiana

Territory was serious, and it would double the territory of the new nation. The American vagabonds were not only knocking at the Spanish door, they also claimed to own the other side of the door, and they were soon bursting through it.

TO PRESS HIS CLAIMS AND LEARN MORE about the land he had purchased, President Thomas Jefferson sent the Lewis and Clark expedition up the Missouri in 1804 and another expedition up the Red River in 1806. The Spanish considered both of these to be intrusions in their territory and sent at least four military forces out of Santa Fe to try and track down Captain Merry, as they called Meriwether Lewis, but they were unable to find the Americans in the vast and poorly known Missouri River region. A Spanish force out of Nacogdoches intercepted the Red River expedition in what is now eastern Oklahoma and turned them back in late July 1806. Even as they did so, another, ultimately more significant expedition was on its way across the southern plains under the leadership of a confident, ambitious young lieutenant named Zebulon Montgomery Pike.

The Pike expedition was not ordered by Jefferson but by his protégé, James Wilkinson, who had secured dual appointments as governor of Upper Louisiana and commanding general of the Army of the West. He was also a traitor and a spy who had no moral compass and no allegiance to anyone or anything except James Wilkinson. Since 1787 Wilkinson had received at least $38,000 from the Spaniards for information of dubious value, and he played both sides of the equation by offering equally questionable Spanish information to American officials. By 1805 Wilkinson was deeply involved with Aaron Burr, Jefferson's former Vice President, in a plot to invade Spanish territory and establish a new political entity in the Southwest. The details of this plot have never been clear, but a letter written by Burr to Wilkinson in secret code on July 29, 1806—which happened to be the day the Spanish turned back the Red River expedition—made it clear that the invasion was imminent:

I, Aaron Burr, have obtained funds and have actually commenced the enterprise. Detachments from different points and under various pretenses, will rendezvous on the Ohio, first of November. Everything internal and external favors views. Naval protection of England is assured. . . . final orders are given to my friends and followers. It will be a host of choice spirits. Wilkinson shall be second to Burr only; Wilkinson shall dictate the rank and promotion of his officers. Burr will proceed westward first August never to return.

Wilkinson did not receive Burr's letter until October, and by that time he was on the edge of war with Spanish soldiers along the contested Louisiana-Texas border. After an initial show of force by Wilkinson's troops, the Spanish withdrew to the Sabine River—the border Spain wanted and would later be negotiated—but Wilkinson had vowed that "the enemy would be pushed westward clear to California." He was about to launch a major offensive when the letter from Burr arrived in his camp, along with another letter that was equally disturbing. Also written in code by yet another conspirator, it informed him that he would be replaced at the next session of Congress, that "Jefferson will affect to yield reluctantly to public opinion, but yield he will." Public opinion, especially in the West, was that Wilkinson was in the employ of the Spaniards, which was absolutely true. Hoping to save his own skin, Wilkinson blew the whistle on the conspiracy; he informed the President of a plot to destroy the Union that "staggered belief and excited doubt." Burr was ultimately arrested and brought back to Richmond, Virginia, to stand trial for treason, with Wilkinson as the star witness, but as the general himself later complained to Jefferson, it seemed "I was more on trial than Burr." Although both were acquitted, Burr's career was ruined, and Wilkinson never escaped the shadow of his treachery.

While the Southwest conspiracy unraveled,

Zebulon Pike was heading westward across the southern plains in what may be the strangest, most poorly prepared and poorly equipped exploratory expedition in American history. The consensus among historians is that Pike himself was a loyal soldier and patriot whose greatest weakness was an admiration for James Wilkinson that bordered on hero worship. Wilkinson probably saw Pike's expedition as paving the way for his own triumphant march into the West. It seems likely that he gave Pike secret instructions to spy on the Spanish and perhaps to find his way into Santa Fe. If so, he undoubtedly would have presented these instructions as essential intelligence gathering for the United States during a time of imminent warfare, which Pike, as an ambitious young officer, would have accepted as an exciting and perfectly legitimate assignment from his superior.

Pike's official written instructions, received from Wilkinson on June 24, 1806, outlined three noncontroversial objectives. First he was to escort over 50 Indians to the village of Grand Osage near the present Missouri-Kansas border. Most of these were Osage who had been captured by the Potawatomi and ransomed at great expense by Wilkinson, but there was also a delegation of eight leaders from the Osage, Pawnee, and Oto who had recently visited Jefferson in Washington, D.C. Pike was also supposed to try and make peace between the Osage and Kansas Indians. Finally, "a third consideration of considerable magnitude" was "to effect an Interview, & establish a good understanding" with the Comanche. Here Wilkinson came closer to his real objective, for he pointed out that "As your Interview with the Cammanchees will probably lead you to the Head

Branches of the Arkansaw, and Red Rivers you may find yourself proximate to the settlements of New Mexico, and therefore it will be necessary you should move with great circumspection."

Pike left from an outpost north of St. Louis on July 15 with 20 other soldiers, an interpreter, a civilian doctor named J. H. Robinson—who was either a spy or a freebooting revolutionary—and the Indians. They ascended the Missouri River in two flatboats, the Indians usually walking beside them on the shore, and then continued up the Osage River. After a month of travel the captives were reunited with their families in a joyful scene that sparked an eloquent expression of gratitude by one of the Osage leaders:

> Osage, you now see your wives, your brothers, your daughters, your sons, redeemed from captivity. Who did this? was it the Spaniards? No. The French? No. Had either of those people been governors of the country, your relatives might have rotted in captivity, and you never would have seen them; but the Americans stretched forth their hands, and they are returned to you!! What can you do in return for all this goodness? Nothing: all your lives would not suffice to repay their goodness.

Son of a soldier in the Revolutionary War, Zebulon Pike was a gifted officer and gracious gentlemen; yet his reputation was tarnished by unflinching loyalty to traitorous General James Wilkinson.

This was exactly the sentiment Wilkinson hoped to encourage, but Pike discovered that repayment for American goodness did not include horses to continue his journey, and he paid exorbitant prices for those he was able to pry away from their owners. Now the party headed north to a group of Pawnee villages on the Republican River near the present Kansas-Nebraska border. In a Pawnee lodge the Osage and Kansas Indians considered a neutral site, Pike

achieved his second objective of getting the warring tribes "to smoke the pipe of peace together, and take each other by the hands like brothers." He also learned that a Spanish force of some 350 men on fine horses had visited the Pawnee just a month before him, a show of such impressive power that it made Pike's little group look pitiable by comparison. Pike convinced the Pawnee to take down a Spanish flag flying over the chief's lodge and replace it with an American flag. But when he saw that "every face in the council was clouded with sorrow, as if some great national calamity was about to be befal them," he gave the Spanish flag back, asking only that "it should never be hoisted during our stay," an astute compromise that brought a "general shout of applause."

Despite the applause the Pawnee were solidly in the Spanish fold, and they threatened the Americans with violence if they continued their journey. Resolutely, Pike slipped around the Pawnee villages and rode south all the way to the great bend of the Arkansas River, following the trail left by the Spanish soldiers. Here the party split. A small group under General Wilkinson's son, who was a lieutenant and second in command to Pike, traveled downriver back to Louisiana while Pike headed up the river with 15 men. It was now October 28, and the next day it began to snow. In an inexplicable oversight Pike had outfitted his men only in summer uniforms of thin cotton, although he must have realized that a trip to the headwaters of the Arkansas and Red Rivers,

The Sangre de Cristo mountains, literally "Blood of Christ," form the southernmost range of the Rockies, running from southern Colorado into northern New Mexico.

wherever they might be, would stretch into the winter months. Seemingly oblivious to the dangers, Pike continued westward, still trying to follow the Spanish trail, which would have led him to Santa Fe and had clearly become of far more interest than meeting with the Comanche.

On the afternoon of November 15 in what is now eastern Colorado, Pike caught site of what "appeared like a small blue cloud" but was in fact the great looming peak that bears his name today. A half hour later the view became clearer, and as he later told the story, "with one accord" the men gave "three cheers to the Mexican mountains." Still following the Arkansas, Pike ordered his men to build a log stockade near the present site of Pueblo, Colorado, and set off with Dr. Robinson and two privates to follow the small blue cloud. On Thanksgiving Day, trudging through waist-deep snow, the little group ascended a lower peak that gave them an unobstructed view of what Pike himself called Grand Peak but is now known as Pikes Peak. He realized it would take another day's march just to reach the base, and he believed that "no human being could have ascended to its pinical" (it was climbed by another American expedition 14 years later). This little side trip, which accomplished nothing, has made Zebulon Pike one of the most famous names among early American explorers.

Returning to the stockade, Pike led his men on a circuitous path deep into the Rockies—mistaking an

Indian trail for the Spanish trail he thought he was following—in freezing temperatures and drifting snow, with only their cotton uniforms and no blankets because their blankets had been cut up to make socks. They slept on the snow or wet ground so close to their fires that Pike remembered "one side burning whilst the other was pierced with the cold wind." Sometimes they were so weak from hunger they could barely move, but Pike and Robinson were both accomplished marksmen and brought down buffalo and deer enough to keep them alive. Finally, on January 27, Pike and ten others crossed the Sangre de Cristo Mountains into the upper valley of the Rio Grande. They had no horses, and five of their comrades had been left behind at various points along the way, two to watch the exhausted, half-starved horses, three with feet too frozen to walk.

THE AMERICANS WERE NOW in uncontested Spanish territory, but Pike always claimed that he believed he was on the Red River, which would have been in territory to which the U.S. had a reasonable claim. Historians are divided as to what was happening here, but it seems Pike really was lost, even if he intended to find his way into Spanish territory all along. He sent Dr. Robinson to look for Santa Fe in the wrong direction, apparently following a faulty map that showed the source of the Red River as being close to the New Mexico settlements, whereas the river actually rises much farther east, in the Llano Estacado. Robinson only reached the capital because he was found by Ute Indians who brought him into the town of Ojo Caliente, and from there he was escorted south toward Santa Fe, which inspired the Spanish to look for Pike. Two lone riders found him on February 16, and ten days later they were followed by a force of a hundred men.

Early in his journey Pike had written to General Wilkinson that if he was caught in Spanish territory, he would pretend to be lost and offer to pay "a visit of politeness" to the commandant in Santa Fe. That is exactly what he did on February 26. "What! Is not this the Red River?" he asked, mustering something close

to genuine astonishment. When informed that it was the Rio Grande, he ordered one of his men to take down the American flag flying over their stockade since the Spaniards "must have positive orders to take me in." Indeed they did; Pike and six of his men left with some of the Spanish soldiers the following day while the rest of the Spanish force remained at Pike's stockade to wait for a party sent to retrieve those still left behind in the Rockies.

On March 3, 1807, Pike reached Santa Fe and was taken to the governor, Joaquín del Real Alencaster, who must have gazed in wonder at the bedraggled visitor who appeared as if by magic out of the wilderness. "When we presented ourselves at Santa Fe," Pike later wrote, "I was dressed in a pair of blue trowsers, mockinsons, blanket coat and a cap made of scarlet cloth, lined with fox skins and my poor fellows in leggings, breech cloths and not a hat in the whole party." Speaking in French, which both men understood, the governor tried to determine what was going on, and he was particularly interested in the connection of Pike to Robinson. Pike denied that Robinson was part of his expedition, which was a mistake because Robinson had already admitted he was. After examining Pike's official papers, Alencaster decided to send him and his men on to Chihuahua for further questioning.

Once that decision was made, Alencaster turned quite charming and offered his disheveled guest a shirt and neck cloth "made in Spain by his sister," as well as a lavish dinner with "dishes and wines of the southern provinces." The governor, "a little warmed with the influence of cheering liquor," accompanied his visitors three miles out of town, and "when we parted his adieu was 'remember Allencaster, in peace or war.'"

The distinction between peace and war was more than a pleasant good-bye, for Pike was under the impression that war had broken out between the United States and Spain, and spies were executed in time of war. In fact, the war never happened; throughout their journey south the Americans were treated with what Pike called "heaven-like qualities of hospi-

View From Pikes Peak, Colorado

tality and kindness." In an interesting coincidence his escort from Albuquerque onward was commanded by Lt. Facundo Melgares, the same officer who visited the Pawnee before him, and the two men became close friends. On the journey to Chihuahua, Melgares gave his new friend complete freedom to talk to anyone and write down anything he wanted. If Pike was indeed sent as a spy, he could not have asked for a better opportunity.

All along the way the visitors were entertained by banquets, dances, and cockfights, and the prettiest young women were often assembled before they arrived. Although Pike was married and apparently faithful to his wife, he was much taken by the dark-eyed beauty and flirtatious manner of the Spanish women. Yet he was also disturbed by what he perceived as a deeply imbedded inequality of the sexes:

> The general subjects of conversation among the men are women, money, and horses, which appear to be the only objects, in their estimation, worthy of consideration, uniting the female sex with their money and their beasts . . . they have eradicated from their breasts every sentiment of virtue or ambition, either to pursue the acquirements which would make them amiable companions, instructive mothers, or respectable members of society. Their whole souls, with a few exceptions, like the Turkish ladies, being taken up in music, dress, and the little blandishments of voluptuous dissipation. Finding that the men only regard them as objects of gratification to the sensual passions, they have lost every idea of that feast of reason and flow of soul, which arise from the intercourse of two refined and virtuous minds.

In Chihuahua, Pike faced the tough-minded Don Nemesio Salcedo, Commandant General of the Interior Provinces, overseeing the entire northern frontier of New Spain. Although he treated Pike with professional courtesy, Salcedo was convinced that both Pike and Robinson were doing something more than getting lost, and his suspicions were confirmed after he confiscated every paper that Pike did not declare personal and had those papers translated into Spanish. In an official letter of diplomatic protest to James Wilkinson, Salcedo laid it on the line: "the documents contain evident, unequivocal proofs, that an offense of magnitude has been committed against his majesty, and that every individual of this party ought to have been considered as prisoners on the very spot." Nonetheless he decided to send the soldiers back, "wishing to give the widest latitude to the subsisting system of harmony and good understanding," and he gave Pike a thousand pesos to help defray the expenses of their return journey.

As Melgares led Pike and his party out of Chihuahua, the gallant Spanish lieutenant told his American friend that he could no longer take notes, to which Pike bowed "assent with a smile" while secretly scribbling observations of all he saw and hiding the papers in the rifle barrels of his soldiers' guns. Escorted first by Melgares and then by other officers, the Americans followed a well-worn but roundabout path that dipped southeastward through the provinces of Nueva Vizcaya, Coahuila, and Nuevo León before finally turning toward the northeast, across the Rio Grande, past Nuevo Santander, and through the heart of Texas—a grand tour of the Spanish frontier that must have exceeded Pike's wildest dreams. (In what may be the strangest single fact of a truly strange expedition, Pike traveled the last thousand miles or so with two grizzly bear cubs he had obtained in the foothills of the Sierra Madre and later gave as a gift to President Thomas Jefferson.)

Finally, on June 30, 1807, almost a year after he had departed, Zebulon Pike and his small group arrived in the United States at Natchitoches, Louisiana. "Language cannot express the gaiety of my heart," he wrote, "when I once more beheld the standard of my country waved aloft!— All hail cried I, the ever sacred name of country, in which is embraced that of kindred, friends, and every other tie which is dear to

the soul of man!" He was soon reunited with his wife and daughter, whom he had left behind on the Missouri frontier, and only then did he discover that his wife had given birth to a son while he was gone, and the child had died.

Although Pike expected to be hailed as a hero, as were Lewis and Clark, he found instead that he was held in deep suspicion in the Burr-Wilkinson conspiracy, which now had the nation in an uproar. Hoping to gain the fame and honor he believed he deserved, Pike published a narrative of his travels in 1810, which fanned the flames of westward expansion and brought him some of the recognition he wanted. He did not live to see the hordes of Americans who followed him on the road to Santa Fe. Rising to the rank of brigadier general, Zebulon Pike was killed in 1813 at the age of 34 during the pivotal Battle of York (now Toronto) in the War of 1812, far from the Southwest he had explored.

AFTER THREE CENTURIES OF OCCUPATION the Spanish colonies in North America were still dominated politically and economically by men who were born in Spain, called either *peninsulares*, in reference to the Iberian Peninsula, or more derisively *gachupines*, "spurs," because they drove the lower classes to work for them with the same brutal alacrity they drove their fine Spanish horses. Directly below the elite were the criollos, or creoles, individuals of pure Spanish blood born in the colonies. Some creoles had large landholdings and attained great wealth, but few reached the highest levels of power though they outnumbered the peninsulares ten to one. Creoles generally had less loyalty to Spain, and Pike made the revealing comment that his friend Lieutenant Melgares, who came from a wealthy and aristocratic Spanish family, "was one of the few officers or citizens whom I found, who was loyal to their king." Yet the imbalance of the higher classes was nothing compared with the inequality that inflicted the mass of common people below them: the Indians; the mestizos, of mixed Spanish and Indian blood; and the castes, a general term for individuals of mixed

African descent. Although Pike traveled in the highest circles of colonial society, he saw and learned enough of the lower classes to offer a surprisingly insightful analysis of the fundamental problem:

> The beggars of the city of Mexico are estimated at 60,000 souls: what must be the number through the whole kingdom? And what reason can it be owing to that, in a country superior to any in the world for riches in gold and silver, producing all the necessaries of life and most of its luxuries, that there should be such a vast proportion of the inhabitants in want of bread or clothing. It can only be accounted for by the tyranny of the government and the luxuries of the rich. The government striving, by all the restrictions possible to be invented, without absolutely driving the people to desperation to keep Spanish America dependent on Europe.

They would not be dependent on Europe for long. In 1808, the year after Pike returned, Napoleon Bonaparte invaded Spain and forced both Carlos IV and his son Ferdinand VII to give up their claims on the Spanish throne. Napoleon's brother, Joseph Bonaparte, tried to rule in their stead, but the intruder king received little support except from Napoleon's army. The chaos across the sea threw the Spanish colonies into a confusion from which they never recovered. That same year the viceroy of New Spain was driven from office by peninsulares after they discovered that he planned to align himself with the creoles and form an independent kingdom of Mexico. Two years later, in 1810, a radical, gray-haired creole priest named Miguel Hidalgo y Costilla led the first charge of a violent revolution of the lower classes. He formed a ragtag army of some 25,000 Indians, mestizos, and castes who murdered and looted wealthy peninsulares and creoles north of Mexico City and mounted a brutal attack on a fortress-like granary in the mining town of Guanajuato, where an eyewitness reported that "naked bodies lay half buried in maize, or money, and every-

Although William Becknell is rightly called the Father of the Santa Fe Trail, substantial stretches were already defined from the west by Pedro Vial and New Mexicans who traded with Indians on the plains, while Zebulon Pike followed parts of the trail from the east in his wayward sojourn to Santa Fe. Nonetheless, Becknell was the first to exploit the natural trading connection between the American Missouri frontier and the Hispano frontier in New Mexico, and his two pioneering journeys in 1821 and 1822 defined the two alternative routes that would be etched into the Southwest by tens of thousands of wagon wheels.

The trail began at the Missouri River; Becknell started at Franklin, but by 1830 the major outfitting point was Independence, a hundred miles farther west, and by 1853 the terminus had moved to Westport in present-day Kansas City. From there it crossed the well-watered plains of Kansas to the great bend of the Arkansas River and followed the northern bank. The shorter and flatter Cimarron Route, which carried the lion's share of wagon traffic, forded the Arkansas at any of several crossings in what would later become the Dodge City area, and then traversed a dangerously dry stretch of some 60 miles before reaching the Cimarron River and cutting through the High Plains into the Canadian River valley of eastern New Mexico. Curving around the southern end of the Sangre de Cristo Mountains, it climbed the relatively easy slope of Glorieta Pass and on into Santa Fe.

The Mountain Route, which was longer but safer from Indian attack, followed the Arkansas to the shadow of the Rockies, where Bent's Fort, completed in 1833, became an important resting place and fur trading center. It then crossed the Sangre de Cristos through one of several passes; in the early days, the most popular was Sangre de Cristo pass, which leads into Taos and then on to Santa Fe. The much rougher Raton Pass was seldom used until the Mexican War, when General Kearny's army built a temporary road to invade New Mexico; in 1865, former fur trapper Uncle Dickie Wooton built a toll road that opened the pass to commercial wagon traffic. Dropping into the Canadian River valley, the Raton Mountain Route joined the Cimarron Route at the Mora River, north of Las Vegas. According to a contemporary calculation, it was 770 miles from Independence to Santa Fe on the Cimarron Route and about a hundred miles farther through Raton Pass.

In 1824, just three years after Becknell arrived in Santa Fe, American traders grossed $190,000. Three decades later, after the Mexican War and the

California gold discovery, the road would carry five million dollars in trade. The first blitz absorbed most of the available coin in Santa Fe, which operated on a local trading economy with little hard cash, so many Americans followed the old Camino Real farther south to the bustling commercial center of Chihuahua. By the late 1830s, more than half the American goods on the Santa Fe Trail were carried to Chihuahua or beyond. Around the same time, Mexican and New Mexican traders became a force to be reckoned with, traveling in the other direction. Although a party from Chihuahua and Sonora reached Franklin in 1825, eastbound trade developed slowly due to the shattered Mexican economy after the war for independence and the undeveloped local economy in Santa Fe. Yet by 1843, American trader Josiah Gregg wrote that "the greater portion of the traders were New Mexicans." While most histories have emphasized the American side of the connection, the fact is that the Santa Fe Trail was a two-way street.

Unlike the Oregon Trail, which carried thousands of emigrant families, the Santa Fe Trail was a commercial thoroughfare dominated by heavy trade

Wagon wheels like this etched a record of the Santa Fe Trail that can still be seen in many sections today, often close beside automobile roads that naturally follow the Trail.

wagons driven by daring teamsters. Some women did travel the trail, but they were few and far between, and the great moment for the teamsters was the entry into Santa Fe after two or three months in the wilderness. In his classic account, *The Commerce of the Prairies*, published in 1844, Josiah Gregg described the scene:

"The arrival produced a great deal of bustle and excitement among the natives. "Los Americanos!"—"Los carros!"—"La entrada de caravana!" were to be heard in every direction; and crowds of women and boys flocked around to see the new-comers; . . . The wagoners were by no means free from excitement on this occasion. Informed of the ordeal they had to pass, they had spent the previous morning in rubbing up; and now they were prepared, with clean faces, sleek-combed hair, and their choicest Sunday suit to meet the fair eyes of glistening black that were sure to stare at them as they passed. . . . Each wagoner must tie a brand new cracker to the lash of his whip; for on driving through the streets and the plaza publica every one strives to outvie his comrades in the dexterity which he flourishes this favorite badge of his authority."

thing was spotted in blood." As the revolution continued, Hidalgo and his associates used their loot to build a larger force of over 80,000, including 2,000 soldiers who had defected from the Spanish Army, but they were crushed by better trained and armed loyalist forces near Guadalajara in early 1811.

Now with only a thousand men, Hidalgo and his compatriots headed north, hoping to reach Texas, where sympathy for his cause was strong, so strong in fact that a retired army captain named Juan Bautista de las Casas had taken over the garrison in the Alamo and captured the governor, Manuel María de Salcedo, nephew of the powerful General Salcedo. This first Texas revolution lasted only six weeks; Casas was executed, his head impaled on a stake and displayed in the main plaza of San Antonio in front of the cathedral. That summer Hidalgo suffered a similar fate. Defeated before they could reach the Rio Grande, the old priest and his fellow leaders were captured and executed under orders of General Salcedo in Chihuahua. The heads of Hidalgo and three associates were sent back to the granary in Guanajuato, where they were displayed in iron cages as a warning to other would-be revolutionaries. But no matter how many heads they cut off, the peninsulares had a revolution on their hands.

In the south Hidalgo's cause was taken up by a mestizo parish priest, José María Morelos, a man of such courage, charisma, and political acumen that Napoleon once said, "with three such men as José Morelos, I could conquer the world." Morelos fought for constitutional government, abolition of slavery, and class equality, and he kept his smaller, better disciplined army under control, which convinced many wealthy creoles that independence was about freedom from Spanish domination rather than wanton murder and destruction of personal property. Unlike Hidalgo and the parade of caudillos, or strongmen, who followed him, Morelos wore the mantle of leadership with self-deprecating humility. He guided the revolution not because he loved the hot glow of power but because he knew he was the best man for the job. When Morelos

was captured and executed by royalist forces in December 1815, the idealistic side of the Mexican independence movement suffered a crushing blow.

In Texas the revolution continued under a wealthy creole landowner, José Bernardo Gutiérrez de Lara, who had large holdings along the Rio Grande in what was then the province of Nuevo Santander. Gutiérrez once pledged "my services, my hacienda, my life" to Hidalgo's cause, and when the royalists took away his lands, he went to Washington and obtained unofficial American support for an invasion of Texas. On August 8, 1812, the self-proclaimed Republican Army of the North, nominally led by Gutiérrez but made up mostly of Anglo-Americans, crossed the Sabine River "determined to besiege Inferno itself," in the words of one adventurer. They took the border town of Nacogdoches without a battle and went on to occupy the presidio at La Bahía, where they endured a cold, three-month siege during which enough royalist soldiers defected to turn the tide. The Republican Army went on to take San Antonio on April 1, 1813, declaring the first Republic of Texas "free of the chains which bound us under the domination of European Spain."

Gutiérrez ordered that the loyalist captives, including Governor Salcedo, be sent to the United States for their own protection, or at least that is what he said to the Anglo-Americans. Led by Antonio Delgado, who later explained that Salcedo had executed his father and brother and impaled their heads on stakes, a guard of 60 Tejanos escorted the royalists a few miles outside town, where they tied the prisoners to trees and made them watch as they sharpened their knives on their boots. Then the Tejanos slit their throats, an act the more gentlemanly of the American soldiers considered inappropriate, even in time of war, not to mention the fact that the murder of his nephew was sure to light the fire in General Salcedo and other royalists. Many Americans believed that Gutiérrez was behind the executions, and he further disappointed them with a Texas declaration of independence that

fell short of democratic ideals. Pressured by the U.S., Gutiérrez left San Antonio in early August, just in time to miss a bloody battle in which royalist forces slaughtered the Republican Army along the Medina River southwest of San Antonio. Among the soldiers who moved on to take the city and its mission-fortress was a tall, handsome 19-year-old lieutenant named Antonio López de Santa Anna. It was his first visit to the Alamo, but it would not be his last.

The restoration of Ferdinand VII to the throne in 1814 brought a small measure of stability to Spain, not enough to save its colonies but enough to finally settle its border dispute with the Unites States. On February 22, 1819, the two nations set new boundaries in the Adams-Onís Treaty, named after Secretary of State

Embracing more than 800,000 acres in southwest Texas, Big Bend National Park is among the largest of the National Parks. Its southern boundary is formed by 118 twisting miles of the Rio Grande—much of its channel carved through limestone canyons— where it changes direction of flow from southeast to northeast, forming the big bend of the "Big River." A land of extremes, elevations range from around 1,800 feet along the river where temperatures may exceed 100°F, to 7,800 feet in the Chisos Mountains where temperatures may drop below freezing.

John Quincy Adams and Spanish envoy Luis de Onís. Spain gave Florida to the United States while the U.S. relinquished its claims to Texas. The border between U.S. and Spanish territories would follow the Sabine River—still the border between Texas and Louisiana—then continue along the Red and Arkansas Rivers into the Rocky Mountains, where it followed the 42nd parallel to the Pacific, now the northern border of California, Nevada, and Utah. Thus Spain retained its troubled Texas province and the buffer zone it so desperately wanted.

The treaty enraged Americans living along the Louisiana-Texas border who believed their own government had betrayed them by giving away the rich, well-watered lands to the southwest. One of them, James Long—an Army surgeon who had married General Wilkinson's niece and embodied the same spirit of reckless expansion—took matters into his own hands. He led a motley army of adventurers, including former "President" Gutiérrez, into Texas territory, where they captured Nacogdoches and proclaimed yet another Republic of Texas on June 23, 1819. Troops from San Antonio drove them back across the border that fall, but Long and Gutiérrez refused to give up and returned the following spring to establish a small fort near Galveston Bay. This was the stronghold of the pirate Jean Lafitte, and though Lafitte had refused to join the American cause, Long felt safer knowing he and his well-armed men were nearby.

The real future of Texas arrived on December 23, 1820, when sad-eyed Moses Austin rode into San Antonio. Originally from Connecticut, the 59-year-

Trained by Jesuits, Miguel Hidalgo was "one of the best theologians in his diocese" whose powerful intellect led to a free-thinking Christianity that bordered on heresy and radical politics that sparked a revolution.

old Austin had great success with lead mines in Virginia and Missouri. For the latter project, which began before the Louisiana Purchase, he had become a Spanish citizen and proved himself a man of honor who insisted that settlers under his dominion obey Spanish law. Along with many on the Missouri frontier, he lost his fortune in the panic of 1819 and hoped for a new start in Texas, but the governor, who was exasperated by Long's intrusion, threw him out without even giving him a hearing. In what must have seemed like a miracle on a distant frontier, Austin ran into an old, aristocratic friend who convinced the governor it was better to let the Anglos settle the underpopulated province under Spanish law than to have them steal it or give Texas back to the Indians. Moses Austin received a grant of 200,000 acres to bring 300 colonists into Spanish Texas, but like his biblical namesake he was not destined to lead his people into the promised land. The long-traveling Connecticut Yankee died of pneumonia contracted during his journey home. His last wish was that his son, Stephen, "prosecute the enterprise he had Commenced."

On February 24, 1821, even before the elder Austin received official approval of his grant, a 37-year-old former royalist commander named Agustín de Iturbide, backed by an unlikely coalition of freedom fighters and conservative church authorities, declared Mexican independence in the Plan of Iguala, sometimes called the Plan of the Three Guarantees for its three basic provisions: protection of the Catholic faith and clergy, without toleration for other faiths; independence under a

constitutional monarchy; and unity of Americans and Europeans. By this time few Spanish troops remained loyal to Spain, and when a new viceroy arrived that summer, he accepted the plan in the Treaty of Córdoba, signed on August 24. The long, complex fight for independence had decimated the nation, with some 600,000 deaths in a population of six million. Yet the final stroke was accomplished without a battle.

Unfortunately for the future of Mexico, Iturbide—who had been an extremely effective if brutal military commander—proved to be a poor politician who misjudged the will of the people and quickly took on the trappings of absolute rule, a fatal error that plunged Mexico into continuing corruption, internal dissent, and class warfare. Seventy years after the declaration of independence, Mexican President Porfirio Díaz pointed to the early death of the charismatic yet humble Morelos as the key to Mexico's failure to live up to its potential:

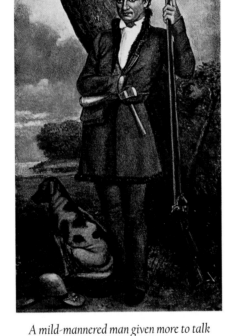

A mild-mannered man given more to talk than fighting, Stephen Austin led the Texas Revolution in its early days with a volunteer army that followed him because of his reputation for fairness rather than skills as a general.

If Morelos had lived to the year 1821, Iturbide would not have been able to take control of the national insurrection; and the nation would not have passed through a half century of shameful and bloody revolution which caused it to lose half of its territory. Today it would be the powerful republic which we would have expected from seventy years of development initiated by the courage, the abnegation, prudence, and political skill, of which that extraordinary man was the model.

The underlying irony of this otherwise insightful analysis was that Díaz himself was a dictator. Such was the destiny of the new nation to the south.

On June 25, 1821, a bankrupt Missouri businessman named William Becknell placed a notice in a local newspaper announcing an expedition in the southern Rocky Mountains "for the purpose of trading Horses & Mules, and catching Wild Animals of every description . . .Every man will fit himself for the trip, with a horse, a good rifle, and as much ammunition as the company may think necessary. . .and sufficient clothing to keep him warm and comfortable. Every man will furnish an equal part of the fitting out for trade, and receive an equal part of the product." While one account indicates that only 4 men answered the call, others suggest 21 men left the Missouri River that September 1, carrying trade goods on packhorses, and headed southwest toward the Arkansas. Older histories maintain that Becknell intended only to trade with the Indians, but based on the route he took and the events that followed, it seems likely that he had his eye on Santa Fe from the beginning. He knew Mexico had declared its independence, and though he did not yet know the results of that declaration, he decided to take a chance.

On October 21 they reached what Becknell called the "left fork of the Arkansas," actually the Purgatoire River, and followed it into the mountains, finally crossing the high and difficult Raton Pass into the valley of the Canadian River. There, on November 13, the Americans met a small patrol of Mexican soldiers who greeted them in friendship although they could speak no English and Becknell's party could speak no Spanish. At a nearby village Becknell found a Frenchman who did speak

San Antonio River

Spanish, and Becknell knew enough French to understand that Mexico was now an independent nation and they would be welcome to sell their goods in Santa Fe. Three days later Becknell's party arrived in the New Mexican capital, where they were received "with apparent pleasure and joy" and sold their small supply of goods at a substantial profit. The governor was Pike's aristocratic friend, Facundo Melgares, who had remained loyal to Spain until the end and had sworn allegiance to an independent Mexico only two months earlier. The Americans would not only be allowed to trade in Santa Fe, Melgares told Becknell, but they could also settle there if they wished.

While most of the party decided to stay in Santa Fe at least temporarily, Becknell and another man left in early December with New Mexican mules, burros, blankets, and money; they made it back to the little Missouri River town of Franklin in only 48 days. According to a man whose father watched them unload their packtrain, "when their rawhide packages of silver dollars were dumped on the sidewalk one of the men cut the thongs and the money spilled out and. . .rolled into the gutter." On a frontier still in the throes of economic depression following the panic of 1819, the clinking of silver—likely Spanish pesos rather than dollars—was a siren song that would in time draw thousands of others on the road to Santa Fe.

The following spring Becknell mounted a more substantial expedition with three wagons and $3,000 worth of trade goods. Looking for a shorter and easier route for the wagons, the men blazed a new trail by leaving the Arkansas just beyond the present site of Dodge City, Kansas, and following the south fork of the Cimarron River across the Llano Estacado. Although this route avoided Raton Pass, there was no available water for the first 60 miles. Becknell's men survived by cutting off the ears of their mules and drinking the blood, and then killing a buffalo to drink the nauseous liquid in its stomach, which prompted one man to recall "that nothing ever passed his lips which gave him such exquisite delight as his first draught of that filthy beverage." Buffalo bile notwithstanding, Becknell and his men again reached Santa Fe and made fantastic profits. "To show what profits were made," reported the same old-timer whose father watched the clinking coins, "I remember one young lady, Miss Fanny Marshall, who put $60 in the expedition and her brother brought back $900 as her share." The Santa Fe Trail was now an open highway between the United States and Mexico.

Stephen Austin discovered the news of Mexican independence three months before Becknell but in much the same manner. He was only a few hours outside San Antonio, leading an advance party of settlers, when Tejano riders "brought the glorious news. . .with acclimations of 'viva independencia.'" The news was glorious indeed to a man of Austin's staunch republican sensibilities, but it ultimately meant that he had to renegotiate his land grant with the new government in Mexico City. Austin was in the capital in May 1822 when a well-orchestrated mob proclaimed Iturbide as emperor, and he was there for Iturbide's coronation that July. The new emperor had more to worry about than Anglo colonists, and it was not until the following February that he signed Austin's grant. The would-be Texan was finally about to leave when a republican backlash, spurred by Santa Anna—who had a sudden and very public conversion to republican ideals, although he later admitted he did not know what the word "republic" meant—forced Iturbide to abdicate on March 19, 1823. The empire had lasted ten months, but the chaos of Mexico's struggle to govern itself was only beginning.

Mexico adopted a new constitution in October 1824, modeled on the Constitution of the United States, with the key exception that there would be no freedom of religion; as it was under Spain, the Catholic Church was the only acceptable faith. By this time Austin was back in Texas, working overtime to bring his struggling colony to fruition. Like his father, Stephen was a man of deep, abiding integrity who demanded similar qualities of the colonists he allowed to settle under his agreement with Mexico.

"No frontiersman who has no other occupation than that of a hunter will be received," he declared, "—no drunkard, no gambler, no profane swearer, no idler." Austin's colonists obeyed Mexican laws and became Mexican citizens, although they needed a little help from a liberal Irish priest to get around the Catholic requirement. Other Anglo empresarios were also given land grants and rights of settlement, but two of the most enthusiastic never realized their dreams. James Long and James Wilkinson both died in Mexico City—Long from a bullet in 1822, Wilkinson three years later from an overdose of opium.

By 1830 there were probably 7,000 to 10,000 Anglo-Americans in Texas and only some 3,000 Tejanos. The flood of wild-eyed Americans that the Spanish once feared had become a reality, though the goal of these tall, fair-skinned Anglos was not the mines of Mexico but the piney woods across the Louisiana border and the rich cotton-growing bottomlands along the Gulf. Land in Texas cost 12.5 cents an acres, one-tenth of what it cost in the United States, and the Spanish did not limit a settler to 80-acre lots, as the U.S. government did. They would give a man a whole square league— 4,428 acres—if he was going to ranch and become a Mexican citizen. Farmers got smaller grants, only 177 acres, so many cotton farmers had quick and temporary conversions to ranching. Such generosity, along with tales of dark-eyed señoritas in loose, low-cut blouses, often drew a different kind of adventurer than the solid, hardworking family men that Moses and Stephen Austin had promised. Throughout the borderlands Texas beckoned to men who were running away from their past. The three initials, GTT, Gone To Texas, were carved into cabin doors and scribbled in letters and account books, closing out one life as another began.

Disturbed by rampant Anglo immigration, Mexico took steps to slow the tide. On September 15, 1829, President Vicente Guerrero issued an edict abolishing slavery. Although Indians and mestizos were often held in a form of indentured servitude, there were few actual slaves in Mexico outside Texas, and the edict was widely seen as an attempt to suppress the Anglo-Americans. In fact, there were relatively few slaves in Texas, but the outcry was so great and the Anglos were so important to the Texas economy that Mexican authorities decided to make an exception for Texas. An official government report by a Mexican general who had traveled through the settlements spelled it out: The Anglo-Americans were living as English-speaking Protestants on Mexican soil, not as the Mexican Catholics they professed to be. "Either the government occupies Texas now," warned one official, "or it is lost forever." A new law on April 6, 1830, revoked all unfulfilled empresario contracts, prohibited new slaves, and closed the border to further immigration from the United States.

The law enraged Americans living in Texas, but it did not stop others from joining them, and the pace of immigration actually increased in the years that followed. By 1834 another Mexican official who traveled through Texas estimated that there were 20,700 Anglo-Americans, 600 or 700 slaves, and about 4,000 Tejanos. The two most successful empresarios, Stephen Austin and Green DeWitt, were allowed to continue legal settlement in their own fiefdoms, but the majority of the newcomers were illegal immigrants. For a time Austin continued to advocate an orderly state under Mexican law, but his moderate voice was often drowned out by wilder and more desperate war dogs who had Gone To Texas to escape their troubled pasts. Three of these would go down in Texas history with Stephen Austin, but they were as different from the spare, sober, and moralizing Father of Texas as a man could be and still occupy the same historical space and time.

The first was a solid six-footer who accompanied Dr. Long to Texas and made a small fortune smuggling African slaves from Jean Lafitte's stronghold in Galveston to the auction block in New Orleans. He spent money as fast as he made it and achieved a dubious, if intriguing, reputation as a fighter, semi-gentleman, and land speculator before moving to Texas in 1830, where he took care of his money problems by marrying

AGUSTÍN DE ITURBIDE

1st The religion of New Spain is and will be the Catholic, Apostolic, Roman faith, without tolerance of any other.

2nd New Spain is independent of the old [Spain] and any other powers, even on our continent.

3rd Its government will be a moderate monarchy, in accordance with the specific constitution and adaptable for the kingdom.

4th Its emperor will be His Majesty Fernando VII,. . .or other individual of a ruling house deemed suitable by the Congress.

5th Until the Cortes [i.e., Congress] meets, there will be a junta whose object will be such a meeting and carrying out the Plan in all its implications.

11th The Cortes will immediately establish the Constitution of the Mexican empire.

12th All the inhabitants of New Spain, without any distinction of Europeans, Africans, or Indians, are citizens of this monarchy with the opportunity of all employment according to his merits and virtues.

13th Persons of all citizenship and their property will be respected and protected by the government.

14th The secular and regular clergy will be preserved in all their privileges and preeminences.

16th A protecting army will be formed to be called the Army of the Three Guarantees, because under its protection will be: first, the conservation of the Roman Catholic Apostolic religion,. . .second, independence under the system described here; third, the intimate unity of Americans and Europeans; guaranteeing these bases so fundamental to the happiness of New Spain, and before allowing them to be violated, the army will sacrifice their lives from the first to the last man.

the beautiful teenage daughter of the richest Tejano family in San Antonio, lying about his own wealth, and offering a dowry that included vast and nonexistent holdings in Arkansas. When his bride and her parents died in a cholera epidemic, he sued their estate to get back the fictitious Arkansas lands, asking for the equivalent in real Texas land or Mexican silver. He did not get it, but he did become a land commissioner and signed away a half million acres in a single month.

The second was a tall, handsome, debt-ridden frontier lawyer who left his pregnant wife and son behind in Alabama and presented himself as a widower to Mexican authorities. He proceeded to bed every willing partner he could find, detailing and numbering his conquests in his diary, along with his persistent and painful venereal disease. He read romantic Walter Scott novels by candlelight and used mercury to treat his syphilis, which makes men mad and only added to his already overtaxed romantic and mercurial imagination. He once pulled a butcher knife on a fellow lawyer during a trial and was forced to back down sheepishly when the opposing attorney countered with a tiny, broken penknife. When he decided to settle down again, he gave his fiancée syphilis.

The third was a giant of a man, six-foot-two or four, with broad, powerful shoulders. He was a lawyer too, more a fighter than a lover, who turned his heroics in the War of 1812 into a political career that took him to Washington as a congressman and to Nashville as a two-term governor of Tennessee. After his storybook marriage to a southern belle mysteriously collapsed, he resigned as governor and went to live in alcoholic delirium among the Cherokee, who nicknamed him "Big Drunk." Even so, his old commander, President Andrew Jackson, sent him on official trips to Texas, and he decided to settle, claiming a married man's grant in Stephen Austin's colony and a single man's grant in another colony.

During the 1830s these three men and others like them would forge the destiny of Texas and, with it, the destiny of the United States. Their names were James Bowie, William Barret Travis, and Sam Houston.

L l a n o E s t a c a d o , N e w M e x i c o

M A N I F E S T D E S T I N Y

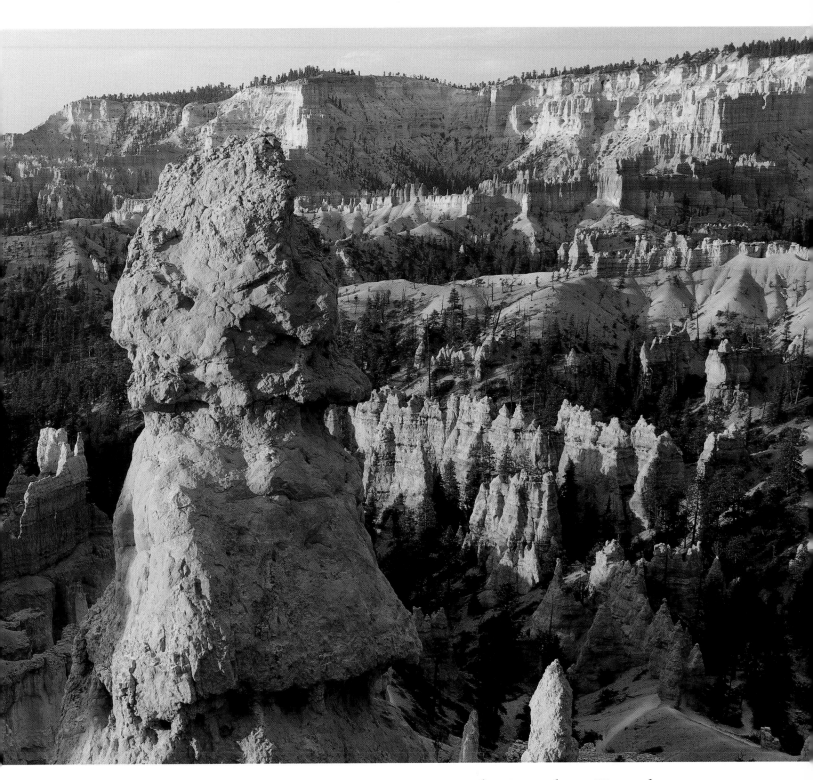

Bryce Canyon National Park, Utah

G r e e n R i v e r , U t a h

1 8 2 6 - 1 8 4 8

MANIFEST DESTINY

Well into the 19th century, maps of the West showed a mythical network of lakes and rivers west of the Rocky Mountains, including the great Río Buenaventura, believed to rise high in the Rockies and flow in a roughly straight line all the way to the Pacific Ocean. The Spanish priests Domínguez and Escalante, who explored the eastern edge of this territory in 1776, had given the name San Buenaventura to what is now the Green River. Their partial information, passed on through German scientist and cartographer Baron von Humboldt, merged with a healthy dose of wishful thinking to form a river route from Missouri to California. In 1826, based on an interview with William Ashley, the founding father of the Rocky Mountain fur trade, a St. Louis newspaper blithely announced that "the Great Author of nature, in His wisdom" had prepared a wagon route to the Pacific along the Platte and Buenaventura Rivers. "So 'broad and easy is the way' that thousands may travel it in safety, without meeting with any obstruction deserving the name of a Mountain."

Jedediah Smith joined William H. Ashley's fur-trading expedition up the Missouri River in 1822 and for the next decade he saw more of the West than any other white man. Smith's most important contribution to the westward movement was his rediscovery of South Pass in 1824; though the Pass had been used by fur trappers returning from the unsuccessful Astoria colony on the Columbia River in the winter of 1812-13, the route had been forgotten. Smith's rediscovery of the sloping passage over the Rocky Mountains paved the way for thousands of wagons that would later roll over the trail to Oregon and California.

It was a great story, but it was not true. And the writer neglected to mention that California and all the land through which the mythic river ran belonged to Mexico, a minor detail that never stopped Americans from dreaming of a destiny that would extend their growing nation across the continent. The term Manifest Destiny was not coined until 1845, but by 1826 the destiny was manifest enough to make men like William Ashley, who had navigated the Green River and correctly guessed that it flowed into the Colorado rather than the Pacific, persist in believing in the elusive Buenaventura.

That year was Ashley's last in the mountains. Tired of the rough wilderness life—and knowing that the real profits were in supplying the fur trappers rather than wading cold mountain streams—he sold his interests and retired to Missouri, where he entered politics and continued to trumpet the cause of western expansion. His fur-trading company was

taken over by three trappers, one of them Ashley's former partner Jedediah Strong Smith. Like Ashley, Smith was an unusually well-mannered and thoughtful man in a rough and tumble frontier world, but he truly loved the wild country and saw more of the American West than any other individual in the early 19th century. By 1826 Smith had already traveled throughout the Missouri River region and the northern Rocky Mountains, and his rediscovery of the gentle, sloping South Pass in what is now Wyoming opened the way for the great westward migrations that would follow. In the fall of 1826, while his partners trapped on northern streams where they could expect rich beaver hunting, Smith led his own party toward the southwest into the land of mythic waterways. Although he undoubtedly hoped to find the Buenaventura and may have been looking for another entry into the British-controlled Columbia region, he mentions neither of these by name in his journal, emphasizing instead the universal lure of trekking through uncharted territory:

In taking the charge of our S western Expedition I followed the bent of my strong inclination to visit this unexplored country and unfold those hidden resources of wealth and bring to light those wonders which I readily imagined a country so extensive might contain. I must confess that I had at that time a full share of that ambition (and perhaps foolish ambition) which is common in a greater or lesser degree to all the active world. I wanted to be the first to view a country on which the eyes of a white man had never gazed and to follow the course of rivers that run through a new land.

Smith's journey began after the summer fur-trading rendezvous that was held on the Bear River in what is now southeastern Idaho. With a party of 18 men, at least 2 traveling with Indian wives and children, they headed north to Soda Springs, where they hunted buffalo and "dried three horse loads of most excellent meat" before working their way south down

the Wasatch Range, past the Great Salt Lake, and on to Utah Valley. There they met Ute Indians, who were "cleanly quiet and active and make a nearer approach to civilized life than any Indians I have seen in the Interior," and bought freedom for two "Snake" women (probably Shoshone) who had been captured by the Ute and now joined the trappers. Crossing the mountains westward, they reached the Sevier River and followed it south before a wall of rock forced them farther west into a low desert country where the streams "all sunk in the sand." As Smith drolly commented, "it was useless for me to look for Beaver where there was no water."

A few days later they encountered Paiute Indians who "had never seen or heard of horses before and of course were much frightened when they saw the men as it seemed to them sailing through the air." Some of Smith's men were frightened as well, and three of them deserted, two taking their "women and Boys" and the other taking the two Snake women. Their buffalo meat was gone, but the near-starving men managed to kill a couple of antelopes and soon came upon a small river that flowed swiftly toward the southwest. Smith named it the Adams River in honor of President John Quincy Adams, but it is the Virgin River today. Down the little stream they met less frightened Paiute who gave them corn and pumpkins, "a treat that made my party in their sudden hilarity and Glee present a lively contrast to the moody desponding silence of the night before."

Following the Virgin through broken red rock country, they traversed what is now Zion National Park and continued on toward the Virgin's junction with the Colorado, lost today beneath the waters of Lake Mead. As they neared the big river, they found another Paiute village, where the people assured them there was plenty of beaver to be found along the lower Colorado, a falsehood Smith explained as "a general characteristic of indians to answer your questions in the manner that they think will please you without any regard to the truth." Drawn by the promise of beaver, the trappers followed the Colorado to a large Mojave

Virgin River, Utah

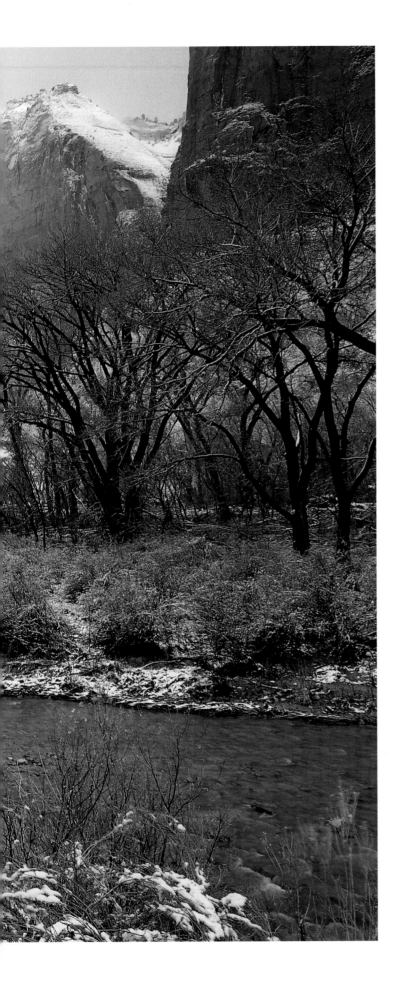

village near present-day Lake Mojave, where they were "treated with great kindness." By this time they had few horses and no prospects of beaver. After careful consideration Smith decided to cross the desert to the California settlements, hoping to resupply himself for a journey to the north, where "I expected to find beaver and in all probability some considerable river heading up in the vicinity of the Great Salt Lake." He was still chasing the Buenaventura.

Guided by two Indians who had run away from the missions, Smith's company crossed the "dry rocky sandy Barren desert," following much the same route that the Franciscan Fray Francisco Garcés had taken during his solitary travels in 1776, though Smith had no way of knowing that the Spanish friar had walked these hot sands before him. Like Garcés, they picked up the Mojave River, which Smith called the "Inconstant" for its habit of disappearing into the sand, and followed it into the area of present-day Victorville. Finally, in late November, the party descended into the fertile San Bernardino Valley, where they saw "fine herds of Cattle in many directions." The hungry men helped themselves to one of them and made their way to an outpost of the San Gabriel Mission. The Indian people there stared at them in amazement, wondering "how indians could be so white," according to Smith, because only Indians lived in the direction from which they came. Soon Smith and his men reached San Gabriel itself, then among the largest and most prosperous of the California missions. They were the first Americans to reach California by land.

Smith was a sober Methodist who seemed equally amazed by the quantity of alcohol that the mission priests consumed as by the genuine warmth and hospitality with which "a people of different religion from mine" received him and his men. Their two Indian guides did not fare as well; they were imprisoned as runaways, and one died in his cell. Smith believed this punishment came not from the kindly priests but from the civil authorities who were giving Smith troubles of his own. He was summoned by Governor José María

Echeandía to San Diego, which the governor was using as his capital instead of Monterey. A tall, gaunt man who towered several inches above the six-foot Smith, Echeandía was thoroughly befuddled by this American in a leather hunting shirt who had appeared from the east. The Mexicans were eager to trade with Americans; there were American ships in the harbor at that very moment, and one of the captains served as Smith's host in the city. Yet the idea of Americans arriving by land was too strange and disconcerting for the officious Echeandía, and this talk of trapping beavers was even more bizarre. The closest he could come to describing his visitor was *pescador*, fisherman, an interesting term for a man who had just crossed the desert.

After weeks of bureaucratic delays Governor Echeandía finally gave Smith permission to leave the way he had come, specifically rejecting the American's request to travel through northern California. The trapper's sea captain friend was heading up the coast, so he hitched a ride to San Pedro, bought supplies from the captain, and headed back to San Gabriel. Smith's party recrossed the San Bernardino Mountains—supposedly honoring his promise to "leave the way he had come"—only to double back and head north into the San Joaquin Valley, where they caught their first sight of the snow-capped Sierra Nevada, which Smith named Mount Joseph after Father José Bernardo Sánchez, his genial host at the San Gabriel Mission. The trapping got better as they moved north, and by the spring of 1827 they had a fair supply of beaver pelts. Realizing that no Río Buenaventura flowed through the massive granite walls of Mount Joseph, Smith decided to take two men and find a way across the mountains, leaving the rest of his trappers on the Stanislaus River. On May 27, 1827, after a night of "howling winds that yet bellowed through the mountains bearing before them clouds of snow and beating against us cold and furious," Smith and his two companions crossed the Sierra at what is now called Ebbetts Pass. They were the first whites to do so, and unlike those who followed, they did it from west to east.

Now the real hardship began as they traversed the seemingly endless succession of lower mountain ranges and sandy deserts of the Great Basin, yet another territory where no white men had walked before. Their path took them south of the Humboldt River, which would later allow wagon trains to cross with some available water, and they faced such hunger, thirst, and heat that they buried themselves in the sand to cool off and barely subsisted on leathery horseflesh. Finally, on the third of July, the three men straggled into the annual fur-trading rendezvous on Bear Lake, just south of where it had been held the year before. "My arrival caused a considerable bustle in camp," Smith wrote, "for myself and party had been given up as lost. A small Cannon brought up from St Louis was loaded and fired for a salute."

Smith had little time to rest, for he had told his men on the Stanislaus to wait only until September 20 before giving him up for dead. Ten days after arriving at the rendezvous, he headed back toward California, again with 18 men and following roughly the same path he had taken the year before. This time disaster struck as they crossed the Colorado. While Smith and eight others were in midstream, the previously friendly Mojave launched an attack, killing ten men still waiting on the shore and seriously wounding one of the men in the river. Hoping to distract the warriors, Smith spread his supplies on the opposite shore and continued on into the desert—nine men, one badly wounded, with no horses, no water, and only 15 pounds of dried meat. Miraculously, Smith took them though to the San Bernardino Valley, where they were able to obtain some supplies and horses from a mission outpost before continuing on to the Stanislaus. He reached his men on September 18, just two days before his deadline. They were all healthy, having passed "what hunters call a pleasant Summer," and like countless Americans after them, they raved about the California climate.

The political climate was something else. Having lost his supplies to the Mojave, Smith was forced "to try once more the hospitality of the Californias," but this time he found a dour and hostile priest at Mission San José who locked him in the

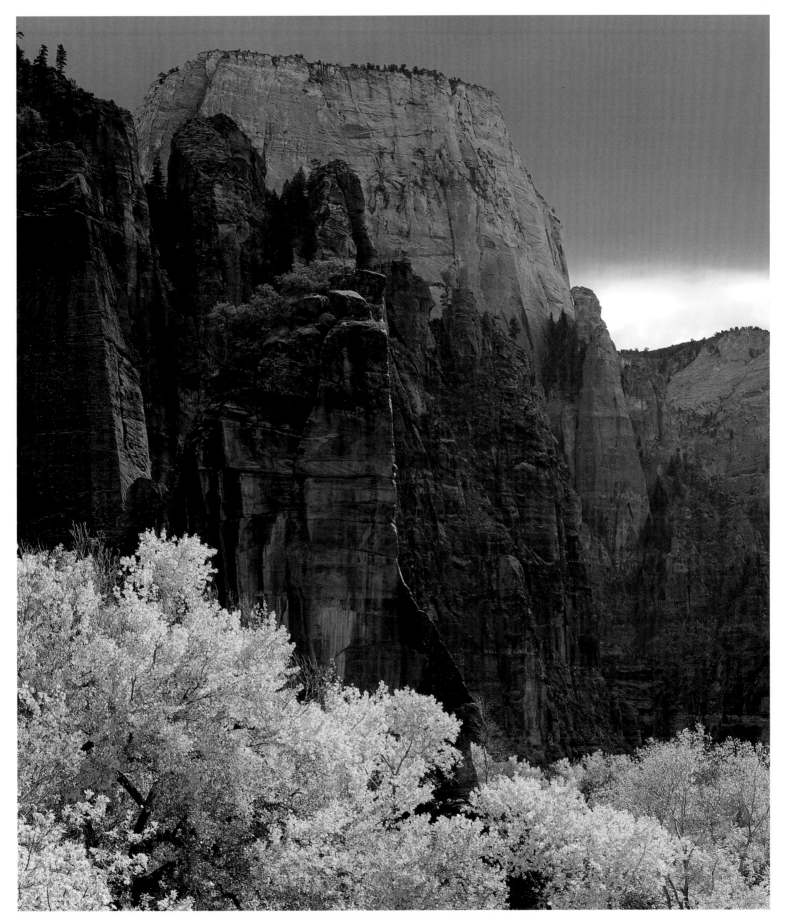

Z i o n N a t i o n a l P a r k , U t a h

guardhouse and did not bother to feed him. Governor Echeandía had moved back to Monterey, and he was even more suspicious and perplexed than the year before. Yet once again, Smith managed to extricate himself from the bureaucratic vise though sympathetic friends—several American sea captains and an Englishman whom Echeandía respected. Smith obtained permission to leave through the north and trade for what he wanted.

In yet another pioneering enterprise he sold his beaver pelts to a ship's captain in Monterey and used the money to buy horses and mules, which were cheap in California and would sell for a good profit back in the Rockies.

Driving 315 animals, Smith and 20 men headed north, trapping along the way, hoping to reach the Columbia and circle back east to the next rendezvous. Most of them never made it. In Oregon they were attacked by Umpqua Indians, who killed 15 men and stole the beaver pelts and horse herd. With the luck that had served him from the beginning of his time in the wilderness, Smith happened to be away from the

The Mojave spoke a Yuman language and were culturally related to other tribes who lived along the Colorado. Though more warlike than most California Indians, the Mojave were friendly to Jedediah Smith's party on his first visit and only attacked him on his second journey because they had been mistreated by other trappers in the meantime.

main party at the time of the attack. Three years later his luck ran out. While leading a caravan along the Santa Fe Trail, he went ahead to look for water in the bone-dry Cimarron Cutoff that had been pioneered by William Becknell. A band of Comanche surrounded the veteran trapper and fired a musket ball

into his back. Smith fired a single shot in return, killing their chief before they finished him off with their lances. Jedediah Smith was 32 years old, and when he died, his knowledge of the West died with him. It would be over ten years before others would rediscover his secrets.

THE CALIFORNIA MISSION world that Jedediah Smith visited was about to undergo fundamental and permanent change. Since the age of enlightenment, progressive thinkers had viewed the missions as little more than slavery. The democratic fever that began with the American Revolution spread to Mexico and posed obvious problems for the paternal relationship between mission priests and their Indian charges. In 1813, during the time when King Ferdinand VII was driven from the throne, a liberal Spanish congress, or Cortes, had ordered all missions ten years or older to be converted into parishes and the land distributed to the Indians. Ferdinand abrogated the decree when he returned to power, but the last Spanish viceroy restored it in 1821, and that same year the Plan of Iguala specifically retained all acts of the Cortes that did not affect Mexican independence. According to the plan, all inhabitants of New Spain were citizens, "without any distinction of Europeans, Africans, or Indians," with the right to all forms of employment "according to his merits and virtues."

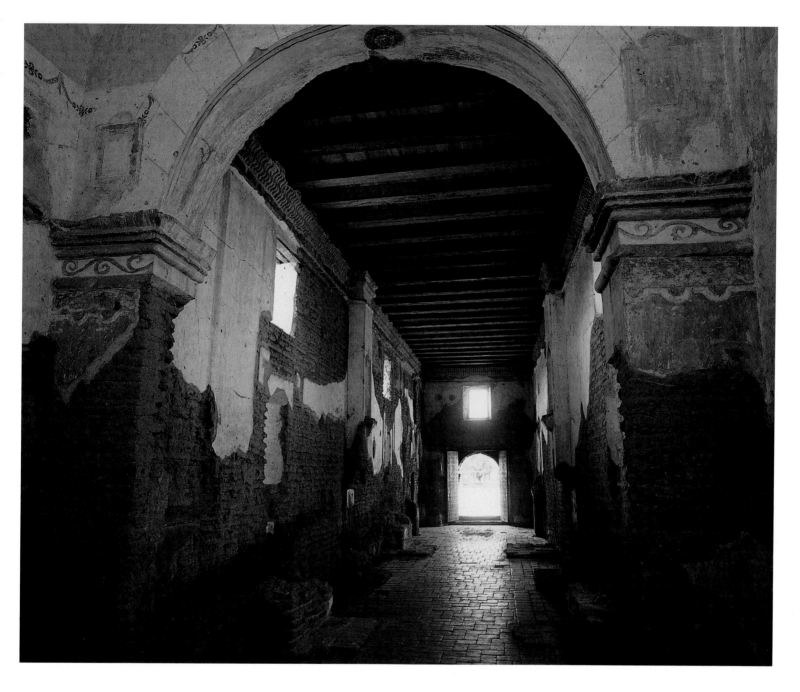

The constitution of 1824, which replaced the plan as the legal foundation of the Mexican Republic, guaranteed the equality of all citizens without mentioning the Indians, but the old order of the Spanish Cortes lingered in the legal shadows, and it was clear that the missions were living on borrowed time. Jedediah Smith, who had a fair understanding of the events in Mexico, offered an interesting explanation of how the mission priests kept the Indians under control even as their legal power to do so was slipping away:

Founded on the east bank of the Santa Cruz River in January 1691 by the Jesuit Eusebio Kino, Mission Tumacácori was moved to the west bank after the Pima Revolt of 1751 in order to be closer to the newly established presidio of Tubac. The first real church was built between 1753 and 1757; when the Jesuits were expelled a decade later, the Franciscans took over Tumacácori, and around 1800 began to build a larger church, which was completed in 1822 and served until the mission was abandoned in 1848.

THE MORMON
EMIGRATION TO UTAH

During the night of September 21, 1823, Joseph Smith, Jr., 18-year-old son of an upstate New York farmer, was visited by the angel Moroni, who told him that "there was a book deposited, written upon golden plates, giving an account of the former inhabitants of this continent, and the source from whence they sprang." Four years later, Smith obtained these plates and began to translate them, completing his work in 1829 and publishing it the following year as the Book of Mormon, named for the last great prophet and record-keeper of the Nephites, descendants of a prophet who came from Jerusalem to North America around 600 B.C. Or so Smith told the story. A man of remarkable charisma, Smith founded a new church that was first called the Church of Christ and later the Church of Jesus Christ of Latter-day Saints, although its members were and still are more commonly known as Mormons.

Under Smith's guidance the Mormons moved from New York to western Ohio and then to the area around Independence, Missouri, which they saw as the Promised Land, until anti-Mormon violence drove them back across the Mississippi River to Nauvoo, Illinois. There Smith's people prospered, growing to over 10,000 in Nauvoo alone, but again anti-Mormon feeling rose among their neighbors, fueled now by rumors that Smith and other church leaders secretly practiced polygamy (which was true), and Smith made plans to move his flock to the Rocky Mountains, so far from civilization that no one would bother them. On June 27, 1844, before he could carry out his vision, Smith and his brother were murdered by an angry mob who broke into a jail where Smith was being held on charges of arson, treason, and polygamy. The majority of Mormons accepted the leadership of Brigham Young who had been one of Smith's closest advisors.

Young now guided his people westward, an enormous undertaking that required movement in stages with efforts to grow food along the way. By the end of 1846, some 16,000 Mormons were farming in Iowa or camped near Omaha, Nebraska. In the meantime, the Mexican War had broken out, and 526 Mormon men in Omaha enlisted as the Mormon Battalion, donating their pay and clothing allowances to finance the trek. In April 1847, an advance party of 143 men, 3 women, and 2 children headed up the north bank of the Platte River in search of the Promised Land. On July 24, when Brigham Young first saw the Great Salt Lake spreading below him in the distance,

he supposedly said, "This is the place." And so it was. "I could not help shouting hurrah, hurrah, hurrah," one man wrote, "... here is my new home at last."

The pioneers immediately set to work, plowing fields, digging irrigation ditches, planting crops, and building houses out of adobe bricks. By early October, over 1,500 others had joined them, and another 2,400 made the trek the following year. In 1849, the Mormons declared the provisional state of Deseret, stretching southwest to San Diego and south to the new Mexican border. The federal government, which had just won most of this area from Mexico, wasn't about to give it away to a religious group that it regarded as suspicious at best and treasonous at worst. Yet, the government could hardly ignore the fact that the Mormons had proven themselves the perfect agents of Manifest Destiny. In 1850, the huge territory of Utah was formed, extending east into present Colorado and west to the California border.

Brigham Young served as the first territorial governor and superintendent of Indian Affairs, and while the Mormons had great success with Indians, Young and his ever growing flock found themselves increasingly at odds with the federal government over church domination of civil government, exclusion of outsiders from economic affairs, and the practice of polygamy. In 1857, President Buchanan sent 2,500 troops—about one-third of the regular army at that time—into Utah to remove Young as governor and occupy the territory. Young had been stockpiling arms, but he decided not to fight, directing some 30,000 followers to abandon the northern settlements around Salt Lake City and retreat into central and southern Utah. Young was replaced as governor in April 1858, and that June the federal army marched through a deserted Salt Lake City and established Camp Floyd in the Salt Lake Valley. Conflict between Mormons and the federal government continued for decades, and it was not until 1896, nineteen years after Young's death and six years after the church's official repudiation of polygamy, that Utah was admitted to the Union.

In this late 1880s photograph, two Mormon women pose with their children in front of a dairy at what is now the tiny town of Mormon Lake, Arizona, just southeast of Flagstaff.

Although since the revolution they are by express provision declared free and the fathers were ordered to inform them of the fact yet it does not appear that it has made any material change in their situation. It is not uncharitable perhaps to suppose that the fathers in making known to them their right to freedom have done it in such a way that it appeared to them from their ignorance a change not to be desired. They said to them—I am told—You live in a good country you have plenty to eat to drink and to wear your father takes care of you and will pray for you and show you the way to heaven. On the other hand if you go away from the Missions where will you find so good a country who will give you cloths or where will you find a father to feed you to take care of you and to pray for you. Such arguments as these coming from a source long respected and venerated and acting on the minds of ignorant and superstitious beings has had the effect to keep the indians in their real slavery without the desire of freedom.

The Navajo began weaving blankets around 1700, borrowing Pueblo technology while developing Navajo designs. This rug reflects the strict geometry of the Teec Nos Pos style.

"Such arguments" had special significance in California, by far the most successful mission system in what is now the United States. In 1823 the Franciscans established their final outpost in a 21-mission chain that stretched along the coast from San Diego to Sonoma, north of San Francisco. At that time there were over 21,000 Indians living at the missions, and it was their unpaid labor, along with the intelligent management of the padres, that held the California economy together. Mission fields and shops produced a large proportion of the agricultural and manufactured goods consumed in the territory, as well as a surplus to trade for imported items. At the same time the missions dominated the prime coastal areas, forcing the settlers, or Californios, to establish their ranchos in the inland valleys. This presented a knotty problem for Mexican authorities: California could not really grow as long as the missions stood in the way, yet to secularize the missions was to risk short-term economic disaster. And then there was the underlying question of how the large Indian population would adjust to life outside the protective mission cocoon.

During the 1820s California governors encouraged partial secularization. This included establishing Indian towns and offering mission land and full rights of citizenship to selected Indians who seemed more ready for freedom than their peers. Few Indians took advantage of these programs, probably due to a fear of the unknown reinforced by the priestly arguments that Smith described. Finally, on August 17, 1833, the Mexican government ordered the secularization of all missions throughout Mexico, and California was thrust into a painful, chaotic transition that destroyed the once thriving religious settlements and scattered the Indian people who had lived in them. Although mission lands were sup-

posed to belong to the Indians, wealthy Californios took charge as *mayordomos*, or overseers, and the Indians passed from being wards of the missions to peons of the mayordomos. Without the guiding hands of the padres, few Indians stayed for long, preferring to find work on nearby ranchos or joining tribes still living in the interior. The mayordomos treated the missions like private assets, selling off lands and property to fill their own pockets. By 1840 one priest lamented, "All is destruction, all is misery, humiliation and despair." Yet what was bad for the missions and the Indians was good for the Californios. In 1820 there had been only 20 ranchos in California; by 1840 there were 600.

New Mexico was unique on the northern frontier in that the missions did not control large areas of land or Indian labor. The land was instead owned and worked by the Indians of a particular pueblo who offered minimal land and labor to support the local priest. Although the Pueblo embraced certain aspects of Catholicism, they continued to perform their traditional dances and ceremonies in public, which shocked outside visitors who did not understand the centuries of compromise between Pueblo and priests. In 1817-18 a representative of the bishop of Durango, who claimed ecclesiastical authority over New Mexico, was horrified to discover that the Pueblo "know little more about God than do the pagans," while "Not a single Franciscan knows the language of the Indians." By this time the Pueblo population was in serious decline, and the Hispano population had nearly tripled. The colonists felt frustrated that the Franciscans focused on the Indians instead of ministering to the needs of believers.

The process of secularization began in New Mexico under Spanish rule and continued after Mexican independence, but in the end the real issue was not secularization but rather the shortage of priests, regardless of whether they were Franciscans or members of the secular clergy. In 1826 there were only 14 priests in all of New Mexico—5 *curas*, or secular priests, and 9 Franciscans. After the federal order of April 1834, the Franciscans hung on because there was no one to replace them, but by 1840 the old missionaries were dead, and the number of curas was woefully inadequate. Faced with a vacuum of traditional ministry, the Hispano people developed new traditions, most notably the Penitentes, a secretive confraternity of laymen that still flourishes in New Mexico today. The origins of the Penitentes are murky, but by 1833 they were powerful enough that the bishop of Durango denounced them as brothers of "butchery" due to extreme physical penances such as self-flagellation and mock crucifixion—ritual adaptations by pious Catholics in a priestless land.

There were even fewer priests in Texas than in New Mexico, but there were also fewer people who needed their services. As in California, the Texas missions controlled large tracts of valuable land, and the rapid decline in the Indian population made it difficult for the Franciscans to justify continued operations. San Antonio de Valero was fully secularized in 1793; the four missions south of the city along the San Antonio River were partially secularized the following year and the lands distributed to the Indians, with two Franciscans serving as parish priests. Full secularization was completed by 1824, with remaining mission lands given to eager Tejanos, many of whom were already squatting on them anyway. Two missions in the Goliad area near the Gulf Coast continued with tiny congregations until 1830, but by that time Texas was hurtling toward a revolution that would end the old order once and for all.

The flash point of the struggle would be the old mission, San Antonio de Valero. Beginning in early 1803, the all-but-abandoned compound served to garrison soldiers and their families from a mobile cavalry company called the Second Flying Company of San Carlos de Parras, named after the region in Coahuila where the company was originally formed. Although the company occupied the compound off and on during the tumultuous decades that followed, the old stone buildings fell into such disrepair that the men who died there in 1836 may not have known that it was ever a mission at all.

WILLIAM BARRET TRAVIS

WRITTEN FROM THE ALAMO
FEBRUARY 24, 1836

The People of Texas & All Americans in the World:

Fellow Citizens & Compatriots—I am besieged, by a thousand or more of the Mexicans under Santa Anna—I have sustained a continual Bombardment & cannonade for 24 hours & have not lost a man.—The enemy has demanded surrender at discretion, otherwise the garrison are to be put to the sword, if the fort is taken—I have answered the demand with cannon shot, & our flag still waves proudly from the walls—I shall never surrender or retreat. Then, I call on you in the name of Liberty, of patriotism & every thing dear to the American character, to come to our aid, with all dispatch—The enemy is receiving reinforcements daily & will no doubt increase to three or four thousand in four or five days. If this call is neglected, I am determined to sustain myself as long as possible & die like a soldier who never forgets what is due to his own honor & that of his country—Victory or Death!

And those who heard their story would remember it not by the name of the saint for whom the Franciscans christened the mission but by a nickname bestowed during the time of the Flying Company, many of whom came from a little Mexican town near Parras called San José y Santiago del Álamo.

IN THE SPRING OF 1833 Antonio López de Santa Anna was elected president of Mexico, emerging victorious in a civil war between liberal federalists, who supported state's rights and more civil control over the church, and conservative centralists, who wanted a strong central government and the protection of traditional church wealth and power. Four years earlier the dashing, dynamic general had become a national hero by defeating the first and only Spanish attempt to reconquer Mexico. Astutely reading the national mood, Santa Anna threw his support behind the people, riding the liberal populous agenda to the presidency.

The Anglo-Americans of Texas were genuinely encouraged by Santa Anna's ascent, for populism and state's rights were exactly what they wanted. There were other rumblings to be sure: hot-headed war dogs, including William Travis, had stirred up rebellion in the port region of Anahuac the year before, and big Sam Houston helped write a proposed state constitution at the time Santa Anna assumed the presidency. Yet even this was for a Mexican Texas, separate from the more populous and powerful state of Coahuila to which it had been joined under the Constitution of 1824. The Texans appointed Stephen Austin to carry the proposed constitution and other petitions to Santa Anna, and though he waited four months to see him, Austin found El Presidente receptive. There were not yet enough people in Texas for separate statehood, but the government granted other requests, including repeal of the anti-immigration provision, reduction of tariffs, and trial by jury. In December 1833 Austin rode out of

Mexico City, feeling he had done well for his constituents. That's when things got strange.

While waiting for Santa Anna, Austin had written an uncharacteristically inflammatory letter to the town council of San Antonio de Béxar suggesting that Texas take unilateral steps toward self-government. This letter fell into the hands of Mexican authorities, and he was arrested on the way home, returned to Mexico City, and thrown into solitary confinement for three months on charges of sedition. Even after his release Austin was held in Mexico City for another 18 months. He was there in June 1834, when Santa Anna returned from his hacienda in a new incarnation as a strong-armed, centralist, church-defending conservative. In early 1835 Santa Anna got rid of his liberal vice president, suspended the Constitution of 1824, and brutally suppressed a liberal uprising in the state of Zacatecas. His brother-in-law, Gen. Martín Perfecto de Cós, led an army into Coahuila, and the word was that El Presidente would go after Texas next.

Stirred by the events in the south, Travis sparked yet another rebellion in Anahuac while Jim Bowie led a citizen's militia to take over a Mexican armory in Nacogdoches. Yet still, most Anglo settlers hoped for peace—they were farmers, not fighters—and many considered the war dogs to be little more than troublemakers. The screw turned in September 1835, when Stephen Austin returned from Mexico while over 400 soldiers under General Cós landed on the Texas coast and marched toward Béxar. Austin had always been the voice of moderation, but his time in prison had changed him, and he saw the change in Santa Anna as well. "Every man in Texas is called upon to take up arms in defence of his country and his rights," he announced. "It is expected that each man will supply himself with provision arms and ammunition to march with."

Hoping to defuse the situation, the Alamo commander, Col. Domingo de Ugartechea, sent a hundred cavalry to the Anglo settlement of Gonzales with orders to take possession of a small cannon designed to fire a six-pound ball. A beat-up metal tube the length of a man's arm, the cannon had been spiked by driving a rod through the torch hole so it was difficult to fire and didn't do much more than make a lot of noise. Yet this small, nearly useless cannon became the symbol of the incipient revolution. The people of Gonzales refused to give it up, defying the Mexican cavalry with a homemade flag that said "Come and Take It." In early October, their little cannon mounted on wheels and spitting out horseshoes and nails like an overgrown shotgun, the Texans drove the Mexicans back to San Antonio, killing two *soldados* while themselves suffering nothing worse than a bloody nose. The Texas Revolution had begun.

Drawn by the engagement at Gonzales, others joined the cause, forming a motley army in buckskin breeches, many wearing moccasins instead of boots, heads covered with sombreros, top hats, and coonskin caps. "A fantastic military array to a casual observer," wrote blacksmith Noah Smithwick, who arrived the day after the battle. The purpose was as varied as the uniforms, as Smithwick went on to explain: "I cannot remember that there was any distinct understanding as to the position we were to assume toward Mexico. Some were for independence; some for the constitution of 1824; and some for anything, just so it was a row. But we were all ready to fight."

The week after the Gonzales battle another group of Texas Volunteers took the poorly defended presidio at Goliad and obtained $10,000 worth of guns, ammunition, and other much needed military supplies while cutting off retreat for General Cós. In the meantime the Texas Army continued to grow. William Travis, who had missed the Gonzales battle because of the flu, joined the fray he had worked so hard to create, as did Stephen Austin, who reluctantly accepted election as general although he had no military experience and was exhausted from his long imprisonment. With Austin in command, the ragtag army moved on toward Béxar, picking up men along

the way, including James Bowie, who had the physical charisma and daring in battle that Austin lacked, and Sam Houston, who had been nominated as commander in chief at a convention in San Felipe. When Houston advised the disorganized army to retreat into east Texas for training while the convention met again to enact a legal framework for the war, the volunteers shouted him down and vowed to take Béxar. That night Houston soothed his ego with a drinking binge of such impressive magnitude that an eyewitness later told him "the hour of midnight was disturbed by howlings of your madness, calling for a pistol to kill yourself." Jim Bowie, almost as big as Houston and a genuine friend to the troubled giant, cut through the madness to stop him. Houston returned to San Felipe with other delegates while the Texas Volunteers remained under the leadership of Stephen Austin.

Recruits continued to arrive, including Tejano volunteers led by Juan Seguín, the alcalde of Béxar. The Texas Army swelled to 600 men, almost as many as General Cós had under his command. Austin's army approached the city from the south, moving up the chain of missions along the San Antonio River. On the foggy morning of October 28, Jim Bowie and an advance party of 90 men routed 300 Mexican soldiers at Mission Concepción, but Austin—who had promised to join them—arrived too late to apply the final blow that might have ended the war then and there. They moved on to besiege Béxar, where General Cós's men were entrenched behind the walls of the Alamo and the fortified city across the river. Although the forces were fairly equal, Cós had 20 cannon—the largest collection

William Barret Travis deserted his wife and children, lied about his background, and spread syphilis with a succession of sexual encounters, but he proved a leader of courage and uncommon eloquence during the desperate defense of the Alamo.

of artillery west of the Mississippi—and Austin knew it would be suicide to launch an immediate attack, just as he knew it would be difficult to maintain momentum: "Whether the army can be kept together long enough to await the arrival of reinforcements, and the necessary supply of heavy battering cannon and ammunition, I am sorry to say, is somewhat uncertain." Some 200 men left in the first few days, but others arrived to take their places, drawn from the United States by the promise of adventure and free land. The most notable of these were the New Orleans Grays, named for the uniforms they wore—the only real uniforms in the Texas Army.

While the siege dragged on, the convention met in San Felipe and voted against declaring independence from Mexico over the objections of Sam Houston, who was commander in chief of an army that did not exist since all the men fighting were volunteers. At the Alamo a majority of the men refused to attack, and in late November, Stephen Austin left Béxar to take the Texas case to the United States. His successor, Col. Edward Burleson, planned to lead a retreat, but dashing thrusts by Bowie and the New Orleans Grays, along with a Mexican defector who reported low morale in the fort and town, energized the Texans. Led by a corrupt, yet charismatic, land speculator named Ben Milam, the rebels attacked Béxar in the early morning of December 5, moving from house to house by cutting their way through adobe walls, picking off the poorly armed soldados with long hunting rifles that were accurate at over 200 yards. By the morning of December 9 the Texans controlled Béxar, with minimal casualties; General Cós, still holding out in the Alamo,

had lost some 150 in the fighting and more to desertion. The following day the Mexicans surrendered with the pledge they would leave Texas and never fight again against the Constitution of 1824. "All has been lost save honor," wrote one Mexican officer. "We were surrounded by crude bumpkins, proud and overbearing."

THOSE CRUDE BUMPKINS now controlled the Alamo, and many of them believed they had won the war. Most of the colonists went home while adventurers drifted eastward, drawn by the promise of an attack on the Mexican port city of Matamoros. By January 1836 there were just 80 men at the Alamo. The Texans never reached Matamoros, but the idea led to such dissension that the provisional government split between a governor and

This painting by Harry A. McArdle captures the chaotic intensity of the Battle of the Alamo. "The tumult was great, the disorder frightful," wrote one Mexican officer; "it seemed as if the furies had descended upon us; different groups of soldiers were firing in all directions, on their comrades and on their officers, so that one was as likely to die by a friendly hand as by an enemy's." Although the authorship of this account has been questioned, the description is accurate and more Mexican soldiers died at the hands of their comrades than were killed by the Texans.

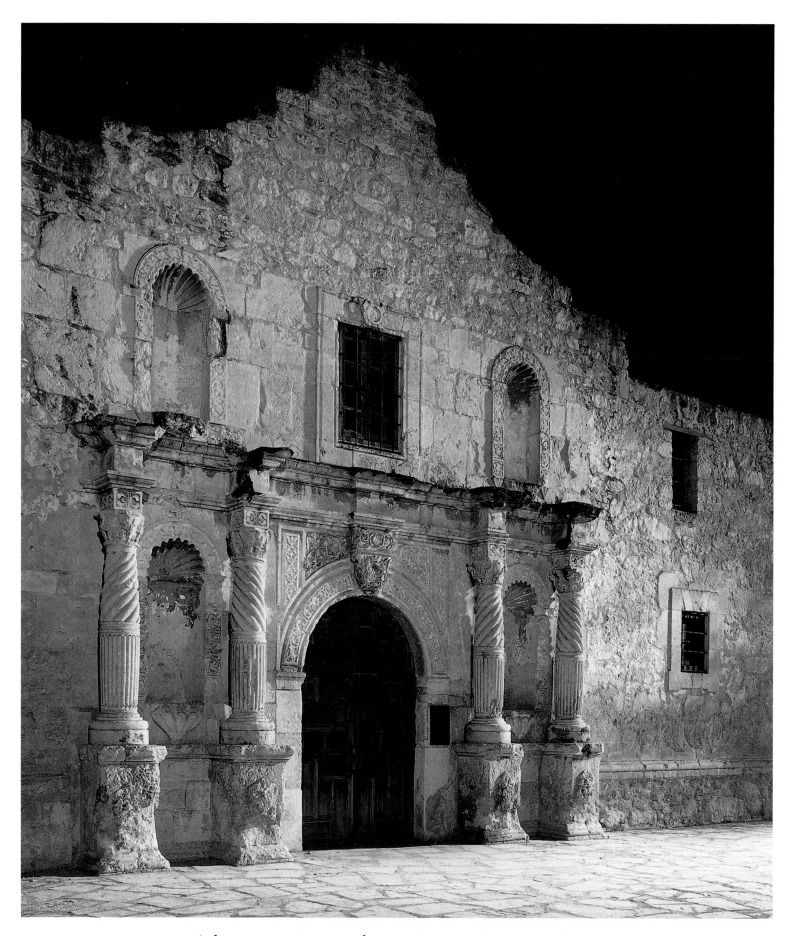

Alamo Facade, San Antonio

acting governor while four different men claimed the powers of commander in chief. One of them, Sam Houston, sent his friend Jim Bowie with 30 men to reinforce the Alamo in mid-January. Houston considered the old mission of such little strategic importance that he suggested it might be better to blow it up and drag the cannon to east Texas. Bowie, who had strong ties with the Tejano community in Béxar through his marriage, believed it was essential to stop the northward march of Santa Anna, who was rumored to be approaching the Rio Grande with 7,000 soldiers. Bowie and Alamo commander James Neill decided to make a stand:

> The salvation of Texas depends in great measure on keeping Bejar out of the hands of the enemy. It serves as the frontier picquet guard and if it were in the possession of Santa Anna there is no strong hold from which to repell him in his march toward the Sabine. . . . Colonel Neill and myself have come to the solemn resolution that we will rather die in these ditches than give up this post to the enemy. . . . Our force is very small. . .only one hundred and twenty officers & men. It would be a waste of men to put our brave little band against thousands.

The day after Bowie's appeal for reinforcements, William Travis arrived with about 30 mounted men. Throughout the conflict Travis had struggled for recognition and rank, and he had finally obtained an official commission as Lieutenant Colonel of Cavalry with orders to raise a force of a hundred men, a tough job at a time when the Texans had "lost all confidence in their government and officers." Or so Travis complained, and he was not far off the mark. Even Sam Houston took a leave of absence to parlay with the Cherokee, while others fought over control of the phantom army. Still the Texas cause and the promise of new adventures could inspire a certain kind of man, and it inspired David Crockett, who, after being defeated for Congress, had

told his constituents to "go to hell, and I will go to Texas." Already commissioned a colonel in the Tennessee militia, Crockett raised his own company of Tennessee Mounted Volunteers and reached the Alamo a few days after Travis. "We are now one hundred and fifty strong," wrote military engineer Green B. Jameson on February 11. "Col Crockett & Col Travis both here and Col Bowie in command of the volunteer forces."

There were now three colonels at the Alamo. Neill had gone home that same day to tend to his sick family, leaving Travis in command, but the volunteers preferred Bowie, so the two men forged an uneasy alliance while Crockett graciously offered to serve as a "high private." On the morning of February 23, 1836, Travis awoke to find the Tejanos of Béxar evacuating the city. They had received warning that the Mexican Army was camped about eight miles to the west. Quickly the Texans prepared for a siege, herding cattle and bringing corn into the Alamo, while Travis scribbled desperate pleas for reinforcements. By late afternoon the advance guard of the Mexican Army—about 1,500 men—was in the streets of Béxar, and Santa Anna ordered a bloodred flag raised to the bell tower of the cathedral, signifying to the Texans there would be no quarter, no mercy, no paroles. Travis replied with a booming shot from the biggest gun he had, an 18-pound cannon. Santa Anna fired back with two howitzers. The siege had begun.

James Bowie, who was desperately ill with a lung infection, handed full command to William Travis the next morning. Travis proved himself to be an officer of uncommon bravery, honor, and eloquence. His pleas for reinforcements, sent out by couriers who slipped through the Mexican lines, still ring as powerful statements of patriotic courage in a desperate situation. At the time the siege began, there were about 150 men in the Alamo, along with four women and a handful of children. The only other significant Texas army at this time was a force of 420 men at the presidio of Goliad under Col. James Fannin, who begged to be relieved of his command, stating simply that "I

Chisos Mountains, Texas

am incompetent." Fannin knew of the situation at the Alamo, and at one point he marched out of the presidio with 320 men to come to their aid, but his officers decided to turn back for fear that the presidio "might fall into the hands of the enemy." With that decision the fate of the Alamo was sealed.

The only known reinforcements arrived on March 1, the eighth day of the siege, when 32 men and boys from the Gonzales area, the youngest just 15 years of age, entered the stone walls of the old mission. The following day, delegates to a convention held at Washington-on-the-Brazos declared Texas independence. Sam Houston had recently returned, and he was again appointed commander in chief, but an old communication from Fannin led him to believe that the Alamo had been reinforced. Another 60 men from Gonzales may have arrived on the night of March 3, but this is uncertain, and it probably would not have mattered anyway. That same day the besieging forces swelled by another thousand, making more than ten Mexican soldados for every Texan defender.

Still more were on their way, but Santa Anna decided it was enough, and he launched his attack in the early morning darkness of Sunday, March 6. The Texans took a toll with cannon, rifles, and muskets, but the Mexicans kept coming over the walls, stepping across fallen comrades, giving the defenders no time to reload. Travis was among the first to die, felled by a single shot to the forehead while defending the porous north wall. Bowie was killed on his sickbed. Crockett may have been executed, or he may have died as a "high private" in the midst of the melee. By dawn it was over, the smoky air reeking of gunpowder and blood. The only known survivors were the women, children, and Travis's black slave, Joe, who had fought beside his master but was assumed to be a noncombatant. Santa Anna ordered the Mexican dead—whom he underreported as 70—buried in the cemetery, while the dead Texans were burned. The traditional count is 182, from the Tejano alcalde in charge of the burning, but there may have been another 60 to 80 men who died outside the walls and were either burned in other pyres or dumped into the river. "Much blood has been shed," said Santa Anna, "but the battle is over; it was but a small affair."

Sam Houston was finally on his way to help when he discovered the truth of the tragedy from Susannah Dickinson, the wife of one of the defenders, who had witnessed the horror while holding her daughter in her arms. Like the other women, Santa Anna had given Mrs. Dickinson a blanket and two pesos and sent her on her way to tell the world what the Fearless Son of Mars would do to those who opposed him. Houston and Mrs. Dickinson cried together, and Houston must have cried for Texas, too. He alone, it seems, understood the implications of an untrained army facing a regular military force of vastly superior numbers. He withdrew to the northeast and ordered Captain Fannin to withdraw as well; yet again Fannin proved indecisive and was forced to surrender to Gen. José Urrea outside Goliad. Although Urrea tried to spare the Texans, Santa Anna sent direct orders to the officer in charge of the prisoners. On March 27, Palm Sunday, 342 men, including Captain Fannin, were summarily executed.

The bloodbaths at the Alamo and Goliad energized Houston and the Texans while lulling Santa Anna into illusions of invincibility. The opposing armies met on April 21 among the moss-draped wetlands of Buffalo Bayou and the San Jacinto River. By this time Houston had raised 900 men and had a few brief moments to train them. Santa Anna and General Cós had a combined force of 1,400, but when Houston ordered an afternoon attack, he surprised the soldados taking a siesta. With cries of "Remember the Alamo! Remember Goliad!" the Texans overwhelmed the sleepy Mexican forces, killing 630, most of them in a slaughter after the fighting stopped, and capturing 730, including over 200 wounded. "Our loss," reported Houston, whose own ankle was shattered by a rifle ball, "was two killed and twenty-three wounded, six of them mortally." Santa Anna was captured the follow-

Copper Canyon, Chihuahua, Mexico

ing day. Although the soldiers shouted for his death, Houston spared the Mexican president in return for ordering his troops to leave Texas. Seven months later Santa Anna arrived home to a cool reception, blaming his defeat on inexperienced soldiers and the tradition of the siesta: "I never thought a moment of rest. . .could be so disastrous."

THOUGH TEJANOS OFFERED ESSENTIAL SUPPORT, the Texas Revolution was an Anglo-American production from start to finish. The people of the United States had coveted Texas since the days of Aaron Burr, and the news of Houston's victory was met with unbridled enthusiasm in the South, while northern thinkers worried that Texas would strengthen the southern slavocracy. No one was more enthusiastic than President Andrew Jackson, who had tried to buy Texas outright before the revolution and had ordered covert operations along the Louisiana border as a backup for Houston's forces. The soldier who brought Jackson the news later wrote, "I am not sure that I ever saw a man more delighted." Yet when the Texans unanimously voted to request annexation to the United States, Jackson's administration turned them down flat. Mexico refused to recognize Texas independence and had forces on the border poised for an invasion, while other nations would consider annexation a blatant breach of international law:

> Prudence, therefore, seems to dictate that we should still stand aloof, and maintain our present attitude, if not until Mexico itself, or one of the great foreign powers, shall recognize the independence of the new government, at least until the lapse of time, or the course of events shall have proved, beyond cavil or dispute, the ability of the people of that country to maintain their separate sovereignty, and to uphold the government constituted by them.

Jackson himself was extremely ill by the time of this statement in December 1836, and it probably represented the thinking of his Secretary of State, John Forsyth, and President-elect Martin Van Buren. But Old Hickory signed it, and the Texans were forced to fend for themselves, preparing for an invasion from Mexico while rebuilding their towns, their farms, and their economy and fighting off the constant threat of Indian attack. With the same go-ahead spirit that had brought them to Texas in the first place, they forged an Anglo republic in what had been a Spanish land, dominating the dwindling Tejano population who now faced racism and prejudice in a place where their families had lived for generations. Juan Seguín, who survived the Alamo only because he carried a message from Travis, was driven from his rancho by a Texas army, "to leave Texas, abandon all, for which I had fought and spent my fortune, to become a wanderer." He went to Mexico, where Santa Anna forced him to prove his loyalty as a figurehead during a Mexican raid on San Antonio in 1842.

The same centralist policies that had sparked the Texas Revolution ignited rebellions across Mexico's northern frontier, including California, Sonora, and New Mexico. The most violent of these occurred in New Mexico, where the political conflict between federalists and centralists was further exacerbated by a more fundamental economic conflict between rich and poor. In August 1837 lower-class insurgents captured the centralist governor, cut off his head, and elected as governor a poor buffalo hunter of mixed Pueblo and *genízaro*, or non-Christian Indian, blood, the first time a man of such ancestry or class had ever held the office. The rebellion was brutally suppressed by a former governor from Albuquerque, Manuel Armijo. Even though he professed loyalty to the centralist regime in Mexico, Armijo was a *nuevomexicano*, born and bred on the frontier, and he led New Mexico in an increasingly independent direction.

In 1841 Armijo faced a different kind of insurgency when over 300 Texans invaded New Mexico, claiming that the border of their new republic stretched all the way to the Rio Grande, a patently ridiculous assertion that included long-established

New Mexican settlements like Santa Fe and Taos. The Texans struggled across the desolate Llano Estacado, and they were so tired and hungry by the time they arrived that Armijo's men easily captured them and marched them another 2,000 miles on foot to Mexico City. Yet the governor recognized that there was genuine appeal in the idea of independence from Mexico, which offered little to the northern frontier except a continuous state of debt. The previous year, when an advance group of Texans had tried to stir up revolt, Armijo had warned government officials that "the people will not defend themselves because they have expressed a desire to join the Texans in order that they may secure better conditions."

Anti-Mexican feelings were even stronger among the Californios, who declared independence in 1836 "until the federal system adopted in 1824 shall be reestablished" and drove away three centralist governors in the years that followed. The leading force behind the rebellion was young Juan Bautista Alvarado, fighting to liberate his land "from the yoke of the oppressors sent by the Mexican government." Unlike the rebellion in Texas, the California insurrection was driven by native Californios rather than outsiders; yet the Anglo population grew steadily between 1841 and 1845, aided by Swiss-born John Augustus Sutter, who carved out a vast, strategically located fiefdom at the confluence of the Sacramento and American Rivers. Although he became a Mexican citizen and promised to obey Mexican laws, Sutter was a great fan of the Americans, and his fort became a way station for illegal American immigrants, while his huge holdings allowed him to offer illegal grants of land. A British observer said of Sutter in 1842: "If he really has the talent and the courage to make the most of his position, he is not unlikely to render California a second Texas." In a sense that is exactly what he did, but before Sutter's California dreams came to fruition, the first Texas sparked a full-blown war.

The 1844 presidential election resounded with cries for the annexation of Texas, and the man who won it, James K. Polk, considered his victory a mandate to grant the Texans their long-held desire to join the United States. In late February 1845 Congress adopted a joint resolution offering Texas admission to the Union, and outgoing President John Tyler signed it on March 1. The Mexican minister in Washington, Juan Almonte, returned to Mexico, calling the annexation "the greatest injustice recorded in the annals of modern history . . . despoiling a friendly nation . . . of a considerable part of its territory." Purported to be the illegitimate son of the revolutionary priest José Morelos, Almonte had been educated in the United States, spoke English perfectly, and probably understood the American people better than any Mexican official of his time, yet even he may not have realized just how much territory was about to be despoiled. Early in his administration, in private communication with his Secretary of the Navy, President Polk stated unequivocally that his real goal was "the acquisition of California."

Whether or not Polk wanted a war remains controversial. Mexico had made it crystal clear that the annexation of Texas would be considered "equivalent to a declaration of war against the Mexican Republic," and in anticipation of armed conflict Gen. Zachary Taylor and his army entered Texas during the summer of 1845, even before the Texans formally approved annexation at the polls. Yet Polk did make what appears to be a good faith effort to buy the land he wanted. He sent Spanish-speaking John Slidell to Mexico City with instructions "to purchase for a pecuniary consideration Upper California and New Mexico," as well as to settle the Texas controversy. Although Polk hoped to obtain the vast region for 15 million to 20 million dollars, he was prepared to go as high as 40 million dollars, almost three times what Jefferson had paid for Louisiana—not a bad deal, considering the desperate state of the Mexican economy and the inability of the central government to control its northern frontier. Unfortunately Mexico never considered the offer because Slidell arrived in the midst of yet another revolution. Both old and new regimes refused to receive him, and Slidell reported per-

sonally to Polk in Washington on May 8, 1846, urging the President "to act with promptness and energy." Though neither man knew it, on that very day Taylor's forces were fighting the first major battle of the Mexican War.

In January 1846, after an early dispatch from Slidell reported the old regime's refusal to see him, the Secretary of War had ordered Taylor to move his camp from the Nueces River—the traditional southern boundary of Spanish-Mexican Texas—to the Rio Grande, which both Texas and the United States now claimed as a new, expanded boundary. From the Mexican point of view this was a thrust deep into Mexican territory, and some American officers agreed, including young 2nd Lt. "Sam" Grant, who would become more famous by his first name, Ulysses. "I was bitterly opposed to . . . the war," he later wrote, ". . . as one of the most unjust ever waged by a stronger against a weaker nation. . . . We were sent to provoke a fight, but it was essential that Mexico should commence it. . . . Mexico showing no willingness to come to the Nueces to drive the invaders from her soil, it became necessary for the 'invaders' to approach within a convenient distance to be struck."

Taylor's army of about 3,000 men reached the Rio Grande in late March. For almost a month a stalemate played out with the Mexican forces at Matamoros across the river, who received three different commanders and various reinforcements until they numbered around 6,000 under Gen. Mariano Arista. On April 25, after a polite exchange of letters made it clear Taylor would not retreat, Arista sent 1,600 men across the river in an effort to outflank the Americans. Taylor dispatched 63 dragoons to investigate, and they fell into an ambush in which 17 were killed or wounded and the others captured. The next day Taylor wrote to the War Department: "Hostilities may now be considered as commenced." The communication reached Polk just hours after his meeting with Slidell, and Polk immediately wrote a war message to Congress, claiming that "Mexico has passed the boundary of the United States, has invaded our territory and shed American blood upon the American soil."

Bent's Fort, Colorado

ON MAY 8 AND 9, just before the official declaration of war, Taylor's outnumbered army won two decisive victories north of the Rio Grande due to more effective use of artillery and what seems to have been greater discipline and enthusiasm on the part of the American troops. "Old Zach" Taylor was an unpretentious man who seldom went in for florid exaggeration, but he proudly wrote to the War Department that "A small force has overcome immense odds of the best troops that Mexico can furnish—veteran regiments, perfectly equipped and appointed. . . . The causes of the victory are doubtless to be found in the superior quality of our officers and men."

Taylor neglected to finish off the Mexican forces, in part because the War Department had refused to appropriate funds for a pontoon bridge that would have allowed him to quickly cross the Rio Grande. By the time he took Matamoros on May 18, General Arista had retreated to fight another day. During the following month, volunteers swelled Taylor's army to 8,000, which presented the difficult question of how to continue a campaign deep into Mexico with untrained men who had only signed up for three or six months. The plan of the war called for Taylor to take the Mexican city of Monterrey, while a second land expedition under Col. Stephen Kearny would march out of Fort Leavenworth, Kansas, first to seize New Mexico and then "to take the earliest possession of Upper California." At the same time, naval ships would blockade the Mexican ports on the Gulf of Mexico and the coast of California, with the western naval forces taking coastal towns and cooperating "in the conquest of California."

Kearny left Fort Leavenworth in June with almost 1,700 men, including regulars and volunteers and an incredible array of animals and supplies: 1,556 wagons, 459 horses, 3,658 mules, and 14,904 cattle. It was by far the largest army ever to cross the southern plains, and they struggled over muddy ravines and rivers until reaching the Santa Fe Trail, now a well-worn path into the Southwest. By July 31 the Army of the West had reached Bent's Fort, the famous trading post built by Charles Bent and Ceran St. Vrain on the north bank of the Arkansas River in what is now southern Colorado. There Kearny wrote a letter to New Mexican Governor Armijo, informing him that while he came "as a friend," he intended to take possession of the province. As he continued toward the south, Kearny received information that Armijo was gathering an army in Apache Canyon, a narrow mountain pass between the old pueblo of Pecos and Santa Fe. Later a letter from Armijo arrived, challenging the intruder that "If you take the country, it will be because you prove the strongest in battle." Unfazed, Kearny reached the sleepy town of Vegas (now Las Vegas, New Mexico) on the eastern slopes of the Sangre de Cristos. After receiving the belated news he had been promoted to general, he climbed to the roof of a flat-topped building in the public square and announced to the puzzled, frightened citizens that they were now living in United States territory:

I have come amongst you by the orders of my government, to take possession of your country, and extend over it the laws of the United States. . . . We come amongst you as friends—not as enemies; as protectors—not as conquerors; . . . for your benefit—not your injury. Henceforth, I absolve you of all allegiance to the Mexican government, and from all obedience to General Armijo. He is no longer your governor; I am your governor. I shall not expect you to take up arms and follow me, to fight your own people who may oppose me; but I now tell you, that those who remain peaceably at home, attending to their crops and their herds, shall be protected by me in their property, their persons, and their religion; and not a pepper, nor an onion, shall be disturbed or taken by my troops without pay, or without the consent of the owner. But listen! he who promises to be quiet, and is found in arms against me, I will hang.

For reasons that have never been clear—but may have included a substantial bribe—Governor Armijo abandoned his defense in Apache Canyon. As the army marched through the mountains, they met a jovial, corpulent alcalde who rode out on a mule shouting, "Armijo and his troops have gone to hell and the canyon is all clear!" Actually Armijo went to Mexico, where he was tried on charges of treason and acquitted. On August 18 Kearny's men marched into Santa Fe and raised the U.S. flag over the New Mexican capital without firing a shot. The soldiers, who had imagined an exotic city of luxury and riches, were so disappointed by the humble streets and adobe buildings that they nicknamed it "Mudtown." Yet Kearny was much taken by the apparent hospitality of the New Mexicans. Six days later he wrote, "The people of the territory are now perfectly tranquil, and can be easily kept so. The intelligent portion know the advantages they are to derive from the change of government, and express their satisfaction at it." Kearny's assessment was overly optimistic, but he would not be around to find out.

By mid-September the territory was "so perfectly quiet" that Kearny decided to move on to California. Two volunteer soldiers who were lawyers in civilian life wrote a new constitution, and as governor Kearny appointed Charles Bent, who had lived in Taos for many years and married a Hispano woman. After reinforcements arrived from Missouri, the First Missouri Mounted Volunteers rode south to Chihuahua, where they joined American forces already occupying the city. Kearny himself rode south along the Rio Grande with only his 300 regular dragoons. On October 6 he met Kit Carson heading toward Santa Fe, carrying dispatches to Washington from California. Carson, who had also married a Hispano woman in Taos and was eager to see his family, reluctantly agreed to guide Kearny west while bringing the general up to speed on the chaotic events in California.

In June, without knowing war had been declared, 35 American frontiersmen had seized the small northern California village of Sonoma and declared the California Republic under a homemade flag with a single star and a grizzly bear. Although he did not participate in this initial action, American Army officer John Charles Frémont—who was in California with an exploring party and may or may not have had secret orders to foment rebellion—took control of the makeshift army and led them south to occupy the abandoned presidio in San Francisco. The so-called Bear Flag Revolt pushed Commodore John Sloat to take Monterey, although he was still not certain that a state of war existed, and in late July Sloat turned over command to Commodore Robert Stockton, who joined Frémont to subdue Californio resistance and declared California to be United States territory. As far as Carson knew, the situation was under control, which prompted Kearny to send 200 men back to Santa Fe, a decision he came to regret. In fact, Stockton's imperious rule had stiffened resistance, and the Californios had retaken southern California. Kearny, who treated the New Mexicans with careful restraint, later judged that the renewed Californio resistance rose because they were "most cruelly and shamefully abused by our own people."

Kearny's troops reached California in early December. By that time the Americans had retaken San Diego, and Kearny's exhausted dragoons, along with 35 sailor-soldiers, clashed with the Californios in the beautiful San Pasqual Valley, about 35 miles northeast of the city. American losses were heavy for a small force—18 dead and 13 wounded, including Kearny himself—and they avoided defeat only because reinforcements arrived the following day. Los Angeles fell to combined army and naval forces on January 10, and the war in California effectively ended three days later when Frémont arrived from the north and negotiated a treaty with Californios in the San Fernando Valley.

Less than a week after the Californios agreed to peace, the New Mexico that Kearny had thought "so perfectly quiet" erupted in bloody revolt. There had

always been a powerful undercurrent of resistance to the American occupation, and a major rebellion involving leading citizens of Santa Fe was barely averted in December. In January, Governor Bent returned to his home in Taos, believing that his long-standing connections with the Hispano community would afford him protection. "Why should they want to kill me or my family?" he asked. "Have I not been their friend?" He had, but he was also an American who dared to sit in the Palace of the Governors. Now he was in Taos without the protection of the soldiers who put him there. In the early morning hours of January 19 a mob of Hispanos and Pueblo Indians brutally scalped, murdered, and decapitated Bent as his horrified wife and children watched. In a planned and coordinated insurrection, over 20 other Americans or Hispanos with American sympathies were killed over the next few days in the Taos area and the mountain village of Mora.

Faced with a major rebellion in the north, the commanding officer in Santa Fe, Col. Sterling Price, fought his way up the Rio Grande, clashing with rebel forces that numbered as many as 1,500 in one battle and over 600 in another. On February 3 the Americans reached Taos Pueblo, where the rebels had retreated into the adobe church and the two large, multistoried adobe buildings behind it. Price ordered an artillery attack on the church, but the soft, thick walls proved so resistant to modern weaponry that even "a ball of a 12-pounder will pass without doing any more damage." On the second day of bombardment the soldiers cut small holes in the walls and manually threw artillery shells inside, which reduced resistance enough to haul a six-pound cannon to near point-blank range and pour three rounds of deadly grapeshot through the widening breach. "The storming party. . .entered and took possession of the church without opposition," wrote Price, while other forces chased down the fleeing rebels. The battle was costly to both sides: Seven Americans died in the fighting, and 45 were fatally wounded; 154 rebels were killed,

and 16 others were later tried and executed. An Indian leader named Tomacito was simply shot in his cell by an American soldier. "The Indian deserved to be killed," remembered a fellow volunteer, "and would have been hanged anyhow, but we objected to the informal manner of his taking off." Scattered attacks continued into the summer, leading Price to a discouraging but more honest assessment than Kearny's: "It is certain that the New Mexicans entertain deadly hatred against Americans."

For better or worse the two peoples would be forced to live together. After his victories along the Rio Grande, General Taylor conquered Monterrey in September 1846 and won a brilliant, decisive victory over a much larger force under General Santa Anna in February 1847, not the first time the "Napoleon of the West" had failed to live up to his self-proclaimed greatness on the field of battle. The following month Gen. Winfield Scott landed over 10,000 men at Veracruz and marched inland, ultimately taking Mexico City on September 14, 1847. The war officially ended with the Treaty of Guadalupe Hidalgo on February 2, 1848, and the old Spanish territories of Texas, New Mexico, and Alta California—almost 1.2 million square miles of grasslands, rivers, mountains, and deserts—became part of the United States.

Rabid expansionists wanted the rest of Mexico, too: "We must SEIZE HER MINES," cried the *New York Globe*, "—hold her towns. . . . DESTROY THE NATIONALITY of that besotted people. . . . UTTERLY DESTROY THEM as a separate and distinct nation." We did not, but even so "Mr. Polk's War" achieved what it had set out to achieve, at a cost of about 13,000 American lives, most lost to disease rather than battle, and some 118 million dollars, including 100 million dollars for military operations, a 15-million-dollar payment to Mexico for the land—which was Polk's lowball offer before the conflict—and up to 3.25 million dollars to compensate private American claims. Mexican casualties were much higher, at least 30,000 and probably more, but no one bothered to count.

Both the Spanish and Mexicans had struggled to populate their northern frontier, which had never lived up to the early dreams of gold and glory. That was all about to change, and though the American people continued to crow about the God-given destiny that took them across the continent, it was in fact a single stroke of well-timed fortune that turned the tide: On the cold morning of January 24, 1848, nine days before the Mexican War was officially over, a crusty, competent carpenter named James Marshall, who was building a sawmill for John Sutter in a pristine valley carved by the clear, swift American River, found gold.

One of the earliest photographic images of a war scene, this daguerreotype captures Brigadier General John E. Wool (left of center) and his staff entering Saltillo during the Mexican War. After raising an army of volunteers in the Mississippi and Ohio Valleys, Wool had marched from San Antonio, Texas, with 3,400 men and crossed the Rio Grande into Coahuilla. He decided against continuing to Chihuahua where there were few enemy troops and "all that we shall find to conquer is distance." Instead, Wool remained in Coahuilla and offered welcome reinforcements to the weary army of Zachary Taylor.

WHITE EYES,
FAST GUNS

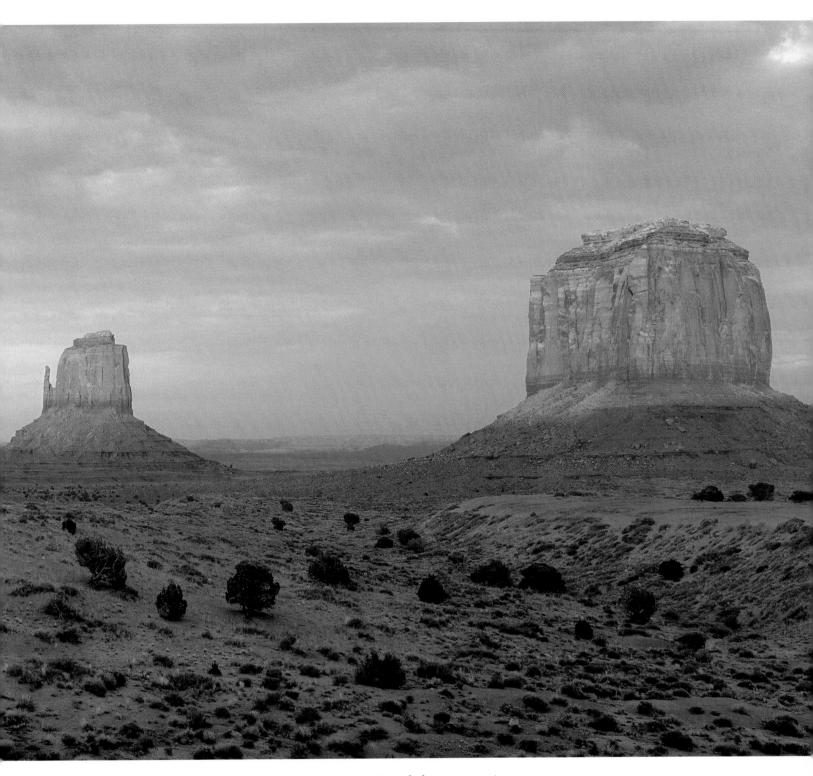

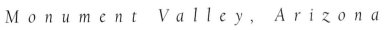
Monument Valley, Arizona

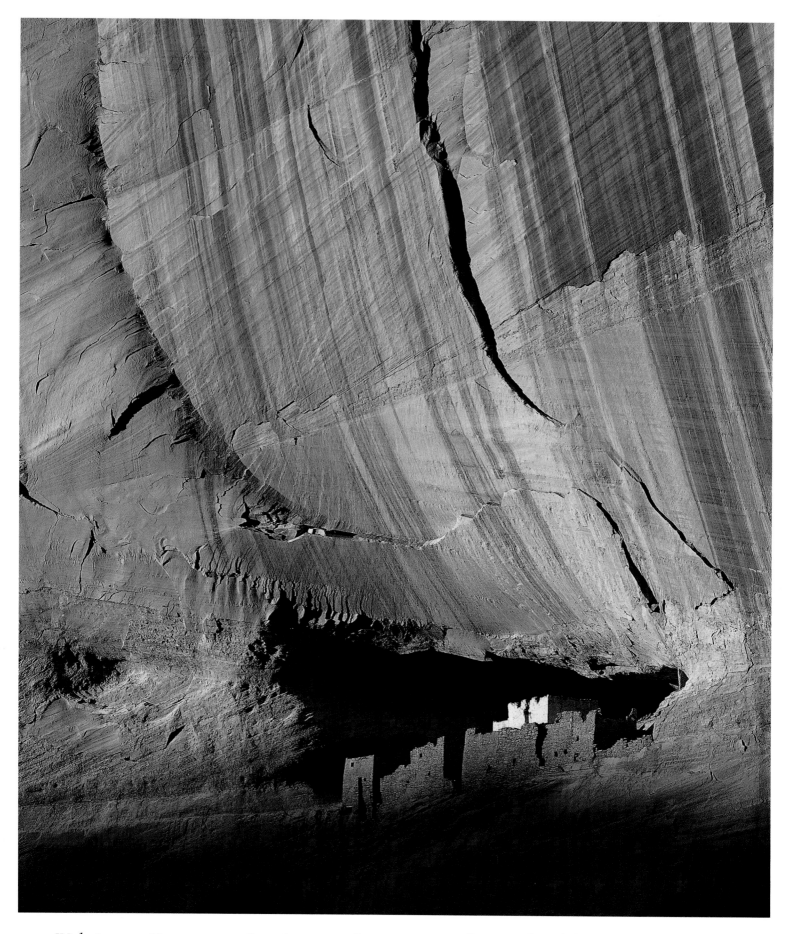

White House Ruins, Canyon de Chelly, Arizona

1 8 4 6 - 1 8 8 1

WHITE EYES, FAST GUNS

STEPHEN KEARNY PROMISED THE PEOPLE OF NEW MEXICO THAT THE AMERICANS WOULD PROTECT THEM FROM THE APACHE AND NAVAJO WHO "COME DOWN FROM THE MOUNTAINS AND CARRY OFF YOUR SHEEP, AND EVEN YOUR WOMEN, WHENEVER THEY PLEASE." HE POINTED OUT THAT THE MEXICAN GOVERNMENT HAD FAILED TO PROTECT THEM AND STATED WITH A SIMPLICITY BORN OF ARROGANCE AND IGNORANCE: "MY GOVERNMENT WILL CORRECT ALL THIS." IN THE FALL OF 1846 KEARNY ORDERED COL. ALEXANDER DONIPHAN, COMMANDER OF THE FIRST MISSOURI VOLUNTEERS, TO PARLEY WITH THE NAVAJO BEFORE HEADING SOUTH TO CHIHUAHUA TO JOIN THE FULL-SCALE INVASION OF MEXICO.

Doniphan met with the Navajo on November 21, 1846, at Ojo del Oso, or Bear Springs, east of present-day Gallup, New Mexico. He estimated that there were 500 Indians present, but he wrongly believed they included "all the head chiefs," a typical problem in the American approach to Indian relations. In fact, many leaders did attend, but there were others who did not. The principal spokesman for the Navajo was a young chief named Zarcillos Largos, whom Doniphan described as "very bold and intellectual." Largos began by saying that "he was gratified to learn the views of the Americans" and that "he admired their spirit and enterprise, but detested the Mexicans." As negotiations continued over several days, Doniphan emphasized that the U.S. soldiers now controlled New Mexico and that it was their duty to protect the people "against violence and invasion." It was an interesting point from a man who had just invaded New Mexico. Largos made the most of the irony:

Americans! You have a strange cause of war against the Navajos. We have waged war against New Mexicans for several years. We have plundered their villages and killed many of their people, and made many prisoners.

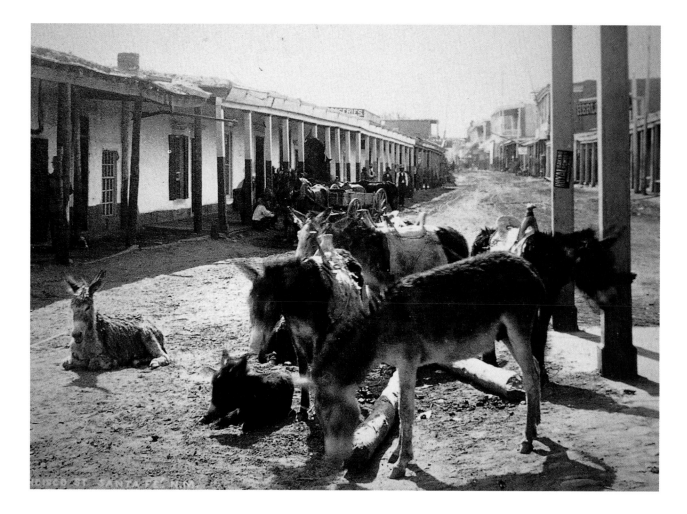

This 19th-century photograph by pioneering western photographer William Henry Jackson captures a dusty, sleepy scene on Santa Fe's San Francisco Street, which runs south of the plaza and ends at St. Francis Cathedral. The New Mexican capital was generally a disappointment to early American visitors, who imagined a dazzling city of riches and luxury and found instead a relatively poor backwater, dubbed "Mudtown" by Kearny's soldiers during the Mexican War.

We had just cause for all this. You have lately commenced a war against the same people. You are powerful. You have great guns and many brave soldiers. You have therefore conquered them, the very thing we have been attempting to do for so many years. You now turn upon us for attempting to do what you have done yourselves. We cannot see why you have cause of quarrel with us for fighting the New Mexicans on the west, while you do the same thing on the east.... This is our war. We have more right to complain of you interfering in our war, than you have to quarrel with us for continuing a war we had begun long before you got here.

Nonetheless, Doniphan convinced Largos and the other leaders to sign a treaty promising "firm and lasting peace and amity. . .between the American peo-

ple and the Navajo tribe of Indians," but the raids on New Mexican settlements continued because they were an integral aspect of the Navajo economy and culture, and neither the soldiers nor the New Mexicans could stop them The aptly named Fort Defiance was established in 1851 in the heart of Navajo territory just south of Canyon de Chelly, but even this full-time Army post was not enough to quell the Navajo threat. The Diné, or People, as they called themselves, were too numerous, too strong, and too smart. They raided with fierce bravery and dazzling horsemanship comparable to the Comanche and kept huge herds of sheep and raised a variety of crops and fruit trees, like the Pueblo. It was a tough combination to beat.

On his way to California, Kearny himself had a similar encounter with a band of Chiricahua Apache under the famed chief Mangas Coloradas, a giant of a man who towered over the small, trim American general as he towered over his fellow Apache. Like the Navajo, the Apache were disposed to friendship with the Americans because they were both fighting the Mexicans. The northern Mexican states of Sonora and Chihuahua faced such constant harassment that they launched a war of extermination, offering bounties for Apache scalps. "You have taken Santa Fe," one Apache chief told Kearny, "let us go on and take Chihuahua and Sonora; we will go with you. You fight for the soil, we fight for plunder; so we will agree perfectly."

The most lucrative plunder for Apache, Navajo, and Mexicans alike was slaves, and the Americans were determined to stop the traffic, even though slavery was still perfectly legal in the South. In 1851 John Russell Bartlett, the U.S. commissioner for the joint U.S.-Mexican team surveying the new border between the countries, met Mangas Coloradas and his people near the abandoned copper mines of Santa Rita del Cobre in southern New Mexico. Once again Mangas expressed a genuine desire for friendship with the Americans, but the situation threatened to turn ugly when Bartlett gave protection to two young Mexican boys who had been captured by the Apache. "Why did you take our captives from us?" asked Mangas. "You came to our country. You were well received by us. Your lives, your property,

General Stephen Watts Kearny served in the infantry during the War of 1812. Transferred to the west in 1819, he later became commander of dragoons and in 1837 published the definitive manual for dragoon operations.

your animals were safe. . . . We were friends! We were brothers! Believing this, we came amongst you and brought our captives, relying on it that we were brothers, and that you would feel as we feel."

MANGAS COLORADAS was not alone in his confusion over the American policy toward captives. The new territories acquired from Mexico heated the national debate over slavery to fever pitch due to the Wilmot Proviso, a proposed law specifically prohibiting slavery in those territories. Although supported by northern states, Southerners were so vehemently opposed to the proviso that there was serious talk of secession in 1850. The crisis was temporarily averted by the Compromise of 1850, in which California was allowed to enter the Union as a free state, which upset the balance between free and slave states, while the Northerners gave up their insistence on the proviso and allowed new territories to vote on the issue of slavery. As part of this compromise New Mexico and Utah were officially formed as U.S. territories, with their western borders extending all the way to California, and Texas gave up its claims to eastern New Mexico in return for a much needed payment of ten million dollars from the federal government. New

Mexico voted against slavery in 1850 and reversed itself in 1859, but the dry and mountainous land was ill suited for the plantation economy, and slavery never became common.

The rich, well-watered bottomlands of east Texas were perfectly suited for cotton plantations, and Texas quickly became a bastion of the southern slavocracy, just as Northerners had feared. Of all the territories obtained from Mexico, Texas grew the fastest due to the combination of cheap land, early Anglo settlement, and proximity to the already settled states in the south. By 1820 the Tejano population of the province may have fallen as low as 2,000. In 1836, the year that Texas declared its independence from Mexico, the population was over 50,000, including 30,000 Anglos, 5,000 black slaves, 3,500 Tejanos, and 14,000 Indians. In 1860, on the eve of the Civil War, the Lone Star State had a population of over 600,000, including more than 180,000 slaves.

By this time settlers had begun to edge west of San Antonio, but the vast majority of the population was still in the east, and the Comanche made life miserable for whites on the western frontier. A double dose of epidemics in 1848 and 1849 had devastated the mighty Comanche nation, killing half the population, but those who remained were still powerful enough to impede the spread of American settlement. In the far southwestern corner of the state, some 4,000 people—Pueblo Indians, Mexicans, and Anglos—lived in the El Paso area. The old Spanish town of El Paso del Norte was south of the Rio Grande, and so it remained a part of Mexico, later renamed Ciudad Juárez. However, three nearby mission communities originally settled by Pueblo refugees at the time of the Pueblo Revolt suddenly found themselves north of the river in 1829 after the Rio Grande cut a new channel. These settlements were now on American soil, and several Anglo settlements developed after the Mexican War. In 1859 a new American El Paso was laid out across the river from the old one.

California was almost as unsuccessful as Texas under Spanish-Mexican rule. At the time of the gold

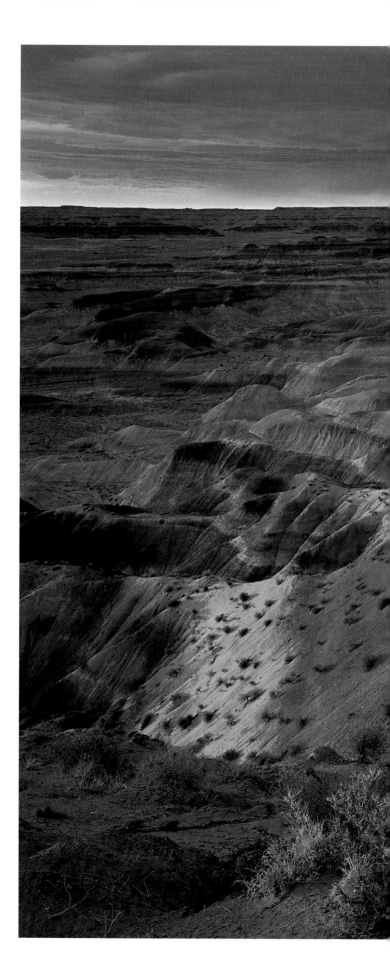

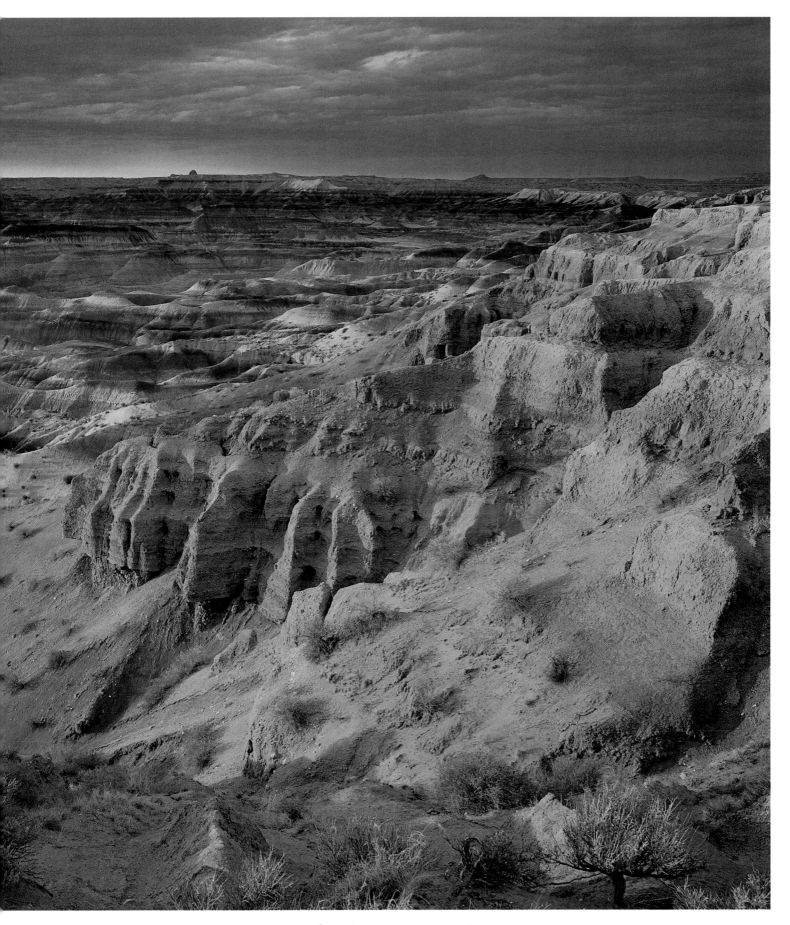

Painted Desert, Arizona

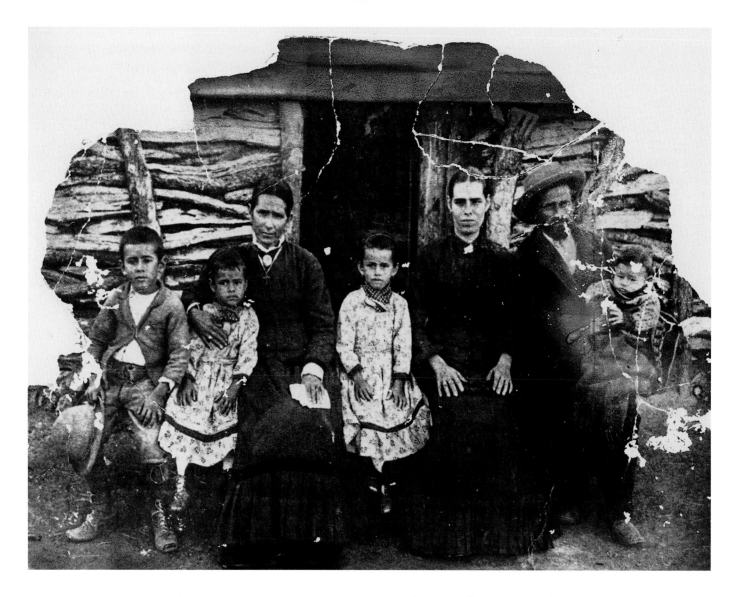

The Campos family poses in front of their log cabin in Encinal, Texas. Although Tejanos fought with Anglos during the Texas Revolution, Mexican-Americans suffered discrimination under Anglo rule. In 1901, the Anglo-Mexican conflict came to a head when a man named Gregorio Cortez killed an Anglo sheriff who had shot his brother after accusing the two Mexicans of horse-stealing. For ten days, Cortez eluded various Anglo posses that numbered as many as 300 men, becoming a folk hero to fellow Mexican-Americans who celebrated his daring in a famous ballad or corrido: "Then said Gregorio Cortez, with his pistol in his hand, 'Ah, so many mounted Rangers just to take one Mexican!'"

discovery there were perhaps 14,000 non-Indian people in California; two years later the U.S. census of 1850, conducted in an atmosphere of utter chaos, counted 92,597. Perhaps the most interesting fact from this census besides the remarkable growth is the ratio of men to women. There were only around 7,000 females in the entire state, and just under 2,500 of them lived in southern California, where traditional Californio culture was relatively untouched and the male-female ratio was almost one to one. Adjusting for the fact that the ratio was fairly equal among the young and the old, there was only one eligible woman for every twenty men in northern California.

It was a recipe for trouble, a horrible echo of the early days of the Spanish soldados, except this time there were no priests and little military or civil

authority. American miners raped Indian women with such ferocity that they often killed them, or left them with sterility caused by syphilis. When Indian men resisted, they killed them, too. In one telling incident James Marshall tried to stop a mob of miners about to kill some Indians in the Coloma Valley where the rush began, and the miners threatened to kill Marshall, too.

By 1853 one forty-niner commented, "Live women are now so plenty that a miner wouldn't take the trouble to drop his pick to look at one." In truth, women were hardly plenty, but they were now arriving regularly to join their husbands and settle with their families. In 1860 the population of California was about 380,000, with almost 100,000 women. Asians and Indians were counted separately for the first time, 35,000 and 18,000 respectively. The Indian count is low because it included only those living in the "general population" and excluded Indians on reservations or out of reach of the census; scholars guess there may have been 30,000 in all, or one-tenth of the precontact population.

The rush also widened a separation between northern and southern California that had begun under the Californios. The mines were all in the north, and naturally the growing population was in the north as well. In 1860 only 7 percent of the people lived in southern California, from San Diego to San Luis Obisbo, and a third of these were Indians. Although the census did not yet keep separate figures for Hispanic descent, most non-Indians in southern California had Spanish and Mexican blood, and many of them still lived the same agricultural rancho lifestyle they and their families had lived under Mexico. Thus, while northern California developed

Though their rituals and organization were New Mexican, the penitentes—*who scourged themselves with ropes like those above—followed the footsteps of European lay religious societies.*

rapidly into a modern industrial society, southern California remained a sleepy backwater where little really changed with the coming of the Americans.

New Mexico was by far the most successful of the former Spanish colonies in what is now the United States; by the time of the Mexican War about 50,000 Hispanos lived in the territory, along with some 10,000 Pueblo Indians who enjoyed full rights of citizenship. Unlike Texas and California there was no big rush of Anglos, for there was little gold to be found, and the easily irrigated lands were already taken. American merchants looked for opportunities, soldiers established frontier forts, and lawyers jockeyed for position under the new government. Yet the numbers of these newcomers was minimal. The census of 1850 counted 61,549 people. Though no breakdown is available, there were probably no more than 1,500 Anglos and perhaps as few as a thousand. At a time of rampant racism and anti-Catholicism, the United States found itself trying to govern a brown-skinned, Spanish-speaking, devoutly Catholic people.

The Pueblo also posed a troublesome question. From the beginning the Americans recognized the fundamental difference between these peaceful agrarian people and the warlike raiders who preyed on them. The first Indian superintendent of New Mexico petitioned the federal government to protect Pueblo lands and continue the right to vote the Pueblo had held under Mexico. They did vote in early territorial elections, but the idea of Indians voting was anathema for most Americans on the frontier, and the right was taken away by the territorial legislature in 1852, not to be restored until 1948. The Pueblo managed to hold on to their tribal lands, but they were denied protection

from trespassers in a truly bizarre 1867 territorial court decision. The antitrespassing laws were made to protect "wild, wandering savages," said the judge, and thus did not apply to the Pueblo who were "the most law-abiding, sober, and industrious people in New Mexico." As events played out, it did not pay to be an Indian, whether wild-wandering or sober-industrious, under American law.

IN 1853, A SOUTH CAROLINA RAILROAD promoter named James Gadsden, acting as an official minister to Mexico, negotiated the purchase of over 29 million acres of land in what is now southern New Mexico and Arizona for 10 million dollars. The Gadsden Purchase resolved a conflict regarding the new international boundary and guaranteed that the fertile Mesilla Valley of New Mexico—considered the best route for a transcontinental railroad—would be in U.S. territory. By this time General Santa Anna was back in power in Mexico, and his treasury was so strapped for cash that he was happy to sell.

It would be almost 30 years before a transcontinental railroad ran through the fertile region on its way to the Pacific. By the time of the Gadsden Purchase the conflict between North and South had become so acrimonious that neither side would approve a railroad line that might give the other an economic or military advantage. Instead the Overland Mail Company, commonly known by the name of its president, John Butterfield, was provided federal subsidies to establish regular mail and passenger service to California. Beginning in St. Louis and Memphis, the lines merged at Fort Smith, Arkansas, and continued in a swooping southwesterly curve through the Indian territory and the heart of Texas all the way to American El Paso (at that time called Franklin). From there the line passed through the Mesilla Valley on to Tucson, Yuma, Los Angeles, and San Francisco. The over 2,700-mile journey took about three weeks of dusty, jostling travel day and night, but it got you to California or back, and it gave many Easterners their first glimpse of the American Southwest.

On its way from Mesilla to Tucson the Overland line wound through a mountain pass in what is now southeastern Arizona, where a year-round limestone spring provided sweet and essential water on the long desert journey. The spring and the pass were both called Apache because they were controlled by a band of Chiricahua led by Cochise, son-in-law of Mangas Coloradas. At first Cochise cooperated with the Americans, allowing them to use the spring and contracting to supply wood for the stone stage station that was built nearby. Then, in late October 1860, a half-breed boy and a herd of cattle disappeared from a ranch southeast of Tucson, and the boy's American stepfather, John Ward, blamed Cochise, although it later turned out that another Apache band had been at fault. On the evening of February 4 young 2nd Lt. George Bascom, supported by 54 mule-mounted infantry, met with Cochise at Apache Pass to resolve the affair. He did not.

Speaking through an interpreter, Cochise denied any part in the abduction and offered to help find the boy. Bascom made a show of friendship, serving coffee and food while his soldiers surrounded the tent. When the lieutenant informed Cochise he was under arrest, the tall, strong Apache pulled out a big knife, slashed the side of the tent, and escaped into the night through a hail of bullets, his coffee cup still in his hand. Or at least that is how Cochise remembered it. Bascom kept Cochise's wife, two children, his brother, and two nephews as hostages, and when he refused to negotiate without the Ward boy, the situation rapidly deteriorated. Cochise launched two attacks on the stage station, where the soldiers took refuge behind the strong stone walls, and captured a wagon train and harassed the stagecoach. By February 8 eight Mexican teamsters had been tortured and killed, two civilians killed in battle, several soldiers wounded, and four Americans taken hostage. A medical relief party brought three Apache hostages, followed by 70 dragoon reinforcements whose officer assumed command of the disas-

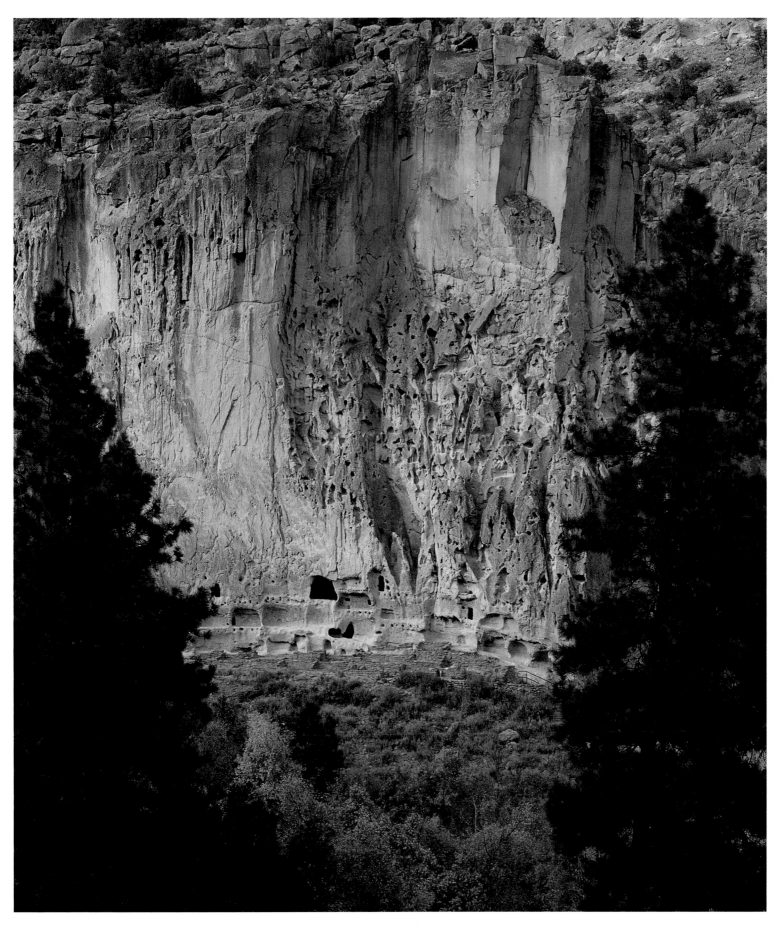

Long House Pueblo, New Mexico

trous operation. On February 18 the soldiers found the four American hostages so horribly mutilated that one of them, a well-known employee at the stage station, could only be identified by the gold fillings in his teeth. Although Bascom protested, two officers who out-ranked him decided to hang the six Apache male hostages, including Cochise's brother and nephews, leaving their corpses dangling in the desert sun.

The Bascom affair turned the once friendly Cochise into a cruel and single-minded enemy of the "white eyes," as the Apache called the Anglo-Americans. After retreating south of the border, he returned that spring to begin a war of revenge that would last a decade. According to one Arizona pioneer, Cochise and his warriors killed over 150 men, women, and children in 60 days. That July, in the midst of this rampage, the blue-coated soldiers at Forts Buchanan and Breckinridge, both deep in Apache territory, burned their forts and marched to the east, and it is hardly surprising that Cochise thought he had driven them away.

In fact, the Civil War had begun, and the blue-coats were marching east to fight other white eyes dressed in gray. That same month a wild-eyed, Indian-hating Texas colonel named John R. Baylor slipped into New Mexico with around 300 men and occupied the town of Mesilla, where a recent influx of Texas ranchers were already flying the Confederate flag. Just three miles north of town, over 550 federal troops were stationed at Fort Fillmore, but the men were so demoralized and the commanding officer was so inde-cisive that after a skirmish in Mesilla he abandoned the fort and marched north through the searing heat of the Jornada del Muerto—the same desert that almost killed the Oñate expedition three centuries earlier. Baylor's men easily captured the dehydrated troops, only to set them free because they did not have enough food to feed them. Union forces abandoned another fort in southern New Mexico, and on August 1, 1861, without suffering a single casualty in battle, Baylor declared all of southern New Mexico Territory, from the Texas border to the Colorado River, to be the Confederate Territory of Arizona, with Mesilla as its capital and himself as provisional governor.

Baylor's first daring thrust was followed by a larger invasion under Henry H. Sibley, a curly-whiskered, hard-drinking, West Point graduate who had resigned his U.S. Army commission in Taos and headed down the Rio Grande with Confederate defec-tors, leaning out of a wagon along the way to inform a group of startled soldiers: "Boys, if you only knew it, I am the worst enemy you have." Commissioned a brigadier general in the Confederate Army, Sibley gath-ered 3,500 men in San Antonio, envisioning a grand invasion that would take not only New Mexico but also the goldfields of Colorado and California. Beginning in October, he and his men moved on to Fort Bliss in El Paso, crossing the 630-mile stretch of dry West Texas plains and deserts in small groups to give the water holes time to replenish their precious sup-plies. After leaving a large force in El Paso and sending a smaller detachment to Tucson, the invading army of over 2,500 men and 15 pieces of artillery moved up the Rio Grande in February 1862, heading for Fort Craig, the only federal fort still occupied in Confederate Arizona. It was the same march that Union refugees from Fort Fillmore had made the previous summer, but now the searing desert heat had turned bitter cold and sleet fell "so hard as to almost peel the skin off your face," according to one Confederate soldier.

The commander of Fort Craig and all Union forces in New Mexico was Col. Edward R. S. Canby, a logical and dedicated officer who had been Sibley's classmate at West Point and best man at Sibley's wedding. Although he had a larger force of some 3,800 men, only a third of them were regular soldiers, and the others were a mixed bag of volunteers, including Spanish-speaking New Mexicans who were frus-trated by racism, language problems, and Canby's inability to pay them for their service. Kit Carson, who spoke Spanish, led the best trained group of these Hispano soldiers, but even they grumbled when their personal horses were worn out by long marches

and Canby could offer no new mounts or compensation. New Mexico had been taken by force just 16 years earlier, and loyalties did not run deep.

Deciding that the fort was too strong to attack, Sibley's army made a daring march around it, crossing the icy Rio Grande seven miles south of the fort and then struggling over a rugged, sandy volcanic shelf east of the river toward another ford called Valverde, about six miles north of the fort. As expected, the move forced Canby to come out and fight, and on February 20 a bloody battle raged along the eastern bank of the river. The South gained the advantage when 750 screaming Texans captured a six-gun battery of Union artillery. Canby's army retreated to the fort while Sibley's men—now desperate for food and supplies—marched north toward Albuquerque. Sibley was apparently drunk during the march around the fort and drunk again during the battle; he retired to an ambulance while his officers made the decisions. One soldier wrote, "The Commanding General was an old army officer whose love for liquor exceeded that for home, country, or God."

Sibley's army moved slowly, which gave federal troops in Albuquerque time to burn supplies and retreat to Santa Fe. Although the Confederates believed that the Hispano people would rally to their cause, they discovered that the New Mexicans hated Texas more than they hated the United States, and they received little civilian cooperation. The Texans did find some supplies at an outpost on the edge of Navajo country and captured a supply train heading for Fort Craig, which gave them enough food to last for 40 days. While Sibley stayed in Albuquerque, part of his force continued north to Santa Fe and occupied the city without a shot. Federal troops, along with the civilian government, had once again retreated, this time moving east across the Sangre de Cristo range to Fort Union, located north of Las Vegas on the Santa Fe Trail. This was the largest federal depot for ammunition and supplies in New Mexico, and the Texans planned to capture the fort and head north to take the booming goldfields of Colorado.

Fortunately for New Mexico and the Union cause, the meager troops at Fort Union were reinforced by 950 volunteers from Colorado, tough miners and frontiersmen who marched 400 miles through cold, rough country over snowbound mountain passes in just 13 days. The discipline and focus of these soldiers is even more amazing considering that they were led by an irrational, hot-tempered Denver lawyer named John P. Slough, who so antagonized the troops that his own men later tried to kill him in the heat of battle. The real leader of the Colorado Volunteers turned out to be a massive, bullhorn-voiced Methodist minister named John Chivington, who would become infamous for the Sand Creek Massacre.

Slough took charge of all forces at Fort Union, including his Colorado Volunteers, some New Mexico Volunteers who had fought at Valverde, and the regular federal troops. He began to march toward Santa Fe on March 22. Unaware of the reinforcements, Confederate major Charles Pyron went out to meet him with just 400 men, and on March 26 an advance party under Chivington skirmished with Pyron's troops in Apache Canyon, the strategic cleft in the mountains where Governor Armijo had gathered his forces to resist Kearny's army during the Mexican War. Although Chivington's men got the best of the fighting, they withdrew to await the rest of the federal troops while Pyron desperately called for reinforcements. Around 11 a.m. on March 28 the armies met in a rocky, pine-covered valley near Glorieta Pass, located east of Apache Canyon and west of the old pueblo of Pecos. Although his total force outnumbered the Texans, Slough had only about 850 men for the battle because he had sent Major Chivington with some 490 men in a sweep around the battlefield to attack the enemy from the rear.

For six hours the battle raged furiously, artillery booming while opposing troops drew so close at times that "the muzzles of their guns passed by each other over the top of the loosened rocks." With heavy losses on both sides, the Texans gradually pushed Slough's men back, but what looked like a slim Confederate vic-

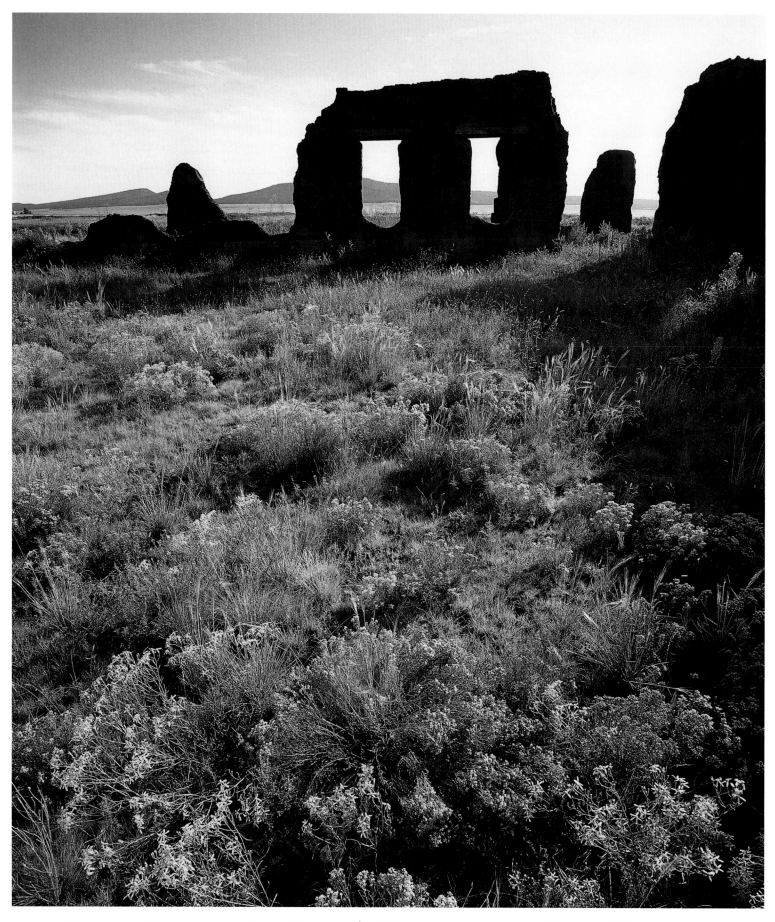

Fort Union National Monument, New Mexico

tory was in fact a devastating defeat. Guided by Col. Manuel Chaves of the New Mexico Volunteers, Chivington's men had made their way over a treacherous mountain path to Apache Canyon, where they discovered the lightly guarded Confederate supply train. Lowering themselves down the mountainside with ropes and leather straps, they overcame the guards and destroyed everything the Texans needed to continue their campaign, burning almost 80 wagons with food, clothing, tents, and medical supplies and bayoneting some 500 horses and mules.

With the destruction of their supply train, the Texans were forced to retreat from New Mexico; General Sibley met the army in Santa Fe and led them south along the Rio Grande. Canby left Fort Craig to skirmish and harass them along the way, but, though his troops wanted to finish the Texans off, he let Sibley continue southward, perhaps out of deference to their former friendship or because he did not have enough food to feed a large number of prisoners. The retreat degenerated into a death march, with Sibley hurrying ahead of his men, leaving them to straggle behind suffering from hunger, thirst, and exposure. Of 3,500 soldiers who had left San Antonio to conquer the Southwest, only 2,500 made it back by the end of the summer. The Battle of Glorieta Pass is often called the Gettysburg of the West for the pivotal role it played in the war, and it was the Colorado Volunteers who provided the most effective fighting force. As one defeated rebel wrote, "Had it not been for the devils from Pike's Peak, this country would have been ours."

In April 1862, as Sibley's shattered army retreated down the Rio Grande, a well-trained force of 2,350 men under Col. James H. Carleton was moving out of Fort Yuma, built on the California side of the Colorado River at the same site where Yuma Indians had rebelled against the Spaniards in 1781. Carleton was a Regular Army officer who had served in the Mexican War and on the New Mexico frontier before transferring to the Department of the Pacific, where he organized the California Volunteers and gave them the serious training volunteers seldom received. A ramrod-straight, steely-eyed native of Maine, Carleton demanded absolute discipline, but he also took care of his men, a combination which instilled a fearful respect in those who served under him.

Delayed by heavy rains in California, the volunteers arrived too late to participate in the battles along the Rio Grande, but advance parties skirmished with Confederates north and west of Tucson. By the time Carleton arrived in Tucson on June 7, the Confederates had retreated, and he reestablished federal authority over what he called the "Territory of Arizona," although Congress did not actually create a separate Arizona Territory until the following year. Farther east the rear guard of Sibley's troops lingered in the Mesilla Valley for another month, but they too were forced to retreat by the oncoming California column, which ended the Confederate occupation of New Mexico.

In mid-June three couriers sent out by Carleton to inform Colonel Canby of his arrival were ambushed by Cochise's warriors near Apache Pass. The Apache killed two of them and chased the other 40 miles before he escaped, only to be captured by Sibley's retreating army. A week later three troopers who wandered away from a cavalry detachment at the spring were found scalped, lanced, and stripped of their clothing. Finally, in mid-July, a wagon train escorted by infantry, cavalry, and two mountain howitzers approached the pass on a mission to establish a supply base for the main army to follow. By this time Mangas Coloradas had come to aid Cochise, and the combined bands battled the soldiers for two days from behind rock breastworks constructed on the hills on both sides of the spring, keeping up a rattling fire to prevent the intruders from reaching the life-giving waters. It was the first time the Apache had faced artillery, and the pounding of the howitzers ultimately forced them to retreat. "We would have done well enough," one warrior later said, "if you had not fired wagons at us."

To protect the essential water for military and

civilian travel, Carleton left a detachment of a hundred men to build Fort Bowie on a hill above the spring. The Apache were bent but not broken, and serving at Fort Bowie would be one of the most frightening and lonely assignments on the American frontier. In the meantime Carleton's main army moved on to the Rio Grande, where he took over the Department of New Mexico from Canby, who was transferred to the East. Both Carleton and Canby received promotions to brigadier general in an expanding Civil War army desperate for solid leadership; but with no Confederates to fight, General Carleton used his broad wartime powers to attack the Indian tribes whose raids on New Mexican settlements had become even bolder and more destructive during the time the whites were fighting each other.

Carleton began with the Mescalero Apache who lived in the mountains of southeastern New Mexico between the Rio Grande and the Pecos River. Numbering about 800 people, the Mescalero had been receiving rations at Fort Stanton on the Rio Bonito until the

This cannonball was found at Glorieta Pass, where Confederate victory turned to defeat when Chivington's men destroyed the supply train in Apache Canyon.

Confederate invasion forced Union soldiers to abandon the fort, which in turn forced the Mescalero to raid frontier settlements for food. To carry out his campaign, Carleton chose Kit Carson, who had served under him for a time before the war. The two men shared a mutual admiration, but Carson—who understood Indian lifeways and had personal friendships with some Mescalero—knew that their raiding was a product of desperation and hunger. He argued for the kind of diplomatic approach that had often been tried in the past. Carleton, who respected Indians as warriors but did not think much of them as people, believed that talking and treaty making were useless until the entire tribe had been beaten into submission. It was Carleton who gave the orders.

In late October 1862 a cavalry detachment out of Fort Stanton, which Carson had reoccupied for the campaign, met a group of Mescalero led by two chiefs. Although they made signs to talk peace, the officer in charge ordered his men to open fire, killing the chiefs, four warriors, and a woman. Pursuing the fleeing Indians, the soldiers killed five more warriors, wounded others, and captured 17 horses and mules. The attack disgusted Carson and disturbed Carleton, who worried that it was not "fair and open," but the point had been made. The next month a detachment of California Volunteers thoroughly beat a hundred Mescalero warriors at Dog Canyon in the Sacramento Mountains, and their leaders came in to Fort Stanton to ask for peace. Carson sent them on to Santa Fe, where their spokesman, Always Ready, admitted to General Carleton that "we are worn out; we have no more heart; we have no provisions, no means to live. . .Do with us as may seem good to you, but do not forget that we are men and braves."

What seemed good to Carleton was that the Mescalero should leave their homes and live at a place he had chosen on the Pecos River called Bosque Redondo, for a circular grove of cottonwood trees. The bosque itself was an oasis, but the area around it was a dry, windswept alkaline plain ill suited for agriculture—and still sparsely populated today. Carleton was convinced that only through removal from their homelands and close supervision in what was essentially a concentration camp could the Indians be turned into Christian farmers. Although the course of events proved him wrong, Carleton was considered a humanitarian in his time. By comparison Confederate colonel John Baylor believed that all Indians in New Mexico should be exterminated. His more kindly superior, General Sibley, sug-

Glorieta Mesa, New Mexico

gested they should all be sold into slavery.

By March 1863 some 400 Mescalero had moved to Bosque Redondo, where they were guarded and supposedly protected by soldiers garrisoned at a new outpost called Fort Sumner. About 300 had been killed in the fighting, and perhaps a hundred were still at large, joining other Apache bands, fleeing to Mexico, or hiding in the mountains. Eminently pleased by the first phase of his campaign, Carleton decided to "send the whole of Colonel Carson's regiment against the Navajoes." Carson, who was 53 years old with a beloved wife and several young children in Taos, asked Carleton to accept his resignation, but the general refused, convincing the patriotic and adventurous frontiersman that he was the only man for the job.

While Carson mopped up the Mescalero campaign and prepared for the Navajo, another Carleton subordinate, Gen. Joseph West, waged total war against the people of Mangas Coloradas, who were blamed for a series of attacks that had driven away gold miners at Pinos Altos on the pine-strewn slopes of the Continental Divide. West's campaign got off to a fortuitous beginning when a group of miners captured Mangas himself under a flag of truce and turned him over to the soldiers. West allegedly told his men: "I want him dead or alive tomorrow morning, do you understand, I want him dead." That night, while Mangas slept, the guards prodded the old chief's legs and feet with hot bayonets; when he rose to complain, they killed him with several shots, later claiming he had tried to escape. A soldier scalped him in the morning, and the post surgeon cut off his head and sent it to the East, where a phrenologist proclaimed that the giant Indian had a larger cranial capacity than Daniel Webster. West's forces killed many of Mangas's followers, and the Pinos Altos mines were declared safe by May 1863.

In early July, Carson left Los Lunas, just south of Albuquerque, with 221 men—the advance guard of a force that would number over a thousand—and headed west into Navajo country. At the site of old Fort Defiance he established a new base called Fort Canby, in honor of his former commander, and began to look for Navajo aided by Ute scouts who hoped to enrich themselves with captives. Carson, a staunch Unionist and antislavery man, wanted the Ute to keep their captives because it was customary and would save the expense of feeding them, but Carleton was adamant that all captives go to Bosque Redondo. Unlike the relatively small Mescalero tribe, the Navajo numbered some 12,000 people spread over a vast, rugged, and mostly unknown territory. In a series of scouts that lasted into the winter, Carson's soldiers and their Ute allies found few Navajo to kill or capture; instead they destroyed or captured everything the people needed to live: hogans, sheep, goats, horses, mules, wheat, fruit trees, saddles, and blankets. Carson estimated that he destroyed two million pounds of grain alone.

The final blow came in January 1864, when Carson and 389 New Mexico Volunteers patrolled the rim of Canyon de Chelly while a detachment of 34 men marched through the heart of a side canyon, the precipitous Canyon del Muerto. With the bluecoats in their stronghold, the freezing, starving Navajo began to surrender en masse, 3,000 in the first three weeks. By March 1865 over 9,000 of the once proud lords of New Mexico had made the demoralizing 300-mile long walk to Bosque Redondo. Many died along the way, and though Army records dispute this, Navajo oral tradition remembers that "People were shot down on the spot if they complained about being tired or sick, or if they stopped to help someone. If a woman became in labor with a baby, she was killed. There was absolutely no mercy." There was no mercy at Bosque Redondo either, where Carleton was already having trouble feeding the 400 Mescalero, let alone 9,000 Navajo who were traditional enemies of the Apache. The water was unsuitable for drinking, the soil unsuitable for farming, and timber had to be hauled from a hundred miles away. Disease and starvation were rampant, and in late 1865 the Mescalero escaped and returned to their mountain homeland,

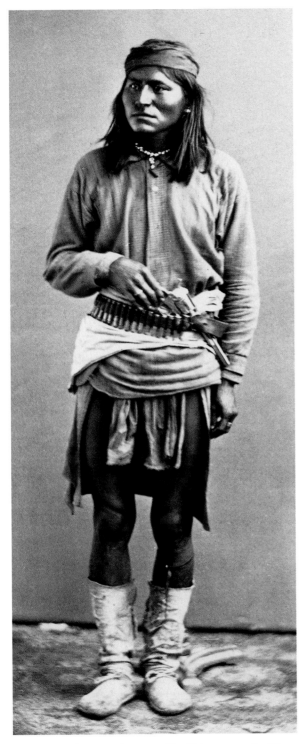

The Mescalero were devastated by U.S. troops under Kit Carson, but after fleeing from Bosque Redondo they managed to obtain a reservation in their traditional homeland—a better situation than most Apache tribes.

where they were later given their own reservation.

Despite the obvious failure of his Bosque Redondo experiment, Carleton stubbornly refused to allow the Navajo to leave. He was relieved of his command in 1867, and the following year Gen. William Tecumseh Sherman—who could hardly be accused of being softhearted—was shocked by the conditions he found during a peacemaking swing through the West: "I found the Bosque a mere spot of green grass in the midst of a wild desert, and that the Navajos had sunk into a condition of absolute poverty and despair." Sherman agreed to send the Navajo back to their own country, "but not to the whole of it, only a portion which must be well-defined." Even a well-defined portion sounded good as long as they could return to their sacred Dinetah, or homeland. "After we get back to our country," said Navajo spokesman Barboncito, "it will brighten up again and the Navajos will be as happy as the land, black clouds will rise and there will be plenty of rain. Corn will grow in abundance and everything look happy."

In mid-June the Navajo began a more joyful long walk back to the red rock canyons and pine-covered mesas of the Four Corners region. It would be an exaggeration to say that everything always looked happy in the years that followed, but the Navajo kept the peace treaty they signed with General Sherman, never again rising in arms against the United States. And the ordeal of the long walk forged the once disparate Navajo people into a true Navajo nation that still controls much of its beloved Dinetah.

While the Navajo settled in peace, Cochise continued his relentless war against the white eyes in Arizona. One rancher claimed that between 1868 and 1871 "Cochise's band killed no less than thirty-four of my friends and acquaintances within a radius of fifty miles." The fighting took a toll on the Apache as well, who were pursued by soldiers and harassed by scalp-hunting parties from both sides of the border. In 1869 Cochise met American soldiers face-to-face for the first time since the Bascom incident and admitted

The first non-Indian to penetrate the depths of the Grand Canyon was the Spanish friar, Francisco Garcés, who in 1776 was guided by Havasupai Indians to their isolated village of Supai and then to the river they call Hakatai, the Backbone. "I am astonished at the roughness of this country," Garcés wrote, "and at the barrier which nature has fixed therein." For almost two centuries no other white man penetrated the Grand Canyon, and the entire Colorado canyon country remained terra incognita from the upper Green River to the junction of the Colorado and Virgin.

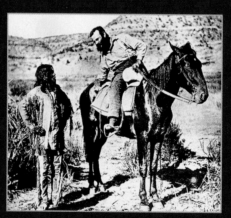

John Wesley Powell lost his lower right arm at the Battle of Shiloh but it did not stop him from pursuing his dream of exploring the rugged Southwest and learning about indigenous peoples. Here Powell confers with a Paiute Indian.

In 1869, self-taught naturalist and geologist John Wesley Powell set off with nine men to fill in the blank space on the maps. They began on May 24 in Green River, Wyoming and floated down the Green with four boats, losing one boat to the wild river early on and a man who abandoned the expedition "saying that he has seen danger enough." On August 13, their 81st day on the river, the expedition entered the Grand Canyon. "We are now ready to start on our way down the Great Unknown," Powell wrote. ". . . We are three-quarters of a mile in the depths of the earth, and the great river shrinks into insignificance, as it dashes its angry waves against the walls and cliffs. . . . they are but puny ripples, and we but pigmies, running up and down the sands, or lost among the boulders."

In the days that followed, Powell and his men were pounded by the angry waves, tossed through treacherous rapids amid sheer granite walls. Finally, they reached rapids that appeared so dangerous that three men abandoned the expedition. Even Powell questioned the wisdom of going on, but his dreams won out. "To leave the exploration unfinished, to say that there is a part of the canyon which I cannot explore. . .is more than I am willing to acknowledge." In a sad irony, the men who abandoned the expedition were killed by Indians while Powell and those who stuck with him shot the rapids and emerged from the canyon on August 29. The next day at the junction of the Colorado and the Virgin they met three Mormon settlers and an Indian dragging the river in search of their remains.

frankly, "I lost nearly one hundred of my people in the last year, principally from sickness. The Americans killed a good many. I have not one hundred Indians now. Ten years ago I had one thousand. The Americans are everywhere, and we must live in bad places to shun them."

The Americans were not quite everywhere in Arizona, but miners, ranchers, and cattlemen were moving into the territory, and along with the Spanish-speaking people who already lived there, they tackled the "Apache menace" without worrying about the distinction between hostile and peaceful Indians. In 1871 the citizens of Tucson formed a militia composed of 6 Anglos, 48 Hispanics, and 94 Papago (or Desert Pima) Indians—traditional enemies of the Apache—under the banner of the Tucson Committee of Public Safety. On April 30 they attacked a band of peaceful Western Apache at Camp Grant to the north of Tucson, where the Apache had asked for American military protection. When the slaughter was over, about a hundred Apache were dead, almost all women and children. President Grant, for whom the outpost was named, called the attack "purely murder," yet a Tucson jury acquitted the perpetrators in 19 minutes.

By this time there was a concerted effort throughout the West to place the Indians on reservations where they would be fed and clothed at government expense until they could support themselves as farmers. This so-called Peace Policy of President Grant was little more than a kinder, gentler version of Carleton's experiment at Bosque Redondo, but most Apache leaders were willing to listen if the whites spoke good words, and as with the Navajo, the words were better if they promised a reservation in their homeland. In 1872 a pious one-armed general named Oliver Howard arrived at Cochise's camp in the rugged Dragoon Mountains with a single military aide, a white trader who had befriended Cochise, and two Apache guides. Impressed by the general's bravery and integrity, Cochise agreed to accept a reservation that would include the Dragoons, the Chiricahuas, and

Apache Pass, thus ending a reign of terror that had lasted for over a decade. Cochise kept the peace, but his death in 1874, followed two years later by the death of his eldest son, Taza, during a trip to Washington, D.C., left his people with uncertain leadership—a void that was gradually filled by a scowling, ill-tempered yet resolute warrior named Geronimo.

Although well-meaning agents and emissaries like General Howard promised various Apache bands reservations in their traditional homelands, the continuing pressure from white settlers along with raids by still hostile warriors led to a new U.S. policy to concentrate all Apache on a large reservation at San Carlos, a forbidding tract of low desert about 110 miles east of Phoenix. The Chiricahua were removed in 1876, but out of some thousand people, only 42 men and 280 women and children actually made the trek. Many others, led by Geronimo and Juh, chief of the Nednhi Apache who lived in the Sierra Madre, fled into Mexico, the first of several daring escapes that Geronimo would make over the next decade. The remnants of Mangas Coloradas's people, led by the old peace chief Loco and the inspired young war chief Victorio, also came to San Carlos, and they hated it as much as the Chiricahua hated it. One Apache later called San Carlos "the worst place in all the great territory stolen from the Apaches. . . . Where there is no grass there is no game. Nearly all of the vegetation was cacti. . .food was lacking. The heat was terrible. The insects were terrible. . .What there was in the sluggish river was brackish and warm." The warm, brackish water bred malaria, and the Indians died in droves. "It is because of the sickness that we must be put there—" said another Apache, "they wanted us to die."

Victorio broke out of San Carlos with 310 people in September 1877 and returned to his homeland around Ojo Caliente in the mountains of western New Mexico, where he surrendered to American authorities, explaining that he wished to live in peace in his own land. For a year they were left alone, "happier than they ever have been," but in late 1878 most of

Pecos River, New Mexico

his band was forced back to San Carlos while Victorio and 90 warriors ran for freedom. In August 1879 Victorio returned to Ojo Caliente with fewer than 40 men, killing eight soldiers and stealing a herd of horses and mules before setting off on a 14-month rampage that left a trail of death and destruction across New Mexico, Texas, and Chihuahua. Chased by some 4,000 Mexican and American troops, Victorio never had more than 110 warriors and usually had less, while traveling with hundreds of women and children. Yet again and again he eluded his pursuers and defeated them in battle before finally reaching the end of the line in mid-October 1880 at Tres Castillos, a desert oasis in Chihuahua where Mexican troops killed Victorio and 77 others while taking 68 prisoners—a bounty of scalps and captives for which the commanding officer was allegedly paid the equivalent of $27,450. One American officer estimated that Victorio's rampage left over a thousand dead Mexicans and Americans, probably an exaggeration yet a fair barometer of the Apache threat that still cast its shadow over the Southwestern frontier.

IN 1866 TEXAS CATTLEMEN Charles Goodnight and Oliver Loving drove their longhorns across the Llano Estacado and up the Pecos River to Fort Sumner, New Mexico, where they sold part of the herd to government contractors who were scrambling to feed the starving Navajo at Bosque Redondo. Goodnight and Loving were the first cattlemen to understand the economic implications of the forts and reservations in the West, and the Goodnight-Loving Trail, which extended north into Colorado, became a well-traveled conduit of food on the hoof. Loving died after an Indian attack on their third trip up the trail, but Goodnight continued to drive longhorns into New Mexico with another cattleman named John Chisum, who liked what he saw in the broad grasslands along the lower Pecos and decided to stay in the area. By 1873 Chisum had a ranch that extended 150 miles along the river, all in the public domain; two years later he had 80,000

head of cattle run by a hundred cowboys.

Chisum shipped beeves to the north and east, but he also supplied beef to the Mescalero Reservation and Fort Stanton in the towering, pine-covered mountains west of his ranch. Except for Chisum, who contracted directly with the government, almost all food for the reservation and fort was supplied by a former Army major named Lawrence Murphy, first working out of the fort itself and later establishing a large store in the town of Lincoln, nine miles down the Rio Bonito. Murphy ran no cattle of his own, so he contracted with smaller ranchers who often built their herds at Chisum's expense, selling the stolen cattle at cut-rate prices. Murphy also contracted with farmers for grain and other staples; when his suppliers delivered, he made a nice profit, and when they did not, he either took their lands or held them in a continuous state of debt. Murphy's two-story store became known as The House, and just about everyone in Lincoln County—with the exception of John Chisum and his friends—was in debt to The House.

In early 1877 John Tunstall, a tall, sandy-haired young Englishmen from a well-to-do family, decided he wanted to get in on the action. That April he wrote to his family that he planned "to get the half of every dollar that is made in the county by anyone." In partnership with Alexander McSween, a Scottish lawyer who had previously served both The House and Chisum, Tunstall established a ranch about 30 miles south of Lincoln and a competing store in the town, complete with a bank that had few assets except John Chisum's name as president. By this time Lawrence Murphy had sold The House to his associates James Dolan and John Riley, who obtained financial backing from the most powerful man in the territory, Thomas B. Catron, U.S. Attorney for New Mexico and reputed head of a corrupt political machine called the Santa Fe Ring. Murphy, Dolan, and Riley were all Irishmen, as was Murphy's good friend, County Sheriff William Brady, and this cabal—with Catron's money on the line—had no intention of letting the English and Scottish interlopers take over their monopoly.

In order to protect his investment, Catron hatched a complex legal plan in which Dolan had McSween arrested for embezzlement and his assets attached in a civil suit over an insurance policy. When Dolan and Brady also tried to take Tunstall's assets as McSween's partner, tensions quickly escalated, and Tunstall raised a small army of ranch hands who were better with a gun than a branding iron, including a teenage drifter called Billy Bonney. On the cold late afternoon of February 18, 1878, Tunstall, Billy, and three

WILLIAM H. BONNEY

WRITTEN TO GOVERNOR LEW WALLACE FROM THE SANTA FE JAIL
MARCH 4, 1881

Santa Fe
In Jail
March 4, 1881
Gov. Lew Wallace

Dear Sir

I wrote You a little note the day before yesterday but have received no answer. I Expect you have forgotten what you promised me, this Month two Years ago, but I have not, and I think You had ought to have come and seen me as I requested you to. I have done everything that I promised you I would, and You have done nothing that You promised me.

I think that when You think The matter over, You will come down and See me, and I can then Explain Everything to you.

Judge Leonard, Passed through here on his way East, and promised to come and See me on his way back, but he did not fulfil his Promise. it looks to me like I am getting left in the Cold. I am not treated right by [Marshal] Sherman, he lets Every Stranger that comes to See me through Curiosity in to see me, but will not let a Single one of my friends in, not Even an Attorney.

I guess they mean to Send me up without giving me any Show but they will have a nice time doing it. I am not intirely without friends.

I shall expect to see you some time today.

Patiently waiting
I am Very truly Yours, Respt.
Wm. H. Bonney

other men were riding into Lincoln when Tunstall was ambushed and killed by a sheriff's posse who claimed he resisted arrest; the autopsy showed "that a rifle or carbine bullet had entered his breast and a pistol bullet entered the back of his head coming out of the forehead."

Unlike Tunstall, McSween eschewed violence and refused to carry a gun, but he now found himself at the head of a citizen's militia called the Regulators. About half Anglo and half Hispanic, they included solid citizens who hated The House, along with paid gunslingers like Billy Bonney. While Dolan and Sheriff Brady continued to claim legal authority based on the previous warrants, McSween obtained a warrant for the arrest of the posse that had killed Tunstall, and in early March a party of 11 Regulators, led by Tunstall foreman Dick Brewer, captured two posse members and picked up a third man of questionable loyalties along the way. All three men were found dead with exactly 11 bullets in their bodies, one for each Regulator. On April 1 Billy and five others killed Sheriff Brady and a deputy while they were walking down the single street of Lincoln. Three days later Brewer and a member of the sheriff's posse named Buckshot Roberts were killed during a shootout on the Mescalero Reservation.

The House collapsed in bankruptcy later that month, but the Regulators and the Dolan men kept

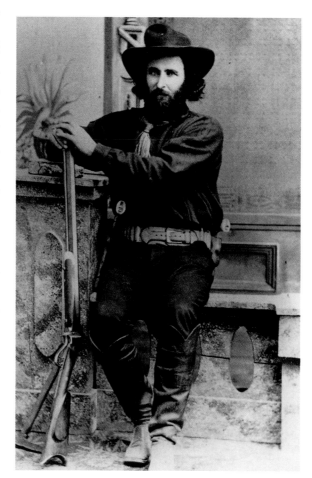

Described as "about the queerest specimen of humanity ever seen," Ed Schieffelin was a prospector's prospector who sold his Tombstone claims soon after "civilization" arrived and headed for the Yukon in 1882, 15 years before the Klondike gold rush.

fighting in the courts, the town, and the countryside. On the night of July 14 Alexander McSween and 60 Regulators rode into Lincoln and took up defensive positions in several buildings, including McSween's house. The following afternoon a sheriff's posse of about 40 men arrived and took up their own positions. For four days the opposing sides fired hundreds of long-range shots, killing one man and seriously wounding another while terrorizing the non-combatants of the town. On the morning of July 19, 40 soldiers led by Col. Nathan Dudley arrived from Fort Stanton with a howitzer and a Gatling gun. Although claiming neutrality, Dudley ordered the howitzer pointed at two of the Regulators' strongholds, forcing the men to run for the hills and leaving the last group alone in McSween's house. That afternoon the soldiers simply watched as the posse set the McSween's adobe house on fire. It burned slowly, but by 9 p.m. the flames drove the men outside, and in a flurry of half-blind gunfire McSween and three of his men were killed, along with one of the posse men.

Violence continued to plague Lincoln County even after the Five-Day Battle. The worst of it came from a band of hardened Texas desperadoes who arrived around the time of the battle and co-opted the tougher members of the sheriff's posse into a brutal gang called the Wrestlers, who fought for nothing but

Implicated in the robbery of a store where three men and one woman were killed, John Heath meets frontier justice— without benefit of a trial—at the end of a rope in 1884 Tombstone, Arizona.

plunder and good times, killing men indiscriminately, raping their wives and daughters. In October President Rutherford B. Hayes declared Lincoln County to be in a state of insurrection, which legally allowed new governor Lew Wallace to use federal troops. Wallace dragged his feet, but he finally visited Lincoln in March 1879, and after getting rid of Colonel Dudley he sent the soldiers after the outlaws. He also made a pact with Billy Bonney, promising him pardon or immunity for the murders of Sheriff Brady and Buckshot Roberts in return for his testimony in another murder. Billy kept his side of the bargain, but as he drifted onto the outlaw trail, Wallace found him expendable. Of over 50 men indicted for crimes during the Lincoln County War, only Billy and Colonel Dudley stood trial, and only Billy was convicted.

In the spring of 1877, as John Tunstall made his move to "get the half of any dollar" in Lincoln County, a lanky, scraggly-haired prospector named Ed Schieffelin began poking around in the desert mountains of southeastern Arizona, which were still under the constant threat of raids by Chiricahua Apache. As Schieffelin later told the story, the soldiers at Camp Huachuca warned him: "You'll find your Tombstone if you don't stop running through this country all alone as you are while the Indians are so bad." That August, after finding promising silver ore, Schieffelin filed two claims in Tucson under the names Tombstone and Graveyard, but he was too broke to work the claims, and he could not get the Tucson money men to back him. "They would neither look at me or the ore," he wrote, "and said that they didn't want any mines. Government contracts and Posts were good enough for them and that a man was foolish to be spending his time looking for imaginary fortunes."

After returning to Camp Huachuca and paying to have his mule shod, Schieffelin was down to his last 30 cents, so he headed north to the already established mining district of Globe, where he worked for three dollars a night turning a windlass and enlisted his brother, Al, and mining engineer Richard Gird to

join his search for a fortune. In February 1878 Schieffelin found a rich silver vein in the Tombstone area that assayed at an incredible $15,000 a ton, which prompted Gird to exclaim, "Ed, you lucky cuss—you have hit it." The Lucky Cuss Mine was a small vein, but Ed found a deeper lode in the Tough Nut Mine, while another prospector discovered the Grand Central and sliced off a share for the Schieffelin party called the Contention, which yielded five million dollars in the first five years. Schieffelin and his partners sold that one for a paltry $10,000, but before moving on to new diggings, the ever restless Ed Schieffelin netted $300,000 for all his claims—a millionfold improvement on his 30 cents.

As miners swarmed over the region, the town of Tombstone appeared as if by magic in the once desolate shadow of Cochise's beloved Dragoon Mountains. By late 1879 there were about a thousand residents, and a year later there may have been as many as 7,000, the largest town in the territory. "All roads led to Tombstone," wrote John Pleasant Gray who arrived on a crowded stagecoach in July 1880.

Like all boomtowns, Tombstone drew men "of restless blood," as Wyatt Earp described himself, saying he left once-booming Dodge City because it "was beginning to lose much of its snap." The Earps reached Tombstone in December 1879, just as the town was picking up speed. There were three brothers at first: James, Virgil, and Wyatt, each with their common-law wives. Another brother, Morgan, and his female companion joined them in July, followed by Wyatt's good friend Doc Holliday and his paramour, Big-Nose Kate. The Earps filed mining claims and speculated in real estate while James tended bar, Wyatt gambled and rode shotgun for Wells Fargo, and Virgil took to "lawing," first as a deputy U.S. marshal and later as town marshal of Tombstone. They were much like other men looking for "snap" in Tombstone, but they had a clannish, aggressive attitude that made enemies in a wide-open frontier world. Within a year they found themselves embroiled in a growing feud with another clannish family and their friends, who were collectively known as the cowboys.

The feud exploded on the cool, windy afternoon of October 26, 1881, when Virgil, Wyatt, Morgan, and Doc confronted Ike and Billy Clanton and Frank and Tom McLaury in a vacant lot next to Camillus Fly's boardinghouse, beyond the back entrance of the O.K. Corral. By this time Virgil was town marshal, and he had supposedly deputized the others to help him disarm the Clantons and McLaurys. The shooting lasted less than 30 seconds. When it was over, Billy Clanton and the McLaurys lay dying, Virgil and Morgan were badly wounded, Doc had a flesh wound, and Wyatt was untouched. Ike Clanton, who was unarmed to begin with, escaped when the shooting began. The next day the pro-Earp *Tombstone Epitaph* claimed, "The feeling among the best class of our citizens is that the Marshal was entirely justifiable in his efforts to disarm these men, and that being fired upon they had to defend themselves, which they did most bravely." Another point of view was expressed by a large sign in the window of the undertaking parlor where the bodies were displayed: "MURDERED ON THE STREETS OF TOMBSTONE."

Like the killing of John Tunstall, the Tombstone shoot-out set off a bloody chain of revenge that left Virgil crippled, Morgan dead, and assorted cowboy corpses scattered across the countryside. While the Earp-Clanton feud was more personal than the Lincoln County War, it did represent two larger forces that conflicted throughout the West. The Earps were newcomers, Northerners, and Republicans who lived in town and used their sideline as lawmen to create an orderly climate that favored their own business interests. The cowboys were southern Democrats, some of whom had lived on Arizona ranches long before Tombstone existed, who preferred a looser legal hand that favored their interests, which included rustling cattle and having some fun in town. As was true in Lincoln, both sides in the Earp-Clanton drama had no real values except their own self-interest and an ingrained western code that demanded violent and immediate redress of any wrong, real or perceived.

Sacramento Mountains, New Mexico

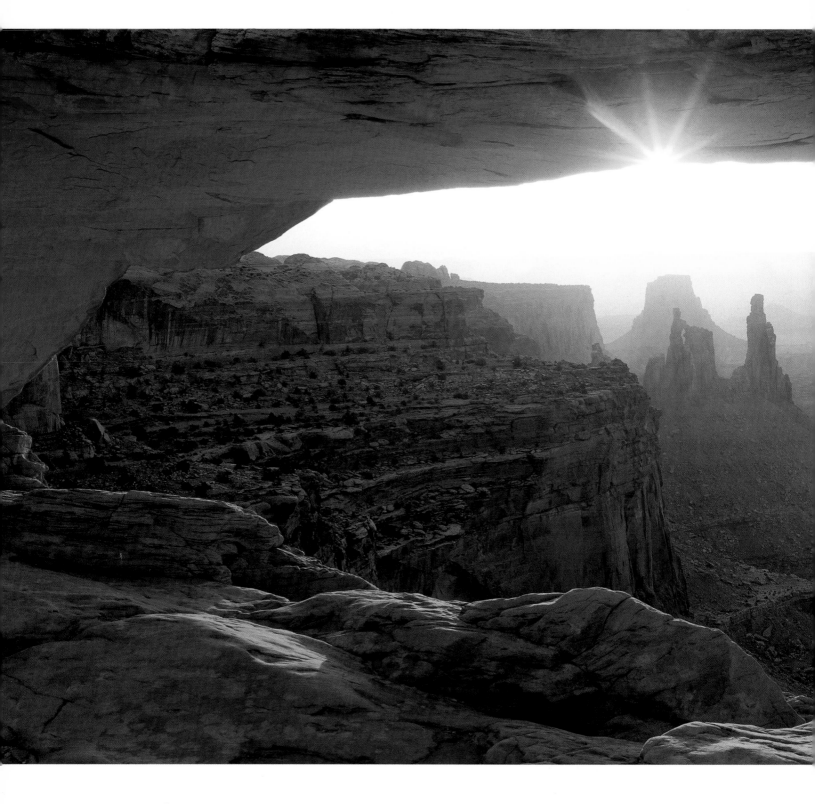

LARCENY, LAND, & WATER

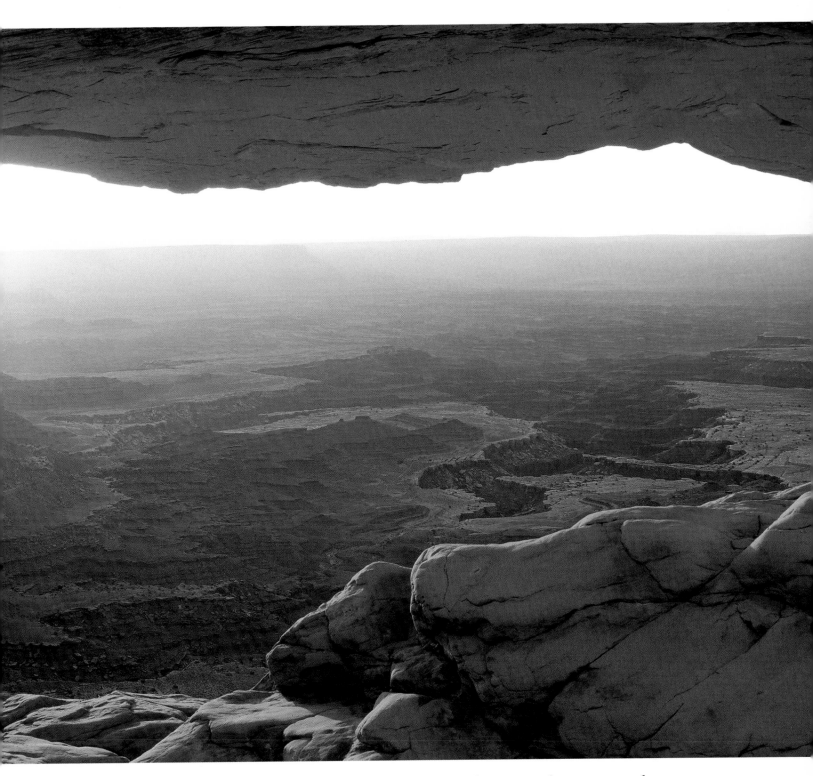

Canyonlands National Park, Utah

Water and Sandstone, Zion National Park, Utah

1 8 7 7 - 1 9 1 3

LARCENY, LAND, & WATER

In the spring of 1882 Roy Bean headed west from San Antonio with a mule-powered wagon carrying a big canvas tent, a barrel of whiskey, and a good supply of bottled beer. The money men were building a railroad in the rough, dry country west of the Pecos, and Bean figured the railroad workers might need a little refreshment. As it turned out, they also needed a little "lawing," and Bean provided that as well.

Bean first set up shop in a tough camp called Vinegaroon, located near the junction of the Pecos and Rio Grande. A few months later he moved some 20 miles west to another camp called Eagle's Pass and sent an official announcement to a San Antonio paper that he had opened a new saloon "where can be found the best wines, liquors, and cigars." The announcement was dated July 25, the same day a group of Texas Rangers brought a man charged with aggravated assault to Bean and asked him to act as a judge. He must have done a good job because he received an official appointment as justice of the peace a week later and soon moved back with the rangers to Vinegaroon, a veritable cesspool of mayhem and murder. With a combination of common sense, bluster, and crude humor, Judge Roy Bean helped tame the wild railroad tent town.

After the line was completed in January 1883,

Bean decided to stay in a new town called Langtry that developed as a refueling stop near the old site of Eagle's Nest. Although Bean claimed he named the town after the fantasy love of his life, beautiful English actress Lillie Langtry, it was actually named after a railroad engineer. That kind of fact never got in the way of a good Roy Bean story and Bean told lots of stories in Langtry over the next two decades, dispensing law, liquor, and humor until his death in 1903. He was a big man in a small town, a legend in his time, prosperous and responsible enough to bring his children west to join him, important enough to stage the World's Heavyweight Championship on an island in the Rio Grande at a time when boxing was outlawed in the United States. Bean married lovers as justice of the peace and divorced them, though he had no legal power to do so, because he "aimed to rectify his errors." He

also served as coroner and did some interesting things with corpses, leaving one outside his saloon to draw business and fining another $40 for carrying a concealed weapon, exactly the amount he found on the body. Bean kept it, too, as he kept most fines he collected, claiming simply, "My court is self-sustaining."

By the 1890s Langtry was a favorite stop for tourists traveling on the railroad, and Bean was always ready to meet them in front of his Jersey Lilly saloon, keeping change from a five-dollar bill for a 35-cent ice-cold beer that was as warm as the Texas sun. Sometimes the tourists got their feathers ruffled, but the smarter ones accepted a little larceny as the price of admission.

FOR ALL HIS FRONTIER CHARM, Judge Roy Bean was a bit player in a production where the stars exercised a level of larceny that would have made old Roy dizzy and envious at the same time. More often than not, railroad building in the West was about making huge fortunes at public expense rather than serving real needs for transportation. Land grants to western railroads in the 1860s alone totaled some 155 million acres, or about one-twelfth of what would become the 48 contiguous states. On top of this, railroad promoters received millions of dollars in federal subsidies and bonds, all granted by corrupt officials in return for railroad stock, kickbacks, and outright bribes. The lid came off this collusion with the Credit Mobilier scandal of 1873, in which Vice President Schuyler Colfax and a slew of congressmen, including future President James Garfield, were exposed for taking bribes from the Union Pacific. That same year a financial panic slowed the pace of railroad building, but as the economy rebounded, the railroad tycoons once again raced to enrich themselves at the expense of the American people.

In the Southwest the race involved four different lines approaching from different directions. The Southern Pacific (SP), formed by the Big Four cabal who had built the western half of the original transcontinental railroad, gained such a stranglehold over California that the people called it the Octopus. Its federal charter

only allowed it to build to the California line, and it first headed toward the present site of Needles, planning to parry a thrust from the east by a company called the Atlantic & Pacific. However, when the powerful Texas & Pacific led by supreme lobbyist Thomas A. Scott received a federal charter to build along a more southerly route from Texas all the way to San Diego, the Southern Pacific built farther south toward Fort Yuma, which crews reached in the spring of 1877.

Now things got interesting. Fort Yuma was an Indian reservation, and only the federal government could grant a charter to build on the reservation. The Southern Pacific made a leap of faith over the reservation and received territorial charters from Arizona and New Mexico to build what was supposedly a separate line. It then shipped a prefabricated steel bridge around the Baja peninsula and up the Gulf of California to span the Colorado River at Yuma. When the federal government offered only tepid and temporary approval, it built across the reservation anyway, ignoring the protests of the Fort Yuma commander, whose garrison was off fighting Indians in Idaho. Finally, in the middle of the night on Saturday, October 6, 1877, Southern Pacific crews laid tracks across the Colorado River bridge, and the following morning a train decked out in American flags rolled into the Arizona town. "THE IRON HORSE HAS SNORTED IN THE EAR OF NATIONAL AUTHORITY," proclaimed the San Francisco *Alta California.* "Now what are you going to do about it, Uncle Samuel?"

Uncle Samuel did nothing but accept the fait accompli. The Southern Pacific's Collis P. Huntington, who could match Tom Scott when it came to bribery and lobbying, met with President Rutherford B. Hayes, whom Scott had helped put in the White House through a complex deal in which Scott promised to build a transcontinental railroad from the South, Hayes promised to withdraw federal troops and end Reconstruction, and southern Democrats gave the Republican Hayes the disputed electoral votes he needed. Now Huntington convinced the President that, despite his debt to Tom Scott, the

Southern Pacific should build through the rough desert land along the border. As Huntington recalled the meeting:

He was a little cross at first; said we had defied the Government, etc., but I soon got him out of the idea.... He then said, "What do you propose to do if we let you run over the bridge?" I said, "Push the road right on through Arizona." He said, "Will you do that? If you will that will suit me first rate."

Notwithstanding the presidential enthusiasm, the Southern Pacific dawdled in Yuma for over a year because Huntington's partners believed the railroad was over its head in debt. A series of events changed their minds. New mineral discoveries in Arizona, including Ed Schieffelin's Tombstone, made it more lucrative to run rails into the desert, while rumors circulated that Jay Gould, then the richest and probably most larcenous man in America, was sniffing around the Texas & Pacific for possible acquisition. Then too, Huntington's life-long partner, Mark Hopkins, the sober-minded accountant of the Big Four and the only man who could rein in Huntington's expansiveness, died in March 1878 while inspecting the Yuma crossing. By November the rails were stretching out of Yuma toward Tucson.

To the north the Atchison, Topeka, & Santa Fe built across Kansas and reached Pueblo, Colorado, in

Judge Roy Bean poses with his four children (l to r), Zulema, Roy Jr., Sam, and Laura. Bean also had an adopted son named John. While the others moved away, Sam stayed in Langtry and required all his father's resources to free him after killing a man in a quarrel.

March 1876, an event celebrated, according to a local paper, with "the biggest drunk of the present century." Now the line set its sights on New Mexico, determined to follow the old Santa Fe Trail through Raton Pass. Another ambitious railroad, the Denver & Rio Grande, also had its eye on the pass, but unlike the Santa Fe, which was a standard gauge line, the Denver & Rio Grande used a narrow gauge rail that allowed it to build more quickly in the mountains. By February 1878 it was only a few miles from the pass, sure that it "owned" the essential gateway by right of getting there first. A ruthlessly aggressive company, even by western railroad standards, the Denver & Rio Grande had thoroughly alienated the people of Colorado, and their poor public relations came back to haunt them.

The Santa Fe secretly obtained a charter from New Mexico, and in yet another midnight maneuver a grading team slipped into the pass with help from an old mountain man named Uncle Dickie Wootton, who operated a toll road through the pass and was smart enough to know that toll road days were over. He probably did not like the Denver & Rio Grande to begin with, but when the Santa Fe offered him 50 dollars a month for the rest of his life, that sealed the deal. Wooton rounded up a mob of armed men to guard the graders, finding most of them at a saloon in nearby Trinidad, Colorado, which had been

bypassed by the Denver line. When the Denver & Rio Grande men, also carrying guns, arrived the next morning, there was a tense standoff, but Wooton's mob and the rough grade that had been built through the night carried the day for the Santa Fe. The two lines fought a longer, more violent war later that year over a westward pass through the Royal Gorge of the Arkansas; the Denver & Rio Grande won that one and went on to dominate Colorado as the Southern Pacific had dominated California. But it was the Atchison, Topeka, & Santa Fe that became the romantic railroad of the Southwest.

By July 4, 1879, the Santa Fe had reached Las Vegas, New Mexico, but it refused to build into its namesake city until the citizens approved a $150,000 bond issue for a stub line through the mountains. Continuing on through Albuquerque, where it received similar financing from the citizens, the line met the Southern Pacific at Deming, New Mexico, in December 1880 to form the nation's second transcontinental railroad. The Deming connection was a temporary measure for both competing railroads, each with its own transcontinental visions. By this time the Santa Fe had obtained enough control over the Atlantic & Pacific to use its charter to build westward along the 35th parallel, running from Albuquerque to Needles, where it ran smack into the Southern Pacific. After a year of obstructionist tactics by the SP, which would "lose" Santa Fe freight shipments with annoying regularity, the two railroads worked out a deal: The Santa Fe bought the SP tracks from Needles to Mojave and leased running rights to the bay area, while the Southern Pacific took over a line that the Santa Fe had built to the port of Guaymas, Mexico, which threatened the SP's monopoly on west coast shipping connections.

Golden spike ceremonies marked the completion of transcontinental railroad lines.

Earlier the SP also made a deal with Jay Gould—who preferred buying railroads to building them—agreeing to meet the Texas & Pacific in El Paso and share the profits, but Huntington undercut the deal before Gould could get there, putting together local lines to create his own route all the way to New Orleans. Roy Bean's moment in the sun came during the completion of the Galveston, Harrisburg, and San Antonio, popularly known as the Sunset, which had a charter to build through Texas and was manipulated and later absorbed by the Southern Pacific in much the same way the Santa Fe manipulated and absorbed the Atlantic & Pacific.

In 1885 the Santa Fe connected at San Bernardino with the California Southern, subsidized by citizens from San Diego who had originally courted Tom Scott's Texas & Pacific and were punished by the Southern Pacific's refusal to serve them. That same year the Santa Fe reached Los Angeles on a leased Southern Pacific line, and in 1887 it completed its own rails to the growing city, setting off a rate war that dropped passenger fares from $125 to $25 for the journey from the Mississippi Valley to the West Coast. For one day in March the fare actually dropped to a dollar. While the Southern Pacific was infamously cavalier in its treatment of passengers, the Santa Fe offered gourmet meals at stops along the way, prepared in Fred Harvey's kitchens and served by the famous Harvey girls, who were such a rare commodity on the frontier that their contracts required them to forfeit half their wages if they married within a year. Harvey insisted that the Santa Fe allow passengers a full half hour for their dinner stops, and the engineer would signal their orders in advance with a special whistle code.

The arrival of the Southwestern railroads set off a land rush in southern California that ultimately led to the dramatic shift in population from north to south that characterizes the state today. Sleepy San Diego grew from 5,000 in 1884 to 32,000 in 1888, with people so desperate to buy land that they paid $500 to hold a place in line outside the office of a new subdivision. Among those who arrived was Wyatt Earp, always on the lookout for a place with snap. He found plenty in San Diego, where he ran three gambling halls, speculated in real estate, and, after winning a Thoroughbred in a card game, developed a small stable of racehorses that allowed him and his third wife, Josephine, to consort with a higher class of sporting folk than they had known in the smoky bars of Tombstone. As in every boom, speculation could only go so far, and not all who came stayed, but the census of 1890 showed that southern California grew at an astonishing rate of 170 percent in a single decade while the rest of the state barely exceeded the national growth rate of 26 percent. In 1893 a depression gripped the nation, second only to the Great Depression of 1929, yet southern California continued to grow by almost 50 percent, more than twice as fast as the rest of the state and the country. Los Angeles County led the charge, with over 100,000 people in 1890 and 170,000 in 1900 (with more than 100,000 inside the city limits.) That year San Francisco boasted some 343,000 residents.

Although the Southern Pacific played a major role in the growth of California, its monopolistic stranglehold on in-state shipping suppressed the economic activity the boom created. Other lines engaged in similar shenanigans, but no railroad was more deeply hated by the people it served than the Octopus of the Southern Pacific. Its freight rates were based not on costs or distance but on the ability of any given customer to pay, and the art was to set the rate at a level that would leave just enough to allow the customer to continue in business while skimming all profits into the coffers of the railroad. Sometimes the rate fixers misjudged, as they did when they raised the shipping rate for lemons 15 cents a carton, which happened to be exactly the profit margin of the growers. When the growers uprooted their trees, the SP reduced the rate.

Another ploy was to settle farmers on railroad lands with vague promises of moderate land prices while charging much higher prices when the time came to pay. In the Mussel Slough area of the San Joaquin Valley, the SP lured settlers with promises of land at $2.50 to $10 an acre and then demanded $25 to $40 an acre after the settlers had done all the work of irrigating and developing the land. When the settlers refused to pay the inflated prices, the railroad tried to evict them by force on May 10, 1880, and the farmers fought back in a battle that left five settlers and two railroad men dead. Hostility toward the Southern Pacific remained so strong in the valley that nine years later a pair of unlikely train robbers named Chris Evans and John Sontag—viewed by the citizens as latter-day Robin Hoods—were able to hit the railroad five times and elude a massive four-year manhunt, chased by up to 3,000 men, before finally being captured in a blazing shoot-out. Although Sontag died in the shootout, Evans received a pardon in 1910 when Governor Hiram Johnson was elected on a platform to "kick the Southern Pacific out of politics." That year a new State Railway Commission finally tore the tentacles off the Octopus by ordering a six-million-dollar reduction in freight rates and passenger fares. A reporter who sat in on the commission's hearings later wrote that he felt as if "democracy had been reborn in California."

IN NOVEMBER 1867 a Confederate deserter and itinerant gold miner named Jack Swilling watched Mexican laborers cutting tall, lush hay that grew along a long, troughlike depression near the Salt River in central Arizona. The hay would feed the horses at Camp McDowell, established in 1865 to protect miners in Prescott, Wickenburg, and other central Arizona diggings against Apache attacks. Swilling apparently had heard stories of an ancient Indian civilization that irrigated the desert, and he realized that the long troughs must be the remains of their canals, just as he realized

Chiricahua Mountains, Arizona

that the tall, lush hay meant the soil was unusually fertile. He quickly obtained financing from miners in Wickenburg and organized the Swilling Irrigating and Canal Company, cleaning out the old Hohokam irrigation ditches and constructing new ones as necessary. Although early settlers considered calling it Pumpkinville after their first big crop, someone of more esoteric leanings—probably Swilling or an Englishman named Darrell Duppa—suggested that the settlement be called Phoenix, as they were attempting to build a new civilization on the ashes of an old one.

Historically, the great lure of the Southwest had always been gold and silver, and though the Spanish conquistadores missed the signs, there were deposits of both—attested by finds at Prescott, Wickenburg, Pinos Altos, Globe, Tombstone, Silver City, and many others. None of these produced the kind of transforming wealth found in California, however, and the real long-term mineral resource of Arizona and western New Mexico turned out to be copper. By 1804 the Spanish had begun working a copper mine at Santa Rita del Cobre, not far from Pinos Altos, and an American name Charles Poston established a copper company at Ajo, west of Tucson, before the Civil War. Both of these suffered repeatedly from Indian attacks, and it was not until the early 1870s, when the Apache first agreed to move on to reservations, that large-scale copper mining began. Charles and Henry Lesinsky, wholesalers in Las Cruces, New Mexico, established a successful operation on a tributary of the San Francisco River just across the Arizona border, where the town of Clifton was founded to house Mexican workers whose cheap labor made the operation profitable. Even with cheap labor, copper mining was a difficult enterprise, and the Lesinsky brothers sold out to Scottish capitalists for two million dollars just as huge discoveries in Butte, Montana, depressed the copper market. Forced to produce more copper at lower cost, mine manager James Colquhoun connected with the Southern Pacific Railroad in 1882 and a decade later developed a new approach to mining in

which almost pure copper was chemically leached out of low-grade waste, a process still used in copper mines today. In the early 20th century, open-pit mining—first developed in Utah—spread to Arizona and New Mexico, and today Arizona accounts for about two-thirds of U.S. copper production.

The arrival of the railroads did not create the kind of frenzied boom in New Mexico and Arizona that it did in southern California, but it did have a powerful effect on both territories and moved them slowly but surely into the modern world. In New Mexico, which had struggled with economic isolation since the early Spanish period, the railroads finally brought healthy competition and cheap transportation. While only two banks served the entire territory in 1878, more than 50 banks were chartered in the next 20 years. Property values rose from 41 million dollars in 1880 to 231 million dollars in 1890, and during the same period the number of cattle on New Mexico ranches expanded from 347,000 to 1,630,000, becoming such a lucrative commodity that for a while beeves were the major freight item on the Santa Fe. New towns sprang up along the railroads, and the population grew from 119,000 in 1880 to 195,000 in 1900—not as explosive as the growth in southern California during the same period but still a substantial increase that brought more and more Anglos into the old Spanish-speaking territory.

Arizona had a much smaller population to begin with, only 40,000 in 1880. Seven years later the territorial governor estimated that it had jumped to 90,000, hardly enough for a good-size city but an impressive increase in such a short period of time, particularly considering that even as the railroads brought new opportunity, the "Apache menace" continued to plague white settlers.

DURING THE SUMMER OF 1881, when Southern Pacific tracks were already laid across Arizona, a holy man named Nakaidoklini instigated a Ghost Dance among the Coyotero Apache who lived on the Fort Apache Reservation (now called White Mountain), which had been carved out of the northern half of the huge San Carlos Reservation. Nakaidoklini's movement began after two Coyotero chiefs were killed by rival bands, and the holy man held dances around their graves, claiming he could bring them back to life. The dancing gave hope to a desperate people, and soon Nakaidoklini was speaking of resurrecting other dead warriors and returning to the days when the Apache roamed free. When the dead did not appear—and the followers who had paid him well for such miracles complained—he suggested that they would not return until the white eyes had been driven from the land and that this would happen when the corn was ripe.

Word of the growing movement prompted the agent at San Carlos—whose corrupt practices were responsible for at least some of the unrest—to ask Fort Apache commander Col. Eugene Carr, "to arrest or send [Nakaidoklini] off or have him killed without arresting." Carr hesitated, rightly believing that that such a move would create an uprising rather than prevent it, but he was forced to act by a direct command from his superior, Gen. Orlando Willcox. On August 30, 1880, Carr arrived in Nakaidoklini's camp with 83 soldiers and 24 Apache scouts. Nakaidoklini surrendered peacefully, but as the troops escorted him away, hundreds of armed and painted Apache followed, and fighting broke out along Cibecue Creek. Nakaidoklini, his wife, and their son were killed, along with a number of other Apache and four soldiers. More died in the following month as the suddenly hostile Indians killed soldiers and civilians throughout the area while soldiers and Apache police patrolled the reservations in force, destroying cornfields, arresting leaders and other hostiles, and killing Indians who got in their way—many of them older people who had gone out to try and save what corn they could find.

The Chiricahua had been heavily influenced by Nakaidoklini's teachings, especially Juh and Geronimo, who were back at San Carlos trying to live in peace. In late September, a month after the death of the holy man and fearing arrest by the soldiers, Juh and Geronimo bolted from San Carlos with 72 followers, including Naiche, the son of Cochise. They headed south for the

Chinese Railroad Workers, San Francisco

Sierra Madre of Mexico, killing 13 whites and destroying a wagon train on their way. In Juh's Sierra Madre homeland they joined the remnants of Victorio's people, now led by the wizened warrior Nana, who had wreaked his own vengeance along the border after Victorio's death at Tres Castillos. Although the rugged Mexican mountains offered temporary refuge, Mexican troops were more relentless and ruthless in their pursuit of the Apache than were the Americans, and the Chiricahua decided they needed reinforcements. In April 1882 Geronimo led a raiding party back to San Carlos, forcing over 400 of Loco's peaceful people to follow them to the south. There were perhaps no more than 30 warriors among them, but the Chiricahua hostiles were desperate and every warrior counted.

The U.S.-Mexico border had always been a refuge for Apache raiders, allowing them to escape pursuit from one direction or the other. But this time U.S. troops illegally pursued them across the line, forcing the warriors to lag behind to protect against the Americans. The women and children walked headlong into a Mexican infantry unit that slaughtered them as Victorio's people had been slaughtered at Tres Castillos, killing 78 Apache, only 11 of them warriors, while taking another 33 women and children as prisoners. That fall, as the renegades tried to survive in the Sierra Madre, Gen. George Crook returned to command in Arizona, where he had won his greatest victories subduing the Apache of the Tonto Basin, north of Phoenix, in the early 1870s. Crook was a tough, fair-minded man who eschewed military pomp for comfortable civilian garb and a good strong mule. He pioneered the use of Apache scouts to track Apache renegades, and though he pursued his prey relentlessly, he treated them with respect when he found them. The Apache called him "Chief Tan Wolf" for his khaki fatigues and wolflike ability to track them down in the harsh landscapes they called home. Nana later called him an "honorable enemy." But even Crook would meet his match in Geronimo.

On May 1, 1883, Crook led a force of almost 200 Apache scouts and fewer than 60 regular troops across the border under a new agreement with Mexico. For the first time American soldiers penetrated Juh's stronghold in the Sierra Madre, forcing the surrender of 384 Apache, most of them Loco's people who had not wanted to leave San Carlos in the first place. Geronimo returned to San Carlos in the spring of 1884 with almost a hundred followers and a herd of stolen Mexican cattle, which he firmly believed were his property but which Crook confiscated to show good faith with the Mexican government. Things went downhill from there, and Geronimo escaped again in May 1885, this time with about 140 people, including other leaders such as Nana, Naiche, Chihuahua, and Mangus, the son of Mangas Coloradas. Juh had died in Mexico, and Geronimo was now the leader of the renegade faction. Crook pursued them with 2,000 men, but it was not until March 1886 that Geronimo was finally ready to talk peace, meeting with Crook in a tree-shaded canyon just south of the Arizona border.

By this time Crook had lost patience, and he told the Apache leaders that they could no longer come and go as they pleased, using the reservation when it suited them. "You must make up your own mind whether you will stay out on the warpath or surrender unconditionally. If you stay out, I'll keep after you and kill the last one, if it takes fifty years." After Chihuahua and Naiche offered complete submission in fawning words that hardly befitted proud warriors, Geronimo put his own case more simply: "Once I moved about like the wind. Now I surrender to you and that is all." But that was not all. An American trader, afraid to lose his Indian whiskey concession, got the Apache drunk and told Geronimo he would be hung as soon as he crossed the border. Geronimo and Naiche bolted one last time, with less than 40 followers, half of them women and children. This was the last great freedom flight of the American Indian people. After Crook resigned in disgust—because Gen. Phil Sheridan would not honor the promises Crook had made to the Apache he had captured—he was replaced by Gen. Nelson Miles, who mobilized 5,000 soldiers, one-quarter of the United States Army. At the same time the Mexican

Army pursued them with about 3,000 soldiers.

In five months not a single Apache was captured, while Geronimo's tiny band left a river of blood, mostly on the Mexican side of the border. The governor of Sonora estimated that 500 people died in Sonora alone, probably an exaggeration but still an incredible figure for about 20 warriors. The rampage ended after Miles shipped the Chiricahua from San Carlos to a prison camp in Florida and then sent an emissary to inform Geronimo that his people were gone and there was nothing left to fight for. In September 1886 Geronimo met Miles in Skeleton Canyon, ten miles north of the Mexican border. Miles promised that the renegades would join their families in Florida and later assured them that the past would be "smooth and forgotten." Unlike Crook, Miles had no intention of keeping his promises, and four days after agreeing to peace, Geronimo's renegades were shipped on the railroad to Florida, where the warriors were separated from their families. The desert Indians suffered so miserably in the humid Florida camps that they were later moved to Alabama, but this was not much better. By the end of 1889, out of almost 400 people, 89 had died in the camps, and 30 children had died at the Carlisle Indian School in Pennsylvania. In 1893 the Chiricahua were moved to Fort Sill, Oklahoma, where Geronimo died in 1909. Four years later the Chiricahua were finally freed; some chose to stay in Oklahoma, while others joined the Mescalero Apache in New Mexico.

G E R O N I M O

FROM *GERONIMO: HIS OWN STORY*
TOLD TO ASA DAKLUGIE, SON OF JUH, IN 1905-6 AND EDITED BY S. M. BARRETT

There is no climate or soil which, to my mind, is equal to that of Arizona. We could have plenty of good cultivating land, plenty of grass, plenty of timber and plenty of minerals in that land which the Almighty created for the Apaches. It is my land, my home, my fathers' land, to which I now ask to be allowed to return. I want to spend my last days there, and be buried among those mountains. If this could be, I might die in peace, feeling that my people, placed in their native homes, would increase in numbers, rather than diminish as at present, and that our name would not become extinct.

I know that if my people were placed in that mountainous region lying around the headwaters of the Gila River they would live in peace and act according to the will of the President. They would be prosperous and happy in tilling the soil and learning the civilization of the white men, whom they now respect. Could I but see this accomplished, I think I could forget all the wrongs that I have ever received, and die a contented and happy old man. But we can do nothing in this matter ourselves—we must wait until those in authority choose to act. If this cannot be done during my lifetime—if I must die in bondage—I hope that the remnant of the Apache tribe may, when I am gone, be granted the one privilege which they request—to return to Arizona.

WILD WEST VIOLENCE DID NOT END IN ARIZONA with the capture and imprisonment of Geronimo; even as the Chiricahua were being shipped to Florida, trouble was brewing in Pleasant Valley, an isolated rangeland just west of the Fort Apache Reservation in the shadow of the Mogollon Rim. Bad blood developed between two families and their allies, much like the Earp-Clanton conflict, but the Graham-Tewksbury feud lasted longer, left more men dead, and was fundamentally sadder—while the Earps were shameless opportunists and the Clantons close to outlaws, the Graham and Tewksbury families were decent people trying to make a living in a harsh, beautiful land. The four Tewksbury brothers arrived in the valley first, handsome, dark-skinned men whose beautiful Shoshone mother had died before they reached Arizona. They were soon joined by their father, who was white, along with his new wife and assorted step- and half-siblings. Around 1882 Ed Tewksbury invited John and Tom Graham to settle in the valley, along with their younger half-brother, Billy. At first the two families developed a close friendship and ran cattle together.

Then the friendship soured. John Graham registered a cattle brand for his brother Tom without including Tom's partner, Ed Tewksbury, and the Grahams made an agreement with the most successful rancher in the valley to act as range detectives. They accused the Tewksburys of cattle rustling, and though a jury cleared them, the feud had begun. Squeezed out of the partner-

In this image by Tombstone photographer Camillus S. Fly, Geronimo poses in Skeleton Canyon—where he met General George Crook in March 1886— with three warriors who fought with him to the end (l to r): Yahnozha, Chappo (Geronimo's son), and Fun.

ship, the Tewksburys brought herds of sheep into the cattle country, breaking an unwritten rule that there would be no sheep south of the Mogollon Rim. By this time the big corporate Aztec Land & Cattle Company with its famous Hashknife brand had begun to move into the valley, and some of their cowboys joined the fray. Cattlemen drove one big herd of sheep over a cliff and killed others. In February 1887 a Ute shepherd working for the Tewksburys was found brutally murdered; some reports indicate he was beheaded. By summer the sheep were gone, but the conflict got even uglier and more personal when a rancher named Mark Blevins—whose five sons were allies of the Grahams—suddenly disappeared, and Jim Tewksbury shot and killed one of the Blevins boys along with an enforcer for the Aztec company.

Now the violence exploded into the stuff of dime novels. On August 17 a deputy sheriff in sympathy with the Tewksburys shot Billy Graham in the guts, and the dying young man struggled home with his intestines hanging down to the floor. On September 2 the older Graham brothers attacked the Tewksbury ranch and killed John Tewksbury and another supporter, keeping up a barrage of fire for three days to prevent John's pregnant widow from burying the body while half-wild hogs gnawed at the decaying flesh. Two days after the ranch attack a flamboyant, long-haired sheriff with the improbable name of Commodore Perry Owens went to arrest Andy

Blevins on an unrelated charge in the railroad town of Holbrook. With five quick shots he killed Andy and his teenage brother, Sam, who died in their mother's arms, mortally wounded a family friend, and shot John Blevins in the shoulder in what has been called the most lethal feat of gunplay by a lone lawman in the history of the West.

Later that month another sheriff killed John Graham and Charles Blevins while resisting arrest and went on to arrest Ed and Jim Tewksbury, but no one would testify at their murder trial. When Jim died of tuberculosis in December 1888, only Ed and Tom Graham survived from the original two sets of brothers. Tom moved away for a while, but upon returning to the area in 1892, he was ambushed and murdered near Tempe. Witnesses identified Ed Tewksbury and another man; only Ed stood trial, but his conviction was overturned on a technicality, and he went on to serve as a lawman in Globe before dying of tuberculosis in 1904. Casualty figures for the Pleasant Valley War vary from 15 to 50; some men disappeared, and others were killed for reasons that may or may not have stemmed from the vendetta. There were no real winners, and lurid tales of Arizona's dark and bloody ground only reinforced the image of a wild and dangerous frontier.

WHILE THE PEOPLE OF ARIZONA FOUGHT Indians and each other with guns, Californians fought in the courts over water rights. At issue was ownership of the water in any given stream and California had two conflicting legal precedents. The first, riparian rights, derived from English common law, which formed the basis of the original California constitution. Under riparian rights, water belonged only to those who owned land on the river and could not be diverted except for domestic use. The other approach, prior appropriation, derived from early California mining law, which was also cited in the constitution. According to appropriation, those who used the water first had the right to divert that water as long as they continued to use it for beneficial purposes. In the landmark *Lux v. Haggin* decision of 1886, the California Supreme Court decided that riparian rights held precedence on private lands but that an appropriator could continue diverting water as long as he was using the water before a riparian claimant had obtained the land. The details of this decision, which ran for over 200 pages, were so complex that only lawyers were satisfied. It offered little relief to small farmers, who were least likely to have either sort of claim in a state where the well-watered lands were already owned by large ranchers who had obtained their holdings directly from Spanish and Mexican land grantees or pieced together sprawling estates by purchasing public lands.

Two years later, in an effort to offer relief to small farmers, the Wright Act allowed 50 or more adjoining landowners to form an irrigation district and issue bonds to pay for it after approval of two-thirds of the voters in the district, including nonfarmers. The Wright Act stimulated irrigation and by 1889 California led the nation with almost 14,000 farmers irrigating a million acres. Yet the complexity of private citizens creating a governmental entity proved difficult to sustain, and many irrigation districts failed. A more successful approach was the mutual water company in which land and water remained in private hands, with the members of the company sharing voting rights. First pioneered on a small scale by German immigrants in Anaheim before the Civil War, the idea was developed during the 1880s by Canadian engineer George Chaffey, who established irrigated colonies at Etiwanda, Ontario, and Whittier. Chaffey offered one share in the water company for each acre of land and built the irrigation systems himself, making money by selling the land and offering water rights. He was so successful in California that he accepted an invitation in 1886 to try his hand in Australia.

The Australian project failed for reasons that were not necessarily Chaffey's fault, and by 1900 he was back in California, broke and looking for a new project. He found it in the bone-dry desert of southeastern California, where a shady, if spirited, promoter named Charles Rockwood had obtained enough land along the Colorado River to claim 20,000 acre-feet of

water but did not own enough land beyond the river to actually use it. Chaffey surveyed the long trough running from San Gorgonio Pass near Palm Springs southeast to the Colorado River Delta and discovered that the center of this trough, called the Salton Sink, was 273 feet below sea level, which would allow the river water to reach the area by gravity alone. An old river channel called the Alamo, which wound north through Mexico and avoided the sand dunes that once stymied Juan Bautista de Anza, could be used as his main canal. Almost 50 years earlier, in 1853, American geologist William P. Blake noticed the same broad features and prophetically wrote: "It is indeed a serious question, whether a canal would not cause the overflow once more of a vast surface, and refill, to a certain extent, the dry valley of the ancient lake." Chaffey may have had the same doubts, for he sold out quickly, but before he did, he created one of the great desert water schemes.

Chaffey and Rockwood renamed the area the Imperial Valley and established eight mutual water districts, all controlled by the Imperial Land Company, which in turn was owned by Rockwood's California Development Company. In this big-scale project the settlers usually obtained the land themselves through the federal Homestead Act, which allowed claims of 160 acres in the public domain, while the Imperial Land Company sold water rights at about $22 a share, or $3,520 for a 160-acre farm. At the same time the company obtained its own lands through dummy homesteaders. It offered easy credit, with the land as collateral, so if a farm failed, as many would be expected to do in the desert, the land company got the land to resell at higher prices. It was a brilliant scheme for all concerned, or so it seemed when the first water flowed into the valley in May 1901 and crops began to rise from the rich desert soil under a steady, blistering sun that brought two growing seasons every year.

Pressured by Rockwood, Chaffey sold his interests that first year, but still the desert dream continued to grow, and the farmers who got there first jealously guarded their interests. In 1902, the Reclamation Act was passed to reclaim desert lands through large-scale irrigation projects. Theoretically, reclamation would work in conjunction with the Homestead Act, only irrigating public lands where no single farmer had more than 160 acres. The Imperial Valley seemed like a good test case—and it was desperately in need of the funding and expertise the federal government could offer—but when a man from the newly formed U.S. Reclamation Service started sniffing around the project, a group of farmers tarred and feathered him and drove him out of the valley. They were dreaming big, consolidating 160-acre plots as fast as they could, and they were not about to let some government man tell them how much land they could own. By 1904 about 7,000 people were farming 100,000 acres, grossing $700,000 with the prospects of much better times to come.

Then disaster struck. That same year Chaffey's original canal silted up, and the remaining partners built a sloppy temporary canal with a cheap, lightweight headgate that gave way in the first floods of 1905. During the next three years, some of the rainiest on record, the Colorado carved out a course through the Alamo, wiping out towns, fields, and farmhouses and gradually turning the Salton Sink into the Salton Sea, 40 miles long, up to 15 miles wide, and 80 feet deep. In the early days of the deluge the Southern Pacific Railroad bought out the original developers because it had already invested heavily in the area and had its eye on a huge parcel of potential farmland just across the Mexican border. Yet even with the vast resources of the railroad, which built and rebuilt bridges and sent thousands of boxcars laden with fill material, it still took two million dollars, countless man-hours, and some help from mother nature before the Colorado returned to its main channel and left the Salton Sea behind—an inland lake without outlet, fed by the alkaline runoff of irrigated fields and the heavily polluted New River, which flows into the valley from Mexico. During the 1950s the Salton Sea was touted as a sportsman's paradise, and it remains a popular fishing spot and important stopover for migratory birds. But as the lake becomes saltier with every passing year—it is now 25 to

Salt River Canyon, Arizona

PRESERVING THE LAND

On March 1, 1872, Ulysses S. Grant signed a congressional act establishing Yellowstone National Park, preserving a huge tract in what are now Wyoming, Montana, and Idaho as "a public park or pleasuring-ground for the benefit and enjoyment of the people." It was the first national park in the world, setting a standard followed in over a hundred countries. Three more national parks were established in 1890, all in California: Yosemite, Sequoia, and General Grant (now King's Canyon).

In the Southwest, early preservation efforts focused on archaeological sites. Congress authorized $2,000 to protect and repair Casa Grande ruins in 1889, and three years later, Benjamin Harrison established Casa Grande as the first archaeological reserve. In 1906, Congress created Mesa Verde National Park and passed the Antiquities Act, which gave the president broad powers "to declare by public proclamation historic landmarks, historic and prehistoric structures,

Theodore Roosevelt loved the West and enthusiastically pushed a two-sided program of preservation and reclamation.

and other objects of historic or scientific interest." Theodore Roosevelt used the act to proclaim 18 national monuments before leaving office in March 1909. Half were in the Southwest, including El Morro, Montezuma Castle, Gila Cliff Dwellings, Chaco Canyon, Petrified Forest, Natural Bridges, and the Grand Canyon.

By 1916, there were 14 national parks and 21 national monuments without consistent management. That year, the National Park Service was established with Stephen Mather as director. The National Park Act required the service to "conserve the scenery and the natural and historic objects and the wild life therein, and to provide for the enjoyment of the same in such manner and by such means as will leave them unimpaired for the enjoyment of future generations."

Today the National Park Service administers 384 areas with designations including parks, monuments, battlefields, historic sites, recreation areas, seashores, and scenic rivers—preserving over 83 million acres of landscape and history for future generations.

30 percent saltier than the Pacific Ocean—the entire ecosystem is in danger of collapse. Various biochemical processes cause periodic fish and bird die-offs, testifying to a century-old engineering project gone horribly awry.

In September 1904, even as the Imperial Valley headed for disaster, two unlikely friends headed north out of Los Angeles in a two-horse buckboard, struggling across mountain passes and dry gravel washes and drinking whiskey around starlit campfires as they traveled through the Mojave Desert and into the beautiful Owens Valley, a well-watered emerald jewel spread beneath the towering eastern face of the Sierra Nevada. One of these men, Fred Eaton, was the former mayor of Los Angeles, the handsome, courtly scion of a well-to-do family. The other, William Mulholland, was a rough-hewn, self-taught Irish immigrant engineer who had already made a name for himself as superintendent of the Los Angeles Department of Water and Power. Together, they were on a mission to steal the cold, clear water of the Owens River, which flowed down from the Sierra snows at a rate of about 400 cubic feet per second, enough not only to slake the temporary thirst of Los Angeles, already struggling for water with a population of 200,000, but to allow the City of Angels to grow into a great metropolis of 2,000,000.

The water did not belong to Los Angeles, and it was 250 miles away from the city. No matter. The Owens Valley was almost 4,000 feet higher than Los Angeles, and both Eaton—who was a water engineer before he was a mayor—and Mulholland believed they could build a series of aqueducts and siphons that would bring the water south by gravity alone. As for water rights, that could be arranged as well. Mulholland was an honest man who just wanted to deliver the water his city needed, and in the early days at least he believed there was enough water for Los Angeles and the Owens Valley. Eaton was something else; as soon as they returned to Los Angeles, he slipped off to New York and obtained financing to buy key lands and water rights. Only a threat from the Reclamation Service—which was considering its own irrigation project in the valley—forced him to back down, but he was not finished. For $100 Eaton bought an option on 25,000 acres of grazing land that contained the best site for a storage reservoir. He held the city hostage until it agreed to pay him $450,000 for the rights, while he retained a 12,000-acre ranch and received 4,000 head of cattle and other animals and equipment as part of the deal. Eaton was paid another $100,000 for other properties and water rights, a return of $550,000 on an outlay of about $15,000.

Even so, Eaton refused to allow a big enough dam on his land, which forced Mulholland to reject the idea entirely and guaranteed, according to one historian, "that there would be insufficient water for both Los Angeles and Owens Valley in any future drought." The project went forward anyway, with Mulholland and Eaton, now bitter enemies, as the smiling front men. Eaton returned to the Owens Valley with maps and credentials from a corrupt Reclamation official and bought options on water rights from unsuspecting farmers who thought they were participating in a federal project that would benefit the valley. In the meantime Mulholland gave speech after speech to the people of Los Angeles, convincing them to approve the necessary bonds, first to buy the land and water rights, then to build the expensive and unprecedented aqueduct. "If you don't get the water now," he told them with characteristic Irish wit, "you'll never need it. The dead never get thirsty."

The campaign was heavily backed by a syndicate of powerful men, including Southern Pacific president Edward H. Harriman and *Los Angeles Times* publisher Harrison Gray Otis, who not only had much to gain by the growth of Los Angeles but also used inside information to purchase 16,200 acres in the San Fernando Valley at low desert prices that would be worth millions when the water arrived. On September 7, 1905, the voters approved a 1.5-million-dollar bond issue to buy the land and water rights in the Owens Valley by a 14 to 1 margin. "Owens River is ours," crowed the *Times*, "and our business now is to hustle and bring it here and make Los

Little Colorado River, Arizona

Tonto Creek, Arizona

Angeles the garden spot of the earth and the home of millions of contented people." The people of the Owens Valley, some 8,000 strong, were not contented at all. When the story first broke in the papers, angry farmers had come very near to lynching Fred Eaton, who smooth-talked his way out of the noose and later promised to use his newfound wealth "in being a good neighbor . . . to retrieve myself and clear away all unhappy recollections."

In 1907 a 23-million-dollar bond issue passed to finance construction, and preparatory work began: 500 miles of roads and trails, 240 miles of telephone wire, 2,300 buildings and tent-houses, the biggest cement plant in the world, and two hydroelectric plants for the first major American engineering project powered by electricity. The original plan called for 22 miles of open canals, 53 miles of tunnels, 125 miles of steel siphons and concrete flumes, 137 miles of concrete-covered conduit, 13 miles of reservoirs (for temporary rather than long-term storage), and, at the end, a 20-mile steel pipeline. The biggest obstacle was a five-mile tunnel through the mountains north of Los Angeles. Mulholland wisely got the tunnel crews started first, working from either side of the mountains in a feverish competition that lasted 1,239 days. Between 1908 and 1913 an average of 5,000 men labored on the aqueduct in desert heat that soared as high as 130°F. Food had to be shipped without refrigeration and was often so rancid that the men actually rioted. There were cash-flow problems, a labor strike, a tunnel explosion that killed five men, and a Socialist-led investigation into corruption, but through it all big Bill Mulholland, the man they called the Chief, kept building the "big ditch."

On November 5, 1913, 43,000 people—about one-fifth the population of Los Angeles at that time—gathered along a dry concrete culvert in the San Fernando Valley waiting for the first water to arrive. The man of the hour was William Mulholland, now 58 years old but still a charismatic presence, six feet tall, with a bushy, silver-gray moustache. In his short remarks he was gracious to all who made the dream a reality, especially the hardworking laborers who "do so much for so little. . . . I would rather sit around camp with them than be in a circle of lawyers, doctors or bankers." He also paid tribute to his old friend turned bitter enemy, Fred Eaton, "the father of the big ditch." Eaton himself, angry over the city's refusal to meet his million-dollar asking price for a reservoir on his lands, refused to attend the ceremonies, with the lame excuse that the water carried by the aqueduct at this particular time was mostly rainwater and therefore did not really count.

Finally, Mulholland was presented with an engraved silver cup, which he held aloft to the cheering crowd. "This is yours," he told them. "It was your own fidelity and unfaltering courage that made the work possible. . . . We have the fertile lands and the climate. Only water was needed to make this region a rich and productive empire, and now we have it. This rude platform is an altar, and on it we are consecrating this water supply and dedicating this aqueduct to you, your children and your children's children—for all time." At a signal from the Chief the gates opened and the water began to flow into the concrete channel, a trickle at first, growing steadily stronger until it was a frothing torrent. "There it is," Mulholland shouted over the roar. "Take it!"

They did.

IN 1889 THE TERRITORIAL CAPITAL OF ARIZONA was moved to Phoenix over the loud protests of citizens in Prescott, which had served as the capital during two different periods since 1863. Phoenix was still a small enclave—the 1890 census counted only 3,152 people—but it was growing steadily and centrally located, connected to the Southern Pacific by a line to the south. By 1895 it would also be connected to the Santa Fe to the north. Just as important, it was a new city without historical baggage. Prescott was the first capital, a mountain mining town founded in the heat of the Civil War, but the mining boom was over, and the strong pro-Union stance of the citizens was too much for some Arizonans. On the other hand, Confederate sympathies still lingered in Tucson, which had also been the capital for a time, and, in a territory becoming more Anglo

with every passing year, it was considered too Mexican. Phoenix was a compromise, an attempt by Anglo Arizonans to redefine their territory and make it more palatable to the rest of the nation.

Serious efforts toward statehood began around this time in both Arizona and New Mexico. For Arizona the biggest hurdle was to convince America that it was not "just like hell," as one eastern senator had described it in the early days. Well-publicized violence like the Geronimo breakouts and the Pleasant Valley War did not help the public relations campaign, and in 1891 the Arizona Rangers were established, patterned after their famous Texas counterparts. They were efficient when it came to arrests—over a thousand in fiscal year 1903-04 alone—but so many rangers had cut their teeth as outlaws that they caused as much trouble as they prevented and were disbanded in 1909. In an effort to attack the frontier image from a different angle, the University of Arizona opened its doors in 1891 with a grand total of 33 students. Public education was so poor in Arizona—the first public high school had just been established—that only six students were actually qualified to be college freshmen; the others were in a special tutoring program. Nonetheless, the university outlasted the rangers.

New Mexico had its share of violence, but the most damaging perception of criminal activity in the territory was a history of land fraud, stemming from corruption in Spanish and Mexican land grants. The ultimate land swindle was the Maxwell Grant, which dated back to Governor Armijo, before the Mexican War. Located in northeastern New Mexico, the grant embraced 97,000 to 2,000,000 acres, depending upon who was counting. When the corrupt Santa Fe Ring bought into the grant in 1870 and tried to develop it, things got so nasty that the residents rioted and a number of men were assassinated in what has been called the Colfax County War. The U.S. Supreme Court granted a patent for over 1.7 million acres in 1887, but the only entity that ever made any real money off the grant was the Colorado Fuel and Iron Company, owned by the Rockefeller family, which exploited coalfields below the land.

Settlement of the Maxwell Grant conflict, followed in 1891 by the establishment of a Court of Private Land Claims to handle land grant issues in New Mexico, Arizona, and Colorado, eased national concerns about corruption. But there was a deeper concern, a combination of racism and reality. Four decades after the Mexican War a majority of New Mexicans were brown-skinned, Spanish-speaking Catholics, and a shocking percentage of them were illiterate. In 1890, with a territorial population of 154,000, one-third could not read or write, while only 12,000 out of 44,000 school-age children attended schools. The roots of the problem lay in a traditional agricultural society where Hispano people resisted U.S.-style property taxes and the Catholic Church staunchly maintained responsibility for education, doing the best it could with limited resources. After decades of failed education bills the territorial legislature made up for lost time by creating six different four-year colleges between 1889 and 1893, despite the fact that the first public high school was not established until 1891. If the University of Arizona struggled to find students for one school, the New Mexican colleges could hardly hope to find qualified students for six.

In 1900 New Mexico had a population of 195,000 while Arizona had a population of 120,000, which means that both territories combined, covering almost one-twelfth of the continental United States, had about 28,000 fewer people than lived in the tiny city of San Francisco. In contrast, California now had over 1.4 million while the population of Texas topped 3 million. Low population alone was not a roadblock to statehood; Nevada, granted statehood in 1864 on the heels of the Comstock silver rush, had a population of only 42,000 in 1900, while Wyoming, Montana, Idaho, and Utah had all been admitted with populations comparable to Arizona and New Mexico.

While citizens of the two territories held statehood conventions and wrote draft constitutions, the federal government established a new presence in the

Southwest that focused for the first time on conquering and protecting the land rather than the people who lived on it. Looking for a large-scale project to establish its credentials, the U.S. Reclamation Service accepted the invitation of Phoenix boosters to build a dam on the Salt River just below its confluence with Tonto Creek. The Roosevelt Dam, constructed between 1906 and 1911, was the largest masonry dam in the world up to that time, and the reservoir it created, 25 miles long and 2 miles wide, was the largest artificial lake. Assured of a steady water supply, Phoenix began to boom, its population doubling in the first decade of the 20th century while the dam was under construction and then almost tripling between 1910 and 1920. By that year, with over 29,000 people, it was the largest city in Arizona, surpassing the much older settlement of Tucson. The surrounding area was booming as well, with almost 90,000 people in Maricopa County. If the Reclamation Service was "the new Moses of the deserts," as one historian has phrased it, then Phoenix was the promised land.

Former Los Angeles mayor Fred Eaton (center) masterminded the Owens Valley project, but it was his friend and protégé, William Mulholland (right) who carried it to completion. U.S. Reclamation Service employee J. B. Lippincott (left) was so co-operative that he received a high-paying job for the Los Angeles Board of Public Works and served as Assistant Chief Engineer on the aqueduct.

Reclaiming desert land first flourished during the presidency of Theodore Roosevelt, for whom the Salt River dam was named. Roosevelt truly loved the West, and he believed in both reclamation and preservation. During his presidency the first national monuments were created in the Southwest, including the Grand Canyon and a number of early Indian sites. Serious interest in the Grand Canyon began in 1901, when the Santa Fe Railroad built a spur line to the South Rim. Two years later Roosevelt himself visited the canyon and summed up his vision of preservation: "You cannot improve on it," he said. "The ages have been at work on it, and man can only mar it." Along with establishing national monuments, many of which would later become national parks, the federal government also set aside huge tracts of land in both Arizona and New Mexico as national forests, eliciting moans and groans from ranchers, loggers, and land speculators.

All this federal activity increased the desire for statehood in Arizona and New Mexico. The problem was that both territories still made Washington bigwigs nervous, particularly Senator Albert J. Beveridge of Indiana, chairman of the Senate Committee on Territories. Beveridge was an impressively literate man and a good Progressive in the Roosevelt mold, but he had low regard for the old Spanish colonies that had just been obtained in the Spanish-American War. The service of Spanish-speaking New Mexican soldiers during the war had proved their loyalty to the United States, but the war itself stirred up anti-Hispanic feelings at precisely the time the Southwest territories were making serious noises about statehood. To Beveridge, New Mexico was too Mexican, its majority Spanish-speaking electorate too easily manipulated by political bosses. Arizona still seemed a wild frontier, and

the strong Mormon and Hispanic minorities there made him almost as nervous as the Hispano majority in New Mexico. In fairness to Beveridge, he was also concerned that corrupt mining and railroad interests were using the statehood movement to grab control of the land.

Figuring that two senators of questionable lineage were better than four, Beveridge supported a bill to admit Arizona and New Mexico as a single state to be named Arizona, with its capital at Santa Fe. President Roosevelt also supported the measure and twisted arms among the Progressive branch of the Republican Party. The New Mexicans, who would form a majority in the megastate, generally approved of the idea, but there was resistance from powerful men who insisted on single statehood, including former governor Miguel Otero, a Roosevelt Progressive who had been the first Hispano governor under American rule, and Thomas Catron, a conservative, anti-Progressive Republican who continued to exert enormous power over the territory. Even so, the well-oiled Republican political machine brought out the votes, and the measure passed by a solid majority of 26,195 for jointure to 14,735 opposed during the election of November 1906.

Arizona was another story. There the Anglo majority, who had only recently surpassed the Hispanic population in the territory, did not want to tie their future to a bunch of "greasers," as the papers put it, while the mining-industrial interests feared that the primarily agricultural New Mexicans would keep farm taxes low while raising taxes on the extraction industries. Arizona's political powers were mostly Democrats who did not trust "that Republican unproductive gang" in Santa Fe, in the words of Democratic territorial delegate Marcus Smith, who neatly summed up what he and other Arizonans perceived as the fundamental flaw in Beveridge's joint-state logic: "He proceeds from his own argument on the principle that one rotten egg is bad, but two rotten ones would make a fine omelette." Arizonans voted overwhelmingly against the omelette, 16,265 to 3,141, which effectively put an end to the joint-state concept.

By the time he left office in 1909, President Roosevelt had changed his mind and in his final message to Congress advocated admission of Arizona and New Mexico as separate states. His successor, William Howard Taft, who represented the conservative wing of the Republican Party, was not excited about the idea, but he refused to work against it, and Senator Beveridge's continuing opposition gradually faded into a minority position. In 1910 Congress passed an enabling act that allowed both territories to prepare state constitutions. Although Hispano people were still a majority in New Mexico, the constitutional convention was dominated by Anglo conservative Republicans. Hispano delegates were generally conservative as well, and one scholar has commented that the constitution the New Mexicans created would have been more appropriate in 1810 than 1910. Women were denied the right to vote, and most other Progressive ideas were rejected, although school segregation was forbidden and bilingual education was enabled. Just as significant, the constitution was almost impossible to amend.

The Arizona constitutional convention was dominated by liberal Democrats who created a modern constitution full of Progressive ideas, including women's suffrage, integrated schools, anti-lobbying and anti-corruption provisions, child labor laws, direct primaries, direct election of senators, and the big three of populist politics: initiative, referendum, and recall. President Taft objected so strongly to the recall of judges, fearing it would undercut the power of the judiciary, that he vetoed the first admission bill and only authorized admission after the provision was removed. New Mexico, whose conservative constitution created few objections, was admitted as the 47th state on January 6, 1912, and Arizona followed on February 14. Once accepted, Arizona's Democratic state legislature quickly reinserted the judicial recall provision. That fall, with the Republican Party deeply divided between Taft and Roosevelt, both Arizona and New Mexico joined most of their fellow states in electing the progressive liberal Democrat Woodrow Wilson to the White House.

Havasu Falls. Grand Canyon, Arizona

THE
NEW SOUTHWEST

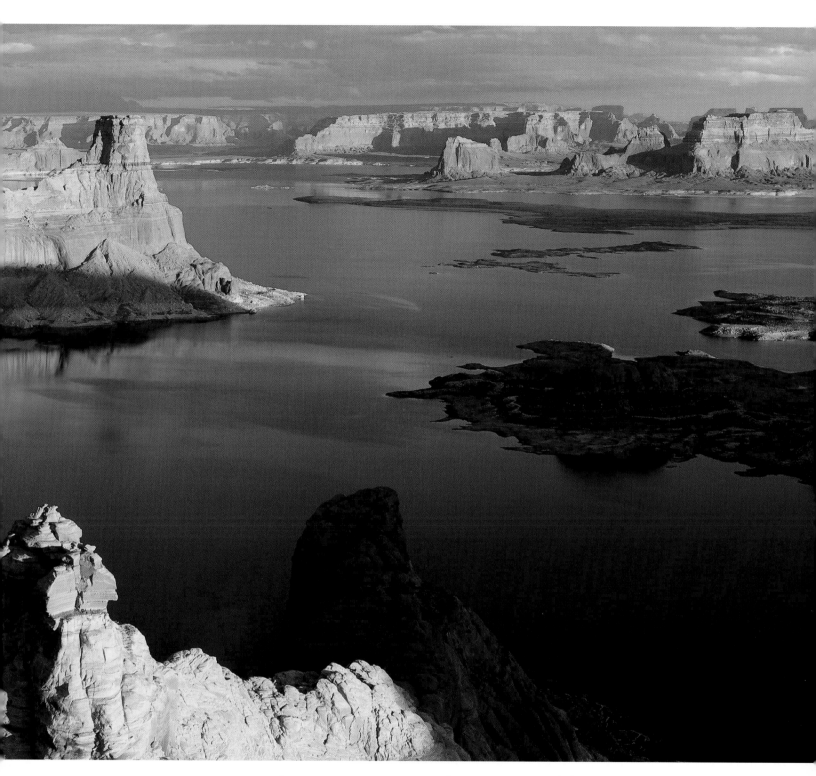

Padre Bay, Lake Powell

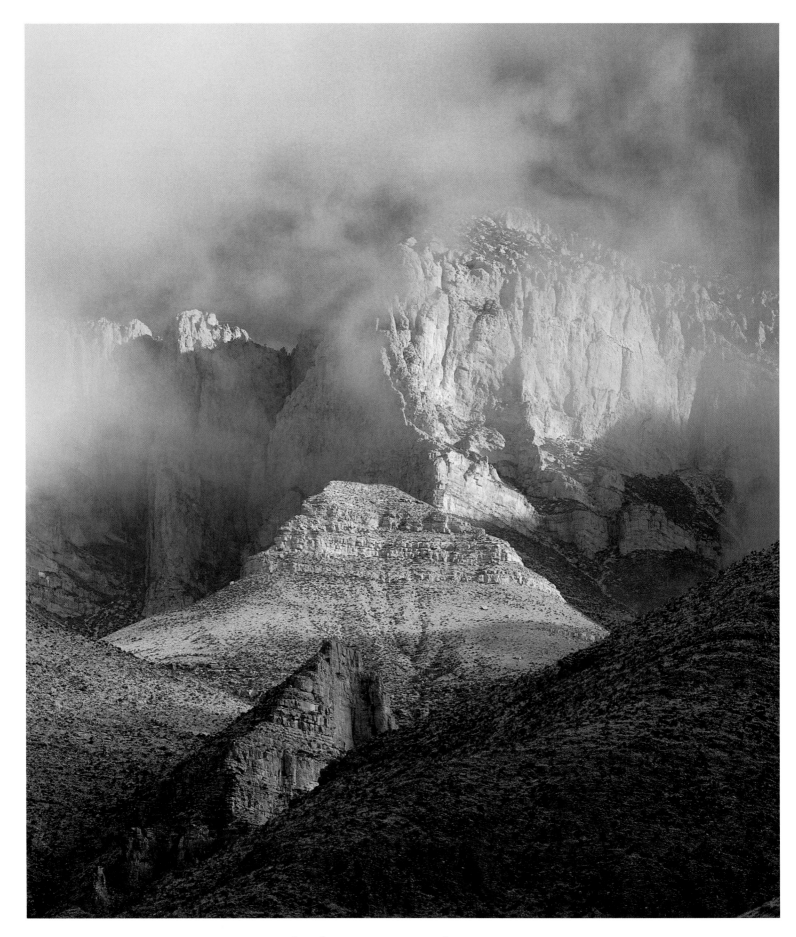

Guadalupe Peak, Texas

1910 - PRESENT

THE NEW SOUTHWEST

IN OCTOBER 1910 A SHORT, SQUEAKY-VOICED MEXICAN INTELLECTUAL NAMED FRANCISCO MADERO SNEAKED ACROSS THE BORDER AT LAREDO, TEXAS, HIDDEN IN A RAILROAD BAGGAGE CAR. HE MOVED ON TO SAN ANTONIO, WHERE HE ISSUED A MANIFESTO CALLING FOR A GENERAL UPRISING AGAINST MEXICAN PRESIDENT PORFIRIO DÍAZ, WHO HAD GRABBED POWER 34 YEARS EARLIER AND REFUSED TO LET IT GO. A DREAMY IDEALIST WHO COMMUNED WITH SPIRITS, INCLUDING THE GREAT DEAD PATRIOT BENITO JUÁREZ, MADERO DEMANDED FREE ELECTIONS, A SINGLE-TERM PRESIDENCY, A FREE PRESS, AND AN INDEPENDENT JUDICIARY. OF LESS IMPORTANCE IN HIS MIND, THOUGH MORE POWERFUL IN THE LONG RUN, WAS A CALL FOR THE RETURN OF CERTAIN LANDS TAKEN FROM PEASANT FARMERS. THE REVOLUTION WAS SCHEDULED TO BEGIN ON SUNDAY, NOVEMBER 20, AND ON THAT DAY MADERO RETURNED TO THE RIO GRANDE, WHERE HIS UNCLE CATARINO WAS SUPPOSED TO MEET HIM WITH 400 MEN FROM COAHUILLA. CATARINO CAME LATE, WITH ONLY TEN MEN; MADERO HAD TEN MEN, TOO. THERE WERE A FEW OTHERS BUT HARDLY ENOUGH TO START A REVOLUTION, AND MADERO WENT INTO HIDING IN NEW ORLEANS, UNDAUNTED IN HIS VISION BUT UNCERTAIN OF WHAT TO DO WITH IT.

An egoless man, Francisco Madero underestimated the power of his words and the purity of his vision. On that same day, scattered uprisings broke out in several Mexican states; most fizzled, as his did, but in the northern border state of Chihuahua—where men had been fighting Apache and wealthy landowners for generations—a revolutionary army emerged under 28-year-old Pascual Orozco, a tough six-footer who had been escorting mining caravans through bandit-infested Chihuahuan mountains. One Mexican historian called it "an army of rags, without money, without any notions of military discipline . . . some carried axes instead of rifles, others, far from inspiring fear, inspired pity."

Like the War of Independence a century earlier, the Revolution of 1910 turned into a complex, protracted struggle with shifting loyalties and alliances. But now there were new factors in the mix: the 1,951-mile U.S.-Mexico border and the palpable concern of Americans for internal Mexican affairs. Under Díaz, Mexico had achieved a level of economic stability; American capitalists had heavy investments south of the border, especially in mineral-rich Chihuahua and Sonora, where old interests in gold, silver, and copper were joined by modern oil companies. The heart of this Mexican-American connection were the twin cities of El Paso and Ciudad Juárez, the old El Paso del Norte, which had been renamed for Madero's spirit mentor. Five American railroads converged at El Paso, meeting Mexican rails that led from Juárez to Mexico City. Recognizing the strategic importance of this railroad connection, Madero crossed the Chihuahua border in February 1911 with about a hundred men, half of them Americans, planning to attack Juárez. It was a good idea, but the timing was not right. Orozco was slow to offer allegiance, federal troops reinforced the city, and Madero's men lacked guns. Instead, he led a disastrous attack on the heavily fortified Chihuahuan city of Casas Grandes.

Despite the defeat, Madero's presence in Mexico electrified the nation, and by April the revolution had spread to 18 Mexican states, including a major insurgency in the south under Emiliano Zapata. President

William Howard Taft sent 20,000 troops to reinforce the border while struggling to convince the Mexicans that there would be no direct intervention. By this time a new army had arisen in Chihuahua, led by a former cattle thief who was born Doroteo Arango but became famous as Francisco "Pancho" Villa. Unlike Orozco, Villa was fiercely loyal to Madero, whom he considered a personal savior. On May 10, 1911, the combined Orozco-Villa forces took Juárez after three days of furious fighting against Díaz's federal troops. The people of El Paso gazed in wonder at the martial spectacle across the river, scrambling for better views on rooftops, standing on railroad cars, or gathering along the riverbank as American soldiers tried to keep them safe from stray bullets. "It was a beautiful sight to see the shrapnel bursting up in the air," recalled an El Paso judge, "and scattering its death-dealing missiles on the hills and valleys surrounding."

With the key border connection in rebel hands, President Díaz resigned on May 25. After a rocky interim government dominated by Díaz supporters, Francisco Madero became president that November in the freest election ever held in Mexico to that time. But the man who received instructions from spirits and combed the *Bhagavad Gita* for inspiration was too magnanimous to control the troubled nation. In 15 months there were three major insurrections, one by Pascual Orozco, others by a nephew of Díaz and a drunken general from Sonora named Victoriano Huerta, who combined forces and had Madero assassinated in February 1913, with Huerta assuming the presidency. A driving force behind the coup was freewheeling American ambassador Lane Wilson, who liked Porfirio Díaz but considered Madero a "fool" and a "lunatic."

Madero's death plunged Mexico into a bloody civil war that lasted throughout the decade. In the northern border region Pancho Villa launched a campaign of vengeance that captured the attention of the world. Financed by two Sonoran generals he met in Tucson, Villa crossed the Chihuahua border in March 1913 with eight followers and began a campaign to cap-

ture the hearts and minds of the people, invoking the spirit of Madero while using a combination of American connections, personal charisma, and strong-arm tactics to build himself an army. In September the revolutionary commanders of Chihuahua and Durango elected him to lead a united force of some 8,000 men to be called the División del Norte, or Division of the North. In quick succession Villa's troops captured the nerve center of the Mexican railroad system at Torreón, recaptured Juárez, defeated 5,000 federal soldiers on the plains of Tierra Blanca, and took the capital city of Chihuahua, where he installed himself as governor for a month and introduced radical land reform measures before returning to the field of battle.

By May 1914 Villa was in the midst of a tri-

Although he later turned against the United States, in his glory days at the head of the División del Norte, Pancho Villa was an American media darling: the "Mexican Robin Hood" and the "future peacemaker of Mexico," who respected American property and people while vanquishing the foes of democracy. In January 1914, a Hollywood company contracted to film the División del Norte in return for $25,000. Villa agreed to schedule battles during the day, simulate combat as necessary, and postpone executions so there would be good light.

In late 1913 thousands of civilian refugees and federal soldiers crossed the Rio Grande at Presidio, Texas, and asked for protection from the American army. Unable to handle so many refugees in Presidio, the commanding officer marched them in groups to the railroad station at Marathon, Texas, and shipped them to Fort Bliss in El Paso, where some four to five thousand Mexican nationals were kept behind barbed wire fences for the first four months of 1914.

umphal southward march with an ever growing army that swelled to over 50,000 men at its height. In June the División del Norte defeated federal forces at Zacatecas, and the following month General Huerta went into exile. The Constitutionalists had emerged triumphant, and no one had played a more important role than Pancho Villa, but his star soon began to fade. The victorious rebels split into two factions: one led by an older, moderate rancher from Coahuilla, Venustiano Carranza, who had the support of several powerful generals, including Álvaro Obregón of Sonora; the other faction was an uneasy alliance between the younger populists Pancho Villa and Emiliano Zapata. During 1915 the split between these rebel factions exploded in full-scale warfare, with Obregón handing Villa a series of stunning defeats. On October 19 the government of Woodrow Wilson, who had called Villa

"the greatest Mexican of his generation," officially recognized Venustiano Carranza as President of Mexico and allowed Carranza's troops to travel by American railroad through U.S. territory in order to reinforce a garrison at Agua Prieta, just across the border from Douglas, Arizona. There Obregón again defeated Villa, aided by floodlights that Villa believed came from the U.S. side of the barbed wire fence.

Villa, who had always protected American property and maintained cordial communications with American officials, felt a deep and bitter betrayal. "I sincerely and emphatically declare that I have much to thank Mr. Wilson for," he wrote sarcastically, "since he has freed me of the obligation to give guarantees to foreigners. . . . I decline any responsibility for future events."

By the end of the year the once proud División del Norte had laid down its arms and accepted amnesty while Villa continued a guerrilla campaign with a few hundred loyal followers. He now had two enemies: Venustiano Carranza and the United States. On January 10, 1916, a small contingent of *Villistas*, Villa's soldiers— apparently acting on orders from Villa—stopped a train in Chihuahua and systematically murdered 17 American mining engineers and the mine manager, sparing passengers of other nationalities. Eight days later Villa assembled 200 men and set off to attack the Texas border town of Presidio, but so many men deserted that he turned back and recruited new Villistas by force, shooting those who refused to join.

On March 8, 1916, Villa's army of 400 men camped four miles from the border town of Columbus, New Mexico, where a few hundred people lived in mostly wooden shacks protected by an army garrison of 600 soldiers. Villa knew that Columbus was a commercial center for an agricultural region on both sides of the border; there would be money in the bank and merchandise in the stores. It was also said that a leading merchant, Russian immigrant Sam Ravel, had taken money from Villa to supply guns and failed to deliver.

The Villistas entered Columbus under cover of darkness at 4:45 a.m. on March 9. They split into two groups: One surprised the sleeping soldiers on the south end of town; the other stormed into the business district, where they were supposed to rob the bank, shoot Sam Ravel, and burn down his properties. As it turned out, Ravel was in El Paso visiting his dentist, but the Villistas captured his 17-year-old brother, Arthur, and forced him to try and open the safe at the store and the bank. Both remained firmly closed, the first through Arthur's bluffing, the second because he did not know the combination. The citizens of the town woke in terror to shouts of "Viva Villa! Viva Mexico!" One young girl later recalled that bullets sounded like "hail on the roof." The Villistas attacked the Commercial Hotel, also owned by Sam Ravel, and shot several guests before burning the hotel to the ground in a brilliant blaze that allowed the American soldiers to distinguish between Villistas and citizens. With a lethal barrage of machine gun fire, the troops drove the invaders out of town by seven that morning. More than a hundred Villistas died, while the survivors escaped with a few dollars, a few horses, and a few guns. Seven American soldiers and ten civilians died; another soldier died the following day.

If the true purpose of the raid was to provoke an American invasion, then it succeeded. Gen. John J. "Black Jack" Pershing pursued Villa with an army of almost 11,000 men, using the Punitive Expedition to test modern methods of mechanized warfare that would soon be used in World War I. Trucks, cars, and motorcycles transported troops and supplies; and the entire Aeronautical Division of the Signal Corps, a grand total of eight planes, flew reconnaissance. By March 16, exactly a week after the attack on Columbus, the first column of 5,000 men had entered Mexico. Although they inflicted substantial damage on Villa's followers, they never found Villa; he was seriously injured in a battle with Carranza's troops and disappeared to recuperate in a mountain cave. Initially, Pershing's forces operated with the secret support of Carranza, but tensions escalated into a battle with Carranza's forces that June, with almost a hundred Mexican and American soldiers killed. President Wilson called out 100,000

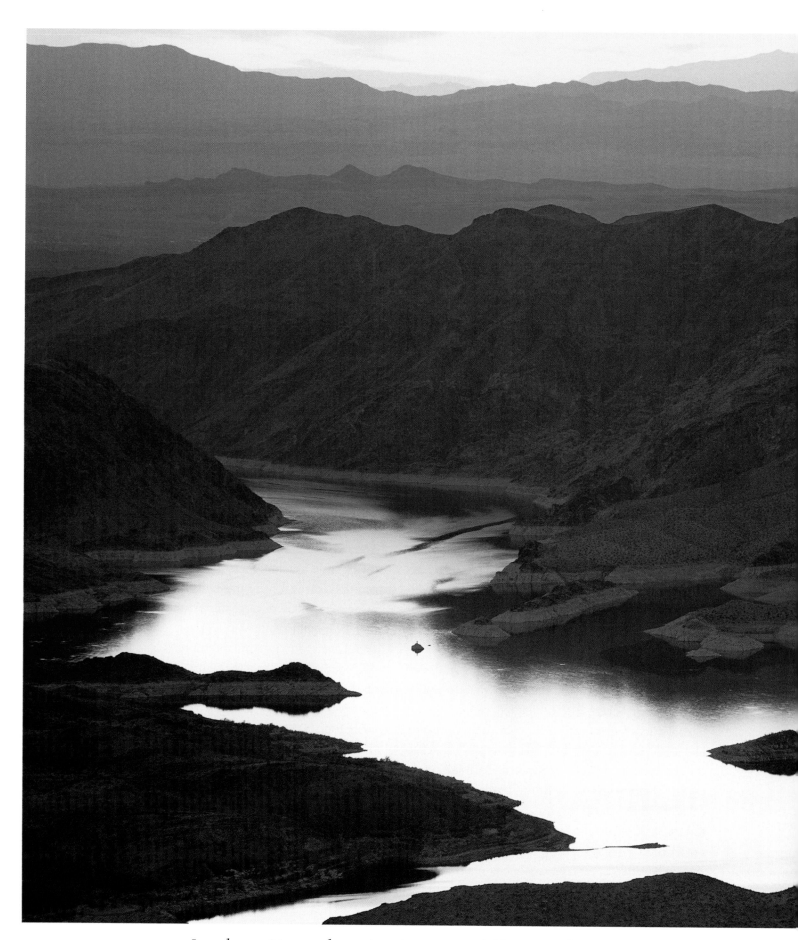

Lake Mead, Arizona/Nevada

National Guardsmen to protect the border, but the situation diffused as Pershing's men retreated to a sandy outpost near a Mormon colony in northern Chihuahua.

The expedition returned to the United States in early 1917 to prepare for World War I, but as Villa had hoped, the American invasion succeeded in renewing his popularity. In September 1916 Villa attacked the city of Chihuahua with almost 2,000 men, freeing political prisoners and embarking on a last-ditch campaign that combined the old Villa flair with a new, more desperate brutality. The ride came to an end in June 1919, when Villistas attacked Ciudad Juárez, wounding several Americans across the river in El Paso and drawing American troops back into Mexico for the last old-style cavalry charge of the West. In 1920 Venustiano Carranza was assassinated before his term of office expired. The interim president cut a deal in which Villa agreed to stop fighting in return for a sprawling hacienda and an escort of 50 men. Villa enjoyed his retirement until he too was assassinated in 1923, blasted by a shower of bullets as he drove his Dodge touring car through a southern Chihuahua town.

AS THE MEXICAN REVOLUTION ROCKED the borderlands of Texas, New Mexico, and Arizona, the city of Los Angeles continued to grow and thrive with the stolen water of the Owens River Valley. By 1920, with a population of over 576,000, Los Angeles had passed San Francisco as the largest city in the West, which also meant it was the largest city in the American lands that once belonged to Spain. Remarkably, during the good times of the Roaring Twenties, it would continue to grow at a rate of almost 100,000 people per year, and the magic elixir that allowed this growth was the water. Although the people of the Owens Valley were outraged when they first discovered plans to build the aqueduct, their anger was tempered during the early years by the fact that Los Angeles took its water from lower in the valley, leaving enough to irrigate their orchards and fields. Also a new prosperity was brought by construction and maintenance of the aqueduct and

a railroad connection with Los Angeles. During the twenties, however, a drought hit Los Angeles and the Owens Valley alike, and suddenly the situation turned.

At the heart of the problem was the lack of a long-term storage facility, a problem that dated back to the early days of the aqueduct project, when former Los Angeles mayor Fred Eaton bought the ideal reservoir site at Long Valley high on the Owens River and then demanded a million dollars to build a reservoir on his land. Eaton's old friend and protégé William Mulholland stubbornly refused to pay the price out of enmity for a friendship gone sour. Instead, Mulholland decided to buy up the remaining water rights, essentially draining the valley dry, and build a storage facility at a less desirable site northwest of Los Angeles at a place called San Francisquito Canyon.

This time the citizens of Owens Valley rebelled, led by brothers Wilfred and Mark Watterson, who owned the Inyo County Bank and had loaned money with casual generosity to almost anyone who needed it. In making his final water grab, Mulholland co-opted the services of their ne'er-do-well uncle George, who was jealous of his nephews' success. As George Watterson and two other men in Mulholland's employ began buying land and water rights from those who were willing to sell, the farmers and ranchers who hung on became increasingly desperate. On May 21, 1924, a group of men obtained three cases of dynamite from a warehouse belonging to the Watterson brothers and blew up a large section of the aqueduct. A few weeks later another section was dynamited, and that November 70 armed men led by Mark Watterson seized floodgates in the heavily eroded Alabama Hills and released the precious water into the desert. By noon the next day some 700 men, women, and children had gathered at the spillway, and the tense situation turned into a five-day barbecue, complete with a mariachi band supplied by Western star Tom Mix, who was making a film in the nearby town of Bishop.

The local Inyo County newspaper called the insurgents an "American community. . .driven to defense of its rights," and even the *Los Angeles Times* expressed sympathy in an editorial: ". . .these farmers are not anarchists nor bomb throwers, but, in the main, earnest, honest, hardworking American citizens who look upon Los Angeles as an octopus about to strangle out their lives." William Mulholland would have none of it. The tough, no-nonsense personality that brought success in building the aqueduct had hardened over the years into something crueler and more callous. Before the troubles broke out, a *Times* reporter had asked him about dissatisfaction in the valley, and he replied with cutting sarcasm, "Dissatisfaction is a sort of condition that prevails there, like foot and mouth disease." Now his public relations people blanketed the state with a propagandistic booklet explaining away the crisis while the people of the valley abandoned their farms and fields and stores.

In 1927 another round of sabotage broke out, this time a series of bigger and more destructive blasts that Los Angeles answered with a trainload of city detectives armed with Winchester carbines and machine guns. They established what amounted to illegal martial law, shining floodlights across the desert and stopping every car that carried men. Remarkably, for all the threatened violence and real dynamite, no one had yet been killed. Someone surely would have been had it not been for another underhanded piece of work by Mulholland and Uncle George Watterson, who searched for dirt on the Watterson brothers until they found some: The two bankers, who had been so generous with money entrusted to them by the people of the valley, had committed large-scale fraud and embezzlement in the process. It was all for the good of the valley they claimed, and most who knew them believed them—the prosecuting attorney said he would have acted as a character witness on their behalf if he did not have to do his job, and the judge cried as he sentenced them to San Quentin. The heart of the Owens Valley resistance was broken.

In early March 1928, just four months after the Watterson brothers were packed off to San Quentin, the reservoir of the St. Francis Dam reached its capacity of 11.4 billion gallons and immediately began to leak. Leaks

are normal in new dams, but normal leaks are clear and the St. Francis leaks were brown, which meant water was seeping through the canyon walls and softening the structure itself. On March 12 Mulholland went out to inspect the dam and quickly concluded that the brown leaks were coming from a construction site. That night the dam exploded, and a massive wall of water, mud, and debris rushed down into San Francisquito Canyon and on into the Santa Clara River Valley before finally spending its fury in the Pacific Ocean between the towns of Ventura and Oxnard. The death toll was estimated at 400 to 450—though grisly remains that turned up years later suggest it may have been closer to 500—with 1,200 homes destroyed and 8,000 acres of farmland laid to waste. The city of Los Angeles paid almost 15 million dollars in damages, which would have not only bought Fred Eaton's Long Valley site but paid for construction as well.

William Mulholland and the Department of Water and Power believed the dam had been sabotaged. Intriguing threads of evidence suggested this was a possibility, but much of this evidence was withheld or given short shrift at the time of the investigations. Mulholland and the city of Los Angeles were deeply involved in yet another, even larger water project—lobbying for a huge dam at Boulder Canyon on the Colorado River—and they feared the idea that the St. Francis Dam might have been dynamited would jeopard-

ize the Boulder Dam project. Then, too, there was plenty of evidence for the other point of view: The dam had failed because it was built on a weak geological formation; the reason it was built on a weak geological formation was that William Mulholland, an untrained engineer who never consulted a geologist, had become a law unto himself in trying to satisfy the endless thirst of Los Angeles.

After a painfully dramatic inquest the coroner's jury laid responsibility on Mulholland, government officials, and the "public at large," concluding that "The construction of a municipal dam should never be left to the sole judgment of one man, no matter how eminent." In November 1928 William Mulholland resigned in disgrace as chief superintendent of the Los Angeles Department of Water and Power. He was 73 years old. When he first went to work in 1876 as a ditchdigger for what was then the privately owned City Water Company, Los Angeles was a dusty town of 15,000. Now it was a booming metropolis approaching 1.5 million, and no one deserved greater credit for that success than hard-driving, hard-drinking Big Bill Mulholland.

The concrete in Hoover Dam could form a monument a hundred feet square and two-and-a-half miles high or pave a standard highway 16-feet wide from San Francisco to New York. The water in Lake Mead behind the dam could flood the entire state of Pennsylvania to the depth of one foot.

THE COLORADO RIVER RISES HIGH in the Rocky Mountains just west of the Continental Divide and

This drought-stricken Oklahoma farm family reflects the combination of dignity and despair of those who suffered through the Dust Bowl years. Drought had been creeping steadily into the Great Plains region during the early 1930s, but the crisis came on April 14, 1935, "Black Sunday," when a giant windstorm covered parts of five states with a layer of dust that turned night to day.

drops over 10,000 feet on its long and torturous 1,440-mile journey to the Gulf of California . . . if it makes it to the gulf, which today happens rarely, only in the wettest years. More often than not, the once great carver of canyons degenerates to a trickle and disappears in alkaline mudflats 10 or 20 miles short of its goal. Draining a vast, arid basin of 244,000 square miles—larger than the states of Arizona and New Mexico combined—the Colorado has been called the most used and abused river in America, every drop of its precious water allocated to feed the needs of thriving desert cities and sprawling desert farms. Over 25

million people depend on the river for life, and 3 million of them would need no other electrical source than the hydropower generated by its dams.

Diversion of water in the Colorado Basin began with the Hohokam and ancestral Puebloans, who tapped tributaries such as the Gila, the Salt, and the San Juan to irrigate their fields. In the mid-19th century Mormon settlers diverted tributaries in Utah, but the first known diversion of the Colorado itself—and the first time water was transported out of the basin—occurred in 1892, when the people of Denver began pumping the headwaters over the Continental Divide through a canal called the Grand Ditch, which can still be seen today as an ugly gash along the pristine mountain ridge. More substantial diversion came in 1901 at the other end of the river, when George Chaffey brought the brownish red, sediment-rich Colorado waters to the Imperial Valley of California. After the disastrous floods of 1905-1907 valley farmers tried to put their tenuous desert world back together, forming the Imperial Irrigation District in 1911 and lobbying the federal government for help in building a new All-American Canal that would run completely on the U.S. side of the border. The old canal ran though Mexico, which not only made it harder to maintain but also allowed farmers on the Mexican side to take half the water. Most of the potentially arable land south of the border was owned by a syndicate dominated by Harry Chandler, publisher of the *Los Angeles Times*, who made a fortune buying San Fernando Valley land with inside information on the Owens River project and later worked against diversion of Colorado River water to Los Angeles in a classic case of putting private greed over the needs of the city he supposedly served.

In 1919 the Imperial Valley farmers managed to get a bill authorizing the new canal introduced into the U.S. House of Representatives, which immediately caught the attention of Arthur Powell Davis, director and chief engineer of the U.S. Reclamation Service (renamed the Bureau of Reclamation in 1923). Although the dam on the Salt River near Phoenix had proved the service's engineering capabilities, the larger reclamation mission to provide new lands for small farmers teetered on the edge of failure due to a variety of factors, including poor planning on the part of the service in settling inexperienced farmers on difficult desert lands. Davis wanted a really big project to show what he could do for the arid Southwest, and he sensed this might be the ticket. "The Imperial Valley problem," he proclaimed, ". . . is inseparably linked with the problem of water storage in the Colorado Basin as a whole." The canal would only work as part of a multipurpose project, with a large dam to control flooding in the lower river and store the excess water from wet years. Such a dam could also produce hydroelectricity, which would be sold to offset the costs of the project. In 1922 two Californians, Congressman Phil Swing and Senator Hiram Johnson, introduced a bill providing for the dam "at or near Boulder Canyon" along the Nevada-Arizona border, a hydroelectric plant, and the All-American Canal.

The Boulder Canyon bill inspired panic throughout the Colorado River Basin, not unlike the panic when the people of Owens Valley first discovered plans for the Los Angeles Aqueduct. Only this time the conflict was not a single city fighting a rural valley over a midsize stream but rather one state battling six others over the biggest river in the Southwest. Anti-California hysteria grew even worse two months after the bill was introduced when the U.S. Supreme Court handed down a decision in *Wyoming v. Colorado*, which affirmed that the old principle of prior appropriation applied to conflicts between states: The state that used the water first established the right to that water. Since the pace of growth in California far outstripped growth elsewhere in the Colorado River Basin, California could theoretically take the lion's share of the river. With the other states threatening to stop the project while fearing the federal government might force it through in the interests of flood control, six of the seven states reached a compromise in November 1922 in which the upper basin states of Colorado, Wyoming, Utah, and New

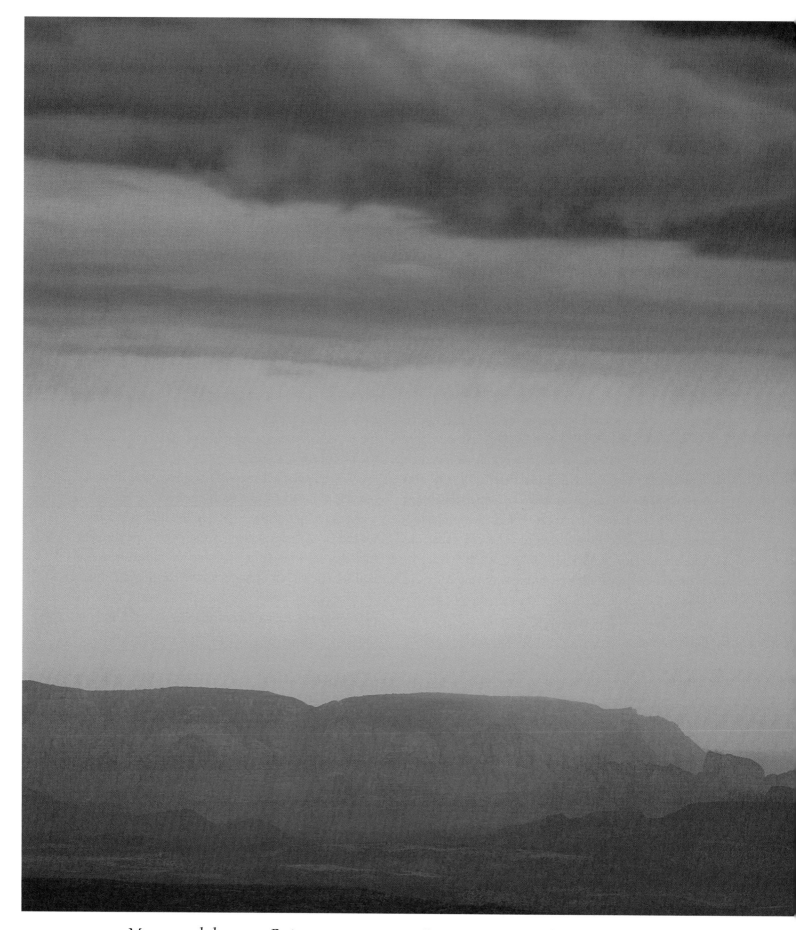

Mogollon Rim, near Jerome, Arizona

Mexico agreed to deliver an annual average of 7.5 million acre-feet of water to the lower basin states of Arizona, Nevada, and California. (An acre-foot, about 326,000 gallons, will cover an acre one-foot deep and supply the indoor and outdoor water needs of one to two households for a year.) Theoretically, a similar amount would remain in the upper basin, while the lower basin could take another million as needed. Only Arizona refused to sign, fearing that since the compact did not allocate water to individual states, California would take most of the lower basin water. In 1928 the final version of the Boulder Canyon Project Act limited California to 4.4 million acre-feet and no more than half of any surplus water, but still Arizona refused to ratify the agreement until 1944, when it began to seek new federal projects of its own, including a canal that would bring water to Phoenix and Tucson.

As the compact was being negotiated, William Mulholland decided to grab some of the water for Los Angeles. He began organizing a bond issue to build a new aqueduct, and in the fall of 1923, even as he prepared to drain every drop from the Owens Valley, Mulholland and other engineers explored the lower Colorado in rowboats, posing for a famous photo that proclaimed to the people of his adopted city: "This water, too, will be yours." In 1928 Los Angeles and a number of nearby cities formed the Metropolitan Water District to build the Colorado Aqueduct, and five years later construction began on a diversion dam on the Colorado along the California-Arizona border. Arizona, already disgusted with the Boulder project, vowed to stop the Californians from anchoring the dam on their side of their river, and in November 1934 Governor Benjamin B. Moeur sent out more than a hundred National Guardsman, gamely announcing, "We may get licked in the affair, but we will go down fighting." The conflict was decided in Arizona's favor by the U.S. Supreme Court because Congress had not officially authorized the dam, but the California delegation soon took care of that detail, and Colorado River water reached the Los Angeles area in 1941. Ironically, neither

PROJECT Y

In August, 1939, Albert Einstein wrote to Franklin D. Roosevelt, explaining that recent scientific work had convinced him "that it may become possible to set up nuclear chain reactions in a large mass of uranium, by which vast amounts of power and large quantities of new radium-like elements would be generated. . . . This new phenomenon would also lead to the construction of bombs, and it is conceivable—though much less certain—that extremely powerful bombs of a new type may thus be constructed." Inspired by Einstein's letter and fears that Germany would develop an atomic bomb, the United States began an all-out effort code-named the Manhattan Project. By fall of 1942, two remarkably capable men shared control of the project: physicist J. Robert Oppenheimer and General Leslie R. Graves. Although Oppenheimer had been involved before him, Graves asked the charismatic scientist to head "Project Y," responsible for research, development, and production of the bombs.

Oppenheimer and Graves agreed that project scientists should be gathered in one place—which the Army required to be remote and uninhabited enough for safety and security, yet with housing for 30 scientists. Oppenheimer also wanted the site to be beautiful enough to maintain morale among top researchers and their families—or as Graves put it, "to keep a bunch of prima donnas happy"—and he knew the perfect place from time he had spent in New Mexico: Los Alamos, on the rugged Pajarito Plateau northwest of Santa Fe. The only large private holdings were a boys' school and a ranch, both quickly obtained by the government with the boys' school providing housing for the first scientists. It was perfect, except for the fact that they would have to build a small city and highly sophisticated research facility 40 miles from the nearest railhead or airport with inadequate roads, insufficient water and electricity, no natural gas, and few available workers.

The M. M. Sundt Construction Company began work in December 1942 and completed more than half the construction by February 2. Personnel began to arrive in mid-March and by the end of the year, there were some 500 employees and 2,000 people living where there had been next to no one. At its wartime height, there would be 3,000 working in the laboratory—a hundred times more than the Army's original estimate—including some of the world's most brilliant scientists. Security was so tight that driver's licenses had no names, and "Los Alamos" was replaced by the vague address: P.O. Box 1663, Santa Fe, New

Mexico. It was necessary to check the level of a big wooden water tank to decide if it was okay to take a bath, while the quickly constructed houses were dangerous. "They weren't bad houses," recalled one woman, "except they just kept catching fire."

The scientific challenges were greater. In December 1942, a team under Enrico Fermi had created the first man-made nuclear chain reaction at the University of Chicago. But Fermi's reaction used natural uranium, which is more than 99 percent U-238, a heavy isotope unsuitable for use in a bomb. Techniques for separating out the lighter isotope, U-235, were in their infancy, while the entire world's supply of plutonium, another fissionable element derived from uranium, could fit on the head of a pin. General Graves ordered a separation plant built in Oak Ridge, Tennessee, devoted primarily to producing uranium with a high proportion of U-235, while a second plant was built in Hanford, Washington, to produce plutonium. Both plants delivered fissionable materials in the nick of time, but when Project Y began neither plant existed and no one knew how to build a nuclear bomb, let

Robert Oppenheimer and General Leslie R. Graves, the two men who drove Project Y to successful completion, inspect the Trinity site shortly after the explosion of the first atomic bomb.

alone a bomb that would explode when and where it was supposed to explode.

In just 28 months, the scientists of Project Y solved these problems and more. They tested the first plutonium bomb on July 16, 1945, in the desolate Jornada del Muerto, literally "Journey of the Dead," at a site code-named Trinity. The bomb exploded just before 5:30 a.m. Enrico Fermi, who watched through dark welding glass from ten miles away, remembered "a very intense flash of light, and a sensation of heat on the parts of my body that were exposed. . . . After a few seconds the rising flames lost their brightness and appeared as a huge pillar of smoke with an expanded head like a gigantic mushroom that rose rapidly beyond the clouds probably to a height of the order of 30,000 feet." By measuring the strength of the air blast, Fermi estimated that the force was equal to at least 10,000 tons of TNT.

Robert Oppenheimer thought of a phrase from the Bhagavad Gita: "I am become Death, the destroyer of worlds." Test director Kenneth Bainbridge put it more prosaically, later telling Oppenheimer, "Now we're all sons of bitches."

Los Angeles nor the other cities needed it, but they would if they continued to grow—which was the point of the project in the first place.

While the battle over the diversion dam broke out downstream, some 5,000 men worked around the clock to construct the massive Boulder Dam higher on the river in record speed, with the first concrete poured on June 6, 1933, the last on May 19, 1935. At the time of completion the dam—later renamed for President Herbert Hoover—was the largest concrete structure in the world, containing 3.25 million yards of concrete with over another million yards in the power plant and other works constructed shortly afterward. The reservoir behind the dam, Lake Mead, is still the largest

ARTHUR RAVEL

EYEWITNESS ACCOUNT OF VILLA RAID ON COLUMBUS, NM
REPORTED BY ARTHUR RAVEL, 17-YEAR-OLD BROTHER OF SAM & LOUIS RAVEL, WHO OWNED
RAVEL & BROTHERS MERCANTILE FIRM.

On the morning of March 9, 1916, I was sleeping in my little house about a block from our store. I awoke to bullets coming through my house. I hid under my bed but could hear the Villistas yelling, "Viva Villa!" and "Y que se matar los Gringos," so was pretty sure of what was happening.

Next thing I knew they broke down my front door. They took me with a Villista on each arm to our store barefoot in my BVDs. They told me to open the safe, but I was able to make them think I didn't know the combination. So they shot the safe door and dial several times to no avail.

They marched me to the Commercial Hotel which was owned by my brothers Sam and Louis and operated by Mr. and Mrs. Ritchie. While at the hotel I saw the killing of several hotel guests. They were brought down the stairs and someone upstairs would yell, "Este es Gringo, matar." (He is an American, kill him.)

From the hotel they took me back to our store and then they marched me down the middle of the street to the Columbus State Bank. Why they thought I knew the combination to the bank safe I will never know. By this time our soldiers had taken a position at the bank. As we walked in the middle of the street our soldiers shot my guards just before we got to the drug store.

I took off running north. I stopped at the telephone company house which was operated by Henry Burton and his sister, Ms. Burton, who was one of my schoolteachers. Now the three of us ran about three miles from town to Mr. Lingo's ranch. From Mr. Lingo's we could see the town was on fire. We didn't know what was burning until we got back to town after daylight. I slid on a pair of Mr. Lingo's pants, which were so big I didn't need a shirt.

man-made lake in the United States, stretching 110 miles upstream toward the Grand Canyon and 35 miles up the Virgin River. It contains 28,537,000 acre-feet of water, a little less than two year's average flow of the Colorado. With the Boulder Dam, the Bureau of Reclamation established itself as the major player in western land use, but amid the hoopla the original mission of the bureau was irretrievably lost. The dam did little or nothing for family farmers, feeding instead the insatiable thirst of big cities and large-scale corporate agriculture in the Imperial Valley.

The Colorado River Compact of 1922 set a standard for interstate water agreements in that a substantial amount of water not yet used was set aside for future growth. Unfortunately for the upper basin states, the original allocations were based on an incorrect estimate of almost 18 million acre-feet; in fact, the average flow is around 15 million acre-feet, and it swings erratically year to year from a high of 24 million to a low of 5 million, making it impossible to guarantee water for everyone who needs it, let alone everyone who wants it. Mexico was promised 1.5 million acre-feet in 1944, while various Indian tribes now have claims on almost a million acre-feet in each of the basins. In 1948 the upper basin states agreed among themselves to divide on a percentage basis whatever flow remained after they delivered the required water to the lower river, paving the way for a new series of projects, including the controversial Glen Canyon Dam, completed in 1963 above the Grand Canyon near the dividing point between the basins. Unlike Boulder Dam, which flooded a relatively unattractive section of the river, Glen Canyon Dam flooded the exquisitely beautiful Glen Canyon, first named in 1869 by explorer John Wesley Powell, who poetically described the enchanting land now lost beneath the waters:

Past these towering monuments, past these mounded billows of orange sandstone, past these oak-set glens, past these fern-decked alcoves, past these mural

curves, we glide hour after hour, stopping now and then, as our attention is arrested by some new wonder.

Originally constructed to store water for the upper basin and control the flow through the Grand Canyon below, the Glen Canyon Dam has so totally altered the ecosystem that a 1995 environmental impact report by the Bureau of Reclamation stated simply: "The river is forever changed." Lake Powell, the giant, deep blue reservoir formed by the dam among red rock spires and twisting canyon walls, is a boater's paradise, and those who enjoy its recreational opportunities fiercely defend the lake and the dam that created it, as do those who depend on its water and hydroelectric power. But some experts question whether the dam was ever necessary, and the Sierra Club—which lobbied for the site in the first place, believing it preferable to another proposed site in Dinosaur National Monument—now advocates serious consideration of draining the lake and letting the river flow. It seems unlikely that this will happen in the foreseeable future, but geological time is something else: The river that carved the Grand Canyon will be here long after the dam and the society that created it are gone.

IN THE EARLY 20TH CENTURY, major oil discoveries in Texas, Oklahoma, New Mexico, and California combined with advancements in mass production and a lingering hatred of the railroads to create a national enthusiasm that can be called the cult of the automobile. In a few short decades the automobile replaced the horse and buggy, offering potential for a new freedom to travel that was limited only by the hardtop roads that ended in dusty trails at the edges of cities and towns. The Transportation Act of 1921 made efforts to coordinate gradually developing state highway systems and set standards for road construction. Four years later a revised version of the act established a comprehensive plan for national highway construction, and in 1926 the designation U.S. Route 66 was officially assigned to a network of roads that would begin out-

side the Field Museum of Natural History in downtown Chicago and end in Santa Monica, California, within sight of the Pacific Ocean.

Unlike other national highways of the time, Route 66 was a diagonal leading from the traditional heart of the Midwest through the heart of the Southwest and on to the promised land of California. At the time it was established, only 800 miles of the 2,448-mile route were paved, but during the hard years of the Depression gangs of otherwise out-of-work men had paved the entire route by 1938. Even before then, Route 66 had played an essential role in the shifting demographics of the nation as hundreds of thousands of refugees from Oklahoma, Arkansas, Texas, and other farm states devastated by drought piled their families and their belongings into the Model T or the Ford truck and headed for California. In his novel *The Grapes of Wrath*, John Steinbeck called Route 66 "the mother road, the road of flight," and for most who traveled it, the flight ended in California.

During the 1930s, while the nation as a whole stagnated at a growth rate of just 7 percent, California continue to grow at almost 22 percent, not as fast as the good-time 20s (when the rate was an astounding 66 percent in a single decade) but still an impressive indication that California had become the primary destination for American people in search of a better life. New Mexico also experienced impressive growth during the '30s, at a higher rate even than California though the population was much smaller, while both Arizona and Texas outpaced the national average. Of course, California did not escape the Depression. Californians lost their jobs and went on welfare, and Dust Bowl newcomers faced the debasing exploitation and prejudice that Steinbeck so eloquently portrayed. Yet still they headed West, drawn by a vague dream of sunshine, palm trees, and oranges, as well as a small but very real difference in economic opportunity: In 1938 the average farm wage in Oklahoma was $1.25 a day without housing; in California it was $2.95 with housing. While officials struggled to support some 1.2 million migrant workers, antimigrant forces proposed draconian measures, including federal inter-

vention to force them back to their home states. In the early 1940s, however, when World War II jump-started the economy, migrants entered the mainstream of California society, leaving the fields to take higher paying jobs as a new wave of brown-skinned, Spanish-speaking workers took their places at the backbreaking work under the hot California sun.

Growth in the Southwest during the 1940s was nothing short of astounding. It began with the war itself as soldiers trained throughout the desert regions, while southern California became the center of the defense industry and San Diego served as a vital naval base and shipping-out point for sailors, soldiers, and aviators bound for the South Pacific. In New Mexico an entire top secret city sprang up almost overnight in the mountains northwest of Santa Fe, bringing America's best and brightest scientists into the once sleepy Pueblo-Hispano world to work on the atomic bomb. There were important bases and defense factories in Texas, Arizona, and Nevada as well, and when the war was over, many military men and women returned to the warm, inviting land they had first seen during training, while defense workers stayed on to build ever more sophisticated airplanes, weapons, and satellites for the Cold War. California and Arizona both grew by over 50 percent during the decade, while Nevada, New Mexico, and Texas all grew at well above the national average.

In Nevada, where the relatively low population had been centered in the north following the Comstock silver strikes, a new population center began to blossom in the south at a desolate crossroads that Spanish travelers had named Las Vegas. Perhaps the most improbable of all desert cities, Las Vegas began as a tiny railroad town in 1905, and 25 years later it had a little over 5,000 people before getting a shot in the arm from construction of the Boulder Dam during the 1930s and the opening of a huge magnesium plant in 1941. Around the same time, two lonely motels with legal gambling opened in the desert on the road to Los Angeles, several miles outside the city limits, but the real transformation began in 1946, when Los Angeles

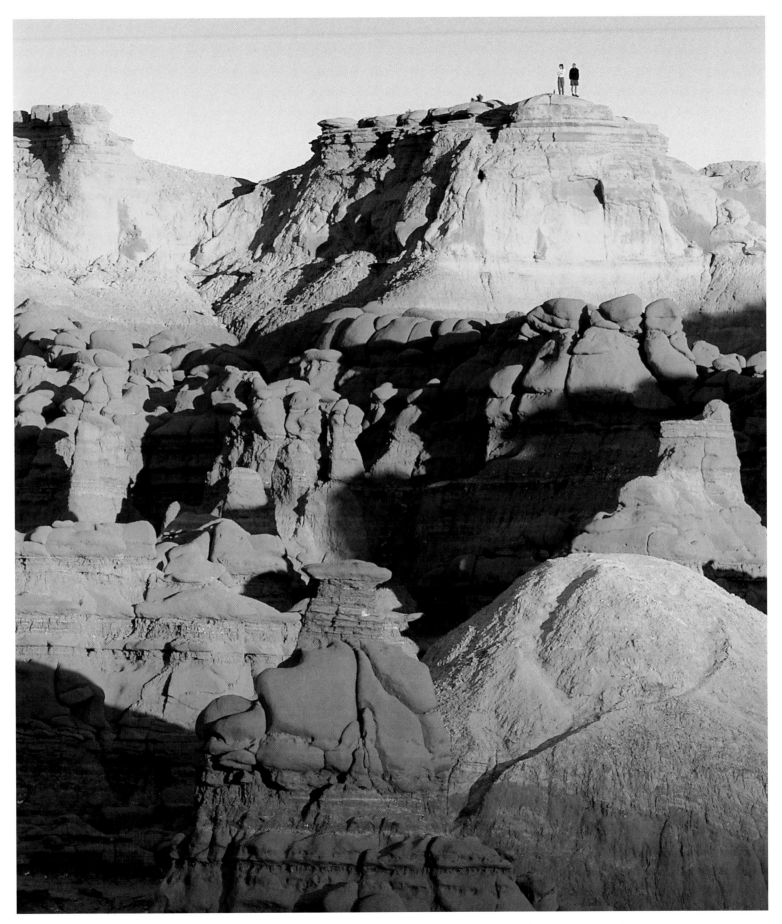

Goblin Valley State Park, Utah

Already growing at a dizzying pace since the turn of the century, Los Angeles exploded after World War II with quickly constructed housing tracts creating the classic suburban sprawl shown in this 1954 aerial photograph. During the fifties the population of Los Angeles County increased by almost two million people, rising from 4.1 million to six million. By the year 2000, the county was home to over 9.5 million, with almost 3.7 million in the city of Los Angeles.

gangster Bugsy Siegel opened his lavish Flamingo Hotel, laying the foundation for what would become the world-famous Vegas Strip.

The explosive growth of the 1940s was the leading edge of a major shift in the American population from the snowbelt states of the industrial Northeast to the sunbelt states of the South and Southwest. In the '50s and '60s the first wave of war-related migration was followed by retirees and families drawn to the promise of cheap suburban homes with neatly manicured lawns and kidney-shaped swimming pools. This began the era of suburban sprawl, when people moved out of city centers all over America, but the vast tracks of available land made the Southwest the poster child of the trend. Los Angeles County, which had remained the leading agricultural center in

California even as urban Los Angeles grew, now became a huge, spreading megalopolis with little distinction between city and suburb and little room for farms. Phoenix experienced exponential growth as well, tripling in the 1950s alone from a population of 106,000 to 439,000 in 1960 living in what was already a sprawling city of 187.4 square miles. Still the sprawl continued as Phoenix aggressively annexed surrounding desert lands until by 1980 it contained almost 800,000 people living in some 330 square miles.

As the Southwest grew in population and agricultural production on irrigated lands, the United States was forced to address the issue of immigration along its 1,951-mile border with Mexico. Before the Mexican Revolution, movement across the border was relatively free; in El Paso it was as easy as walking across a bridge from Juárez and paying a two-cent toll. The border tensions that arose out of the revolution, along with antiforeign feelings engendered by World War I, led to the first attempt to curb immigration in 1917, when Congress raised the head tax for immigrants from four dollars to eight dollars and added a literacy test that required reading from the Bible in the immigrant's native language. Whereas the previous head tax had applied only to Europeans, the new rules applied to Mexicans as well, which forced the poor and often illiterate people looking for work in the United States to cross the border as "visitors" and then get a job anyway. The situation grew more volatile in the early 1920s, when Congress added a ten-dollar visa fee to the eight-dollar head tax and formed the Border Patrol to enforce the new laws.

At first the Border Patrol focused on preventing illegal European and Chinese immigrants from crossing the border through Mexico, but they soon turned their attention to Mexican workers, eliciting protests from large-scale growers in California's Imperial Valley who depended on the Mexicans for seasonal labor in the fields. A compromise allowed workers to be legalized and the requisite fees deducted from their wages, which solved the problem for the growers but did not do much for the workers except lower their already low pay. In 1928, just before the cantaloupe harvest, a strike in the Imperial Valley was illegally suppressed by throwing striking workers into jail. When the workers union protested directly to the president of Mexico, law enforcement officials backed off while growers gave in to the demands of workers—the first time an agricultural strike had succeeded in California.

During the Great Depression, Americans were willing to take menial jobs, and some 500,000 Mexican workers returned to Mexico, either voluntarily or under the strong arm of the Border Patrol. World War II turned the tide again, creating a desperate need for labor, and in order to fill that need while attempting to safeguard the basic rights of the laborers, the United States and Mexico negotiated the Bracero Program in which Mexican laborers could be hired under certain rules. (The term "Bracero," which comes from the same root as *brazo*, or "arm," refers to a day laborer.) The first Bracero agreement lasted from August 1942 to December 1947 and involved a quarter million agricultural and railroad workers. The state of Texas—driven by racist attitudes—refused to follow the rules of the program, so the U.S. government allowed Texas to legalize any Mexican laborer who crossed the Rio Grande. Such racism was not confined to Texas; in 1943 hundreds of off-duty soldiers swept through the Mexican section of Los Angeles, beating up young men in the notorious Zoot Suit Riots.

The second period of the Bracero Program began in February 1948 and lasted until December 1964, bringing some five million Mexican laborers to the United States. Yet even with the program in place, illegal immigration continued because the Bracero Program cost the growers and the government money, and it was thus cheaper to hire illegals. With the general antialien hysteria of the 1950s—defined by the McCarthy hearings but extending to Mexicans as well—attempts to deport illegal workers increased, inspiring one senator to make a statement in 1952 that neatly summed up the absurdity of the situation: "We shall be using more than a million dollars in the next two and one-half months to get Mexican laborers

into our country legally, and at the same time the Department of Immigration is asking for $4 million for the next two and one-half months to keep illegal aliens out." In June 1954 the Border Patrol launched Operation Wetback (named for a racial slur that would be unthinkable for a government program today), sweeping the border from Brownsville to San Diego and deporting over a million Mexicans by the end of the year. The following year, with only a quarter million deportations, the border situation returned to "normal," which meant it was something close to controlled chaos.

In 1962 César Chávez organized migrant farmworkers, and by the end of the decade his grape boycott had brought the plight of the workers and the chaos of the border to national attention. During the early phase of Chávez's struggle the Bracero Program ended under well-meaning criticism that it amounted to little better than slave labor, yet the end of the program simply meant a rise in illegal immigration. Then as now, the workers came as long as the jobs were available. In 1965, attempting to provide more jobs in its own country, the Mexican government created the Border Industrial Program, which encouraged American manufacturers to build plants across the border. The program took off in the mid-1980s when the collapse of the peso made low wages irresistible to American employers. By the late 1980s there were over a thousand plants—called maquiladoras or maquilas—employing more than 300,000 Mexican workers. Though the maquilas have brought relative prosperity and growth to the Mexican side of the border, wages in the maquilas are still lower than what a Mexican can earn in the United States. And therein lies the problem.

The Immigration Control and Reform Act of 1986 offered amnesty to illegal immigrants who had been in the country before 1982, while allowing growers to hire seasonal undocumented workers under certain conditions and mandating stiff penalties for employers who knowingly hired illegals in the future. Although providing a temporary breath of sanity to the border situation,

the effects of the law were short-lived, and the 1990s saw an explosion of illegal immigration with increasingly desperate attempts to control it. In 1994 California's Proposition 187 gained national attention as voters sought to deny educational and social services to illegal immigrants. Although the proposition has never been fully implemented because of legal challenges, the fact that it passed with a strong majority in a state usually noted for progressive social attitudes indicates the level of anti-immigrant sentiment in the border region.

That same year, even as President Bill Clinton spoke out against Proposition 187, his administration began a get-tough policy along the border led by Operation Gatekeeper, aimed at pushing illegal immigration out of the San Diego-Tijuana area. Similar programs were later launched in Arizona and Texas, but though these all-out efforts have been successful in their specific target areas, the effect on illegal immigration as a whole is questionable at best. Even the Immigration and Naturalization Service, which attempts to defend the programs, admits that the number of illegal immigrants has remained steady at about 275,000 each year despite billions of dollars spent to stop them. At the same time, arrests have risen dramatically, indicating that more people than ever are trying to cross. Those who succeed simply move around the heavily blockaded areas, crossing in deserts and mountains where hundreds die each year due to exposure and thirst.

The North American Free Trade Agreement (NAFTA) of 1993 has done much to open the border in economic terms, and some leaders maintain that the border should be as open to human traffic as it is to trade. In early 2001, after meeting with U.S. legislators and governors at an economic forum, Mexican president Vicente Fox announced that he believed his goal of a fully open border might be reached "in time." President George W. Bush has indicated that he will continue his predecessor's tough enforcement of the border, hiring even more Border Patrol officers to "make our borders something more than lines on a map," and in an interview before his election he summed up the problem with President

Fox's open border concept: "When the wage differential narrows, then perhaps it is a strategy we can explore jointly." That wage differential is the driving force, just as it was for the migrant American workers who came to California during the Depression. Whether the border is open or not, Mexican people will continue to cross it as long as they believe they can find a better life on the other side of the line.

IN THE 2000 CENSUS CALIFORNIA had almost 34 million people while Texas passed New York as the second largest state with almost 21 million, which means that about one out of every five Americans now lives in either California or Texas, once the most desolate and underpopulated outposts of New Spain. The rest of the Southwest is less densely populated, yet the four fastest growing states in the nation—Nevada, Arizona, Colorado, and Utah—were all carved out of land once claimed by Spain. The same can be said of six of the ten largest cities: Los Angeles, Houston, Dallas, Phoenix, San Diego, and San Antonio. People who identify themselves as Hispanic or Latino are now the largest minority population in the nation, and though illegal immigration gets the headlines, it plays a fractional role in a larger picture of legal immigration and American-born Hispanic-Latino people, some of whom can trace their roots on this side of the border over the course of four centuries. The heritage of Spain and Mexico imbues the Southwest with a uniquely rich culture, but that is only part of the story. Asians are a strong presence in California, going back to the gold rush, while African Americans are a large minority in Texas, dating back to the days of slavery. American Indian people have been all but lost in the onslaught, yet in New Mexico and Arizona they hold substantial lands and make up a powerful minority population.

During the 20th century the population of the United States grew from around 75 million to 281 million, an increase of some 375 percent; during the same period the seven states that roughly define the American Southwest—California, Arizona, New Mexico, Texas, Nevada, Utah, and Colorado—grew from 5.7 million to 67.7 million, an increase of 1,187 percent. If we go back further, to the time of the Mexican War when the United States obtained most of these lands, the difference would be even more dramatic, but no matter how we crunch the numbers, the fact is that under U.S. control the Southwest has experienced unrestrained growth in what is essentially a desert.

Most of the Southwest receives less than 20 inches of annual rainfall and about half receives less than 10 inches. Water is life and there is a booming population in a dry land. Despite all the talk about rivers, the more pressing issue is groundwater, which farmers and homesteaders have been tapping since the earliest days of settlement. Other essential resources—coal, oil, and natural gas—are also being depleted and unlike groundwater, which can be replenished over time, these are nonrenewable. At the dawn of the 21st century, the raging energy crisis in California offers a sobering reminder that growth cannot continue unabated without the resources to support it. Though the scope and details have changed, none of these issues are really new. Human beings have lived among the deserts, mountains, and rivers of the Southwest for over 11,000 years and they have wrestled with the land, changing and adapting as best they could. None of these cultures ever truly disappeared; their descendants live among us, sharing our modern world while reminding us of the unbroken chain that links us with the past.

We have technical abilities the early people never dreamed of—we can split the atom and bend the rivers to our will—yet we too are being forced to change and adapt to the ever-changing land, to find new solutions to old problems and bring a collective creativity to the questions we face. How will we answer these questions? Will we fade into the stones and sands and cliffs as yet another culture rises in our stead? Or will we break through ancient barriers to find a new and better balance between the land and the people who live on it? Only time will tell.

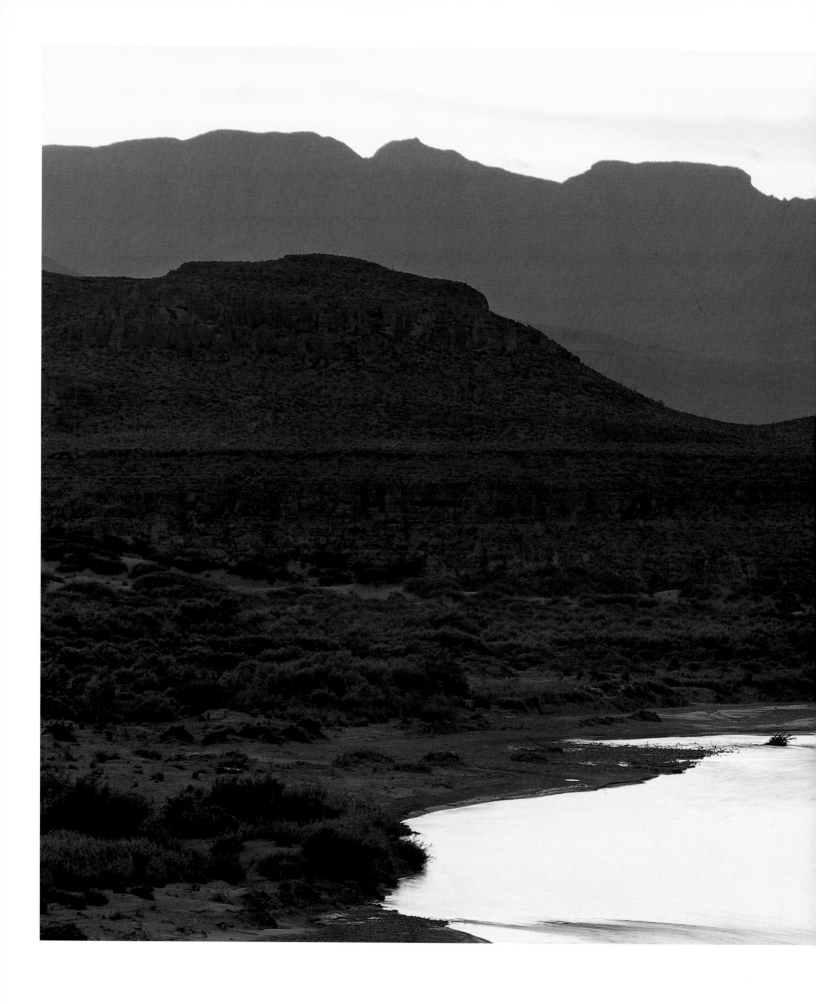

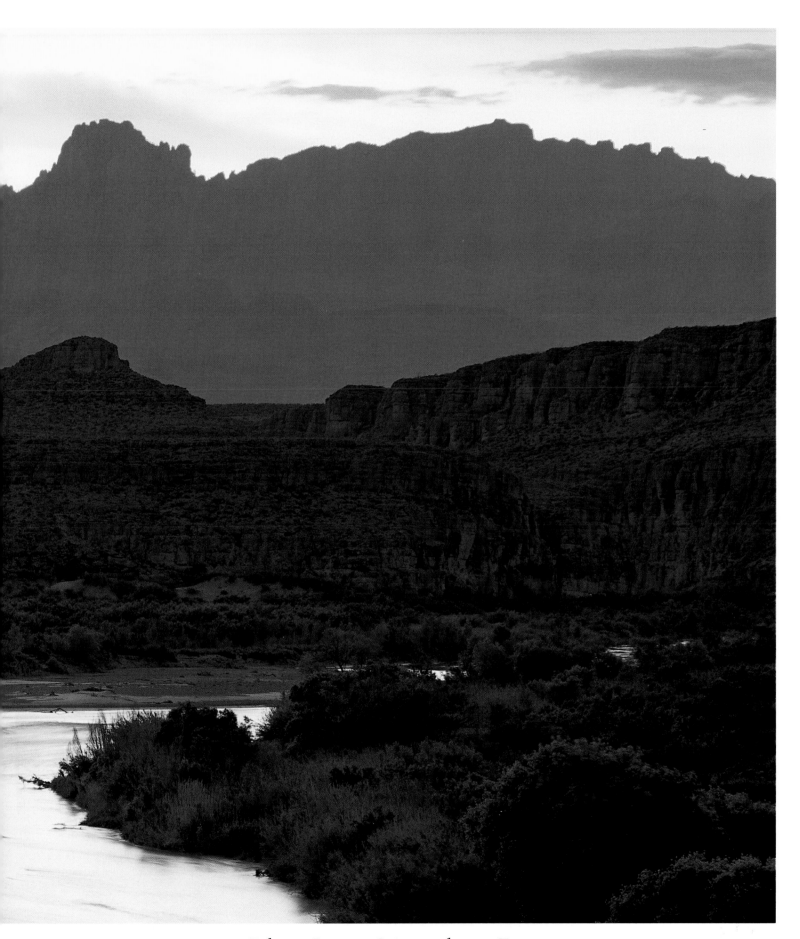

The Rio Grande, Texas

Abbott, David R. "Ceramic Markers of Ancient Communities." Tempe: Office of Cultural Resource Management, Arizona State University, 1999.

Archaeological Institute of America. Website (http://www.archaeology.org).

Ball, Eve. *In the Days of Victorio: Recollections of a Warm Springs Apache.* Tucson: The University of Arizona Press, 1970.

———. *Indeh: An Apache Odyssey.* Provo, UT: Brigham Young University Press, 1980.

Barrett, S.M. *Geronimo: His Own Story.* New York: E.P. Dutton & Co., 1970.

Bartlett, John Russell. *Personal Narrative of Explorations and Incidents . . .* , 2 vols. 1854. Reprint, with introduction by Odie Faulk, Chicago: The Rio Grande Press, 1965.

Bazant, Jan. *A Concise History of Mexico: from Hidalgo to Cárdenas, 1805-1940.* London: Cambridge University Press, 1977.

Boldurian, Anthony T. "Elephants in the Sand." 1994.

Boldurian, Anthony T. and John Cotter. *Clovis Revisited: New Perspectives on Paleoindian Adaptations from Blackwater Draw, New Mexico.* Philadelphia: University Museum, University of Pennsylvania, 1999.

Bolton, Herbert Eugene. *Rim of Christendom: A Biography of Eusebio Francisco Kino, Pacific Coast Pioneer.* New York: The Macmillan Company, 1936.

Bowman, J.N. and Robert F. Heizer. *Anza and the Northwest Frontier of New Spain.* Los Angeles: Southwest Museum, 1967.

Brooks, George R., ed. *The Southwest Expedition of Jedediah S. Smith: His Personal Account of the Journey to California, 1826-1827.* Glendale, CA: Arthur H. Clark Co., 1977. Reprint, Lincoln: University of Nebraska Press, 1989.

Brown, Dee. *Hear that Lonesome Whistle Blow: Railroads in the West.* New York: Holt, Rinehart and Winston, 1977.

Castañeda, Pedro de, et. al. *The Journey of Coronado.* Translated and edited by George Parker Winship. 1933. Reprint, New York: Dover Publications, 1990.

Chartkoff, Joseph L. and Kerry Kona Chartkoff. *The Archaeology of California.* Stanford: Stanford University Press, 1984.

Cordell, Linda S. *Ancient Pueblo Peoples.* Washington, D.C.: Smithsonian Books, 1994.

Covey, Cyclone, trans. and ed. *Cabeza de Vaca's Adventures in the Unknown Interior of America.* The Crowell-Collier Publishing Company, 1961. Reprint: Albuquerque: University of New Mexico Press, 1983.

Crutchfield, James A. *Tragedy at Taos: the Revolt of 1847.* Plano, TX: Republic of Texas Press, 1995.

Dale, Edward Everett. *The Indians of the Southwest: A Century of Development Under the United States.* Norman: University of Oklahoma Press, 1949.

Dary, David. *The Santa Fe Trail: Its History, Legends, and Lore.* New York: Alfred A. Knopf, 2000.

Davis, Margaret Leslie. *Rivers in the Desert: William Mulholland and the Inventing of Los Angeles.* New York: HarperCollins Publishers, 1993.

Davis, William C. *Three Roads to the Alamo: The Lives and Fortunes of David Crockett, James Bowie, and William Barret Travis.* New York: HarperCollins Publishers, 1998.

DeConde, Alexander. *This Affair of Louisiana.* New York: Charles Scribner's Sons, 1976.

Dedera, Don. *A Little War of Our Own: The Pleasant Valley Feud Revisited.* Flagstaff: Northland Press, 1988.

Duffus, R.L. *The Santa Fe Trail.* New York: Tudor Publishing Co., 1930.

Dufour, Charles L. *The Mexican War: A Compact History, 1846-48.* New York: Hawthorn Books, 1968.

Eagen, I. Brent. *San Diego de Alcalá: California's First Mission.* San Diego: Mission Basilica San Diego de Alcalá, n.d.

Edmondson, J. R. *The Alamo Story: From Early History to Current Conflicts.* Plano, TX: Republic of Texas Press, 2000.

Folsom, Franklin. *Black Cowboy: The Life and Legend of George McJunkin.* Revised edition. Niwot, CO: Roberts Rinehart Publishers, 1992.

Fradkin, Philip L. *A River No More: The Colorado River and the West.* New York: Alfred A. Knopf, 1981.

Gregg, Josiah. *The Commerce of the Prairies.* 1844. New York: The Citadel Press, 1968.

Hammond, G. P. and A. Rey. *Narratives of the Coronado Expedition, 1540-42.* Albuquerque: University of New Mexico Press, 1940.

———. *The Rediscovery of New Mexico.* Albuquerque: University of New Mexico Press, 1966.

Handbook of North American Indians.. William G. Sturevant, general editor. Washington, D.C.: Smithsonian Institution Press, 1978-98.

Handbook of Texas Online. Website (http://www.tsha.utexas.edu/handbook/online/).

Historical United States Census Data Browser. Website, (http://fisher.lib.virginia.edu/census/).

Hollon, W. Eugene. *The Lost Pathfinder: Zebulon Montgomery Pike.* Norman: University of Oklahoma Press, 1949.

Hundley, Norris, Jr. *The Great Thirst: Californians and Water, 1790s-1990s.* Berkeley and Los Angeles: University of California Press, 1992.

Jackson, Donald, ed. *The Journals of Zebulon Montgomery Pike, with Letters and Related Documents,* 2 vols. Norman: University of Oklahoma Press, 1966.

Jacobsen, Joel. *Such Men as Billy the Kid: The Lincoln County War Reconsidered.* Lincoln: University of Nebraska Press, 1994.

John, Elizabeth A. H. *Storms Brewed in Other Men's Worlds: The Confrontation of Indians, Spanish, and French in the Southwest, 1540-1795.* Lincoln: University of Nebraska Press, 1975.

Josephy, Alvin M., Jr. *The Civil War in the American West.* New York: Vintage Books, 1991.

Katz, Friedrich. *The Life & Times of Pancho Villa.* Stanford: Stanford University Press, 1998.

Katz, Lienke. *The History of Blackwater Draw.* Portales: Eastern New Mexico University, 1997.

Krauze, Enrique. *Mexico: Biography of Power: A History of Modern Mexico, 1810-1996.* Translated by Hank Heifetz. New York: HarperCollins Publishers, 1997.

Lamar, Howard R. *The Far Southwest, 1846-1912: A Territorial History.* New Haven: Yale University Press, 1966.

Lamar, Howard, R. ed. *The New Encyclopedia of the American West.* New Haven: Yale University Press, 1998.

Lavender, David. *California: Land of New Beginnings.* New York: Harper & Row, 1972. Reprint, Lincoln: University of Nebraska Press, 1987.

———. *The Great Persuader.* Garden City, NY: Doubleday & Company, 1970.

———. *The Southwest.* New York: Harper & Row, 1980.

LeBlanc, Steven A. "Violence in the Prehistoric Southwest." *Discovering Archaeology* 1, no. 3 (1999): 42-47.

Lekson, Stephen H. "The Center of the Universe." *Discovering Archaeology* 1, no. 3 (1999): 56-64.

———. *The Chaco Meridian: Centers of Political Power in the Ancient Southwest.* Walnut Creek, CA: AltaMira Press, Rowman and Littlefield Publishers, 1999.

Long, Jeff. *Duel of Eagles: The Mexican and U.S. Fight for the Alamo.* New York: William Morrow and Company, 1990.

Loomis, Noel M. and Abraham P. Nasatir. *Pedro Vial and the Roads to Santa Fe.* Norman: University of Oklahoma Press, 1967.

Luckingham, Bradford. *Phoenix: The History of a Southwestern Metropolis.* Tucson: The University of Arizona Press, 1989.

Marks, Paula Mitchell. *And Die in the West: The Story of the O.K. Corral Gunfight.* New York: William Morrow and Company, 1989.

Mares, E. A., et. al. *Padre Martinez: New Perspectives from Taos.* Taos: Millicent Rogers Museum, 1988.

Meltzer, David J. *Search for the First Americans.* Washington, D.C.: Smithsonian Books, 1993.

Metz, Leon C. *Border: The U.S.-Mexico Line.* El Paso, TX: Mangan Books, 1989.

Morgan, Dale. L. *Jedediah Smith and the Opening of the West.* Indianapolis: Bobbs-Merrill Co., 1953. Reprint, Lincoln: University of Nebraska Press, 1964.

Myers, Lee. *Fort Stanton, New Mexico: The Military Years, 1855-1896.* Lincoln, NM: Lincoln County Historical Society Publications, July 1988.

Nasatir, Abraham P. *Borderland in Retreat: From Spanish Louisiana to the Far Southwest.* Albuquerque: University of New Mexico Press, 1976.

Noble, David Grant. *Ancient Ruins of the Southwest: An Archaeological Guide.* Revised and Expanded. Flagstaff: Northland Publishing, 2000.

———. *Pueblos, Villages, Forts & Trails: A Guide to New Mexico's Past*. Albuquerque: University of New Mexico Press, 1994.

O'Connor, Richard. *Iron Wheels & Broken Men: The Railroad Barons and the Plunder of the West*. New York: G. P. Putnam's Sons, 1973.

Officer, James E., Mardith Schuetz-Miller, and Bernard L. Fontana, eds. *The Pimería Alta: Missions and More*. Tucson: The Southwestern Mission Research Center, 1996.

Ormsby, Waterman L. *The Butterfield Overland Mail*. Edited by Lyle H. Wright and Josephine M. Bynum. San Marino, CA: The Huntington Library, 1955.

Paul, Rodman W. *Mining Frontiers of the Far West: 1848-1880*. New York: Holt, Rinehart and Winston, 1963.

Pletcher, David M. *The Diplomacy of Annexation: Texas, Oregon, and the Mexican War*. Columbia: University of Missouri Press, 1973.

Polzer, Charles W., S.J. *Kino: A Legacy*. Tucson: Jesuit Fathers of Southern Arizona, 1998.

Pourade, Richard F. *Anza Conquers the Desert: The Anza Expeditions from Mexico to California and the Founding of San Francisco, 1774 to 1776*. San Diego: Union-Tribune Publishing Co., 1971.

———. *The Call to California: The Epic Journey of the Portola-Serra Expedition in 1769*. San Diego: Union-Tribune Publishing Co., 1968.

Powell, John Wesley. *Down the Colorado: Diary of the First Trip Through the Grand Canyon*. Promontory Press, 1970.

———. *The Cañons of the Colorado*. Golden, CO: Outbooks, 1981.

Powell, Lawrence Clark. *Arizona: A Bicentennial History*. New York: W.W. Norton & Company, 1976.

Rawls, James J. *Indians of California: The Changing Image*. Norman: University of Oklahoma Press, 1984.

Reid, Jefferson and Stephanie Whittlesey. *The Archaeology of Ancient Arizona*. Tucson: The University of Arizona Press, 1997.

Reisner, Marc. *Cadillac Desert: The American West and its Disappearing Water*. New York: Viking Penguin, Inc., 1986.

Riley, Carroll L. *Rio del Norte: People of the Upper Rio Grande From Earliest Times to the Pueblo Revolt*. Salt Lake City: University of Utah Press, 1995.

Roberts, David. *Once They Moved Like the Wind: Cochise, Geronimo, and the Apache Wars*. New York: Simon and Schuster, 1993.

Sabin, Edwin L. *Kit Carson Days, 1809-1868*, 2 vols. 1935. Rev. ed., Lincoln: University of Nebraska Press, 1995.

Sando, Joe S. *Pueblo Nations: Eight Centuries of Pueblo Indian History*. Santa Fe: Clear Light Publishers, 1992, 1998.

———. *Pueblo Profiles: Cultural Identity through Centuries of Change*. Santa Fe: Clear Light Publishers, 1998.

Schieffelin, Edward. *Destination Tombstone: Adventures of a Prospector*. Compiled by Marilyn F. Butler. Mesa, AZ: Royal Spectrum Publishing, 1996.

Serpico, Philip C. *Santa Fe Route to the Pacific*. Palmdale, CA: Omni Publications, 1988.

Simmons, Marc. *The Last Conquistador: Juan de Oñate and the Settling of the Far Southwest*. Norman: University of Oklahoma Press, 1991.

———. *New Mexico: A Bicentennial History*. New York: W.W. Norton & Company, 1977.

Simmons, Marc, ed. *On the Santa Fe Trail*. Lawrence: University Press of Kansas, 1986.

Simmons, Marc, et. al. *The Santa Fe Trail: New Perspectives*. Colorado Historical Society, 1987. University Press of Colorado, 1992.

Skiles, Jack. *Judge Roy Bean Country*. Lubbock: Texas Tech University Press, 1996.

Sofaer, Anna and Rolf M. Sinclair. "Astronomical Markings at Three Sites on Fajada Butte." In *Astronomy and Ceremony in the Prehistoric Southwest*, edited by John B. Carlson and W. James Judge. Las Vegas, NM: Maxwell Museum of Anthropology, 1983.

Sofaer, Anna. "The Primary Architecture of the Chacoan Culture: A Cosmological Expression." In *Anasazi Architecture and American Design*, edited by Baker H. Morrow and V.B. Price. Albuquerque: University of New Mexico Press, 1997.

Sonnichsen, C. L. *Roy Bean: Law West of the Pecos*. New York, Macmillan, 1943. Reprint, Lincoln: University of Nebraska Press, 1991.

Sons of DeWitt Colony Texas. Website (http://www.tamu.edu/ccbn/dewitt/dewitt.htm).

Starr, Kevin. *Americans and the California Dream*, 6 volumes. New York: Oxford University Press, 1973-2002.

Stuart, David E. *Anasazi America: Seventeen Centuries on the Road from Center Place*. Albuquerque: University of New Mexico Press, 2000.

Sweeney, Edwin R. *Cochise: Chiricahua Apache Chief*. Norman: University of Oklahoma Press, 1991.

———. *Mangas Coloradas: Chief of the Chiricahua Apaches*. Norman: University of Oklahoma Press, 1998.

Tefertiller, Casey. *Wyatt Earp: The Life Behind the Legend*. New York: John Wiley & Sons, 1997.

Terrell, John Upton. *Estevanico the Black*. Los Angeles: Westernlore Press, 1968.

———. *Pueblos, Gods and Spaniards*. New York: The Dial Press, 1973.

———. *Zebulon Pike: The Life and Times of an Adventurer*. New York: Weybright and Talley, 1968.

Thrapp, Dan L. *The Conquest of Apacheria*. Norman: University of Oklahoma Press, 1967.

———. *Victorio and the Mimbres Apaches*. Norman: University of Oklahoma Press, 1974.

Tombstone Epitaph. Reprint, October 27, 1881.

Torres, Luis. *San Antonio Missions*. Tucson: Southwest Parks and Monuments Association, 1993.

Trafzer, Clifford E. *The Kit Carson Campaign: The Last Great Navajo War*. Norman: University of Oklahoma Press, 1982.

Treaty between the United States of America and the Navajo Tribe of Indians, with a record of the discussions that led to its signing. Las Vegas, NV: KC Publications, 1968.

Trimble, Marshall. *Arizona: A Panoramic History of a Frontier State*. New York: Doubleday & Company, 1977.

Turner, Alford E., editor. *The O.K. Corral Inquest*. College Station, TX: Creative Publishing Company, 1981.

Turner, Christy G. II. "A Reign of Terror." *Discovering Archaeology* 1, no. 3 (1999): 48-51.

U.S. Census Bureau. Website (http://www.census.gov/).

Utley, Robert M. *High Noon in Lincoln: Violence on the Western Frontier*. Albuquerque: University of New Mexico Press, 1987.

———. *The Indian Frontier of the American West, 1846-1890*. Albuquerque: University of New Mexico Press, 1984.

———. *A Life Wild and Perilous: Mountain Men and the Paths to the Pacific*. New York: Henry Holt and Company, 1997.

Villagrá, Gaspar Pérez de. *Historia de la Nueva México, 1610*. Translated and edited by Miguel Encinias, Alfred Rodríguez, and Joseph P. Sánchez. Albuquerque: University of New Mexico Press, 1992.

Walker, Paul Robert. "Rivers to the Pacific." In *Exploring the Great Rivers of North America*. Washington, D.C.: National Geographic Society, 1999.

———. *Trail of the Wild West: Rediscovering the American Frontier*. Washington, D.C.: National Geographic Society, 1997.

Warner, Ted J., ed. *The Domínguez-Escalante Journal: Their Expedition through Colorado, Utah, Arizona, and New Mexico in 1776*. Translated by Fray Angelico Chavez. Salt Lake City: University of Utah Press, 1995.

Water Education Foundation. "Layperson's Guide to the Colorado River." Sacramento: Water Education Foundation, 1998.

Weber, David. J. *The Mexican Frontier, 1821-1846: The American Southwest Under Mexico*. Albuquerque: University of New Mexico Press, 1982.

———. *The Spanish Frontier in North America*. New Haven: Yale University Press, 1992.

———. *The Taos Trappers: The Fur Trade in the Far Southwest, 1540-1846*. Norman: University of Oklahoma Press, 1971.

Weigle, Marta. *The Penitentes of the Southwest*. Santa Fe: Ancient City Press, 1970.

Whiteman, James Ridgley. Interview by author. Tape recording. Clovis, NM, October 10, 2000.

Whitford, William C. *The Battle of Glorieta Pass: The Colorado Volunteers in the Civil War*. 1906. Reprint, with new material, Glorieta, NM: The Rio Grande Press, 1994.

Worcester, Donald E. *The Apaches: Eagles of the Southwest*. Norman: University of Oklahoma Press, 1979.

The Southwest
Gold, God, and Grandeur

Paul Robert Walker

Published by the National Geographic Society

John M. Fahey, Jr., *President and Chief Executive Officer*

Gilbert M. Grosvenor, *Chairman of the Board*

Nina D. Hoffman, *Executive Vice President*

Prepared by the Book Division

Kevin Mulroy, *Vice President and Editor-in-Chief*

Charles Kogod, *Illustrations Director*

Barbara A. Payne, *Editorial Director*

Marianne R. Koszorus, *Design Director*

Staff for this Book

Johnna M. Rizzo, *Editor*

Molly Roberts, *Illustrations Editor*

Cinda Rose, *Art Director*

Alexander Feldman, *Researcher*

Carl Mehler, *Director of Maps*

Matt Chwastyk, *Map Research and Production*

Tibor G. Tóth, *Map Relief*

R. Gary Colbert, *Production Director*

Richard S. Wain, *Production Project Manager*

Janet Dustin, *Illustrations Assistant*

Manufacturing and Quality Control

George V. White, *Director*

Clifton M. Brown, *Manager*

Phillip L. Schlosser, *Financial Analyst*

Library of Congress Cataloging-in-Publication Data

Walker, Paul Robert.
 The Southwest : gold, God, and grandeur / Paul Robert Walker ; photographs by
George H. H. Huey.
 p. cm.
 Includes bibliographical references and index.
 ISBN 0-7922-6436-3 (hc.)
 1. Southwest, New--History. 2. Southwest, New--Discovery and exploration. 3.
Southwest, New--Ethnic relations. 4. Indians of North America--Southwest,
New--History. 5. Indians of North America--Government relations--History. 6. Indians
of North America--Missions--Southwest, New. 7. United States--Territorial
expansion--History. 8. United States--Relations--Mexico. 9. Mexico--Relations--United
States. I. Huey, George H. H. II. Title.

F786.W334 2001
979--dc21

2001031714

The world's largest nonprofit scientific and educational organization, the National Geographic Society was founded in 1888 "for the increase and diffusion of geographic knowledge." Since then it has supported scientific exploration and spread information to its more than eight million members worldwide.

The National Geographic Society educates and inspires millions every day through magazines, books, television programs, videos, maps and atlases, research grants, the National Geographic Bee, teacher workshops, and innovative classroom materials.

The Society is supported through membership dues, charitable gifts, and income from the sale of its educational products.

Members receive NATIONAL GEOGRAPHIC magazine—the Society's official journal—discounts on Society products, and other benefits.

For more information about the National Geographic Society, its educational programs, publications, or ways to support its work, please call 1-800-NGS-LINE (647-5463), or write to the following address:

National Geographic Society
1145 17th Street N.W.
Washington, D.C. 20036-4688 U.S.A.

Visit the Society's Web site at www.nationalgeographic.com.

Printed in Spain.

Printed and bound by Cayfosa Industria Grafica, Barcelona, Spain. Color separations by North American Color, Portage, Michigan.